COLORS IN
FASHION

COLORS IN FASHION

Edited by
**JONATHAN FAIERS AND
MARY WESTERMAN
BULGARELLA**

BLOOMSBURY VISUAL ARTS
LONDON • NEW YORK • OXFORD • NEW DELHI • SYDNEY

BLOOMSBURY VISUAL ARTS
Bloomsbury Publishing Plc
50 Bedford Square, London, WC1B 3DP, UK

BLOOMSBURY, BLOOMSBURY VISUAL ARTS and
the Diana logo are trademarks of Bloomsbury Publishing Plc

First published in Great Britain 2017 by Bloomsbury Academic
Paperback edition first published 2018

Cover design: Sharon Mah
Cover image: Detail of page from Joyce Clissold's dye book 1930s,
Central St Martins Museum & Study Collection. Photograph: Jet.

A catalogue record for this book is available from the British Library.

Library of Congress Cataloging-in-Publication Data
Names: Faiers, Jonathan, author. | Bulgarella, Mary Westerman, author.
Title: Colors in Fashion / edited by Jonathan Faiers and Mary Westerman Bulgarella.
Description: New York, NY : Bloomsbury Visual Arts, 2017. | Includes
bibliographical references and index.
Identifiers: LCCN 2016027533 (hardcover) | LCCN 2015041622 (ebook) |
ISBN 9780567664051 (alk. paper) | ISBN 9780567664044 ()
Subjects: LCSH: Fashion-Philosophy. | Colors-Psychological aspects.
Classification: LCC TT507 .C657 2017 | DDC 746.9/2_dc23 LC
LC record available at http://lccn.loc.gov/2016027533

ISBN: HB: 978-1-4742-7368-8
 PB: 978-1-3500-7740-9
 ePDF: 978-1-4742-7369-5
 ePub: 978-1-4742-7371-8

Typeset by Integra Software Services Pvt. Ltd.
Printed and bound in Great Britian

To find out more about our authors and books visit
www.bloomsbury.com and sign up for our newsletters.

CONTENTS

LIST OF ILLUSTRATIONS

Figures

Plates

LIST OF CONTRIBUTORS

Margaret Olugbemisola Areo obtained a Fine Arts degree specializing in Textile Design and an MFA degree in Textiles from the Obafemi Awolowo University, Ile-Ife, Nigeria and subsequently a PhD in Art History. She was self-employed as a textile/fashion designer for fifteen years after her first degree and succeeded in training many young school leavers in an apprenticeship program. Margaret entered academia after her MFA and is currently Associate Professor in the Department of Fine and Applied Arts of Ladoke Akintola University of Technology, Ogbomoso, Nigeria, where she lectures on all textile-related courses.

Adebowale Biodun Areo graduated from the University of Lagos, Akoka-Lagos, in 1979. He joined the services of the National Commission for Museums and Monuments in Nigeria and was curator at a number of prestigious Nigerian museums such as the National Museums of Ile-Ife, Benin, Ilorin, and Osogbo. Adebowale worked in the Nigerian museum system for over three decades before venturing into academia. He also studied in the Obafemi Awolowo University, where he obtained an MBA and PhD in Marketing. He is currently Associate Professor of Business Administration in the Wesley University of Science and Technology, Ondo, where he lectures.

Beatrice Behlen studied fashion design in Germany before moving to London in 1989. Following a postgraduate course in the History of Dress at the Courtauld Institute, she worked as curatorial assistant at Kensington Palace, taught fashion and design students at several art colleges, and worked at a contemporary art gallery. At the beginning of 2003, Beatrice returned to Kensington Palace where she curated and co-curated exhibitions on royal dress, before moving to the Museum of London in late 2007 where she is Senior Curator of Fashion & Decorative Arts. Beatrice has also been delivering seminars on subcultures and the use of sources at Central Saint Martins since 2005. Out of general curiosity, her experience at Historic Royal Palaces, and fuelled by the holdings of her present place of work, Beatrice's main interest is the link between clothes and biography.

Joy L. Bivins is director of Curatorial Affairs at the Chicago History Museum where she has collaborated on a number of exhibition projects including *Teen*

Chicago; the Chicago installation of *Without Sanctuary: Lynching Photography in America*; *Facing Freedom in America*; and *Inspiring Beauty: 50 Years of Ebony Fashion Fair*. She coedited and contributed to the *Inspiring Beauty* catalog and has contributed to the *Journal of American History*, *Chicago History*, and *NKA: Journal of Contemporary African Art*. Joy received her Bachelor's degree in Afro-American Studies and History from the University of Michigan and earned a Master's degree in Africana Studies from Cornell University.

Anna Buruma trained and worked as a theater designer and later as a costume designer for television and film. During the 1990s, she graduated with an MA degree in Art History from the Courtauld Institute, specializing in the History of Dress. Anna has been the archivist at Liberty & Co. since 1995 and curator at Central Saint Martins Museum since 2005. She has published articles on various aspects of dress, including "'A Clinging Liberty Tea-gown instead of a Magenta Satin': The Colour Red in Artistic Dress" by Liberty & Co. for *Costume* 41. Anna has also written *Liberty in the Fifties and Sixties: A Taste for Design* (Antique Collectors' Club, 2009).

Alison Matthews David is Associate Professor in the School of Fashion, Ryerson University in Toronto, Canada, and Graduate Program Director of the Master of Arts in Fashion program. Her research focuses on material and visual culture in the long nineteenth century. Alison's most recent projects include *Fashion Victims: The Pleasures and Perils of Dress in the 19th Century*, an exhibition co-curated with Elizabeth Semmelhack at the Bata Shoe Museum in Toronto (2014–2016), and the book *Fashion Victims: The Dangers of Dress Past and Present* (London: Bloomsbury, 2015). She is currently working on a second book for Bloomsbury on the history of clothing and crime.

Emmanuelle Dirix is Principal Lecturer of Critical and Contextual studies at Manchester Metropolitan University (MMU) and Historic Research at the Antwerp Fashion Academy. She specializes in fashion history and theory and held previous appointments at the Royal College of Art, Chelsea College of Arts, and the University of Manchester. She regularly contributes to academic volumes, journals, and exhibition catalogs on fashion, textiles, and design. Recent works include *Birds of Paradise: Feathers, Fetishism and Costume in Classical Hollywood. Film, Fashion and Consumption* (2015); *Feathers Fringes and the Spectacular Modern Flapper: Ode to a Fallen Type, Jazz Age: Fashion in the Roaring Twenties. Snoeck* (2015); *Stitched Up—Representations of Contemporary Vintage Style Mania and the Dark Side of the Popular Knitting Revival. Textile: The Journal of Cloth and Culture* (2014); and *Dressing the Decades* (Yale University Press, 2016). In 2011, she curated *Unravel: Knitwear in Fashion* at the Momu, Antwerp, and edited the accompanying publication (Editions Lanoo, 2011), and she has published

a series of Fashion Source books (Carlton-Fiell). Emmanuelle is co-editor of the forthcoming journal *The Journal of Sex, Text and Culture* (Intellect).

Jonathan Faiers is Professor of Fashion Thinking, Winchester School of Art, University of Southampton, and his research examines the interface between popular culture, textiles, and dress. His publications include *Tartan* (Berg, 2008) and *Dressing Dangerously: Dysfunctional Fashion in Film* (Yale University Press, 2013). Recently he has written essays for *Alexander McQueen* (V&A, 2015), *Developing Dress History: New Directions in Method and Practice* (Bloomsbury, November 2015), *London Couture 1923–1975: British Luxury* (V&A, November 2015), and *Critical Luxury Studies: Art, Design and Media* (Edinburgh University Press, March 2016). In 2014, Jonathan launched *Luxury: History, Culture, Consumption* (Taylor & Francis, http://www.tandfonline.com/toc/rflu20/current)—the first peer-reviewed, academic journal to investigate the globally contested subject of luxury. He lectures internationally on textiles and dress and is a founding member of the Winchester Luxury Research Group and a member of the Costume Colloquium's Advisory Committee.

Sarah Fee is Curator of Eastern Hemisphere Textiles & Costume at the Royal Ontario Museum and is a member of the affiliated faculty of the Department of Art at the University of Toronto. She holds degrees in Anthropology and African Studies from Oxford University and the Institut National des Langues et Civilisations Orientales, Paris. For over twenty years, Sarah has been carrying out research in Madagascar, particularly on hand weaving and the social significance of cloth and dress. Her recent research, supported by the Social Sciences and Humanities Research Council of Canada, focuses on the hand-weaving and textile trades of the western Indian Ocean world. Sarah has authored numerous articles on the textile arts of Madagascar and beyond.

Michelle Tolini Finamore is the Penny Vinik Curator of Fashion Arts at the Museum of Fine Arts, Boston, and obtained her PhD from the Bard Graduate Center in New York. She has worked in a curatorial capacity for the Costume Institute at the Metropolitan Museum of Art, and as a fashion specialist at Sotheby's auction house. Michelle has curated a range of exhibitions including *#techsytyle*, *Hollywood Glamour: Fashion and Jewelry from the Silver Screen*, and *Think Pink* at the Museum of Fine Arts, Boston, *Cocktail Culture* at the Norton Museum of Art, and assisted with *Jacqueline Kennedy: The White House Years* at the Metropolitan Museum of Art. She has taught courses on fashion, design, and film history at the Rhode Island School of Design and Massachusetts College of Art. Michelle most recently co-authored *Gaetano Savini: The Man Who Was Brioni* (Assouline, 2015), authored *Hollywood Before Glamour: Fashion in American Silent Film* (Palgrave, 2013), and co-authored *Jewelry by Artists: In the Studio, 1940–2000* (Museum of Fine Arts, Boston, 2010). She has lectured widely and

written numerous articles for both the scholarly and popular press, including *Fashion Theory, Architecture Boston*, *European Dance and Performance Studies*, and *Gastronomica*.

Kate Irvin is Curator and Department Head of Costume and Textiles at the RISD Museum, a part of the Rhode Island School of Design in Providence, Rhode Island. There, she oversees a collection of 30,000 fashion and textile items that range in date from c. 1500 BCE to now and represent traditions and innovations across the globe. Her recent exhibitions and projects at the museum include *All of Everything: Todd Oldham Fashion* (2016); *Swagged and Poufed: The Upholstered Body in the Late 19th Century and Today* (2016); *Ensnared in Flowers I Fall on Grass* (2014); and *Artist/ Rebel/Dandy: Men of Fashion* (2013). She is currently working on a multidisciplinary exhibition that will investigate the theme and aesthetics of repair, both as a concrete action applied to beloved, precious objects and as a philosophical meta-concept having to do with generalized healing in a world saturated with mass-produced goods and the ills generated by their manufacture. The exhibition will showcase sympathetic past practices of repair from around the globe alongside innovative art and design projects that are illuminated and electrified by their example.

Deirdre Murphy is Senior Curator at Historic Royal Palaces. She is based at Kensington Palace, where she has curated exhibitions about royal fashion, court life, Queen Victoria, and led the refurbishment of important palace interiors. Deirdre has also curated fashion exhibitions at the Gallery of Costume in Manchester and the Victoria and Albert Museum. She lectures regularly on fashion history, museum interpretation, and curating at London College of Fashion, Central Saint Martins, and Leeds University. Deirdre is also Chairman of the Costume Society.

Piyanan (Poom) Petcharaburanin graduated from the Faculty of Arts, Chulalongkorn University, where she majored in Italian and minored in English. In 1999, she began her career as a journalist and columnist for sports newspapers and magazines. She was a foreign correspondent in Italy from 2002 to 2004. In 2008, Piyanan became a full-time editor for a work and lifestyle monthly magazine in Bangkok. Her interest in indigenous Thai textiles led to her present position as in-house writer and editor at the Queen Sirikit Museum of Textiles, where she is responsible for exhibition texts, books, and museum publications. She wrote the Thai version of the museum's exhibition catalogs, *In Royal Fashion: The Style of Her Majesty Queen Sirikit of Thailand*, and *The Storyteller: An Exhibition in Honor of HRH Princess Maha Chakri Sirindhorn's 60th Birthday*. Piyanan's research interests include northeastern Thai hand-weaving and natural dyeing techniques, color rules at the Thai court (the theme of an educational installation she helped develop at the museum), and the collection of Indonesian batiks assembled by King Chulalongkorn of Thailand in the late nineteenth century.

Clare Rose is a dress historian with a special interest in the fashion industry from 1840 to 1914, and in the disjuncture between the ways that clothes were discussed and depicted and the visual and material qualities of the garments as artefacts. Her most recent book is *Art Nouveau Fashion* (V&A Publishing, 2014), and she was lead editor for *Clothing, Society and Culture, 1840–1914* (Pickering & Chatto, 2011). She has published extensively and has contributed to exhibitions and publications for Berlin State Museums, The Women's Library London, The National Archives, and The John Johnson Collection of the Bodleian Library. Clare is Lecturer in Contextual Studies for the Degree Program at the Royal School of Needlework, London, and also lectures on the history of dress at the Victoria & Albert Museum.

Michal Lynn Shumate received her BA in Art History from the University of Chicago and is currently an MA candidate in Visual and Critical Studies at The School of the Art Institute of Chicago. Drawing from her background in dressmaking, theater production, and work with collections like the Black Fashion Museum at the Smithsonian Institute and the Fashion Resource Center at SAIC, her writing investigates contemporary fashion and its mode of presentation. Often taking the form of performative lectures, her research topics include fashion exhibitions and runway shows, and more recently, domestic spaces and closets in particular. Michal Lynn's publications include *Fashion in the Expanded Field: The House of Viktor & Rolf* and *Valentino a Roma* (*DRESS*, 2014).

Kate Strasdin is Senior Lecturer of History & Theory at the Fashion and Textile Institute, Falmouth University. She is also a Specialist Visiting Lecturer in Fashion History at the DeTao Masters Academy in Shanghai and an accredited lecturer for NADFAS—the National Association of Decorative and Fine Arts Societies. Kate is Deputy Curator at the Totnes Fashion and Textile Museum, Devon, UK. She has published papers in *The Journal of Design History and Costume*—the Journal of the Costume Society—and has written for *Selvedge*. Her doctoral thesis studied the surviving garments of Queen Alexandra in museums around the world, research that is due to be published as a monograph by Bloomsbury Academic in 2018.

Kimberly Wahl is Associate Professor in the School of Fashion, Ryerson University, Toronto. She holds a PhD in Art History from Queen's University, where her dissertation focused on late nineteenth-century Aesthetic Dress in the context of British visual culture and Aestheticism. This resulted in her first book *Dressed as in a Painting: Women and British Aestheticism in an Age of Reform* (2013). Her current research focuses on the complex relationship between fashion and academic feminism. Kimberly was recently awarded a grant from the Social Sciences and Humanities Research Council of Canada to investigate the interconnections between the Suffrage Movement and dress practices in Britain at the turn of the century.

ACKNOWLEDGMENTS

The compilation of the texts in this publication is the direct result of the Costume Colloquium conferences, which have been held biennially at the Auditorium al Duomo in the center of Florence, Italy, since 2008. This has been made possible by the constant and continual support of the Romualdo Del Bianco Foundation and their umbrella organization Life Beyond Tourism in collaboration with the Association of Friends of the Galleria del Costume. The goals of the Foundation are to provide a forum within the city of Florence for the international promotion of cultural exchange of which the Costume Colloquium is the perfect example. They are to be applauded and thanked for all they do and have done to make the conferences a continual success.

The editors would like to thank their Costume Colloquium IV: *Colors in Fashion* Advisory Committee cohorts (Gillion Carrara, Daniela Degl'Innocenti, Carlotta Del Bianco, Joanna Marshner, Roberta Orsi Landini, Alexander Palmer, and Rosalia Varoli-Piazza). Similar to the committee's selection of speakers for the conference, the editors had an arduous task choosing which out of the many stimulating oral presentations were to be translated into the written texts comprising this volume. Thanks go not only to all who submitted proposals, but also to those whose papers were accepted and spoke at the *Colors in Fashion* conference.

The editors also wish to thank the staff at Bloomsbury, in particular Hannah Crump who believed in this publication since its inception and Winchester School of Art, University of Southampton, for their support.

INTRODUCTION

Jonathan Faiers and Mary Westerman Bulgarella

Any history of colour is, above all, a social history. Indeed, for the historian—as for the sociologist and the anthropologist—colour is a social phenomenon. It is society that "makes" colour, defines it, gives it its meaning, constructs its codes and values, establishes its uses, and determines whether it is acceptable or not.

(PASTOUREAU 2001: 10)

In what is arguably one of the most succinct and yet insightful definitions of the importance of color, Michel Pastoureau the eminent medieval historian, expert on heraldry and holder of the Chair of the History of Western Symbolism at the Sorbonne in Paris, emphasizes color's social construction alongside its essentially mutable status. It is not surprising that it requires the author of over thirty books on subjects including the histories of pigs, bears, and unicorns, the Knights of the Round Table, coins, seals (the sort attached to documents rather than the mammal), the seminal *The Devil's Cloth: A History of Stripes and Striped Fabric*, as well as his work on color with individual books on *Black, Blue,* and *Green*, our childhood memories of color, and its utilization in contemporary photographic practice, to describe color so perceptively. This all-embracing approach to visual symbolism and its importance to cultural formation is also essential to the understanding of color in this volume.

The texts gathered together in *Colors in Fashion* interrogate and discuss how color, via its manifestation through fashionable dress, has played a significant historical role in the formation of society and continues to do so today. Fashion is understood in the context of this book to encompass not only the popularly accepted meaning of the term as typically rapid and cyclical manufacturing and design-led changes in the clothes people wear, but *Colors in Fashion* also asks the reader to consider the term as representing variation and development in established forms of dressing that might be considered remote from the Western concept of fashion. Indeed, fashion is understood both as change and making: that is to "fashion" and how color has been implicated in processes of fabrication that encompass identity formation, colonial expansion, and societal demarcation.

Color is vital to our very existence, since colorlessness is, after all, equated to lifelessness, sterility, and death. We understand being "in the pink" as a state of good health, of passing difficult challenges "with flying colors," and who isn't happy to receive the "red carpet treatment?" However, for every positive chromatic idiom, there are many more that ascribe negative connotations to every color under the sun. We regularly turn "green with envy," "feel blue," are "caught red handed," and might even be named a "yellowbelly." This indeterminacy is temporally, economically, linguistically, and geographically dependent and what was once a desirable hue might rapidly become abhorrent according to where a color is experienced. So to a non-Western viewer, the list of colorful phrases discussed previously might be nonsensical or generate diametrically opposite interpretations. This slippery metaphorical shading becomes even more problematic when color becomes tangible in the form of dress and textiles, so the multiple meanings constructed when color is worn is due, as Philippe Perrot the dress historian suggests, because:

"Clothing, like language, always happens somewhere in geographical and social space. In its form, colour, material, construction, and function— and because of the behaviour it implies—clothing displays obvious signs, attenuated markings or residual traces of struggles, cross-cultural contacts, borrowings, exchanges between economic regions or cultural areas as well as among groups within a single society" (Perrot 1994: 7).

It is this complexity that the *Colors in Fashion* contributors explore and celebrate. The color of fashionable, ceremonial, and occupational dress is the most immediately apparent evidence of its "struggles," "borrowings," and "exchanges." Redolent of the oppressive histories of marginalization and demarcation, the physical signs of wear and age as well as the accelerated and quixotic condition of fashion, color, like Elizabeth Wilson's noteworthy reference to the work of Thomas Carlyle, is understood as "unspeakably meaningful" (Wilson 2003: 3). *Colors in Fashion* is an attempt to speak the unspeakable language of color, to begin to account for its unceasing polysemy—an objective that demands a diversity of discourses that together, it is hoped, provide a set of potential guides through the chromatic complexities of dress.

The origin of these texts is similarly steeped in color, the color of a city— Florence, Italy—the home of the Costume Colloquium. The fourth meeting held in 2014 with a synonymous title to this present volume, was the catalyst for this book. It is entirely fitting that Florence provided the venue for such a richness of chromatic research. It is a city that literally wears its colors on its sleeve, from the bands of green marble decorating the facades of its most illustrious architecture to the rainbow of colors on display in the windows of some of the world's most luxurious retailers. Historically, Florence was the city that provided the setting

for color's shift from medieval allegorical symbolism to a more human-centered appreciation of color ushered in with the Renaissance with which the city is indelibly associated. Florence is so steeped in fashion that it is befitting as the location of the Costume Colloquium conferences.

From its simple, yet meaningful inaugural 2008 meeting *A Tribute to Janet Arnold*, dedicated to the renowned dress historian, Costume Colloquium has developed into one of the most successful and unique gatherings of international, interdisciplinary, and intercultural like-minded people focused on themes related to dress and fashion in all of its vicissitudes. Clothing, dress, costume, fashion, however it is called is, after all, our second skin. It is what we first see when we encounter another human being, often before noticing physical characteristics and certainly before we hear someone speak and therefore it becomes a text that demands interpretation, a statement which says something about who we are and what we think, for as Umberto Eco famously and directly expressed it: "I speak through my clothes" (Eco 1972: 61).

Costume Colloquium is dedicated to understanding, interpreting, and delighting in this language in all of its many and varied forms. The meetings unite those who make, wear, design, recycle, study, analyze, conserve, and preserve dress. Together, attendees discuss how fashion runs our economies, determines our social rituals, and influences our psychological and emotional states. By understanding the global centrality of dress and how throughout history it has played a crucial role in cultural and political formations, and continues to do so today, we can move closer toward a global understanding and tolerance of difference, a difference manifested through the clothes each of us choose to wear. To date, the biennial Costume Colloquium conferences have explored such themes as *Dress for Dance* (2010), *Past Dress-Future Fashion* (2012), *Colors in Fashion* (2014), as well as the most recent edition, *Excess and Restraint in Fashion and Dress* (2016), which auspiciously coincides with the launching of this present volume.

With such a tempting palette of chromatic scholarship to choose from, it has been necessary to select work that initiates a dialogue both with specific formulations of color in fashion and with the other texts included in this volume, and it has been one of the greatest surprises and rewards received as editors of this volume to understand just how communicative color can be. It is hoped, therefore, that the reader will discover for themselves not only new and stimulating research into color by leading scholars but also how so many of the themes discussed individually speak a similar language that transcends historical, cultural, and economic specificities.

The book has been divided into four broad subject areas: "Color and Solidarity," "Color and Power," "Color and Technology," and "Color and Desire." In these sections, color is analyzed as an agent for social change, stratification, and indeed consolidation. Its chromatically unifying function is discussed via its

use in uniforms, military wear, court dress (both Western and non-Western), and also as a subversive agent allowing its wearers to gather under the banner of a specific hue to express political solidarity and visual opposition to the status quo. The important role that technology has had to play in the development of new dyes, ways of applying and experiencing color, and indeed subliminally registering it demonstrates that color in fashion historically has always been an agent for technical innovation and continues to inspire designers, artists, and performers today. The texts gathered together in this volume can be understood as a distillation of the multifaceted and indeed multi-colored contribution to Costume Colloquium IV, a representative selection from the rainbow of research presented and enjoyed that reflects the Colloquium's abiding goal of maintaining the highest standard of academic research, which Janet Arnold had promoted and achieved throughout her career.

Section One: "Color and Solidarity"

Color and the creation of belonging, support, and solidarity through dress and its specific coloring is the subject of this section. Texts in this section discuss color as an assertion of cultural celebration, as protest and opposition. Color is often understood as expressive of a specific political ideology or as simple resistance, but color in dress is never straightforward and as the texts in this section demonstrate it is as mutable, nuanced, and varied as color itself. Commencing with "Color as Theme in the Ebony Fashion Fair" by Joy Bivins, the recent exhibtion held at the Chicago History Musuem devoted to the Ebony Fashion Fair is central to her discussion of how color was understood as culturally determined among African American consumers in the second half of the twentieth century. Questions concerning the increased access to fashionable color, how color was expressive of a specfic cultural bias, and the "education" in color promoted to audiences in the United States, Canada, and the Caribbean by *Ebony* magazine and the Johnson Publishing Company's groundbreaking fashion show are indicative of color's cultural cohesion.

Following the vibrant presentations of the Ebony Fashion Fair, Kimberly Wahl's "Purity and Parity: The White Dress of the Suffrage Movement in Early Twentieth Century Britain" discusses the importance of the "non-color" white to the British Suffrage Movement in the early twentieth century. White's symbolic resonance of purity, spirituality, and as an evocation of Classical antiquity is understood within the context of an Edwardian artistic and fashionable sensibility. The pioneering feminists of the Women's Social and Political Union and their choice of predominantly white dress are understood in Wahl's text as simultaneously highly symbolic, knowingly fashionable, and viusally expressive of a specific political ideology. As with the other texts in this section, Wahl's interrogation of tonally

uniform, consistent color's ability to form optically cohesive fields is exploited for its spectacular effect, a chromatic manifestation of solidarity.

Moving from Edwardian Britain to contemporary Nigeria, Margaret Olugbemisola Areo and Adebowale Biodun Areo's exploration of the Aso-Ebi cloth tradition in their text "Birds of the Same "Color" Flock Together: Color as Expression of Identity and Solidarity in Aso-Ebi Cloth of the Yoruba" demonstrates the fundamental role color plays in ceremonial dress. Originating as a practice referring to the wearing of the same color and pattern of cloth as an expression of familial group identity, Aso-Ebi has extended its original limitations to encompass a broader demonstration of group identification. Allegiance through color is now an essential component of contemporary Yoruba culture with the Aso-Ebi fashion practice indicative of solidarity, unity, cohesion, support, and identification.

Section One closes with Emmanuelle Dirix's "Contradictory Colors: Tricolor in Vichy France's Fashion Culture," which reveals the essential instability and shifting sociopolitical resonance of color. Problematizing a straightforward reading of the tricolor's familiar red, white, and blue in occupied France, the text discusses how our perception of ideological color choices is never straightforward and further complicated when institutionalized in the form of historical exhibitions. Dirix's text shares a concern with other texts in this volume that discuss the disjuncture between the written and mediated descriptions of color and their optical reality, providing in this instance fascinating evidence that the choice of red, white, and blue was not always a political gesture, but an economic expediency.

Section Two: "Color and Power"

Color is powerful. Used throughout history to express privilege, wealth, and dynastic rule, color has been incorporated into visual narratives of nationalism and enduring tradition. The texts comprising this section explore the exercise of power through color, both within established ceremonial and ritual traditions and as expressions of individual assertions of power. Color that can be "read" by both the advantaged and disadvantaged has meant that understandably color has played a central role in court life and the maintenance of social hierarchies. Color has also been used to devalue and detract, and at specific periods of history and in particular locations certain colors have become indelibly associated with the "other," the undesirable and the feared.

The fascinating imbrication between color, fortune, and the calendar is explored in Piyanan Petcharaburanin and Alisa Saisavetvaree's account of "Dress and Color at the Thai Court." The ancient Thai tradition of wearing specific colors on each day of the week is positioned within the cultural and religious traditions of Thai court life and illuminated by accounts provided by nineteenth-century travellers. What might be understood as an ancient tradition that would inevitably

lose its significance and power with the onset of modernism in the twentieth century is seen, conversely, as an example of color's continuing effectiveness as a conduit for dynastic continuity, with the tradition transposed to Parisian couture by the remarkable Queen Sirikit during her royal tours.

Kate Strasdin's "'Gold and Silver by Night'. Queen Alexandra: A Life in Color" also discusses color as a means of communicating royal power and as an effective form of sartorial public relations. Alexandra directly influenced public opinion and augmented her increasing popularity in late Victorian and Edwardian Britain by her astute fashion and color choices. Commencing with a detailed description of how she began to assert her independence from Queen Victoria's dominance of court dress etiquette, Strasdin moves on to explore how Alexandra, once Queen, increasingly deployed color as an effective means of establishing herself as a more subtle and diplomatic monarch, but also fascinatingly how color came to her aid later in life as a form of protection, or armor deflecting unwarranted attention when at her most vulnerable.

Individual prestige and the psychological influence of ceremonial color are the central themes of Deirdre Murphy's account of "Lord Boston's Court Uniform: A Story of Color, Politics and the Psychology of Belonging." Through the detailed analysis of this establishment figure's relationship to his court uniform, its centrality to his own construction of self-worth, and the implication of color in the loss of esteem when prohibited from wearing it, we understand how color has the power to produce trauma and anxiety. As in Wahl's and Areo's texts, color here is discussed as facilitating a sense of belonging, representative of not so much a sense of solidarity and unification, but as an all too fleeting badge of acceptance of admission to the ranks of power, which just as easily vanishes once those colors are no longer able to be worn. Drawing on extensive archival research including first-hand accounts, tailor's bills, and a meticulous study of the uniform itself, her text provides access to color's pivotal position in identification and projection, here demonstrating perfectly the resonance of the simple phrase "you are what you wear."

Proscription, marginality, and mutability are the primary concerns of Jonathan Faiers's study of yellow. In his "Yellow Is the New Red, or Clothing the Recession and How the Shade of Shame Became Chic," the reader understands how one particular color, in this instance yellow, can shift its ideological position according to the culture which views or wears it. For a considerable period in the West, yellow is discussed as the shade of shame—the color of the outcast and the enforced hue of the undesirable—while in the East it is celebrated as noble, powerful, and held in the highest esteem. This seemingly entrenched notion, however, is finally proven to be unstable and the text ends with a consideration of its recent reappraisal in the context of global recession, revisiting again a recurring motif of this volume, which is color's essentially transforming and transformative nature.

Section Three: "Color and Innovation"

Throughout history, developments in color have been at the forefront of technical transformations and have generated equal amounts of creative inspiration and admiration when promoted as fashion. From the synthetic dye revolution of the late eighteenth and nineteenth centuries, developments in early color photographic and cinematic processes and today's contemporary digital revolution have all influenced, and indeed been inspired by, color's infinite possibilities for the demonstration of technical modernisation. Color's relationship to light has been central to so much of this experimentation, a chromatic revelation that continues to grow with each successive wave of technological invention.

Michelle Finnamore's "Color before Technicolor: Colorized Fashion Films of the Silent Era" skilfully combines many of the interrelated subjects of this section in her exploration of the early processes used for coloring silent film. How those same processes often mirrored scientific processes employed in the dissemination of the fashion image itself and advances in textile printing demonstrate clearly the connectedness of color, fashion, and innovation. Most fascinatingly, she reveals how in the primarily black-and-white world of pioneering popular cinema, color was reserved for its representation of the world of fashion, emphasizing the indissolubility of our understanding of fashion as color and of the new as colorful.

The continuing relationship between new technology, fashion, and color is brought up to date with Michal Lynn Shumate's exploration of the Dutch design duo Viktor & Rolf's deployment of blue screen technology in "Color as Concept: From International Klein Blue to Viktor & Rolf's 'Bluescreen.'" Her initial account of this pioneering fashion show then leads Shumate on an exciting voyage of discovery of the importance of the color blue in both fashion and artistic innovation, ranging in subject matter from the Renaissance painter Giotto's innovative use of blue to Yves Klein's championing of the color in the twentieth century. Drawing on a rich palette of literary and critical references, including Derek Jarman's film *Blue* (an inspirational work that also features in the final essay in this volume by Kate Irvin), she returns to fashion proposing that through Viktor & Rolf's often monotone collections the primacy of color over line approaches fashionable color as an ultimately sensate experience, a condition of being in, literally, a state of pure physical color.

Alison Matthews David considers an earlier period of chromatic innovation, namely the development of artificial dyes, in particular the craze for vivid synthetic greens in the nineteenth century. In her text "Tainted Love: Oscar Wilde's Toxic Green Carnation, Queerness, and Chromophobia," she explores how novelty equating to fashionability soon turned to condemnation and fear due to the new dye's harmful physical effects. This physical danger was then transformed into moral danger and became a symbol of society's degenerescence once the color was

favored by members of the Aesthetic Movement of the later nineteenth century. This disapprobation crystallized around the figure of Oscar Wilde and his notorious green carnation. Sharing a similarity with Faiers's discussion of yellow as the shade of shame, Matthews David deploys her study of green to understand not only the mutability of a color's reception but also, crucially for this section, how swiftly the desire for colorful technical innovation is transfigured into a fear of the strange and the unknown.

The section concludes with "Starlit Skies Blue versus Durindone Blue" by Anna Buruma, an insightful and fascinating case study of two contrasting dye books from leading textile colorists of the early twentieth century. This beguiling research into innovative textile color printing employs the close reading of these important records of color experimentation to assess again the complex relationship between fashion, innovation, and color and how the demand for color in the early to mid-twentieth century drove creativity. The contrast between the two working methods is skillfully revealed in Buruma's discussion of the processes themselves recorded in the dye books, but also by an assessment of their physical appearance, and crucially their semantic classification of color. This last concern, the literal naming of color, reoccurs throughout this volume as of vital importance and how the ever-present distance between the optical experience of color and its lexicon was negotiated.

Section Four: "Color and Desire"

The constant desire engendered by color in consumer and producer alike has presaged social change, behavior, and indeed emotional responses throughout history and across groups united often only by their chromatic desires. Ranging from eighteenth-century Ghana to postwar Paris, the desire for color has been the catalyst for cultural transformation and is examined in detail in the texts included in this final section. The authors understandably articulate a number of issues that have been signaled in some of the earlier texts, desire, after all, has always been a catalyst for, and indeed symptom of, solidarity, power, and innovation. Commencing with Clare Rose's "Rough Wolves in the Sheepcote: The Meanings of Fashionable Color 1900–1914," a sudden shift in fashionable color from pastels and delicate shades to a richer more vibrant palette is seen as being implicated within a wider nexus of cultural, artistic, and political changes in society. Essential to Rose's text is the fluidity between the physical presence of color and its "idea," and the allusive vocabulary adopted by fashion writing at this time to record this chromatic shift. The close relationship between fashionable color and art history prefigures that explored by Shumate and is also a topic refocused in the final text in this section by Kate Irwin. The geopolitical consideration of color and its naming discussed by Rose also provides a link to other politicized dress of the same period such as that of the Suffrage Movement

encountered in Wahl's text and Dirix's account of the ideological opposition foregrounded in fashion's use of the French tricolor.

Paris postwar is the setting for Beatrice Behlen's erudite exploration of the desire for that other "non-color" black. In "Le noir étant la dominante de notre vêture …: The Many Meanings of the Color Black in Post-War Paris," Behlen brilliantly situates the emerging fashion for black within a complex literary, philosophical, and artistic discourse, mediated through specific personalities that came to prominence in Paris immediately after the Second World War. Running contrary to prevailing fashions of the time, and flouting gender conventions, the devotees of Parisian postwar black demonstrated the full weight of color as a signifying system. With black popularly understood as nihilistic and emptied of meaning in this context, the text redresses this misconception and reveals that, conversely, it is to paraphrase Wilson again "unspeakably meaningful."

Desire resides at the very heart of Sarah Fee's text "British Scarlet Broadcloth, The Perfect Red in Eastern Africa, c. 1820–1885," which powerfully interrogates the demand for British red broadcloth in West Africa during the nineteenth century. This consumer demand for a specific shade and quality of cloth is embedded within, and symptomatic of, the dominant colonial and economic histories of the area. However, as with Petcharaburanin's discussion of the specific cosmology of the Thai Royal color codes and also Areo's understanding of the unifying ability of color in the Aso-Ebi tradition, Fee's discussion of scarlet broadcloth is evidence of color's ability to assume multicultural influences and its constantly shifting status. Most importantly in this text, fashion, especially the fashion for certain colors, is seen as a global construct rather than the traditionally understood Western system and further proof of the desirability of color unfettered by cultural and geographical boundaries.

The final text in this volume, Kate Irvin's "Lives Lived: An Archaeology of Faded Indigo," returns us to the physical experience of color, in this case blue, and the specific ability of indigo when used in work wear to act as a direct sensory conduit to past experiences. Like Shumate, she too calls upon Derek Jarman and a number of fine artists to take us on a journey into the tonal complexities to be found in indigo-dyed clothing. Irvin's text is not to be understood as a mere nostalgic encounter, instead it is an engagement with color that interrogates fashion's relationship to utilitarian wear, color as a philosophy, and color as a narrative form. For Irvin, the intensity, the fading, and the transference of color are symptomatic of its protean composition—a grounding in the physicality of color that provides a suitable climax to this volume's chromatic voyage. The question David Batchelor asks in his seminal *Chromophobia* seems especially pertinent to all of the texts that comprise *Colors in Fashion*.

Colour is in everything, but it is also independent of everything. Or it promises or threatens independence. Or is it the case that the more we treat colour as independent, the more we become aware of its dependence on materials and

surfaces; the more we treat colour in combination with actual materials and surfaces, the more its distinctiveness becomes apparent? (Batchelor 2000: 95)

Color's independence yet its intrinsic reliance on its incorporation into forms of dress to fully appreciate its objectivity is the subject of the new research gathered together here. It is through forms of dress, whether ceremonial, fashionable, or occupational, that color can be most clearly understood as representative of national identity, of subjugation and resistance. The relationship between color and dress highlights the often violent and uncomfortable histories that provide the background to what might otherwise seem entirely arbitrary or purely fashionable and economic decisions concerning what colors are made available, who produces and wears them. Who has been prohibited to wear certain colors, broken with social convention to wear certain colors, or been forced to wear certain colors is a complex and fascinating story that the texts in this volume reveal. In addition, each understands and takes into account the powerful visual attraction (and sometimes repulsion) that color has exerted throughout history and across geographic, economic, and cultural boundaries. Color's developmental history and dissemination have been shaped by legal battles concerning who has access to color, who has the right to manufacture and apply color, and who can name color, so that underlying our contemporary, apparently relaxed attitude to color lies a chromatic complexity that speaks of wars, economic ascendancies and declines, migrations, and meetings.

It is our sincere hope that the scholarship represented by this compendium of colorful thought will inspire further research into color's centrality to our understanding, appreciation, and experience of clothing. Recalling again the origin of this present volume, we are reminded of the closing remarks to Costume Colloquium IV: Colors in Fashion given by Alexandra Palmer who related the story of how when asking her son which was his favorite color he responded "rainbow," and it is this inclusivity and sense of wonder that we hope is also present in *Colors in Fashion*.

References

Batchelor, D. (2000), *Chromophobia*, London: Reaktion.

Eco, E. (1972), "Social Life as a Sign System," in D. Robey (ed.), *Structuralism: An Introduction: The Wolfson College Lectures*, 57–72, Oxford: Clarendon Press.

Pastoureau, M. (2001), *Blue: The History of a Color*, Princeton, NJ: Princeton University Press.

Perrot, P. (1994), *Fashioning the Bourgeoisie: A History of Clothing in the Nineteenth Century*, Princeton, NJ: Princeton University Press.

Wilson, E. (2003), *Adorned in Dreams: Fashion and Modernity*, London: I.B. Tauris

SECTION ONE

COLOR AND SOLIDARITY

1
COLOR AS THEME IN THE EBONY FASHION FAIR

Joy L. Bivins

Between May 2011 and February 2013, Chicago History Museum staff developed an exhibition entitled *Inspiring Beauty: 50 Years of Ebony Fashion Fair*. The installation, which opened in March 2013, occupied just over 7,000 square feet, or 650 square meters, and included sixty-seven fully articulated mannequins dressed in ensembles created by some of the fashion world's most revered designers, as well as lesser-known but no less significant ones (Plate 1.1). All garments were borrowed from the collection of the Johnson Publishing Company, a key figure in the exhibition story. The *Inspiring Beauty* project explored the history of a unique fashion phenomenon called the Ebony Fashion Fair—a traveling fashion show developed and promoted by Chicago-based media giant, Johnson Publishing Company for five decades. The traveling extravaganza, which regularly featured more than 150 garments in each show, took its name from the fashion column of that company's premier publication, *Ebony*—a magazine developed primarily to visually capture and reflect the best of black American life. This text examines some of the key ideas about the traveling fashion show that *Inspiring Beauty* attempted to interpret. While it explores the history and context of the traveling fashion show, this text also highlights that color, as a reiterated aesthetic theme, was utilized within the Ebony Fashion Fair to shape its audiences' perceptions of the possibilities of fashion and style.

When the first Ebony Fashion Fair took place in 1958, black Americans were still crippled by the challenges of legal segregation and racial violence. Indeed, institutionalized racism impacted nearly every aspect of black life, from where one lived and went to school to where and how one shopped. However, in spite of the realities of racism, this was also a moment full of great promise as the activism and protests of the Civil Rights Movement became more visible and African Americans began to demand fuller inclusion in American life. Against this backdrop of historic change, the Ebony Fashion Fair took to the road bringing

garments to the still-segregated South and the less-segregated North. In its first season, the traveling fashion show stopped in nearly thirty cities around the United States, including Cincinnati, Chicago, Atlanta, and New Orleans. In each venue, it brought the latest European and American fashions to majority black and female audiences. Each show offered eager audiences the chance to see exclusive and unique garments which were typically only accessible on the pages of fashion magazines and almost always on non-black bodies. This formula of bringing high design from European and American fashion centers and presenting those garments on black models remained constant as the show grew and added more designers and new cities to its schedule. Indeed, until its last season in 2009, the Ebony Fashion Fair afforded audiences the opportunity to see creations from haute couture fashion houses such as Dior, Yves Saint Laurent, Emanuel Ungaro, and Valentino. As important, it showcased designs from well- and lesser-known black American designers including Stephen Burrows, Rufus Barkley, and b michael.

In every venue, Ebony Fashion Fair audiences were treated to a show that was just under two hours and included multiple ensembles, ranging from daywear and swimwear to formal evening wear and a bridal finale. In those shows, models did more than simply wear the garments; they performed in them. Models delighted crowds with their dancing, precise twirling, and acting ability performing in short sketches that often featured male and female models dressed in coordinating ensembles. Within the show, fashion and entertainment merged to create a one-of-a-kind experience. The show didn't discriminate based on location either. It brought the same fashions and performance to audiences in smaller towns, such as Itta Bena, Mississippi, or Peoria, Illinois, that it did to those in the American fashion capitals of New York City or Los Angeles. By the mid-1970s, the show had grown so popular that the traveling season lasted the majority of the year—beginning in the fall and ending in the spring. During the next decade the show reached the peak of its popularity and brought designer fashions to more than 180 cities and to tens of thousands of viewers. In addition to a fashion showcase, the traveling show was a charity fund-raiser that raised more than 55 million dollars for various black charities across the United States. Likewise it performed an entrepreneurial role as each ticket came with a subscription to either *Ebony* or *Jet* magazine, a means to increase or, at least, sustain Johnson Publishing Company's readership.

Above all, the Ebony Fashion Fair was a celebration of the fantasy of fashion and garments within it were selected because of their flair, opulence, and exclusivity. The show was a spectacular production, but it was also a celebration of black beauty on a grand scale. It was not lost on anyone in the audience that the garments were not only beautiful but they were modeled on striking women and men who looked like people in their communities, like those in their families, like them. Specifically, the show gave black women a

chance to not only see themselves as the standard of beauty but it, in many ways, normalized the audacious display of black beauty and black glamour. The Ebony Fashion Fair runway, especially in the show's earliest years, provided a platform for its audience to see blackness displayed in ways rarely seen within mainstream culture. In this context, the show aligned itself strictly with *Ebony* and other Johnson Publishing periodicals, which were all about showing black Americans the best of themselves. From its beginning in 1945, *Ebony* specifically celebrated black achievement and showcased black excellence within its pages by highlighting African Americans who were excelling in fields from entertainment and politics to science and business. *Ebony* provided visual examples of black success and beauty and glamour were part of that picture.[1] In many ways, the traveling fashion show reinforced these ideals with an audience who knew precisely what to expect because they had already witnessed such aspirational images within the pages of *Ebony*, *Jet*, and other Johnson publications.[2]

Understanding this is critical in recognizing the traveling show as both a unique fashion experience and a distinctive cultural phenomenon. Throughout its history, the Ebony Fashion Fair amounted to a collection of events, encompassing both the celebration of fashion and a distinctive black American culture. From the show programs and the remaining garment collection, it was clear that Ebony Fashion Fair producers took great care in selecting the very best that the fashion world had to offer. In return, audiences attended dressed in their finery ready to "fit in" with the fashion on view. And, while it's clear that great attention was paid to the details of a particular seasons' hemlines, fabrics, and silhouettes, garments were also selected with a keen awareness of what the women in these audiences wanted to see and would respond well to. Thus certain aesthetic ideas were repeated throughout the history of the traveling show. A preponderance of fine materials, such as leather, feather, and fur, as well as vibrant and stunning color comprised Ebony Fashion Fair looks. The person in charge of striking that balance was Eunice Walker Johnson, the show's long-time producer and director (Figure 1.1).

Eunice Johnson was part owner of Johnson Publishing Company and served as *Ebony's* fashion director and treasurer. For most of her life, Johnson had maintained a deep interest in fashion, art, and design, even pursuing a career in interior design at various points. But, from 1963 until the show ended, she was responsible for establishing and codifying the vision of the Ebony Fashion Fair. In that time, she proved that she had a connoisseur eye, forged relationships with up-and-coming designers as well as established fashion houses, and made it evident that she was a serious consumer of high fashion. She made precise decisions about what Ebony Fashion Fair audiences should see and through the auspices of her company, she purchased everything that audiences saw in a particular season. That purchasing power eventually garnered her access to the exclusive world of high fashion—an exclusivity she shared with those who

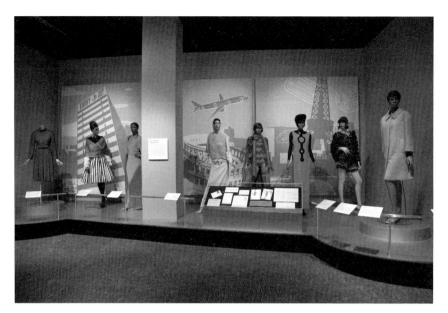

Figure 1.1 Garment grouping entitled "Mrs Johnson's Fashion Fair" introduced the idea that Eunice Johnson was the visionary of the Ebony Fashion Fair. © Photograph by and courtesy of the Chicago History Museum.

attended the Ebony Fashion Fair itself. Her goal was simple: expose audiences via the fashion shows and *Ebony* magazine to the highest quality fashion available. Until the late 1990s when her health began to fade, Mrs. Johnson traveled to the shows and showrooms to personally choose the fashion story for that season's Fashion Fair. She often purchased samples and was able to negotiate deals because of the sheer volume she purchased for the traveling show. Through selected garments, she shared the exclusive world of high fashion with her audiences.

Within the Chicago History Museum exhibition, an attempt was made to explore many of the ideas that Johnson presented consistently within the Fashion Fair shows. The museum project was organized into three thematic sections: *Vision*, *Innovation*, and *Power*. These sections were used to help shape and further the story told within the galleries and provided visitors ways to understand the selected garments. The first section included thirty-five ensembles and established Eunice Johnson as the visionary of the Ebony Fashion Fair by claiming that what audiences saw within the traveling show reflected her vision of glamour, taste, and high design. Garments within this section were meant to encapsulate aesthetic ideas that were repeated throughout the history of the show such as head-to-toe looks or complete ensembles, which reflected the attention paid to every detail of each look, and body-revealing silhouettes that showed the dramatic gowns featured within the traveling show. More than anything, however,

this section introduced the unabashed use of bold color as perhaps the most consistent aesthetic theme of the Ebony Fashion Fair. Selected garments within the Vision section repeatedly reminded visitors of the centrality and importance of color within the Ebony Fashion Fair.

The prevalence of red, blue, purple, and yellow emerged to express an audacious idea about what the women in the audience not only could but should wear. Within the Ebony Fashion Fair, it provided a means for the rejection of old ideas about blackness and the celebration of black beauty. In testament to this, John Johnson, founder of the publishing house and husband to Eunice Johnson, states in his autobiography that "… the show has given Black America and the world a new concept of the kinds of clothes Black women can wear. Before the Ebony Fashion Show, people said Black women couldn't wear red or yellow or purple. The fashion show proved that Black women could wear any color they wanted to wear."[3] Mr. Johnson did not elaborate on who these people were that said black American women could not wear color, but he followed his initial color comments by stating that one of the show's earliest and best models, Terri Springer, frequently sashayed across the stage in spectacular colors that defined "Black is Beautiful" before the phrase became popular in the late 1960s. Color, then, was not only a reiterated aesthetic theme, but it was also a way for the fashion show's producers to shape audiences' perceptions about black fashion, style, beauty, and the possibilities therein. And, while it appeared that color was positioned as a way to highlight and celebrate the diversity of black beauty, at the same time, it was also utilized to express a certain type of freedom: in this instance, freedom from rules that denigrated darker skin tones. As opposed to hiding one's skin with muted tones, the Ebony Fashion Fair invited audience members to use color to enhance and embrace it. Here, again the traveling show intersects with the aspirational images and ideas found within *Ebony* magazine about the possibilities of black life, and those possibilities included celebrating black beauty.

As a result of its significant role within the Ebony Fashion Fair, color was a highlighted and repeated aesthetic theme within *Inspiring Beauty*. Many of the garments within the exhibition are not black—the standard fashion color—but rather reflect the vividness of the garments modeled in *Ebony's* traveling show. Not only were the extant collections bursting with color but its consistent display played a role in what the show attempted to express about the power and freedom of self-presentation. Anything was possible according to the Ebony Fashion Fair—there were few things that audience members could not wear as evidenced by the fashion on the traveling show's runways. In city after city, the Ebony Fashion Fair provided its audiences with access to the possibilities of fashion. And, color was one of the primary tools used to accomplish this.

In *Inspiring Beauty: 50 Years of Ebony Fashion Fair*, this was specifically illustrated by a grouping of dressed figures in an exhibition subsection entitled

"The Power of Color"[4] (Plate 1.2). The purpose of this grouping was to provide visitors not only with a spectacle of luscious and seductive color, but also to give them a reference and an interpretation of what Mr. Johnson stated in his autobiography about pairing the brightest hues with the brownest models. To emphasize what he identified as this unique aspect of the Ebony Fashion Fair, the most vibrant colored garments in the *Inspiring Beauty* exhibition were shown on the deepest dark brown mannequins, which were custom-made for it. In fact, all exhibition garments were displayed on realistic head-to-toe figures created in four brown tones, thus providing the visitors with an experience similar to the unabashed celebration of a multiplicity of brown and black skin tones they might have seen at the traveling show itself. This unique type of display further reiterated the color theme and reinforced the idea that within the Ebony Fashion Fair, who wore the garment (mostly black female models), was just as important as the ensembles on the runway. "The Power of Color" grouping contained ten couture creations by a wide range of fashion designers, including b michael, Nina Ricci, Bob Mackie, Sarli, Balestra, and Fabrice. Also, included here was a full-figured gown, one of two in the show, designed specifically for the Ebony Fashion Fair by Todd Oldham. While this group of figures was the most pronounced expression of color as a repeated aesthetic idea in the exhibition, purple, orange, citrine, and especially red were also very much present throughout the entire exhibition.

The first section of the exhibition establishes Mrs. Johnson as the visionary of the Ebony Fashion Fair and does so by including multiple examples of the types of garments chosen for the show. In the second section, *Innovation*, the story of the Johnson Publishing enterprise takes center stage and only contains ten ensembles. But, many of those ensembles still speak to the abundant use of color within the Ebony Fashion Fair. For instance, a bold yellow gown by Emanuel Ungaro for the Fall/Winter 1987 season signifies the importance of color. Featured in a grouping entitled "Fashion in Orbit," the gown was the cover look for the 1987 season of the Ebony Fashion Fair—proving again that boldly colored garments were often the star of the show and is displayed as the focal point for this fashion-forward group (Plate 1.3). Similarly, in the last section of the exhibition, *Power*, color plays a prominent role. *Power* features nineteen garments that represent the high caliber of fashion that drew audiences year after year to the traveling show. The section is designed to provide visitors with an overwhelming sense of fashion's ability to delight and titillate. Feathers, jewels, and fine fabrics are the hallmark of this section's selections as they were within the traveling show itself. Included within the section is a peach Valentino gown from the Spring/Summer 1974 season, a bold orange and black tiger print designed by Carolina Herrera in the early 1980s, and a purple sequined jumpsuit with matching wool coat from Dior's Fall/Winter 1968 season, one of the oldest ensembles in the exhibition. Each garment selected for this section was chosen as a testament

to Mrs. Johnson's power to bring such fine examples of high design to audiences across the United States in the Ebony Fashion Fair.

Inspiring Beauty: *50 Years of Ebony Fashion Fair* is the first exhibition to interpret the history of Johnson Publishing's famed traveling fashion show. Within the exhibition, an attempt was made to create multiple entry points for those unfamiliar with the content and the numerous visitors, of every hue and from all walks of life, who shared their stories of attending the Ebony Fashion Fair on a regular basis. In the galleries, history, biography, entrepreneurism, and fashion combined to tell a powerful story. The garments were selected, yes, because they were beautiful and iconic but most importantly because they helped to reveal a unique story that reflected the way fashion provided a means of empowerment for black women and helped create impactful images of black beauty. And, this was a critical way in which fashion was used within the traveling show itself. Eunice Johnson shared her exclusive fashion-insider status with many thousands of viewers repeatedly for nearly five decades within the traveling show. These same viewers were able to examine these high fashion garments in person and were encouraged to imagine themselves wearing them.

Mr. Johnson's opinions about color were easily accessible because he, unlike his wife, wrote an autobiography. Eunice Johnson, instead, recorded her reflections and thoughts about the use of color in the many articles she penned for *Ebony* magazine but more importantly, she displayed her ideas through the garments that she selected for the Ebony Fashion Fair runway. Her efforts as a tastemaker, fashion icon, and pioneering businesswoman are worthy of more focused scholarship if for no other reason than to bring attention to her status as an often lone black woman in the exclusive world of high fashion in the middle of the twentieth century. She used fashion to help expand her business and for philanthropic causes but she also used it to open doors previously closed to African Americans. Interpreting this history within the exhibition provided an opportunity to examine and expose the impact of the traveling show for those who witnessed it and were transformed by the ways in which black beauty was celebrated.

Throughout this text, it can be seen that color played a significant role in both the Ebony Fashion Fair shows and the *Inspiring Beauty: 50 Years of Ebony Fashion Fair* exhibition. Within the exhibition, using color as a theme in multiple garment groupings and didactics was not only a way to showcase beautiful garments, but it was also a way to express the personal potential and freedom that the Ebony Fashion Fair espoused. Within the traveling fashion show, the red, yellow, purple, and host of other colors about which Mr. Johnson spoke and Mrs. Johnson displayed continuously and fiercely were used to celebrate not only who one was, but also who one might become.

Notes

1　Green, Adam. (2007), *Selling the Race: Culture, Community, and Black Chicago, 1940–1955*. Chicago and London: The University of Chicago Press, 142–156.

2　Johnson Publishing Company was founded in 1942, and the inaugural issue of *Ebony* appeared in November 1945. In its seven-decade history, Johnson Publishing produced more than a dozen periodicals including *Ebony*, *Jet*, *Tan*, and *Hue*, among others. *Ebony* is the only remaining print publication.

3　Johnson, John with Lerone Bennet, Jr. (1992), *Succeeding Against the Odds: The Autobiography of a Great American Businessman*, New York: Armistad, 260.

4　Titles for each garment grouping were drawn directly from the theme of a particular Ebony Fashion Fair season.

2

PURITY AND PARITY: THE WHITE DRESS OF THE SUFFRAGE MOVEMENT IN EARLY TWENTIETH-CENTURY BRITAIN

Kimberly Wahl

At the beginning of the twentieth century, the color white became a fundamental and central keystone in the symbolic language of the British Suffrage Movement. Countering and complicating the Edwardian taste for white as merely a simple indicator of feminine delicacy and "fashionability," the organizing members of the Women's Social and Political Union, or WSPU, chose white as one of their official colors in 1908, although in practice it was already widely worn by both supporters and non-supporters of the women's movement alike. For members of the WSPU, white stood for purity, green for hope, and purple for dignity. While these three colors adorned and embellished a range of political ephemera and fashion accessories, from suffrage banners for political marches to seemingly innocuous green and purple ribbons and sashes for hats and blouses, white was the dominant color worn, and its symbolic framing within the movement is perhaps the most complex. This text explores the artistic and literary framing of the color white in the mid-to-late nineteenth century and examines its strategic use in first-wave feminism to communicate a range of cultural meanings. These ranged from spiritual and moral values in connection with notions of purity to its implied cultural critique as a perceived cipher of classical antiquity among dress and design reformers of the period.

Historically, fashion has not been widely discussed in academic histories of the Suffrage Movement, yet its role was far more significant than the existing

literature might suggest. The connection between clothing and embodied notions of female agency was linked in fascinating ways through the visual and metaphorical languages of artistic practice, as well as the conventions of spectacle that were central to suffrage demonstrations and processions. However, aside from fashion's integral role in the daily activities of campaigners, the visual and symbolic function of clothing in the iconography of the movement was far more complex, functioning on a number of levels to define and inform the motifs and iconic signifiers of suffrage ephemera and print culture.

Richly imbricated with a range of sartorial and cultural meanings, the white dress of the British Suffrage Movement was both performative and strategic. Its visual iconography drew on a long history of symbolic conventions linking the color white with a range of positive cultural associations. Aside from the obvious popular affiliation between the color white and an assumed purity and innocence embodied in the traditional wedding gown, white in this context was a marker of class and gender difference. Edwina Ehrman, a fashion curator at the Victoria and Albert Museum, has traced the increasing usage of the color white among the upper classes in England, where it was the most popular choice for women's bridal wear from the late eighteenth century onwards (2011: 37). The pristine and precious nature of white garments, together with their rarity and difficulty in cleaning where extremely hot water or various bleaching agents were required to remove stains, made them markers of social mobility and cultural capital. This was particularly true before the advent of gas and electricity, which made cleaning white garments more affordable and convenient through the use of mechanization (Ehrman 2011: 10). This would have been true even toward the end of the nineteenth century when the ready-to-wear market allowed for white dresses and shirtwaists to be made widely available and democratically priced. However, the symbolic and ritual function of the color white goes far beyond indications of class or social capital; indeed, as Ehrman has noted, "White garments were associated with spiritual rites of passage long before they became conventional for bridal wear" (2011: 9).

More importantly, at the time of the most active and militant phase of suffrage activism, from 1909 to 1913, the visual importance of the white dress became increasingly polemical, particularly in terms of its visible and defining presence in large-scale political marches and demonstrations (Figure 2.1). Drawing on the fashionable trope of the Edwardian lingerie dress, its up-to-date status signaled a rarefied and refined delicacy, as well as knowledge of appropriate and conventional dress. Additionally, in contrast with the darker masculine colors of the period, it offered itself as a purified and visible marker of difference, conforming to gender binaries of the period, and was thus reassuringly feminine. To further emphasize the inherent femininity of the color white and its connection with tradition, in 1907, in the pages of *Votes for Women*, the official publication of the WSPU, suffragette, artist, and writer Sylvia Pankhurst contributed an

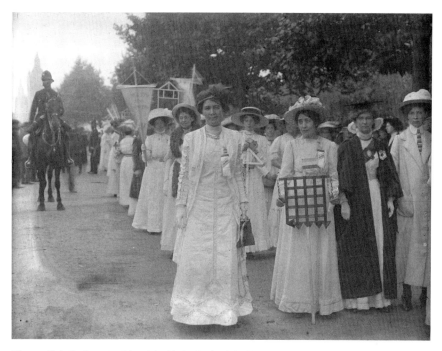

Figure 2.1 Suffragette March in Hyde Park. July 23, 1910. © Museum of London.

article outlining the history of agitation in Britain for universal suffrage—including women's rights—focusing specifically on the 1817 demonstration in St. Peter's Fields, Manchester (which later became known as the Peterloo Massacre). In describing this early demonstration of political agitation for universal suffrage, she wrote: "There were 1,000 women and girls in this company, most of them dressed in white, and many of the women carried babies in their arms" (*Votes for Women*, October, 1907: 8).

On the surface, examples like this appear to affirm, rather than challenge, the Victorian legacy of separate spheres, where public spaces were perceived as the dominion of men and women were relegated to domestic settings. Yet the strategic wearing of white in public demonstrations also stood as a constructed model for ascendancy and respect, a visual affirmation of parity and equality. This was in line with one of the reoccurring arguments in more conservative factions of the women's movement, where a gendered bid for power might result in separate but equal roles for men and women. Thus, politically active women in this period acknowledged that conventional forms of fashionable dress did much in persuading public opinion of the respectability and validity of the women's movement.

Despite this fashionable respectability, however, radical suffragettes were often characterized in the press as unwomanly, frumpy harridans wearing ill-fitting masculine clothing. To combat negative public opinion, leaders of the

WSPU sought to emphasize the importance of appearance and self-care among followers of the movement. In an article entitled "The Suffragette and the Dress Problem" in the July 30, 1908, issue of *Votes for Women*, the author writes:

> The Suffragette of to-day is dainty and precise in her dress; indeed she has a feeling that, for the honor of the cause she represents, she must "live up to" her highest ideals in all respects. Dress with her, therefore, is at all times a matter of importance, whether she is to appear on a public platform, in a procession, or merely in house or street about her ordinary vocations (348).

Dress practices were therefore central to first-wave feminism, and though fashion was often a silent and unacknowledged factor in the shaping of the movement, it has often been presented in reductive terms, or not at all. Mobilized strategically to enhance the status and worth of suffragettes in the public eye, a repertoire of codified principles and military precision were employed in the service of creating a dignified, respectable, and united front. One of the largest political marches of the movement, the Women's Coronation Procession of June 17, 1911, took place less than a week before the official coronation of George V. It featured twenty-nine united suffrage societies and by then the color symbolism and codified appearance of suffrage supporters were firmly fixed. Often in white, to emphasize the purity of spirit and lofty aims of the movement, typical costumes were accented with key colors of specific suffrage associations—for the WSPU it was purple, green, and white, and in the case of the Actresses' Franchise League it was green, pink, and white (Tickner 1987: 265). In a foundational text on the visual culture of the Suffrage Movement, Lisa Tickner argued that the Actresses' Franchise League along with the Artists' Suffrage League and the Suffrage Atelier were largely responsible for the sophisticated and nuanced way that spectacle and performance were utilized in these public processions to great effect (1987: 13–29). Similar to the WSPU, the NUWSS (National Union of Women's Suffrage Societies) adopted colors that included white (the alternate being red and green) and the WFL (Women's Freedom League) took green and gold to complement their use of white as well (Kaplan and Stowell 1994: 169). Regardless of variation, white was always the shared foundational color across the visual iconography of the women's movement.

Thus, to a large extent, despite differing positions on political policy making, or levels of militancy, suffrage dress-practices across associations were somewhat uniform and even communal; many objects, details, and even commercial sources for clothing and textiles were shared. Within specific organizations, color schemes were often regulated, as was the highly visible advice on clothing and etiquette in relation to the movement in the press of the day, both in mainstream fashionable journals and, more tellingly, in the publications of the movement itself. Advocating the official WSPU colors of purple, green, and white in 1908,

Emmeline Pethick-Lawrence, the treasurer for the WSPU and co-founder of the magazine *Votes for Women*, suggested that women should adhere to the preferred color scheme in their choice of dress if participating in the planned march for June 21st of the same month:

> we ask you to be guided by the colors in your choice of dress. That is very important, too. We have 700 banners in purple, white, and green. The effect will be very much lost unless the colors are carried out in the dress of every woman in the ranks. White, cream, or tussore should, if possible, be the dominant color; purple and green should be introduced where other color is necessary. (June 18: 249)

To further emphasize the importance of a unified and cohesive front, guided by the usage of the Union's colors, Pethick-Lawrence went on to argue that "If every individual woman in this union would do her part, the colors would become the reigning fashion. And, strange as it may seem, nothing would so help to popularize the Women's Social and Political Union" (249).

In the weeks following the demonstrations, follow-up reports in *Votes for Women* noted the careful and consistent use of color in the June 21st march: "Many of the younger women wore the uniform of the cause—a white frock, with a 'Votes for Women' sash in the suffragette colors of purple, green, and white" (June 25, 1908: 269). Tellingly, the connection between the official colors of the Union and the commercial aspects of the production and consumption of appropriate fashionable clothing was cited as a factor in the perceived overall effect, popularity, and success of the march:

> One of the most remarkable features of the whole demonstration was the unity of the color scheme, displayed not only in the banners, but in the dresses and decorations of the women who were taking part. We are informed that in the various drapers' establishments in which the special Votes for Women scarves were displayed, several thousand in all were disposed of, and that the whole stock was sold out before the demonstration took place. Fresh orders were given by the Union at the end, but could not be executed in time for the day itself, though a few are now obtainable at Clements Inn (*Votes for Women*, June 25, 1908: 258).

Emmeline Pethick-Lawrence was one of the driving forces behind the strategic and promotional use of color within the WSPU. Her understanding of the importance of pageantry, ritual, symbolism, and spectacle continued to inflect her reminiscences of the movement, years later. In recalling the demonstrations of June 1908, in her later memoir *My Part in a Changing World* (1938), she wrote: "[j]ournalistic imagination" was inspired by "the beauty" as "Youth was largely

represented everywhere" (184). Further, she noted how the majority of speakers and members of the procession "wore white summer frocks with sashes or badges of purple and green," arguing that the spectacle with its "gay crowds" and "great display of colors" resulted in hundreds of new WSPU members being recruited in the days that followed (227). Later, in describing a large procession from 1910, Pethick-Lawrence informs us that due to her position near the front of the march she was able to admire the expansive view of "white summer frocks with sashes or badges of purple and green" and how this color coordination brought women together with "the orderliness of a military force" (184).

That clothing and fashion were ever-present in the mind of suffragists is revealed through an analysis of the print culture of the movement. The prevalence of fashion advertisements in *Votes for Women* establishes the importance of clothing as part of the management of an abstracted and idealized "body of suffrage." In fact, selected advertisements specifically targeted women supporting the Suffrage Movement proffering messages and opportunities to promote and communicate mainstream values of respectability and decorum. They also supported the market for fashionable goods largely perceived to be made for, and by, women during this period. In a 1910 issue, two advertisements emphasize a slim and tailored silhouette, one created through corsetry and the other through the use of a skirt grip (Figure 2.2). In these advertisements (which were common and appear throughout the various issues of *Votes for Women*), themes of modest and appropriate dress are suggested through the promotion of the corset or other garment modifiers as

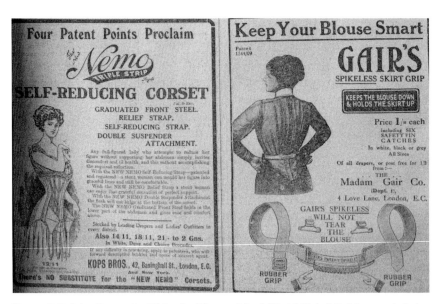

Figure 2.2 Advertisements, "Votes for Women," April 22, 1910. L.S.E. Library, photo by author.

an integral part of the suffrage uniform—implying control, proper attire, and the ability to conform to etiquette and social expectation (*Votes for Women*, April 22, 1910). The emphasis in the advertisement on "fit" and "comfort" indicates the core value of social acceptability and maintaining a "proper" appearance during marches. While this may seem restrictive on one level, the use of mainstream fashion to maintain a non-threatening and therefore acceptable feminine appearance can also be understood as a potentially disruptive phenomenon in and of itself. It has been argued that it was precisely this strategic convergence of "ladylike" behavior and dress in the furtherance of radical political aims that constituted a reconfiguration of the feminine itself as potentially disruptive. As Victorian literary scholar Wendy Parkins has argued, through conformity and the "subversive repetition of practices which were seen to constitute femininity" while simultaneously engaging in political practice, the performance of "middle-class prescriptions of fashionable femininity was a contestation of the construction of the female subject—as decorative but apolitical …" (2002: 105). Forging new feminine identities and conflating domestic and "traditional" feminine experiences and pursuits with a claim to public space, the perceived borders between public and private, masculine and feminine were increasingly being eroded by women's increasing visibility and demands to be heard.

Furthermore, while the color white in the context of mainstream fashion may have had obvious connotations of purity, respectability, decorum, and innocence, it also referenced a more subversive set of cultural meanings as well, having to do with its historical presence in the artistic and literary imagination of the late Victorian period. An earlier and yet often unacknowledged factor in the white dress of the Suffrage Movement is the importance of the color white in artistic and aesthetic circles in the mid- to late nineteenth century. The artist Louise Jopling, who was an active supporter of suffrage, is an important exemplar of the complex role of the color white in both artistic and political settings. Independent and yet married, suitably feminine and often posing for paintings and photographs and yet a professional artist in her own right, Jopling carefully negotiated the roles, constraints, and opportunities open to her as a politically and socially active female artist. Photographed in 1890 by Frederick Hollyer, an image of Jopling in a white dress may appear to simply anticipate the widespread appeal of white in many of the frothy Edwardian conceptions of female dress at the turn of the century. Yet, this photograph also speaks to her knowledge of, and involvement in, earlier artistic and design reform circles of the late nineteenth century, where the color white had a far more complex visual role. Models for aesthetic dress from the 1870s to the 1890s were often historicized, simple in cut and silhouette, and meant to be worn without a corset—features which differed radically from mainstream conventional dress practices (Wahl, 2013). As dress reform and artistic dress practices were often closely allied with British Aestheticism as well as the Arts and Crafts Movement, it is perhaps unsurprising that many of the

artists associated with the Suffrage Movement, also still active in artistic circles, would have had a preference for artistic and aesthetic models of dress. These earlier artistic and aesthetic modes appeared throughout the visual iconography and print culture of the Suffrage Movement—sometimes in contradistinction to what was actually being worn by suffragettes themselves. The impact of the "white dress" of the Aesthetic Movement on the Suffrage Movement would largely affect the visual and material manifestations of its print culture rather than in the actual garments that were worn. The fact that historicism and nostalgia were so pervasive in the progressive political messaging of suffrage print culture is highly significant and clearly affixes the visual cultures of the movement to earlier formations in the art and design realm of the late nineteenth century.

Within the movement itself, the personification of positive cultural values in the form of a woman revealed the impossibility of separating the female body from other ephemera in the visual culture of the Suffrage Movement. White clothing remained a central facet of this material manifestation of suffrage ideals, and yet its myriad connections with the body were articulated in differential ways, depending on the context. As an embodied form of protest, clothing was worn in conventional and regimented ways, signaling the power of fashion to signify allegiance, inclusion, respectability, and "fashionability." However, on a symbolic level, representations of dress served more ephemeral ends, tying the body of the suffragette to a symbolic array of idealizing female stereotypes and tropes that were deemed useful or desirable among politically active women. More broadly, Victorian print culture frequently placed the bodies of women front and center in debates over politics and gender. Both negative and positive depictions illustrate the persuasive power of such images. Interestingly, they also reveal the highly ambiguous nature of the visual realm. A well-known 1912 postcard illustrated by Harold Bird and produced by the National League for Opposing Women's Suffrage lampoons the figure of the suffragette who is depicted behind a classically draped "true model" of woman as a shrieking and unattractive extremist wielding a hammer. In response, in her work for the Suffrage Atelier, Louise Jacobs appropriated this earlier image to produce "The Appeal of Womanhood" (Plate 2.1). Inverting the classical attributes to instead reflect suffrage values, she presents the figure of suffrage as more than just a noble and classically garbed woman, but as a figure of virtue and selflessness (Tickner, 1987: 250). In doing so, Jacobs reconfigures the ideal of the suffragette in the popular imagination and regains the support of an easily swayed public. These two images highlight the inherently ambiguous nature of suffrage imagery when viewed without context or explanation. They also demonstrate the discursive importance of corporeal stereotypes in the Victorian framing of gender—in this context the symbolic overlay of classical drapery and the color white are applied to opposite female "types," whose identity and validity are dependent on artistic representation and the perspective of the illustrators.

As an embodied practice, conventional and mainstream aspects of fashion were incorporated into the repertoire of suffrage identity and visibility. Yet within the symbolic realm, key images of female power and nobility were reliant on an entirely different visual language, mostly drawn from the imagery and artistic authority of the Aesthetic Movement in Britain, which rose in prominence and popularity in the decades preceding the final push for suffrage within first-wave feminism. The color white had a subtle but distinctive role in this setting, particularly in the supportive visual and literary cultures of the periodical press of the late nineteenth century. Classical imagery of dress/drapery adorning the female figure was a constant in the illustrative print culture of the period.

Coming out of the context of the visual culture of the Victorian period, and more specifically drawing on the artistic and erudite language of the Aesthetic Movement, the white dress at the turn of the century can be viewed as a complex and internally contradictory sign of subversion and experimentation. From the iconic "White Girl" series painted by James Abbott McNeill Whistler in the 1860s, to the army of insistent maidens who parade through Edward Burne Jones's paintings of the 1880s, to the literary framing of white dressed women in Victorian fiction as unknowable, mysterious, or even sometimes threatening, women wearing white occupied a fluid and iconic role in the collective Victorian imagination. Whistler's *The White Girl* of 1862 depicts one of the clearest portrayals of early aesthetic dress, and despite his emphasis on the static and material nature of the image, the reception of his painting in press circles tended to emphasize the enigmatic and mysterious nature of the figure, some even equating it with Wilkie Collins's famous 1859 novel *The Woman in White* (Prettejohn, 2007: 164).

Further links between the iconography of suffrage art production and past artistic dress principles can be identified through an analysis of both the visual culture of the Aesthetic Movement—and key political imagery of the Suffrage Movement, particularly in the pronounced interest in classical dress—and the use of personification to signify key tropes conveying artistic or moral values. In this context, the dress reform practices and aesthetic modes of dress from the 1870s to the 1890s become central in shaping iconic suffrage images of female beauty, nobility, and achievement. Here, the color white can be seen as a subtle critique of culture, its fluidity and resonance with past classical ideals falling in line with selected social and sartorial reform tendencies of the period.

By way of example, a prominent dress reform society, the Healthy and Artistic Dress Union of the 1890s cited the artistic and moral superiority of the classical age as an appropriate template for design and dress reform. In a series of tableax vivants entitled "Living Pictures" and performed at St. George's Hall in May 1896, the Victorian imagination conflated performative aspects of social reform, with aspects of classical dress (Figure 2.3). Conceived of by Walter Crane, a member of the Healthy and Artistic Dress Union, and a prominent artist, illustrator, and

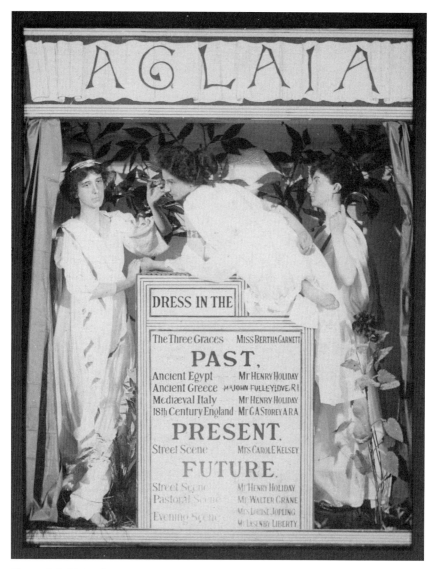

Figure 2.3 Walter Crane "Living Pictures" Series performed at St. George's Hall, May 1896. © Whitworth Art Gallery, University of Manchester.

design reformer of the period, these tableaux reflected the values and progressive reform policies for dress and culture first laid out in *AGLAIA*—the official journal of the Union in the early 1890s. One of the "Three Graces" of Greek mythology, Aglaia was the goddess of beauty, splendor, and glory; in the principles of artistic dress reform of the late nineteenth century, physical and spiritual beauty were conflated in idealized images of femininity drawn from classical sources inflected with notions of Victorian naturalism (Wahl, 2013: 29–32).

Such imagery, and more particularly the performative aspects of reform based on historic dress, would inform much of the visual and symbolic language of first-wave feminism. Thus, within the suffrage campaign of the early twentieth century, the symbolic and material expressions of clothing culture were functioning on different levels. While women in politically active circles were careful to conform to the standards and preferences of mainstream fashion, the visual and literary framing of suffrage often referred back to the experimental and critical practices of the dress reform movement and the sartorial expressions of British Aestheticism, which formed a persistent and pronounced alternative to mainstream Victorian dress practices. The color white was significant in both of these contexts, and the contiguous role of these differential legacies in the Suffrage Movement points to the complexity and richness of the color white as a cipher of cultural meaning. The dual and strategic use of dress to communicate a range of crucial social values may partially explain the success of the movement, where the iconography of suffrage art production and the embodied conventions of dress in practice were able to coexist in two distinct yet complementary visual realms.

The myriad and imbricated meanings of the color white in the visual culture of the Suffrage Movement leads one to question the overtly fashionable appearance of the Suffragette. An analysis of the material and visual cultures of the movement reveals instances of reform, change, and artistic experimentation with regard to clothing during this time. The interest in historical figures from the past alludes to the perception of medieval and classical dress as timeless and therefore valuable. Yet at the same time, there are also references to some of the more avant-garde dress reform aspects of the Aesthetic Movement in the 1870s and 1880s—widely perceived at the time to provide an embodied form of emancipation for women who felt that mainstream fashion enslaved and restricted women's freedom of movement, mentally and physically. It could be said that by the end of the First World War, the women's movement had begun to address themes beyond the goal of suffrage. Artistic freedom and female autonomy started to have a more overt impact on clothing culture, including mainstream fashion.

The presence of the color white in the complex visual cultures of suffrage served as a reminder of the complex nature of color symbolism and the ways in which cultural meanings could accrue through processes of signification. In some visual and literary views of the movement, the color white gestured toward modernity, fashion, and contemporary taste. Prominent suffragette Christabel Pankhurst was often seen as the embodiment of this new spirit. Emmeline Pethick-Lawrence recalled her popularity with the press, remembering her as the "embodiment of youth and charm" and in recounting her appearance at a routine legal proceeding wrote: "Christabel, in a white frock with a sash of purple and green, looked like a flower in that dingy Court" (1938: 200).

While Christabel Pankhurst's youthful and fashionable appearance in public was often commented on in the press, as a visual and iconic figure of suffrage, she was sometimes pictured in romantic and historicized ways—in line with typical images of female suffragists in postcards, banners, and memorabilia of the movement. By way of example, in a post card entitled "Saint Christabel" illustrated by Charles Sykes, sometime between 1908 and 1914, a trajectory of history and tradition is invoked by the depiction of Pankhurst in a white dress modeled along medieval and archaic lines. Shown framed by a stained glass window and encumbered by chains, this image portrayed Pankhurst clasping her hands and gazing upwards, in a pose invoking a plethora of art historical references linking female sainthood with religious fervor. Simultaneously, this image referenced earlier incarnations of artistic dress which were shaped by mid-Victorian medievalism and the influence of the Arts and Crafts Movement. Finally, this image clearly allied Pankhurst's popular image with other images of Joan of Arc, a shared symbol of female virtue and purity found across a range of suffrage ephemera; Pankhurst personally identified "with the 'virgin saint' and [quoted] her in speeches" (Betterton 1996: 74).

In the visual iconography of suffrage ephemera and its attendant print culture, the color white can also be seen as a kind of cultural critique, at once historicist and classicizing, but at the same time heralding an as yet unseen level of spiritual and physical equality between men and women. Pushing the ritual and symbolic significance of the color white further into the realm of martyrdom, Pethick-Lawrence emphasized the powerful spectacle of those members of the movement who had been imprisoned marching in the Coronation Procession of 1911:

> [T]he most significant and beautiful part of the pageant was the contingent of those who had been in prison. They marched in white, a thousand strong, each one carrying a small silver pennant, and in their midst was borne a great banner depicting a symbolic woman with a broken chain in her hands and in inscription: FROM PRISON—TO CITIZENSHIP (1938: 254).

Pankhurst herself described this particular demonstration as "the most joyous, beautiful and imposing of all our manifestations" (1959: 184).

In conclusion, the white dress of the Suffrage Movement functioned as a composite visual signifier, overdetermined, symbolically rich, and capable of cultural critique. Yet at the same moment, on the surface it often appeared to be reassuringly feminine and conventional. It could be said that therein lay its power as a political tool for change, as well as an exemplar of the power of color in fashion.

References

Betterton, Rosemary (1996), *An Intimate Distance: Women, Artists and the Body*, London: Routledge.

Ehrman, Edwina (2011), *The Wedding Dress: 300 Years of Bridal Fashions*, London: V&A Publishing.

Kaplan, Joel and Sheila Stowell (1994), *Theatre and Fashion: From Oscar Wilde to the Suffragettes*, Cambridge and New York: Cambridge University Press.

Pankhurst, Christabel (1959), *Unshackled: The Story of How We Won the Vote*, London: Hutchinson & Co.

Pankhurst, Sylvia (October 1, 1907), "The History of the Suffrage Movement Chapter I—the Battle of Peterloo," *Votes for Women*, 8–9.

Parkins, Wendy (2002), "The Epidemic of Purple, White and Green': Fashion and the Suffragette Movement in Britain 1908–14," in *Fashioning the Body Politic: Dress, Gender, Citizenship*, 97–214, Oxford: Berg.

Pethick-Lawrence, Emmeline (June 18, 1908), "Women's Sunday," *Votes for Women*, 249.

Pethick-Lawrence, Emmeline (1938), *My Part in a Changing World*, London: Victor Gollancz Ltd.

Prettejohn, Elizabeth (2007), *Art for Art's Sake: Aestheticism in Victorian Painting*, New Haven and London: Yale University Press.

Tickner, Lisa (1987), *The Spectacle of Women: Imagery of the Suffrage Campaign, 1907–14*, London: Chatto & Windus.

Votes for Women (July 30, 1908), "The Suffragette and the Dress Problem," 348.

Wahl, Kimberly (2013), *Dressed as in a Painting: Women and British Aestheticism in an Age of Reform*, Lebanon: University of New Hampshire Press.

3

BIRDS OF THE SAME "COLOR" FLOCK TOGETHER: COLOR AS EXPRESSION OF IDENTITY AND SOLIDARITY IN *ASO-EBI* CLOTH OF THE YORUBA

*Margaret Olugbemisola Areo and
Adebowale Biodun Areo*

Nigeria, a country in West Africa, has been described as "the most glamorous nation on earth" (Plankensteiner and Adediran 2010: 221). This glamour is reflected in the way the people dress. In further describing the Nigerian people, Dele Momodu in an interview with Plankensteiner states:

> Nigeria is the most glamorous nation on earth. I don't know of any place where people dress the way we dress ... Nigerians love good things ... They love to dress well ... I think Nigerians are created on a different day. Nigerians are different from other Africans ... When you see a Nigerian man or woman, you would know ... I really don't know the origins, but that is how God created us: to be very ambitious, very flamboyant, very colorful, very outgoing.

Of all the over 200 ethnic groups in Nigeria, the Yoruba of Southwestern Nigeria are still the most lavishly, colorfully, and well dressed. Dressing well and

being fashionable is an integral part of Yoruba culture. Representations of clothing on objects of art found in Esie, Ile-Ife, Owo, all towns located in Southwestern Nigeria, show evidence that the Yoruba race have always been well-clothed. An observer in the 1890s was quoted to have said: "The Yoruba is, by custom, a fully-clothed mortal. It is considered in the highest degree unfashionable to appear in the public streets without a complete covering of two or three ample and well-dyed cloths draped round the body in not ungraceful fold" (Eicher 1976: 32). The significance of cloth is reflected in the Yoruba saying "Aso l'edidi eniyan"—that is, cloth is the essence of man (Okediji 1991).

Nudity is an abomination among the Yoruba race. To appear nude in public is evidence of insanity, abject poverty, or lack of family cohesion. It is a symbol of being alone; and a display of nudity would reflect adversely on that person's family. Family cohesion and connectedness is still vital among the Yoruba, an individual in this culture will typically enjoy a strong extended familial connection system comprising of his nuclear family, uncles, aunts, cousins, nieces, nephews, great uncles and aunts, second, third, and even fourth cousins spanning many generations, both maternally and paternally; hence there are too many people whom such a person might dishonor by going naked. Hence the saying, "A'i l'aso l'orun paka, o ti di apero fun gbogbo omo eriwo." Literally, this means: the issue of the lesser masquerade going naked has become a point of discourse for all traditional worshippers. This metaphorically means: an injury to one is an injury to all; and a nakedness of one is the nakedness of his whole clan, both maternal and paternal, and all that are connected to him. No man is an island in Yoruba culture.

The Yoruba people celebrate life, and every achievement and progression in life or in social status is marked with celebration and many rites of passage such as naming, wedding, burial/funeral, house warming, and chieftaincy installation ceremonies. For all of these occasions, cloth and appropriate dress feature prominently. While industrially printed cotton material, African Print, *Ankara* or the resist-dyed cloth *Adire* may feature in everyday attire, *Aso-Oke* still remains the oldest indigenously esteemed cloth for the celebration of notable events.

There is a fine line between cloth and people of the Yoruba. Sayings such as "Eniyan bo'ni l'ara ju aso lo" (people cover you better than cloths) and a song like "Eniyan l'aso mi, bi mo ba b'oju weyin ti mo ri eni mi, eniyan l'aso mi" (people are my cloth, whenever I look around me and I see my people, I am assured that people are my cloth) attest to this fact. Each person acts as the individual fiber of the fabric that is the well-knit extended family. Each family is always bound together like a bunch of broom (*osusu owo*), which sweeps better and cleaner than single stems of broom (*gaga owo*).

Family cohesion and clothing as an integral part of everyday life of the Yoruba is expressed in a cultural tradition known as *Aso-Ebi*. *Aso-Ebi* serves the dual purpose of covering physical nakedness and also on a higher level of covering social nakedness, expressing the place of the celebrant (in any of the

rites of passage) in society and in the hearts of his people. An individual's wealth, connectedness, and affluence are therefore gauged by the guests at his event and those who bought his *Aso-Ebi*.

Aso-Ebi is a Yoruba term coined from two Yoruba words: *Aso*, meaning cloth and *Ebi*, meaning family. The term refers to a distinctive clothing or a common cloth worn by relatives when celebrating a notable event. *Aso-Ebi*, therefore, is a form of communal, kinship dress. Even if its concept originally implied a distinctive dress worn by members of a family to celebrate a social event, the practice due to cultural dynamism has metamorphosed and now includes various other levels of significance. The tradition has survived and evolved despite a succession of political, economic, and geographical changes. This transformation has led to it becoming a national phenomenon reaching far beyond the Yoruba race. Rather than declining, or becoming obsolete like many other sociocultural practices, the concept of *Aso-Ebi* has persisted, evolved with modernization, and has now become a national culture for Nigerians within the country and those in the diaspora.

However, despite the evolution and transmigration of *Aso-Ebi* cultural traditions, there is still a dearth of literature about the custom. Adopting literary materials, oral tradition, fashion journalism, celebrity reportage, photographs, and personal observation, this text traces the origin of the practice of *Aso-Ebi*, its dynamic evolution, and concludes that rather than choosing a single cloth item as *Aso-Ebi* for an occasion, color is now the most important element and deciding factor in *Aso-Ebi* tradition.

The origin of *Aso-Ebi* from an oral tradition is traceable to the Yoruba hand-woven fabric *Aso-Ofi*. This is probably because of the prestige accorded this cloth; and, second, because *Aso-Ofi* is indigenous to these people. It is the cloth highly regarded for celebrating rites of passage. It is produced locally, with all the materials for its production also sourced locally. *Aso-Ofi* was used in celebration. It is the tradition to commission a particular pattern of *Aso-Ofi* for a group of family members celebrating an event.

Archaeological finds of sculptures dating back to tenth and twelfth century AD found in Ile-Ife, a town in Southwestern Nigeria believed to be the cradle of the Yoruba race by Fagg, have representations of clothing on them, the texture of which indicates that *Aso-Ofi* was the likely material represented on these objects (Areo and Areo 2012b). Oral tradition in the form of proverbs and songs reinforces the prestige accorded *Aso-Ofi* for celebrations. For example, the following sayings/proverbs emphasize the centrality of Aso-Ofi:

"Sin mi ka re'le ana ki gbe ewu etu wo" (a person asked to escort a groom to his in-law's house for his wedding event should not put on *etu*);

"sanyan l'oba aso, alaari l'oba ewu" (*sanyan* is the king of cloth, *alaari* is the king of dressing);

"A ran omo l'aso, Iseyin ni ohun aso" (we sent someone to buy woven cloth, but Iseyin weavers had none available) [Iseyin was a town renowned for the woven fabric].

Etu, Sanyan, and Alaari were the major indigenous variants of handwoven fabrics worn at ceremonies. *Aso-Ofi* were made to order or commissioned. No doubt in the past, most *Aso-Ebi* were made from handwoven narrow band cloth (Eicher 1976: 41). The few literary works available on *Aso-Ebi* link its origins to ancient times, while others trace its development to a post–Second World War boom. William Bascom (1969) believes that its origin is traceable to the age-grade celebrations (celebration of people in the same age bracket of two years interval), in which the celebrants use similar cloths as a mark of fraternity. This is found in Owo where attaining the leadership age grade known as *ero* is celebrated wearing a specially commissioned handwoven cloth known as *girijo* (Akinwumi 1990: 46–51, 1992: 8–3; Asakitipi 2007).

This practice in recent times is found in the usage of uniform by different age grades (*regbe-regbe*) during the annual *Ojude-Oba* celebration in Ijebu-Ode. John and Margaret Drewal (1990) also trace the origin of *Aso-Ebi* to the pairing found in Yoruba *Gelede* masquerade, a form of comradeship in which two groups decide to dress alike.

The usage of the same fabric, same style, or head-tie is used to show the status of women and their female associations known as *egbe*. Nwafor (2013) asserts that the tradition of *Aso-Ebi* is a remnant of the post–First World War boom and conspicuous consumption that has remained as a national culture until now.

Whatever may be the origin of the *Aso-Ebi* tradition, it is pertinent to note that it has become a significant part of Nigerian dress culture and it is featured in all ceremonies that indicate change in status or social advancement such as naming, age-grade celebration, birthdays, housewarmings, chieftaincy installations, investitures, and weddings. This practice has even been extended to political gatherings where uniform *Aso-Ebi* is used as propaganda cloth for political campaigns (Areo and Areo 2012a). The use of uniformed propaganda developed with the emergence of political parties in the early 1950s (Post and Jenkins 1973: 428–30; Sklar 1963: 303–304). Adegoke Adelabu was credited as the first Nigerian politician to order factory-produced political party propaganda cloth (Akinwunmi 1997: 10).

There are several reasons for the survival and sustainability of the *Aso-Ebi* culture; first is the fact that Nigerians have a strong associational culture and a vibrant social life. This is because "we are all connected." There is an unbroken thread of social interaction or connectivity "because you will know somebody, who knows somebody, who knows somebody, who knows somebody" (Plankensteiner and Adediran 2010: 222).

Second, the need to belong in an environment where no "man is an island" is a fostering factor. Each individual asserts his identity and social connection through the *Aso-Ebi*. Third, urbanization, which has resulted in internal developments of indigenous dress culture, as well as external influences in terms of exposure to foreign fashion, via celebrity lifestyle, and fashion magazines, has also fuelled the *Aso-Ebi* practice.

The fourth reason according to Familusi (2010) is that a distinguishing feature of *Africanness* is a spirit of oneness manifesting in "we feeling," "live and let live," serious concern for others, and fraternity. This is born out of unavoidable interactions with other members of society. In other words, *Aso-Ebi* serves as a means of enhancing solidarity and reinforcing social identity among the different groups and therefore ensuring collective unity and survival.

Additionally, the importation of a variety of material of broader width, which are finer, more easily accessible and more colorful have aided the continuation of the *Aso-Ebi* tradition. Wearers do not have to wait endlessly for commissioned weavers to complete the fabric, and after choosing their particular fabric design and color can, within the space of a few hours, obtain the desired quantity of cloth directly from the market. Furthermore, media coverage of celebrities' lifestyle and ceremonies has encouraged the *Aso-Ebi* phenomenon.

The final contributing factor is the concept of seed and harvest time or "reciprocity." When individuals contribute to the success of another's celebration, their names are automatically mentally registered, and more recently in black on white within the celebrants' guestbook. Anytime the contributor has their own occasion to celebrate, all those they had supported in the past must, as a rule and as societal expectation, buy and wear their chosen *Aso-Ebi*. Hence the Yoruba will say, "gba mi ni igba ojo, ki n gba e ni'gba oda" (come to my aid in rainy days, so I can also support you in your time of scarcity). "Cooperation and mutual helpfulness are virtues among the Yoruba" (Dopamu and Alana 2004).

This reciprocity is even evident in a radio jingle on Osun State Radio Station where a woman, chastised for never staying at home to spend quality time with her family, retorts: "awon ore mi lo ma npe mi, mi si le se kin ma lo, nitori ojo to ba ma kan emi na" (it's my friends who invite me, and I must not just turn down their invitations, because of when I will need them during my own celebration). It is the height of shame, an indication of bad character, or lack of cordiality with others, not to have a crowd at one's events. The concept of "the more the merrier" reflects the evidence of your connection and status in society.

There is a connection between *Aso-Ebi* and the concept of uniform dressing of Yoruba age grade known as *Egbejoda*. *Egbejoda* means cloth made for collective use by a women's and men's group, club, or society. *Egbe* means society, age-grade, association, or group (Plates 3.1 and 3.2). Around the late 1950s, the term "and co.," which is an abbreviated form of "and company" referring to celebrants and their guests, was used to describe the uniform clothing. *Aso-Ebi*

usage evolved with burial or funeral rites where the children and close relatives of the deceased wore the same cloth in order to show their solidarity and identify them from the general crowd of participants at such events (Plate 3.3).

The introduction and importation of large yardages of different materials have also increased the access to a wide variety of cloth, which can be used as uniforms for people belonging to the same family group at Christmas and other holidays celebrated in Nigeria, such as Easter and Eid-el-Kabir. These materials also feature at weddings and other special ceremonies. Today a variety of commercial textiles ranging from factory-printed Ankara fabric to velvets, brocades, and embroidered fabric (collectively known as laces) are used together with the indigenously handwoven *Aso-Ofi*.

The concept of *Aso-Ebi* has widened beyond the cloth worn to identify the celebrant or to differentiate guests to the extent that it now includes and recognizes other types of relationships such as friends, work colleagues, religious affiliations, district and social memberships in addition to well-wishers. As a result, there is no specific limitation to the type of cloth worn at any particular ceremony. A passage from Dympna Ugwu-Oju's essay to support Phyllis Galembo's (1997) photographic documentation of *Aso-Ebi* in Benin illustrates this expansion of *Aso-Ebi*:

> An example of a decent *Aso-Ebi* showing was when Patrick and Janet, both middle-level public servants were married in Lagos, Nigeria, in June, 1991. Guests counted 15 different *Aso-Ebis* that were worn, representing different affiliations, with the groom or bride. The immediate families of the bride and groom wore *Aso-Ebis* of fuchsia and green silks respectively. Patrick's mother and each of his sisters (6 of them) brought their friends who showed their support by dressing in varied colored *Aso-Ebis* expressly selected by the family. Patrick's three older sisters' co-workers made *Aso-Ebi* also. So the groom's family alone wore a total of eleven *Aso-Ebis*. In addition to the one worn by Janet's family, her maternal aunts had their own distinct uniforms and so did her aunts on her father's side. Janet's female co-workers also wore an *Aso-Ebi*. This particular occasion recorded fifteen different types of *Aso-Ebi*.

However, in recent times, the variety of *Aso-Ebi* featured at any ceremony has been fine-tuned by the color stipulated by the celebrant and his nuclear family. It is not uncommon for people to ask "kolo wo ni won pe?" (What color has been specified for the occasion by the celebrant?).

In twenty-first-century Nigeria, the norm now is to specify the "color code" on the invitation cards being sent out to friends and relations for a ceremony. Thus, "color code" in the case of marriages usually comprises a set of two color combinations, one for friends and relatives of the groom and the second for those of the bride. In this way, it is easy to distinguish to which side each guest

belongs. The individuality of the guest is expressed by the style in which each *Aso-Ebi* has been sewn.

The implication and relevance of color-coding in *Aso-Ebi* is that each group member associated with the celebrant can choose material of their choice and within their financial capability. Their choice of fabric must explicitly be, however, within the "color code" specified by the celebrant. Color, therefore, has become the unifying factor for the *Aso-Ebis* of all the different groups and relationships of guests at any event.

The usage of *Aso-Ebi* is seen as a temporary leveller of class, since all guests wear the same cloth, thus bridging the gap in financial status between the rich and the poor. This gap, in recent times, is widening again since a single event or ceremony may feature as many as fifteen cloths as seen in the case cited by Ugwu-Oju. What we find now is that each group is choosing an *Aso-Ebi* that is commensurate to its financial standing, so that the color specified by the celebrant, rather than the *Aso-Ebi* itself, now serves as the "common denominator," a feature shared by all members of a group, and the social leveller. In celebration of many events, the "color code" is reflected not only in the *Aso-Ebi*, but also in the decoration of the event venue such as the cake, the chairs, the tablecloths, and all the other associated trappings.

There is a strong party/event culture in Nigeria and every weekend is filled with many celebrations. In many cases where the venue is too large, for instance if a football field is the venue, often, two sets of celebrants with their guests may have to share the same location with each celebrant taking a portion of the field for entertaining their guests. In such a case, the specified color code of each celebrant serves as an identifiable feature and thus plays the role of guiding or directing each guest to the celebration they are attending.

Since *Aso-Ebi* serves as a means of identification, each group showing their solidarity to the celebrant experiences a sense of pride. They also communicate their cohesion, as in the following song:

> *Egbe a wa yoo, won se b'osu lo yo*
> *Aso ti a ro, olowo fara m'olowo*
> *Ewu ti a wo, olowo j'ogun idera*
> *Gele ti a we sukusuku bam-bam*
> *Eni t'oba wu, ko be,*
> *Egbe awa yoo, won se b'osu lo yo*
> (Our group emerged brilliant as a new moon
> Our choice of cloth is that of the wealthy, flocking together
> Our head-tie is the height of elegance
> The envious will die of envy
> Our group has emerged as a new moon.)

At events, there is a psychological sense of camaraderie among each group, just as "birds of a feather flocking together" so, too, do the guests of each of the celebrants sit together. This makes it very easy to identify the relationships of each group to the celebrant.

Socially, special recognition and treatment are accorded each group wearing *Aso-Ebi*. A popular slang reflects this: "ko wo Ankara, ko je semo," meaning *semovita* (a particular Nigerian dish) will not be served to those not wearing Ankara fabric. (Ankara is the factory-printed cotton.) This, by implication, shows that buying and wearing the *Aso-Ebi* at events affords its wearers special dishes and privileges. At many such occasions, the type of *Aso-Ebi* one wears determines the quality of the party favor you will be gifted from the celebrant. *Aso-Ebi* makes it easier for those distributing such items to pick the deserving guests out of the crowd.

The *Aso-Ebi* "color code" also often serves as the invitation card or entry ticket. It is not uncommon in the Yoruba region to hear advertisers on radio stations giving the location where the uniform for an upcoming event can be purchased and its price. *Aso-Ebi* can now even gain its wearers admittance to musical shows or live performance. Typically, such advertisements are concluded with the statement: "ko wo Ankara, ko wo le o" (no entrance without the chosen Ankara fabric—simply put, "this cloth admits the wearer").

Psychologically, whoever goes to an event without wearing the *Aso-Ebi* is likely made to feel highly conspicuous and no guest wants to be asked why he or she is not wearing the prescribed dress. Many would rather borrow money to buy *Aso-Ebi*, rather than appear at the event in different attire and non-conformists are perceived as being too poor to afford the cloth.

While the *Aso-Ebi* may consist of full garments, there are occasions when the *Aso-Ebi* is in the form of handwoven *Aso-Oke* made into *gele* (head-tie) and *ipele* (shawl) for women, and caps for men. The actual dress may now be in any other material such as lace of specified color. The desire and compulsion to belong at all costs has been a significant contributing factor in the wide scale adoption of *Aso-Ebi*.

Aso-Ebi means more than showing solidarity by wearing a uniform material, since it is speculated that on few occasions the practice has its own economic benefit for the celebrant who would often have added some extra money to the market selling price in order to make room for the party favors that will be given to each guest who purchases the fabric.

Many people benefit economically from the practice of *Aso-Ebi*. Major beneficiaries are the cloth merchants, the cloth sellers, the tailors, and the celebrants. Another group is the printers who are commissioned to print the party favors that are eventually distributed to guests.

The practice of *Aso-Ebi* has become so sophisticated and entrenched in Yoruba culture that as the invitation cards are being given to the intending

guests, the "color code" is already printed on the card. It is also to be noted that recently, a list of the different types and categories of *Aso-Ebi* that are to be worn for the event and their prices are often attached to the invitation card. The friends of such celebrants were often notified of where to collect their *Aso-Ebi* or a general point of collection for these cloths. In some other instances, the details of the account into which the money for the cloth is to be paid is indicated in the note attached to the invitation card, and the cloth is delivered to individuals after payment has been made. It is equally the practice these days that as the intended *Aso-Ebi* is being delivered to those who have paid, the party favor for the event is packaged with the cloth. This shows that even before you sew the cloth or attend the event you already know and have collected your party favor prior to the actual celebration.

Similarly, journalists who specialize in celebrity coverage concentrate more on the various styles the cloth is made into, and this constitutes the major topic of their reportage and these reports serve as a form of sales catalog for tailors. Professional and amateur photographers benefit immensely at such events by taking instant photographs known as "wait and get."

Aso-Ebi, which originated among the Yoruba as a family uniform, has been transformed into a national and international phenomenon. It has become a form of identity and a cultural practice that has been imbibed by other ethnic groups within Nigeria and beyond. The concept of *Aso-Ebi* is now found among the Igbo of Southeastern Nigeria where it is called *ashebi*. It is also found among the Northern Nigerians who call it *Yaye, Anko*, or *Aso-Ebi*. Therefore, *Aso-Ebi* has become a national cultural phenomena, rather than a strictly Yoruba one (Ajani 2012: 116).

Through *Aso-Ebi*, guests at ceremonies have been able to enforce the respect of the celebrant, thus supporting the Yoruba system of according value, found in sayings such as "Iri ni si ni ise ni l'ojo" (your dress will determine the way you will be addressed or the reception that will be accorded).

For the Yoruba, it is the height of civilization and sartorial style to be elaborately and appropriately dressed for a ceremony. Through the *Aso-Ebi* family kinship cloth, the people express their identity, solidarity and support for each other, and maintenance of the collective societal memory.

The *Aso-Ebi* has become a source of wealth and a form of economic opportunity to many at different levels, namely the cloth merchants, the retailers, the tailors, the sewing notions merchants, graphic artists who emboss design on the party favors, photographers, and fashion photo journalists who chronicle these events in pictures in their journals.

By psychologically instilling a sense of compulsion and reciprocity, *Aso-Ebi* practice is sustained. Since culture itself is dynamic, the practice has evolved from an old cultural tradition with new forms in a modern society. An old cultural expression spanning decades has been made to fit into the modern society

through modifications in its practice. *Aso-Ebi*, therefore, has developed to transcend the Yoruba boundaries of its origin to become a national phenomenon, which is fast spreading to other African countries and Africans in diaspora.

Though the *Aso-Ebi* as a concept was originally meant for family members and believed to be a social leveller, the scope of participants in its usage has widened beyond the family and now includes colleagues, church members, school mates, friends, and acquaintances. Where a single clothing item was chosen for all the family members, a present-day ceremony could feature up to fifteen or twenty types of cloth depending on the affluence, wealth, and affiliations of the celebrant. The different types at such an occasion may now range from $15 to $50. The price range depends on the financial power of the buyers. Availability of this different class and cost of *Aso-Ebi* has been raised to an economic commodity.

No matter how varied the types and classes of *Aso-Ebi* are, the introduction of a "color code" for every ceremony in recent times constitutes a new form of social levelling. Ability to dress within the specified "color code" ensures that the guest will be able to "flock" or feel at ease with guests wearing a similar color. Color, therefore, has become a means of expressing identity and solidarity in the Yoruba *Aso-Ebi* practice.

References

Ajani, O. A. (September 2012), "*Aso-Ebi*: The Dynamics of Fashion and Cultural Commodification in Nigeria," *The Journal of Pan African Studies* 5 (6): 108–18.

Akinwunmi, T. M. (1990), "The Commemorative Phenomenon of Textile Use among the Yoruba: A Survey of Significance and Form." PhD Thesis, University of Ibadan.

Akinwunmi, T. M. (1992), "Taboos on Ritual Textiles among the Owo, Yoruba of Nigeria, as Instrument for Controlling Social Roles and Textile Quality," *Yabatech Academic Journal* 1 (2): 7–10.

Akinwunmi, T. M. (1997), "Provenance and Significance of Propaganda Cloth in Nigerian Political Party Elections, 1954–1983," *African Notes* 21 (142): 16.

Areo, M. O and A. B. Areo (2012a), "Textiles, Political Propaganda and the Economic Implication in Southwestern Nigeria." Textiles and Politics: 13th Biennial Symposium of Textile Society of America. September 19–22, 2012. Washington, DC.

Areo, M. O. and A. B. Areo (May and October, 2012b), "Dynamic Faces and Marketing Strategies of *Aso-Oke* amidst Phases of Massive Cultural Change," *ELA: Journal of African Studies* (31 and 32): 32–58.

Asakitipi, Areta (2007), "Functions of Handwoven Textiles among the Yoruba Women in Southwestern Nigeria," *Nordic Journal of African Studies* 16 (1):101–5

Bascom, William (1969), *The Yoruba of Southwestern Nigeria*, New York: Holt, Rinehart and Winston.

Dopamu, P. A and E. O. Alana (2004), "Ethical Systems," in N. S. Lawal, M. N. O Sadiku, and A. Dopamu (eds), *Understanding Yoruba Life and Culture*, 167, Trenton, NJ: Africa World Press Inc.

Eicher, Joanne Bulbolz (1976), *Nigerian Handcrafted Textiles. Ile-Ife*, 32, Nigeria: University of Ife Press.

Familusi, O. O. (October 2010), "The Yoruba Culture of *Aso-Ebi* (Group Uniform) in Socio-Ethnical Context," *Lumina* 21: 1–11.

Galembo, Phyllis (1997), "*Aso-ebi*: Cloth of the family. Benin City, Nigeria, Christmas and New Years 1991–1994." An essay in support of Phyllis Galembo Photographic Chronicling of Usage of *Aso-Ebi* in Benin. New York Foundation for Arts. Library of Congress Catalogue Card Number 97–93274.

John, Drewal and Margaret Drewal (1990), *Gelede: Art and Female Power among the Yoruba*, Bloomington: Indiana University Press.

Nwafor, Okechukwu (2011), "The Spectacle of *Aso-Ebi* in Lagos. 1990–2008," *Postcolonial Studies* 14 (1): 45–62.

Okediji, Moyo (1991), "The Naked Truth: Nude Figures in Yoruba Art," *Journal of Black Studies* 22 (11):30–44. African Aesthetics in Nigeria and the Diaspora. Sage Publishers.

Plankensteiner, Barbara and Nath Mayo Adediran, (eds) (2010), "African Lace: A History of Trade, Creativity and Fashion in Nigeria." Catalogue to an exhibition of the Museum Fur Volkerkunde Wien-Kunsthistorisches Museum and the National Commission for Museums and Monuments, Nigeria, with the support of Embroidery Industry 225, the Austrian Ghent/Kortrijk, Snoeck Publishers.

Post, K. W. J. and G. D. Jenkins (1973), *The Price of Liberty: Personality and Politics in Colonial Nigeria*, 373–4, N429, Cambridge: Cambridge University Press..

Sklar, R. L. (1963), *Nigerian Political Parties: Power in an Emergent African Nation*, 304, Princeton, NJ: Princeton University Press.

4

CONTRADICTORY COLORS: TRICOLOR IN VICHY FRANCE'S FASHION CULTURE

Emmanuelle Dirix

There can be no permanent loss of collective memory, only temporary self-inflicted amnesia.

<div align="right">WILKINSON (1996: 88)</div>

This text is concerned with the use of the French tricolor in fashion and dress and, by extension, in the visual culture of the fashion press in Occupied France, and more specifically with questioning how the meaning of these fashion objects has been positioned within the postwar history of Vichy France.

While several important works have been written, most notably by Lou Taylor (1992, 1995a) regarding the issue of collaboration by the haute couture houses, little has been said about the actual material culture produced during the time, and even less about its potentially problematic symbolic nature. Dominique Veillon in her seminal work "Fashion under the Occupation" (2002) took a more traditional historic approach and gave a thorough descriptive overview of the "goods" produced, yet she only hints at the gray areas of their meaning and mostly remains neutral in her assessment concerning issues of collaboration versus resistance.

The absence of discussion about these (tricolor) objects' potential variable symbolic meanings has resulted in the all too often unproblematic categorization of these items and images. Consequently, their existence is almost exclusively seen as a material manifestation of an underlying resistance to both the Vichy regime and the occupiers. This text wishes to challenge that their reading is

this straightforward. Furthermore, it poses the argument that rather than being examined objectively and thoroughly as historic objects, they instead have been co-opted by, and utilized in, the creation of a postwar Vichy narrative imposed from above and all too easily adopted from below. Their ambiguous potential has been removed from, and by, postwar narratives, which have categorized them as a singular homogenous group, which, in turn, has hermetically sealed them against objective, substantiated interpretation.

Similarly, the role of material culture in the creation of memory, and specifically collective/popular memory, needs questioning. Collective memory for the purpose of this text is defined as:

> The memory of a nation … (that) is created after reception of many signals. Here we have termed a vector everything that puts forward a voluntary reconstruction of events with a social end. Whether conscious or not, whether bearing an explicit or an implicit message, the many representations of an event all come together in defining a collective memory. (Rousso cited in Wilkinson 1996: 88)

By extension, it thus draws attention to the disjuncture between the past, conceived as everything that ever happened, and history, conceived as what agents of culture present the past to have been, and how objects have been co-opted into history rather than being treated as agents of the past.

It therefore makes a case against approaching material culture as indisputable evidence of history, and instead argues for it to be regarded as remains of the past and consequently for its reading to be opened up to allow for ambiguity that has the ability to expose and disrupt its often linear affirmative function in collective memory. This is an ambiguity that is often lacking but that needs to find a voice in this retrospectively created narrative, namely, the tricolor objects' ability to challenge the demarcation between villains and heroes, between collaborators and resistance activists (Cone 1992b).

On June 14, 1940, the German army marched into Paris after France's military defeat. An armistice was signed on 22 June, and the northern part of France, including Paris, was occupied by German troops. In the days prior to the fall of Paris, the government had moved first to Bordeaux then to the spa town of Vichy and would remain in the latter for the duration of the war, governing a country split in two both physically and mentally. The eighty-four-year-old newly appointed President de la République and First World War hero Maréshal Petain broadcasted on October 30 that France had entered a path of collaboration with Germany, thus making state collaboration official (Kedward 1985; Paxton 2001).

The government and country continued to be represented by, and indeed use, the tricolor, which despite the now-accepted version of events was never banned, only its use as an actual material flag was not tolerated at various times

between 1940 and 1944 in the occupied zone; indeed, it would have been near impossible to suppress or ban let alone police the use of the simple color combination of red, white, and blue in everyday life (Plate 4.1). In the unoccupied zone, the Vichy government made extensive use of the tricolor (both as flag and as a color combination) in their propaganda; a variation featuring the addition of a *francisque* axe (a double-headed axe with concentrically colored blue, white, and red blades) and seven golden stars within the white stripe was Petain's presidential standard and while also used extensively by the regime it did not replace the republic's original tricolor, nor its use.

The republic's tricolor originated during the French Revolution and its representative values of liberté, égalité & fraternité continued to symbolically define France; the tricolor was both a tool used by and an affirmation of the government as supposed protector and executor of French values. However, in a country that was occupied by "the enemy" — even if an official collaboration had been agreed — and that was no longer free, the tricolor inevitably took on new, or rather multiple and often contradictory, meanings.

The population of France during the Vichy years can be roughly divided into three groups: those who actively supported collaboration (Fascist and Nazi sympathizers), those who actively supported resistance (Gaullists), and those who are best classified as "other" (including, but not exclusively, Pétainistes). To each of these groups, the tricolor was a pertinent symbolic signifier but one whose signified meaning varied radically.

While all in France felt mentally and physically humiliated by the country's military defeat and the subsequent occupation, it needs to be acknowledged, however uncomfortable, that even if a significant proportion of the population might not have liked the physical occupation of their territory, they were not wholly ideologically opposed to the ideas and visions of their victors. This was sadly evidenced by the ease with which certain individuals and institutions facilitated and collaborated in the "cleansing" programs of the Nazi regime. To this group of *collaborationnistes*, as Hoffmann (1974) and later Paxton (2001) call them, the tricolor was synonymous not simply with France and Frenchness, but a country deeply tied up with a specific and often very problematic purist view of national identity and nation-state.

De Gaulle's Free French government in exile also used the tricolor but added the two-barred Lorraine cross as a sign of their commitment to reclaim annexed territory and to differentiate themselves from the puppet Vichy government and position themselves as the *true* leaders and protectors of France. A scarf by the English company of Jacqmar from this period (in the collection of the Museum of London) features a pattern consisting of the *Forces Navales Françaises Libres* badge including the Lorraine cross, the breast badge of the Free French Air Force, the "Moustique" or mosquito breast badge — which "could only be worn by men and women who had joined the Forces Françaises Libres before August

1943, when their units were amalgamated with the French Army of North Africa" (Behlen 2011)—de Gaulle's signature, and the text *Forces Françaises Libres*; the design is executed in red, white, and blue on a light blue ground and serves as a useful example of material fashion culture utilizing the tricolor within a context of active resistance. However, as the use of such a scarf or this "adapted" tricolor (or the Lorraine cross) would have been too dangerous on French soil, the matter is further complicated by the fact the republic's tricolor could thus be used as a symbolic substitute to disguise a more radical rejection of the Pétainiste regime under the guise of conformist support. Hence for those who actively resisted it was equally a sign of Frenchness *but* one that went beyond government politics and that was closely aligned to the revolutionary values of 1789—values and ideals inherent to the nation, and ones that superseded governmental politics and that could indeed be contrary to them, as was the case during the war years.

The third group, those not actively engaged in either collaboration or resistance, felt it was their patriotic duty as French citizens to continue to support the government and Pétain's leadership without critical questioning but it needs to be understood, often without exaggerated commitment. It is interesting to note that after the war many in this group were unclear if their support of Vichy meant they had been collaborators or resisters; unsurprisingly, many preferred retrospectively to classify themselves as the latter. During the war, for this group the tricolor meant supporting France, but by extension and without much questioning, also the government and France's "values" even if those values had undergone a major reform under Pétain's Révolution Nationale. (One of the many outcomes of this national revolution was the substitution of the words *liberté, égalité, fraternité* with *travaille, famille, patrie*; it is impossible to determine if for the population these values substituted those originally associated and symbolically represented by the tricolor, but this is highly doubtful.) The way this group understood, valued, and used the tricolor is the least straightforward and the most problematic to pin down especially as their understanding and value of it shifted as the war progressed. While to the collaborators and resisters the tricolor's meaning was fixed, to the "ordinary" Frenchman its meaning was rather more fluid and diverse. So to every one of these groups, the tricolor symbolized Frenchness and their commitment to it, but crucially their interpretation of Frenchness varied radically.

In recent years, several books, articles, and exhibitions have been staged about fashion and dress culture under Vichy. In nearly all of these, fashion objects (garments and accessories) in a tricolor palette and fashion imagery from the Vichy period have been included or referred to. In the case of, for example, a silk scarf decorated with the image of Pétain, the object is clearly highlighted as problematic and categorized as state propaganda; however, in cases where such explicit imagery beyond the use of red, white, and blue is absent, the objects are most commonly framed as expressions of symbolic resistance to the

occupiers, which is of course problematic in light of what has been discussed in regard to the potentially diverse symbolic meanings of the tricolor.

In more critical contexts, such as Veillon's study (2002), the question as to the reason why people might have donned tricolor items is raised and indeed makes the pertinent point that wearing does not equate to resistance per se, however the possibility of these items expressing the opposite of resistance is not entertained. As Taylor (1995b) pointed out, there is still too little linking of art and design to Vichy ideology (Plate 4.2).

The same approach yet more explicit can be found in the catalog to the 2009 exhibition *Élégance et système D. Paris 1940–1944*, curated by the Palais Gallièra but interestingly staged at the Musée Jean Moulin (named after the high-profile member of the resistance—the museum context inevitably also implicitly frames the objects on display as the material culture of resistance). What sits uneasily about the catalog is its complete neutrality in regard to the objects and their descriptions. While academic and curatorial neutrality is laudable, objectivity should not be considered equal to, nor be confused with neutrality (Haskell 2000). Indeed, beyond factual information about how the objects were made, and historical tidbits about the popularity of hats, no wider critical context to the period and fashion production is introduced.

Considering its theme and location, it is reasonable to suggest the exhibition would attract a majority of French visitors. This of course made the absence of context and the perceived neutrality of the approach somewhat contrived and anything but neutral. In fact, its lack of questioning and challenging of received wisdom affirms that the audience implicitly "knows" the wider context and indeed the official, culturally accepted narrative of this period through their embodiment of France's collective memory of the Vichy years.

One of the objects featured in the catalog is an issue of the fashion publication *Mode du Jour* from 1941. At first glance, its cover appears very French indeed being a composition of red, white, and blue. Several other French women's magazines including *Elle, Marie-Claire, La Femme d'Aujourd'hui*, and *Le Petit Echo de la Mode* regularly employed this tricolor palette (Plate 4.3). When first encountering these magazines it is easy to categorize them as subversive or defiant, especially as tales of "symbolic resistance" are plentiful when it comes to fashion and cultural life under Vichy. The most well-known is that of Couturiere Madame Grès who utilized the tricolor in her collections supposedly to the great annoyance of the Germans who, in fact, shut her atelier down several times. It would be natural to assume these magazines propose a similar act of symbolic resistance through color. However, the Grès tale while regularly repeated in interpretative history cannot be substantiated through primary research. While there is little doubt Grès was an outspoken opponent of the Germans, there is no indisputable evidence she was shut down specifically for her use of red, white, and blue. Her flouting of the German imposed fabric restrictions in her

pleated creations (which in itself could be interpreted as an act of defiance) was to "blame" not her supposed/or potentially intended symbolic resistance.

There is no unequivocal evidence the occupiers had an explicit issue with the use of the red, white, and blue color combination in material or visual culture, aside from when presented in flag format, but this is more closely aligned to the conflation of national flags and patriotism and as a marker of physical ownership of territory. Indeed Cone (1992b) points out that tricolor painting which emerged as an artistic movement around 1941 was generally well received, not suppressed, and merely considered as an expression of innate Frenchness by German critics. The popular "reading" of these magazine covers as symbolic resistance is thus skewed by the incorrect belief that the occupiers had a moral stance on, and furthermore tried to unilaterally suppress expressions of Frenchness.

Tricolor objects and images, or specifically their imposed and culturally restricted readings, are part of the wider myth of "résistancialisme" (Rousso 1990) that emerged after 1944. As Roland Barthes (1972) stated, myth repeated enough times becomes truth. In the case of these magazine covers, the "real" truth is far less subversive. The excessive use of red and blue ink was simply attributable to the heavy rationing of chemicals, which resulted in only certain colors being liberally available. A closer look inside the publications affirms this. Page after page is filled with illustrations of what appear to be patriotically tinted fashions but upon reading the descriptions it becomes evident that red and blue in fact had to stand in for every color of the rainbow. This disjuncture between fashion image and description is not unique to Vichy France and what is important is the fact that the outcome of material shortages, so central to these objects, is overlooked or omitted from their biography in the exhibition and catalog which leaves these magazines open to interpretation. Interpretation is dependent on many factors including how the object is physically framed (i.e., what other objects it is complemented or contrasted with, the design of the exhibition space, the identity of the institution) but also on what prior knowledge the viewer brings to the table.

In the case of tricolor objects and imagery, that prior knowledge is all too often shaped by what revisionist historians have termed the Vichy syndrome: the postwar collective French memory of the war years and a syndrome that was created as much to hide as to reveal (Rousso 1990, 1994; Paxton 2001). Rousso described this construct as

> a process that sought: first, the marginalization of what the Vichy regime was, and the systematic minimalization of its hold on French society … second, the creation of an objet de mémoire, the "Resistance," far greater than the algebraic sum of the acting minority who were resisters … third, the assimilation of this "Resistance" into the entire nation, notably a characteristic of Gaullist résistancialisme. (Rousso in Cone 1992a: 192)

The Vichy syndrome does not deny collaboration but denies it was widespread; more importantly, it denies the possibility of it being widespread among the good people of France through the creation of a narrative that foregrounds the resistor as the true Frenchman or woman; this "constructed" historic resistencialism is thus central to contemporary French national identity.

This syndrome was not merely a creation by the state; its citizens played and continue to play their part, as do historic relics. Indeed a vital part of this process of "altering" the past into an acceptable history involved the creation of a supportive visual and material narrative that both developed new media (film, TV documentaries) and rearranged existing surviving objects that affirmed this collective memory. In terms of artifacts, this was achieved by the imposition of a symbolic order that dealt in extremes only: good, evil, resistance, or collaboration. In such a system, tricolor objects are used to smooth out friction and create simplicity when in fact they *are* historic friction. The Vichy syndrome strips away ambiguity and so protects the status quo through the repetition of a myth that is easy to swallow and that tastes good to boot.

Collective memory, shaped by the Vichy syndrome, thus places certain sanctioned meanings on objects such as tricolor fashions either explicitly or implicitly by co-opting them into its story as powerful signs of something they may not originally have been, hence why the myth that the tricolor was banned needs to be perpetuated as it allows the mere existence of red, white, and blue items to immediately be categorized as something of great sign value. The whole issue is, of course, further complicated by the fact that upon liberation all designers, if not every Frenchman and woman, went "tricolor-mad" and these "vive la liberation" items naturally skew our understanding of the earlier occupation items even further.

Manifestations of this collective memory are found both implicitly and explicitly throughout the exhibition catalog; the little explanation or context that is included to "help" frame certain objects is historically contentious and yet entirely in line with the accepted narrative. In the Section "Accessoires de Propaganda," it states, "L'administration Francaise doit cooperer avec l'occupant" (the French administration has to/is forced to cooperate with the occupier). Most prominent Vichy historians dispute this was a case of "had to," indeed the fate of neighboring countries suggest it was a choice. It is not the intention of this text to judge whether this choice was right or wrong but it is highly problematic and worrying that over time this revised interpretation of history that denies France's war leaders any agency in the matter of collaboration has become official truth and is reproduced by cultural agents such as museums whose job it is to conserve the past, not to help rewrite it.

The catalog then deals more appropriately with the persecution of Jews in the garment industry but while there is acceptance that the Vichy regime (but it is to be noted not the French people) played an active role in the victimization

of Jews, it fails to point out that at times they acted on their own accord and initiative without orders from the Germans to do so.

The final section of the catalog is named "L'accessoire, symbole d'opposition et de résistance." It explains that an accessory is sometimes used in support of Vichy propaganda but that it can equally be an act of resistance to the government and the occupier; once again there is no mention of the possibility of collaboration, the word simply does not appear hence its existence is negated. The underlying tone is similar to Veillon's: one that negates the possibility that fashion and one's engagement with it can ever be construed as collaboration.

It *is* a possibility and in France this was explicitly evidenced in the "pastoral" and "traditional" fashions (Figure 4.1) resurrected or invented as part of Petain's moral right-wing national revolution, which are uncomfortably similar to the sartorial ideas promoted by German National Socialists in the 1930s. Sadly this possibility of sartorial collaboration is one that contemporary agents and agencies of culture do not, or cannot, entertain let alone give voice to.

This denial or refusal to question results in the several examples of women wearing tricolor accessories in Paris that are cited in the catalog, being categorically presented as acts of defiance and resistance. This text does not deny the possibility that these were not, or could not be, acts of resistance but it is necessary to raise doubts about the reasons why they get presented as such without questioning. These are all examples of how the objects are "made to fit in" and substantiate a narrative of good, pure, but oppressed, French people desperate for freedom and with a hatred for their occupier/oppressors. For many that was the reality of the matter but history shows us that for many it was not, and that the tricolor could be symbolically implicated in criminal acts such as the deportation of the Jews as much as in acts of resistance.

The lack of personal stories and personal agency in regard to the objects in the catalog that are undeniably about propaganda or collaboration is equally interesting and revealing. While personal stories of brave women who wore the tricolor are featured in the accessories and resistance section, in the propaganda and persecution section only the abstract, depersonalized agents of oppression are mentioned: Vichy, the Government, the Occupiers, The Germans. This is strange since fashion is about the personal as much as it is about the collective. Yet when the discussion turns from resistance to collaboration, the personal disappears and is substituted by the abstract: internal evil has to remain impersonal, faceless, nameless, and thus blameless.

The catalog does not challenge, instead it affirms that common beliefs are instruments of power and self-preservation and "that memory functions as a shield in the present rather than as a bond with the past" (Wilkinson 1996: 87). By leaving unchallenged the willful misperceptions of those who lived through Vichy and without questioning the motives that led them to falsify their memory of the past, it exposes that "Parallel with the history of Vichy another history was

Figure 4.1 Pastoral-inspired ensembles *Pour Elle* magazine 13/8/1941. Author's image.

taking shape, that of its memory, of its persistence, of its development after 1944 up to a date that today remains impossible to determine" (Rousso in Wilkinson 1996: 87–88).

That there was symbolic resistance in Vichy France is not in doubt, but the promotion that it was as clear-cut and indeed prevalent as suggested by revisionist French historic narratives needs to be challenged. In similar need of interrogation is the reading of material culture featuring a tricolor palette because as this text has argued without this, these objects can only ever function as predetermined agents in an altered history and solely as evidence of a flawed cultural truth. These objects are about Frenchness; Frenchness meant different things to different people during Vichy, as it does now. Nevertheless, by presenting Frenchness instead as a homogenous and hermetically sealed idea and by wanting to make everything, including objects, fit into one of two neat boxes—the correct or the corrupted, resistance or collaboration—we miss the objects' true meanings and potential, that is, their ability to highlight that national identity and collective memory are constructs based on myths, ones that material culture can affirm but more importantly that it can disrupt through the exposure of those sanctioned and sealed narratives and lay bare their true contradictory colors.

References

Barthes, R. (1972), *Mythologies. 1957*, Trans. Annette Lavers, 302–6, New York: Hill and
 Wang.

Behlen, B. (2011), http://blog.museumoflondon.org.uk/jacqmar-france-libre-and-
 peckham/ (accessed October 10, 2015)

Cone, M. C. (1992a), "'Abstract' Art as a Veil: Tricolor Painting in Vichy France, 1940–
 44," *The Art Bulletin* 74 (2):191–204.

Cone, M. C. (1992b), *Artists under Vichy: A Case of Prejudice and Persecution*, 25–34,
 Princeton, NJ: Princeton University Press.

Confino, A. (1997), "Collective Memory and Cultural History: Problems of Method," *The
 American Historical Review*: 1386–403.

Falluel, F. and M. L. Gutton (2009), *Elegance et Systeme D Paris 1940–44*, Paris
 Musées.

Haskell, T. L. (2000), *Objectivity Is Not Neutrality: Explanatory Schemes in History*,
 Baltimore: JHU Press.

Hoffmann, S. (1974), *Decline or Renewal? France since the 1930s*, Viking Press

Kedward, H. R. and R. Austin (eds) (1985), *Vichy France and the Resistance: Culture &
 Ideology*, London: Croom Helm.

Kedward, R. (1991), *Occupied France: Collaboration and Resistance 1940–1944*, Wiley-
 Blackwell.

Le Boterf, H. (1997), *La vie parisienne sous l'occupation*, Éditions France-Empire.

Paxton, R. O. (2001), *Vichy France: Old Guard and New Order 1940–1944*, Columbia
 University Press.

Rousso, H. (1990), *Le Syndrome de Vichy: de 1944 à nos jours*, Vol. 135, Seuil.

Rousso, H. and A. Goldhammer (1994), *The Vichy Syndrome: History and Memory in
 France since 1944*, Harvard University Press.

Taylor, Lou (1992), "Paris Couture, 1940–1944," *Chic Thrills: A Fashion Reader*: 127–43.

Taylor, Lou (1995a), "The Work and Function of the Paris Couture Industry During the
 German Occupation of 1940–44," *Dress*, 22 (1):34–44.

Taylor, Lou (1995b) "Artists Under Vichy: A Case of Prejudice and Persecution• Le
 Project culturel de Vichy• Jacques Fath• La Mode sous l'Occupation débrouillardise
 et coquetterie dans la France en guerre (1939–1945)," *Journal of Design History* 8
 (2):149–51.

Veillon, D. (2002), *Fashion under the Occupation*, Berg Publishers.

Wilkinson, J. (1996), "A Choice of Fictions: Historians, Memory, and Evidence,"
 Publications of the Modern Language Association of America: 80–92.

SECTION TWO

COLOR AND POWER

5
DRESS AND COLOR AT THE THAI COURT

Piyanan Petcharaburanin and Alisa Saisavetvaree

Cambodian, or Khmer, culture has had a profound influence on the art and culture of its mainland Southeast Asian neighbors, particularly Thailand. Both Khmer and Thai culture were in turn profoundly influenced by widespread, early contact with the Hindu-Buddhist belief systems of India. One important example is Thailand's astrological system, which was adopted from Khmer concepts based on Hindu cosmology and which associates a particular color with each day of the week, based on the color associated with the deity who protects that particular day, as follows:

Day of the Week	Color	Celestial Body	Hindu Deity
Sunday	Red	Sun	Surya
Monday	Yellow	Moon	Chandra
Tuesday	Pink	Mars	Mangala
Wednesday	Green	Mercury	Budha
Thursday	Orange	Jupiter	Brihaspati
Friday	Blue	Venus	Shukra
Saturday	Purple	Saturn	Shani

Surya is the Hindu sun god. In Hindu cosmology, he presides over Sunday. Chandra is the word for moon in Sanskrit, Hindi, and other Indian languages, of which he is the god. In addition, Chandra is identified with the Vedic lunar deity Soma. As Soma, he presides over *Somvar* or Monday. Mangala is the Sanskrit name for Mars, the red planet. He presides over *Mangala-varam* or Tuesday. In Hindu mythology, Budha—not to be confused with the founder of Buddhism—is the name of the planet Mercury. Budha presides over *Budhavara* or Wednesday. Brihaspati is the regent of Jupiter and is often identified with that planet. He

presides over *Guru-var* or Thursday. Shukra is identified as the planet Venus. He presides over *Shukravar* (also known as *Devanagari*) or Friday. Shani, the son of Surya, is embodied in the planet Saturn and is the Lord of Saturday.

Both Thai and foreign journals and memoirs show that men and women associated with the Siamese royal court in the Ayutthaya era (1350–1767) chose the colors of their daily clothing with these associations in mind, both to differentiate themselves from those of lower status and to bring good fortune. Specific patterns and colors were, in fact, restricted to the court or to the king and his immediate family.

In battle, during the Ayutthaya era, male courtiers would wear specific colors, which were thought to bring them victory. This practice of wearing particular colors on a given day survived until the end of the Ayutthaya period and was carried over into the Rattanokosin era, which began in 1787. During the reign of King Rama II (r. 1809–1824), the UNESCO-recognized poet Sunthorn Phu (1786–1855) compiled his "poetic guide" or "guide in verse" to princely conduct and upright behavior that was first published around 1821 and is still taught in Thai schools today.

Sunthorn Phu based his poem on an earlier *Sawasdi Raksa*, composed in the Ayutthaya period in an archaic poetry style called *chan* that was difficult to understand. Sunthorn Phu's newer, more comprehensible poem shared the same concepts as the original, including the scheme of specific colors recommended for each day of the week. Astrologers would refer to this scheme and pick the most auspicious hues for each day's battle tunics.

According to *Sawasdi Raksa*, the proper manners of a gentleman are as follows:

> After getting out of bed in the morning, you must refrain from anger. Turn your face towards the East and South, and pronounce three times an incantation according to the Buddhist formula over the water for washing your face …
>
> When wearing a phanung, or loin-cloth, after twisting its two ends together in front, one end is tucked finally on the right side, you will be free from harm of crocodiles and other beasts …
>
> When going to war, you must select the auspicious color matched to each day of the week.
> Sunday: Red is auspicious
> Monday: Light yellow is to have a long life
> Tuesday: Purple is lucky
> Wednesday: Yellow-red or glittering multi-colored
> Thursday: Yellow-green
> Friday: Bluish-gray
> Saturday: Black is a terror to the enemy
>
> (Sriyaphai and Narakorn 1977: 214–215)

In the nineteenth century, both men and women of the court adopted the practice of wearing particular colors on a given day as a daily custom. This was most easily followed in women's dress.

At first, fashionable court women followed the auspicious colors for each day by wearing one shade for the hip wrapper and another for the shoulder cloth. Later, it became fashionable to highlight the day's color with a garment of a contrasting color. For example, on Sundays, associated with red, many women would highlight a red hip wrapper by wearing a green shoulder cloth, or vice versa. Since red and green are complimentary colors, the juxtaposition of green with red would make the red stand out all the more while also pleasing the eye.

This tradition was especially popular during the reign of King Rama V (r. 1868–1910) as attested by several sources. According to the king's niece HSH Princess Chong Chitra Thanom Diskul (1886–1978), the women in the court matched their shoulder cloths with hip wrappers following the lucky colors of each day and took care to wear different colors on the top and bottom. Wearing a single shade, while not incorrect, was considered less beautiful and fashionable.

Although the colors associated with a particular day are based on the Hindu cosmological system as described earlier, traditional Thai color names are normally taken from natural objects such as flowers, plants, and animals.

As described in the princess's memoirs, the chart of auspicious colors was as follows:

> Sunday: A bright green bottom with a ruby-red top or a lychee-red bottom with a yellow-green top (Plate 5.1a);
>
> Monday: A pale yellow bottom with a blue or reddish-pink top or a dove-gray bottom with a yellow-orange top (Plate 5.1b);
>
> Tuesday: A light green bottom with a purple top or a mauve bottom with a light green top (Plate 5.1c);
>
> Wednesday: A steel-gray bottom with a deep, pea-green top or a soft orange top with a dark green bottom (Plate 5.1d);
>
> Thursday: An orange bottom with a pale yellow-green top or a light blue-green bottom with a ruby-red top (Plate 5.1e);
>
> Friday: A royal blue bottom with a bright yellow top (Plate 5.1f);
>
> Saturday: A purple bottom with a chartreuse top (Plate 5.1g).

In addition, for Buddhist holy days a red bottom with a pink top was considered appropriate.

Temple murals also attest to these traditions. For example, a mural painting at Matchimawat Temple, Songkla Province, southern Thailand, which dates c. 1851–1868, depicts a court woman wearing red and green on Sunday. A mural painting at the Mahasamanaram Temple in the Petchaburi Province of western

Thailand from the same period illustrates court women wearing yellow-orange and dove-gray indicating the scene is taking place on a Monday.

According to Emile Jottrand, a Belgian legal adviser to the Siamese Ministry of Justice from 1898 to 1902, men at the court of King Rama V were also continuing to match the colors of their clothes to the day of the week.

> 29 Sept. 1899. Earlier in the Court, I ask for an interpreter to accompany me to an office situated in the enclosure of the King's Palace. The interpreter excuses himself, saying that he will not be admitted dressed in a red phanung [a formal hip wrapper], the color red being exclusively reserved during Sundays for the King and the princes.
>
> This forces me to call for an interpreter dressed in a blue phanung. Thus, I have come to learn that each day of the week has a color which is exclusively reserved for it: on Sundays the phanung is red; on Mondays yellow; on Tuesdays it is deep blue; on Wednesdays scarlet, on Thursdays green; on Fridays gray, and on Saturdays black. The Siamese may wear these colors at home, or in the city, but they cannot enter the palace dressed in this fashion, except if they are princes. (Jottrand 1996: 214–215)

Jottrand's description of the color of each day follows those from the old *Sawasdi Raksa*, composed in the Ayutthaya period. These colors do not fully correspond to actual practice in the Rattanakosin era, which associated yellow-red, not green, with Wednesday, and black, not purple, with Saturday. Thus, it seems likely that in that period male aristocrats and courtiers were adhering to one color tradition and fashionable women of the court were following another, newer one. It is the latter system that forms the basis of modern concepts of daily color associations in Thailand today.

The women of the court were famed not only for their colors in fashion, but also for their skill at caring for textiles. In addition to being carefully washed, their fabrics were routinely glazed, pleated, and perfumed—procedures that were performed in the inner court. These royal women occasionally carried out such activities themselves, but more often their servants did the work under their direction.

Several cleaning methods were used, depending on what each textile was made from and where it was worn on the body. Large silk brocade or painted cotton hip wrappers were commonly washed one at a time in boiling water scented with sweet Madagascar jasmine. Sticks or small paddles were used to agitate the textile and loosen the dirt. Fenugreek seeds were also added to the water before the textile was immersed; their sticky mucilage stiffened the fabric and allowed it to be glazed with a shiny finish.

Breast wrappers and shoulder cloths were both less dirty and made of more delicate fabrics than hip wrappers. They were most often given a simple soak

in clean water. Similarly, gold brocade, gold net, and gold-embroidered textiles used as hip and breast wrappers or shoulder cloths were too fragile to be washed in boiling water. Instead, they were spread flat so their gold threads would not break, soaked in coconut water, rinsed in clean water, and dried.

After washing and drying, the cloths, especially hip wrappers, were spread flat and polished to make them shiny—a feature prized by the court. The shine came from fenugreek mucilage deposited on the fabric during washing, which created a glossy finish when it was buffed with a smooth, rounded tool, often formed from cowrie shells but also agate, glass bottles, or even small cannonballs.

Women of the court always perfumed their colored shoulder cloths and hip wrappers before getting dressed. It was said that the sweet fragrance lingered long after they had left a room. They scented their textiles using traditional methods of burning aromatics and creating perfumed waters and oils, employing a wide range of ingredients that were grown domestically or obtained through trade. The wearer's favorite fresh flowers, such as Chinese rice flower, ylang-ylang, and different kinds of jasmine, were selected to make scented water.

The perfumed cloths were usually stored in closed wooden boxes to help the fragrance last longer. Again fresh flowers, such as salapee, Chinese rice flower, ylang-ylang, and different kinds of jasmine, were often added to the box. Scented cheesecloth was also used instead of fresh flowers.

Washed, glazed, and perfumed hip and breast wrappers were smoothed with a wood-pressing implement. Shoulder cloths were pleated both by hand and with a special press. Two people were needed to hand-pleat a shoulder cloth, one on each side holding it taut while folding it. The fabric was then placed in a heavy wood press, which set the pleats. A *raang jeeb*, a tool with bamboo teeth between which the fabric was inserted, was also used to pleat shoulder cloths.

The color tradition probably remained in force until the end of the reign of King Rama V, who died in 1910. However, King Rama V's reign also saw the gradual Westernization of court dress. The Hindu-derived practice of wearing specific colors for each day of the week was gradually abandoned by the Thai court during the reign of his successor, King Rama VI (r. 1910–1925), as their dress continued to Westernize. By the early 1930s, court dress was fully Western, or nearly so. The color traditions, however, were in some measure revived under Thailand's present monarch HM King Bhumibol Adulyadej (r. 1946–present) and his wife, HM Queen Sirikit.

His Majesty King Bhumibol ascended the throne in 1946 when he was nineteen years old. Four years later, in 1950, He married seventeen-year-old Sirikit Kitiyakara, daughter of the Thai ambassador to France. In their early years on the throne, Their Majesties made official visits to almost every part of the country to learn about the challenges faced by ordinary Thais. In the late 1950s, they began to travel abroad, starting with neighboring countries such as Vietnam, Indonesia, and Myanmar (Burma).

In 1960, Their Majesties began a series of state visits to the United States and fourteen European countries. This ambitious undertaking lasted seven months. The Queen, who devoted considerable effort and thought to her tour wardrobe, was eager to have "traditional" attire that was recognizably Thai to wear during the tour. However, since Thai clothing had become Westernized, there was no longer a characteristically Thai court dress for the Queen to wear. Therefore, Her Majesty, with the help of an advisory team that included historians, designers, dressmakers, and ladies-in-waiting worked to create an entirely new version of "Thai national dress" that combined elements of nineteenth-century court dress with modern tailoring. Over the course of about two years, eight different styles made of handwoven Thai textiles, of varying degrees of formality, were designed to be worn on a wide variety of occasions. The Eight Styles are known in Thai as *Phra Rajaniyom* ("Royal Favor"). This wardrobe was so successful on the royal tour that other Thai women began to wear it (Figure 5.1a–h).

> 5.1a Thai Ruean Ton: The most informal of The Eight Styles, it is the popular attire for Thai women attending engagement parties or religious ceremonies and as uniforms for those in the hospitality industry.

> 5.1b Thai Chitralada: This long-sleeved, high-collared silk jacket and long plain silk or silk brocade wrap skirt is formal daytime attire.

> 5.1c Thai Amarin: This dress is similar in appearance to Thai Chitralada, but more formal because it is made from silver or gold brocade. It is worn for welcoming parties, balls, or a Royal birthday procession.

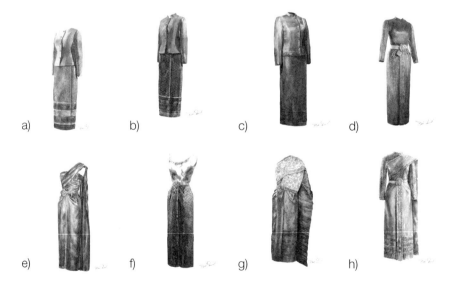

a) b) c) d)

e) f) g) h)

Figure 5.1 The Eight Styles known as *Phra Rajaniyom* ("Royal Favor"). © Queen Sirikit Museum of Textiles.

5.1d Thai Boromphiman: This one-piece dress is worn for formal events and official ceremonies. Royal brides can also wear it.

5.1e Thai Chakri: This style features a skirt with a front pleat and an attached traditional Thai shoulder cloth. It is worn for Royal ceremonies, but brides-to-be may also wear it for daytime engagement or wedding ceremonies.

5.1f Thai Dusit: This formal attire is made of gold brocade with an elaborately embroidered bodice.

5.1g Thai Chakraphat: This style of dress is usually worn for formal banquets and official dinners.

5.1h Thai Siwalai: This dress is worn for Royal ceremonies or formal day or evening functions.

Besides Thai style dresses, Her Majesty also commissioned a wardrobe of Western fashion design by French couturier Pierre Balmain for the 1960 tour. The Queen needed the proper clothes for every occasion depending on conventional Western dress etiquette for royalty. It was Her Majesty's dressmaker Urai Lueumrung who suggested She consider Pierre Balmain's work in 1959. After talking to him and looking at the sketches, Their Majesties were satisfied with them and decided to have him create both Western and Thai wardrobes for the state visits.

Balmain lent a certain "Thainess" to his work for the Queen by using handwoven Thai silk purchased from Jim Thompson's Bangkok-based company in many of Her Majesty's ensembles. Working with Thai designers and the Queen, some of Balmain's works were inspired by traditional Thai dress, for example, the *Thai Chakri–Chong Kraben* variation and the Thai variation with double *sabai* tails. The *Thai Chakri—Chong Kraben* variation is the tailored ensemble suggestive of traditional wrapped and draped garments. However, the shoulder cloth (*sabai*) is sewn into the side seam of the bodice and the short, unsewn trousers (*chong kraben*) are tailored into knee-length breeches gathered into a waistband from which hang ornamental panels. The Thai variation with double *sabai* tails is a dress of metallic brocade and decorated with traditional gold net and beads (Leventon and Gluckman 2012).

As reported by many of the journalists who covered the royal couple during the state tour, Balmain worked traditional Thai color symbolism into his designs for the Queen's Western wardrobe. From this point, the Thai tradition of certain colors being associated with particular days of the week became newsworthy.

She dresses in Western style in the daytime but reverts to tradition in Paris-made Eastern garments at night. The Queen's 24 trunks are packed with dresses that are a different color for every day of the week. The colors are:

Sunday, red; Monday, yellow; Tuesday, pink; Wednesday, green; Thursday, orange; Friday, blue; and Saturday, mauve. (Sydney Sun, NSW, Australia 1960)

The press was fascinated by this story. Many newspapers talked about Balmain's designs being keyed to the belief in Thailand of auspicious colors for each day (Leventon 2016). Although there is little evidence to suggest that the Queen actually took them into consideration when choosing what to wear on any given day, there is evidence that Her Majesty did include some outfits that followed the tradition of wearing auspicious colors (Plate 5.2).

Specific colors have, however, become associated with individual members of the royal family, according to the day of the week on which they were born. His Majesty the King, for instance, was born on Monday so his color is yellow; the color for Her Majesty is blue because she was born on Friday August 12, 1932 (Plate 5.3). Therefore, every twelfth of August there is a ceremony to celebrate Her Majesty's birthday for which many Thais wear blue shirts or dresses.

HRH Princess Maha Chakri Sirindhorn, the second daughter of King Bhumibol and Queen Sirikit, was born on Saturday, April 2, 1952, so her assigned color is violet. Princess Sirindhorn does often wear violet for official engagements on Saturday, as evidenced by the red-violet silk dress worn to an exhibition opening at the Queen Sirikit Museum of Textiles on Saturday, May 30, 2015. In her honor, event attendees and museum staff also wore shades of violet.

Royal color associations can also spread beyond dress. For example, for Loi Krathong, a festival in November where people release baskets decorated with candles, incense, and flowers onto the water to pay respect to the goddess of water, Their Majesties' baskets are decorated with flowers in the color of their respective birthdays. The royal flags for Their Majesties, which bear the ciphers of HM King Bhumibol and HM Queen Sirikit, are also color-coded according to their birth dates.

The cosmological system of colors associated with days of the week has roots in the tenth-century Hinduized Khmer kingdoms of Thailand, which continued in various forms to the beginning of the current dynasty in the late eighteenth century. This tradition still remains in the court after 160 years, although the practice has been modified over time. Most Thais are still aware of this and many, even today, will sometimes wear a color associated with the day of their birth for good luck.

References

Jottrand, E. (1996), *In Siam*, Bangkok: White Lotus Press.

Leventon, M. (2016), *Fit for a Queen*, Thailand: River Press.

Leventon, M. and D. C. Gluckman (2012), *In Royal Fashion: The Style of Her Majesty Queen Sirikit of Thailand*, Bangkok: Siri Wattana Inter Print Co., Ltd.

Sriyaphai, C. and N. Narakorn (1977), *Sunthorn Phu's Poetic Guides*, Bangkok: Klang Wittaya.

6

"GOLD AND SILVER BY NIGHT." QUEEN ALEXANDRA: A LIFE IN COLOR[1]

Kate Strasdin

Alighting from the royal yacht on March 7, 1863, the young Danish Princess Alexandra, imminent bride-to-be of Edward Prince of Wales, was the subject of a detailed description in *The Times*. The royal correspondent William Russell wrote:

> An instance of the desire of Her Royal Highness to consult the interests of the people of her adoption, and to prepare a pleasant surprise for the Queen was mentioned as resting upon authentic detail. Ascertaining some time ago the favorite color of Her Majesty, silver grey, she caused a poplin dress of that shade to be manufactured at the well-known establishment of Messrs. Fry of Dublin, and appeared in it for the first time on the occasion of her entry (Russell 1863: 40).

It was an astute choice, appealing both to the British public and more personally to her dominant mother-in-law to be. It offered a respectful nod to Queen Victoria's favorite color while also indicating a sartorial shrewdness at which Alexandra would excel for the almost half century of her public life.

This text will consider how such a prominent a figure as Alexandra meticulously managed her appearance through clever color choices. Lacking a political voice, she nonetheless was able to appeal to a broad spectrum of society, from her peers to the British public and from those at home to those abroad. Non-verbal communication through dress that was reported upon so frequently in the Court Circular[2] bolstered her popularity during times when other members of the British

monarchy, her husband included, were not held in such high regard. Alexandra utilized color choices in garments to speak for her in the public sphere of her life, allowing dress to create both a diplomatic and a patriotic narrative relative to the occasion. In more recent years, this attention to sartorial detail has become more commonplace for prominent female royals who use the symbols and colors of dress as a form of compliment to nations and institutions during public appearances; however, this strategy was in its infancy in the second half of the nineteenth century. While Queen Victoria recognized that this could be a useful visual tactic, the death of Prince Albert meant that her legacy in dress terms was to be famously monochromatic. Following her husband's death in 1861, Queen Victoria chose to wear only black garments for the rest of her life as a visual marker of her continuing grief for his loss. Alexandra too was changed by life experiences that also included profound loss and her color choices changed as these events left their mark upon her, both physically and mentally, the color palette of her dress mapping her emotional states. This text will examine how Alexandra relied upon garment choices to shield her from some of the more problematic aspects of her changing physicality when public expectations of her clothed royal body were required to mask her own corporeal limitations. Additionally, this text will provide an opportunity to consider how the surviving garments from Alexandra's wardrobe, including over 130 objects conserved in museum collections around the world, paint in the colors of Alexandra's apparel which otherwise remain bound to the grays of contemporary photographs.

From the very beginning of her life as a popular member of the British monarchy, Alexandra embraced color in dress. Through the annotation of her clothing reported in the Court Circular between 1870 and 1890, we get a sense of the spectrum of strong colors which Alexandra wore on chronicled occasions. Although these reports represent just a fraction of the public outings that Alexandra made in her almost forty years as Princess of Wales, they capture the range of color that she was prepared to embrace and was entirely in keeping with the broad range of colors then in vogue. Charlotte Nicklas's (2009) recent research has revealed the scope of color in dress during this period while C. Willett Cunnington's seminal volume charting changes in dress in the nineteenth century confirms the variety of color in dress that was both available and acceptable, suggesting that the young Princess's choices were, if not fashion forward, at least recognizably modish (Cunnington 1990). The shared public awareness of her appearance might be suggested as conspiratorial in nature, where the Princess and her public could recognize what each particular color choice signified. There was a sophisticated sartorial vocabulary utilized in the columns of the fashion periodicals and the broad variety of hues described offered to those in the role of observer an assortment of color that might be decoded, thanks to the ubiquity of such fashion journalism. Alexandra was astute at choosing garments appropriate to the time and place of wear and color

was part of that choice. The complexity of the descriptions offered by the Court Circular of Alexandra's attire supports the idea of this communal knowledge of the garments described. For example, from March 1883, "Her Royal Highness the Princess of Wales wore a dress of dark green velvet over a jupe[3] of pale green brocade embossed with gold and volants[4] of lace, fastened with bunches of shaded carnations" (*The Times*, March 6, 1883). From May of the same year: "Her Royal Highness the Princess of Wales wore a gold satin dress interwoven with currant-color over a jupe of same silk covered in fine plisses[5] of tulle striped in gold and narrow fringes of currants" (*The Times*, May 29, 1883). While in July 1885: "Her Royal Highness the Princess of Wales wore a dress of myrtle green Lyons velvet and eau de nil satin duchesse, trimmed with silver tissue and Irish lace" (*The Times*, July 3, 1885).

There are few surviving garments associated with Alexandra that pre-date 1890. A rare piece now in the collections of the Fashion Institute of Design and Merchandising Museum, Los Angeles, supports the reputation of the vibrancy of her dress (Plate 6.1). It is a vibrant blue wool blouse with white braided trim and has an inner waistband attached at center back. The strings continue around to the center front waist but are not attached, causing the blouse to fall free. It is entirely handmade and lined in China silk dating to c.1863. It was possibly worn as a maternity garment as it incorporates the adjustable element in its construction. Blue was apparently a color that she often preferred, according to an early biographer Sarah Tooley: "Blue is her favorite color and was much used for her dresses and bonnets at one time" (Tooley 1902: 161). It is possible that there was some sentimental attachment to her choice of blue. Charlotte Crosby Nicklas observes that certain colors were named after popular public figures and while she does not record a color named for Alexandra, there was a Dagmar blue, named in honor of the Princess's younger sister (Crosby Nicklas 2009: 270–280). There is no surviving evidence that Alexandra herself chose Dagmar blue for garments in her own wardrobe but a synchronicity of color choices between the sisters was to be an occasional feature of their relationship.

Such diversity of color remained a feature of Alexandra's wardrobe for almost thirty years, and it was during this period she established herself as one of the most popular and recognizable women of her day with a reputation for greater affability than many other members of the monarchy. She rarely spoke in public and so arguably her reputation was built upon the widely disseminated image of her strikingly colorfully clothed royal body.

Knowing the frequency with which descriptions of her appearance featured in the press, Alexandra used such accounts to make some diplomatically canny selections in dress for certain civic occasions. As suggested earlier, her non-verbal communication through dress, via her vibrant color choices, was used to even greater effect when Alexandra was in attendance as the Queen's representative

both at home and abroad. Notable examples were the highly sensitive State visits to Ireland in 1868 and 1885.

The royal couple had first visited Ireland together in April 1868, less than twelve months after heightened activity by the Irish Fenian activists had caused widespread governmental anxiety (Kelly 2006). Queen Victoria had her reservations about the possible dangers of such a trip in the face of Irish hostility although she herself had sailed across the Irish Sea on a similar visit in 1849. In spite of Victoria's reservations, it was Disraeli who entreated with her to allow Alexandra to accompany her husband, recognizing how powerful her presence might be: "Is it not worth Your Majesty's gracious consideration whether the good might not be doubled if His Royal Highness were accompanied by the Princess? Would it not add to the grace and even the gaiety of the event?" (Battiscombe 1969: 92). The Queen consented and the trip proved to be immensely successful in no small part owing to the appearance of Alexandra who silently expressed her fondness for the Irish on her return to England: "All that the Princess could do to show the friendly Irish populace that she had not forgotten them was to appear at Ascot in the same outfit that she had worn at Punchestown Races—a green dress of Irish poplin trimmed with Irish lace, with Irish shamrocks in her white bonnet" (Battiscombe 1969: 96).

She took the same approach for the State visit made with Edward in 1885. *The Times* described Alexandra's chosen attire for a number of functions, the garments for which were all presumably intended to compliment the Irish people. On April 9 at a Drawing Room and Levee in Dublin: "The Princess of Wales wore a dress of bronze velvet draped in gold embroidery embossed with shamrocks. Her head-dress and tiara were of diamonds" (*The Times*, April 9, 1885). Three days later at a State Ball in Dublin: "The Princess of Wales wore a dress of cream satin duchesse trimmed with gold and silver embroidery, veiled in lisse embroidered with gold and silver shamrocks; her headdress was a tiara of diamond ornaments" (*The Times*, April 12, 1885). Finally, on April 22, the newspaper described the Princess of Wales' dress for the Citizen's Ball in Dublin: "Her Royal Highness the Princess of Wales wore a dress of green velvet over a jupe of pale green satin and silver gauze, draped with Irish lace, fastened with bouquets of shamrock and lilies of the valley" (*The Times*, April 22, 1885).

These decorative accents consisting of national symbols, while not dominating the ensemble, were nonetheless an obvious and therefore easily reportable means of paying a monarchical tribute. During another State visit to the country in 1904, Alexandra was in mourning according to the etiquette which still prevailed at that time. In recognition of her role during the visit, however, she waived such protocol as *The Queen* reported on May 7: "Queen Alexandra, who doffed her mourning for the occasion, a compliment thoroughly appreciated, appeared in black velvet covered with a beautiful paletot of bright green cloth adorned with velvet appliqué and sable, and a toque of green chiffon to match" (*The Queen*,

May 7, 1904). The relatively simple gesture of donning an emerald green outer garment in public was enough to secure both press editorial and local popularity. After her return from Ireland, Alexandra made one final sartorial gesture of her appreciation of the Irish welcome she had received as reported in *The Times* on May 18 at the first Drawing Room in Buckingham Palace. The Princess of Wales wore: "a dress of rich yellow satin and silver brocade, draped with silver lace; corsage to correspond, made by Mrs Sims of Dublin" (*The Times*, May 18, 1885). This resplendent color description is one of the only instances during this period that a newspaper mentioned a dressmaker by name, surely intended as a diplomatic tribute.

Regular royal visits to Scotland also precipitated similar sartorial choices based upon national identity. Evidence for this survives in two tartan ball gowns both datable to the years between 1865 and 1870. For Alexandra herself, a young Danish woman, tartan held no symbolic associations at all but she was able to recognize its significance for others among her new social and familial circles. Queen Victoria herself participated in the mythologizing of Scottish national dress with her appropriation of tartan as her visits to Scotland became ever more frequent. Sir Walter Scott's colorful tales ultimately assisted in the adoption of tartan into "Britishness" after its banishment due to its rebellious associations. However, the wearing of tartan by the British army began to imbue it with a changing sense of loyalty to the crown when worn in a military context: "Tartan as a sign of patriotic valor could also signal its final manifestation: heroic martyrdom" (Pittock 2007: 133). Along with Victoria's sentimentality toward tales of the Jacobites and her romanticized Highland vision, she was to fill Balmoral with a host of commissioned decorative objects that referenced the tartan aesthetic. Alexandra's sentiments regarding her Scottish sojourns were apparent in her description of the house near Balmoral—the couple's Scottish residence as "dear old melancholy Abergeldie" (Battiscombe 1969: 220). Nonetheless, she recognized that a sartorial nod to its traditions would be appreciated both by her mother-in-law and those in attendance at the public functions during which these vibrant red, green, and white gowns were worn. Both of Alexandra's dresses are extremely similar in both style and color of tartan although separated by a number of years and so are suggestive of a uniform, a hint that she was perhaps "dressing up" for her Queen exemplifying this tactical approach to color in dress.

As for Alexandra's own sense of national pride, this was an area of some difficulty. In an early edict from Queen Victoria following her son's engagement to the Danish Princess, it was accepted that: "There must be no Danish lady-in-waiting to encourage her to talk in her own language; no little Danish maid even. Ladies-in-waiting and maids alike must be of sound English stock" (Fisher 1974: 47). Alexandra's Danish heritage was a serious drawback to the marriage as far as Victoria was concerned. Ideally Edward's bride would have hailed from Germanic roots but Alexandra had been Albert's favored choice and she

deferred to his wishes in death as in life. Wisely, Alexandra opted to flatter her indomitable mother-in-law frequently through her choice of garments when in the United Kingdom, but there is evidence to suggest that when representing the British monarchy abroad she felt no such compunction to try and deny her ancestral heritage. A working sketch by the artist Nicholas Chevalier reveals the vibrancy of color choice in Alexandra's dress worn to the wedding of Grand Duchess Maria Alexandrovna to Prince Alfred on January 23, 1874. The Princess of Wales is depicted wearing an ensemble consisting of a white lace bodice and underskirt, surmounted by a red overskirt, train, and sash. Red and white are the colors of the Danish flag. This was a wedding attended by a diversity of European royalty and Alexandra represented her adopted nation of Great Britain. Nonetheless, the gown of her choice was a reflection of her own national identity on a world stage.

Where Alexandra had favored strong, bright colors from the 1860s through to the 1880s, changes in her life wrought by illness and loss were to have a visible effect upon her sartorial chromatic choices. In January 1892, Alexandra suffered one of the greatest losses of her life with the death of her eldest son Prince Albert Victor (or Eddy as he was popularly known) from pneumonia. The heartbroken Alexandra wrote to her mother in Denmark on the day of his funeral: "I have buried my angel today and with him my happiness" (Fisher, 1974: 143). Biographers acknowledged the Princess's rejection of strong colors from this point onwards until her own death in 1925: "she began a period of mourning that was to last for years. Never again did she dress in the old, bright colors which had for so long been her hallmark" (Fisher 1974: 143). The contemporary biographer Sarah Tooley published her book *The Life of Queen Alexandra* in 1902, only a decade after Eddy's death. She too records: "of late years she has preferred silver, gray and pale shades of heliotrope" (Tooley 1902: 161). As Queen Victoria had mourned her beloved Albert for thirty years in deepest black, so too Alexandra's grief manifested itself through her choice of dress. Unlike Victoria, however, Alexandra recognized that descent into unrelenting black would be an unpopular decision and wisely opted for the muted shades of half mourning. Many more of Alexandra's garments survive from the 1890s onwards and all from this period support the suggestion that she rejected the brighter tones of her earlier years as Princess of Wales. In museums as dispersed as Tokyo and New York, Toronto and London, Bath and Los Angeles, all of Alexandra's extant garments there conserved and dating to after 1892 are either silver, gray, white, mauve, pale yellow, cream, purple/lilac, or black. It demonstrates astuteness on her part that, despite her grief, there was still a public expectation that she should appear suitably elegantly attired.

Adhering to accepted mourning etiquette did not preclude Alexandra initiating change from the rigid enforcement of mourning wear that affected women in particular. Full mourning dress was an obligatory aspect of a woman's

wardrobe in the nineteenth century and mourning warehouses such as Jay's in London catered to a variety of budgets. The complexities of mourning could be problematic for those attempting to live and work within the circle of the royal household as Marie Mallett, lady-in-waiting to Queen Victoria, on a stay at Balmoral recorded with some exasperation in a letter home:

> I am in despair about my clothes, no sooner have I rigged myself out with good tweeds than we are plunged into the deepest mourning for the King of Portugal, jet ornaments for six weeks! And he was only a first cousin once removed. So I only possess one warm black dress. It is a lesson never, never to buy anything but black! (Mallett 1968: 32)

A document found among Queen Mary's papers in the Royal Archive reveals that Alexandra conformed to the mourning requirements of the period. The inventory made by Alexandra's dresser, Mrs Giltrap, of her mistress's clothing compiled after her death records: "Three Good Black Spangled Court Gowns; One High Blk & Steel Gown worn at functions; Many other good black dresses left in the wardrobe"(Giltrap 1925). Alexandra remained aware of the public's expectations of her clothed royal body but by the 1890s she was at the forefront of the emerging reaction to the rigors of strictest mourning as deep crape began to fall from favor. Lou Taylor's seminal work on mourning dress describes Alexandra's minor non-conformity at the funeral of her own son Eddy: "Princess Alexandra of Wales refused to wear [crape] at the funeral of the Duke of Clarence in 1892 and then at Queen Victoria's funeral in 1901" (Taylor 1983: 222).

While generally observing court etiquette there was one occasion, however, when Alexandra decided to subvert, albeit harmlessly, the status quo directly through the choices she made regarding the color of her dress. This small act of defiance was remarked upon by Lady Louisa Antrim, one of her ladies-in-waiting:

> The Queen's showmanship became conspicuous the moment she was asked when full mourning had to stop. Could her Court drop the black dresses and jet beads for a grand function that happened to coincide with the last official day? Refusing to give a ruling ("such questions bore me intensely"), Alexandra guessed that her ladies would stick cautiously to black, as indeed they did, while she herself appeared in stunning white, gleaming with jewels, like a solitary star in the night sky. (Longford 1979: 79)

This new resolve was a signal of intent—that as Queen, Alexandra would control the sartorial expectations assumed for her.

It is from 1901 and the assumption of her new role as Queen that the surviving garments associated with Alexandra undergo a change of aesthetic. Without exception, these dresses shimmer. Constructed from silk and chiffon and richly

embellished in beadwork, metal thread embroidery, sequins, and spangles they are uniform in their conspicuousness. While the palette of the foundation layers remained the same as those from the 1890s, confined to white, mauve, pale yellow, gray, silver and gold, and some black, the embellishment applied to the surface of each garment that dates to after 1901 exceeds anything from her years as Princess of Wales (Plate 6.2). Almost overnight, it would appear, the new Queen (she refused to be called Consort) ensured that she would take center stage at evening events due to her adoption of sparkling attire.

A clear distinction, immediately noticeable, is in the nature of the embellishment on her evening wear. The gowns from the 1890s display a few elements of applied decoration—a lace trim, a décolletage decorated with motifs of pearl or diamante, a figured silk, but generally consist of largely unadorned bodices and plain, gored skirts. Where the later garments differ is in their almost total surface decoration. Five of these later gowns exhibit trailing floral designs, repeated in motifs across the bodice and covering the garment with gold or silver embroidery, reminiscent of Alexandra's coronation gown. Four others do not feature any discernible motifs, but are covered with spangles and sequins across their entirety. This tendency toward more overtly spangled public garments was recalled by Margot Asquith in her memoirs: "The Queen, dazzlingly beautiful, whether in gold and silver at night, or in violet velvet by day, succeeded in making every woman look common beside her" (Asquith 1922: 128). Her recollection was of Alexandra "the Queen" in a conspicuous and sparkling display at formal functions.

The most obvious conclusion to draw from Alexandra's later evening dresses is the need on her part for visibility. The new Queen, who had been subservient to her mother-in-law for forty years, was now allowed to outshine every other woman in the room. These garments suggest that she expressed this right literally in her sartorial choices. As a visual demonstration of her place at the very top of the aristocratic hierarchy, Alexandra covered herself in fabrics that would have glittered under the artificial lights of the ballrooms, at the State dinners, and myriad evening functions she was obliged to attend. Alexandra had decided that "majesty" should be represented sartorially through a gem-covered display. She wanted to be the image of a Queen that Victoria, for all her solemnity and strong monarchical sense of duty, had never been at functions where she was the most important woman present.

There is also the possibility that this overt glitter of silver and gold was born out of yet another motive. From the late 1860s, Alexandra had been left profoundly deaf and with a limp following a bout of rheumatic fever she had suffered in 1868. On a daily basis, she coped remarkably well. Lord Esher remarked that in spite of her deafness "she says more original things and has more unexpected ideas than any other member of the family" (Brett 1934: 346). Large evening functions were, however, challenging for her. She wrote a grateful letter to her daughter-in-law

after one such occasion: "You, my sweet May are always so dear and nice to me and whenever I am not quite au fait because of my beastly ears you always by a word or even a turn towards me make me understand" (Cited in Pope-Hennessy 1959: 328). As the deafness worsened, she adopted a practical strategy in her approach to these larger, formal occasions. The extensive photographic record shows that in private and during the day, Alexandra dressed relatively simply. The surviving evening gowns reveal that at formal functions her style underwent a significant change. As with so many of her sartorial choices from a fifty-year career, these public outings that were so much a trial to her had to be managed astutely. The sparkling, embellished garments became a form of armor for her, acting as a barrier and shield from the public and its gaze, protecting her true self through a shimmering and diverting display. Her glittering clothes were intended to distract from the fragile corporeal reality and offer a vision of "queenliness" that might fend off unsolicited conversation.

Alexandra never recorded in her own words her relationship with dress and so it is impossible to know for certain how she managed these tensions between her public and private clothed body. It is possible, however, to understand more about her physicality and disguise through clothing via an analysis made of a single garment now in the collections of the Royal Ontario Museum, Toronto. The dress is a court gown dating to c.1902 and its color and embellishment fit the notion of the conspicuousness she exhibited in public garments after 1901. The foundation fabric is bright yellow silk appliquéd with small round silver spangles and paste diamante studs but most striking of all are the large hand-painted purple irises placed at intervals over the skirt and bodice. Close scrutiny of the bodice revealed that the iris motifs painted down the center back at the fastening did not match—they appeared lopsided when the hooks and eyes were drawn together. It is as though the couture house responsible, Morin Blossier, had made a rather ill-fitting garment. This seemed unlikely and, prompted by the ROM Curator, Alex Palmer, I contacted Jean Druesdow.[6] Jean had mounted a number of Alexandra's gowns at the Metropolitan Museum of Art for an exhibition in 1982 and her reply was illuminating. She wrote: "The dresses belonging to Alexandra at the MMA indicate that she had some curvature of the spine—the center back is not straight or symmetrical, as I recall, and there was much talk about it when we did the 'Belle Epoque' Exhibition" (Druesdow 2011). This then was the explanation for the mis-matched purple irises. A spinal curvature has never been mentioned by any of Alexandra's previous biographers. The limp that she had carried for so many years had apparently caused this deterioration in her spine and her clothing was altered accordingly. Rather than displaying some failing on the part of the couturier, the boldly painted iris motifs were cleverly placed so that they sat symmetrically when the dress was worn by the Queen, thus disguising the deformity. She normalized her silhouette through structural changes to the gown and with the sleight of hand of a stage magician misdirected the observer

through bright colors, spangled embellishments, and the swirl of the purple iris away from any unwanted speculation about her health and well-being. It is a strategy that was described in a more recent context by Jean Spence, writing of her struggles to present a "normal" silhouette following a mastectomy. She describes the problems of clothing an altered body as: "part of the landscape of every woman's efforts to clothe herself in a manner which reflects her own self-perceptions and desires but which must be ever alert to the ascription of feminine identity in the public world" (Spence 2001: 186). More than most women of her generation, Alexandra faced this challenge daily, masking and shielding elements of herself in a regally glittering display.

There are four instances (so far attributed) of photographs that relate directly to known surviving garments—Alexandra's wedding dress of 1863, a fancy dress of 1874, a half mourning dress of the 1890s, and her coronation gown of 1902. In each of these cases, the reality of the fabric and its vibrancy exceed the limits of clarity of nineteenth- and early twentieth-century photography. While images of their marriage were extensively circulated, only a study of the dress itself revealed the silver weft and the glitter this lent to the overall effect. Although a detailed description of the 1874 fancy dress was given by *The Times* ("HRH wore a ruby colored Venetian dress, with a blue front to the skirt, sewn with jewels and gold embroidery" *The Times*, August 8, 1874) only the garment can reveal the actual richness of that description. The coronation gown, captured in its resplendence by Luke Fildes in 1902, is brought more vividly into three dimensions when studied at close quarters with its gold lame underdress, embroidered gold net overdress, gold lace, and faux pearls. Focusing, however, on one particular garment allows the dichotomy of object and image to be examined more clearly. An iconic image of four generations of the royal family appears to show Alexandra wearing a rather plain outfit. The photograph depicts her standing next to her daughter-in-law Mary and behind Queen Victoria who is holding her great-grandson David (future King Edward VIII) (Figure 6.1). The image was taken on the day of David's christening in 1894, a momentous occasion celebrating the longevity of the monarchy in this photograph spanning four generations. Alexandra is the grandmother and mother-in-law in this image although the effects of retouching have perpetuated the myth of her youthfulness. In the picture, her dress appears plain and unadorned, impossible to discern its detail from among the grays of the developed print. The dress itself is revealed to be far more decorative (Plate 6.3). It is a striking gown of half mourning complete with lilac spotted silk ground, black moiré trimmings, and coffee-colored lace. In spite of its associations with grief and the palette of its materiality, it is anything but subdued. The lilac ground has faded somewhat with time, but within the folds are revealed the vibrancy of the color and the contrast with its black polka dot print. As with so much of her public wardrobe, it is of Parisian manufacture, the waist tape confirming that it was made by Mme Fromont, Rue de la Paix, Paris. Alexandra's choice

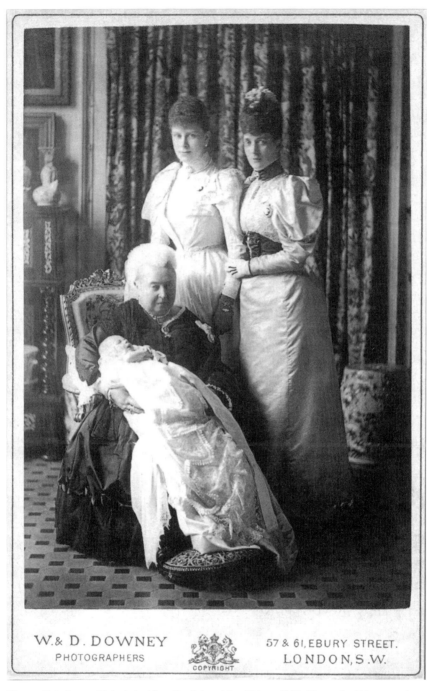

Figure 6.1 Queen Victoria holding the future King Edward VIII, Alexandra Princess of Wales and the Duchess of York, 1894, carte de visite, Author's own collection.

on this day of public celebration was canny. She ensured that she conformed to expectations of etiquette in a dress of half mourning for her eldest son Eddy, who had died less than two years previously. However, it was not muted half mourning. Next to Victoria's black and Mary's pale lace gown, Alexandra's was a more colorful and dramatic choice. Hers was not the role of faded grandmother but of perpetually stylish Princess in French couture. Lord Esher observed in 1901: "The Queen—retaining her grace and beauty—does not strike one as a grandmother!" (Brett 1934: 298).

Following her husband's death in 1910, Alexandra largely retreated from public life. She was no longer required to present a dazzling display of regality, nor did she have to negotiate the daily reports on her appearance in the press. Her wardrobe accounts reveal that after 1910 her consumption of dress reduced radically and she lived in comparative isolation at Sandringham, her favorite residence. For fifty years, however, she had played an important role at the heart of the British monarchy, using her appearance to bolster both her own and royalty's popularity. She dressed diplomatically for State visits in a manner that is now taken for granted with female members of the royal family. She used the colors of her attire not only as a subtle indicator of her grief but also as a concealment of her physical difficulties, the grand display acting as colorful armor. She also used color in her dress to make public statements of her place in the hierarchy of monarchy such as her choice of gown for her grandson's christening in 1894. Color was central to these choices that are now revealed in the garments that have outlived the Queen.

Notes

1 In her 1922 autobiography, Margot Asquith recalled Queen Alexandra's great ability to dress appropriately for any given occasion: "whether in gold and silver by night or in violet velvet by day" (Asquith 1922: 128).

2 The Court Circular was an authorized account released by the Royal household of the whereabouts and activities of key members of the royal family that was printed daily in *The Times*.

3 *Jupe* is the French word for "skirt" and was commonly used in the nineteenth century to denote this part of a larger ensemble.

4 A ruffle of lace.

5 *Plisses* is another French textile term that means "fine pleating." This was often carried out by a *plisseur*, which was a specific textile trade.

6 I am indebted to the Royal Ontario Museum for their support given to me as their chosen Gervers Fellow in 2011 and also for Alex Palmer's helpful suggestions during my research there.

References

Asquith, M. (1922), *The Autobiography of Margot Asquith*, London: Thornton Butterworth Ltd,.

Battiscombe, G. (1969), *Queen Alexandra*, London: Constable.

Brett, M. (ed.) (1934), *Journals and Letters of Reginald Viscount Esher*, London: Ivor Nicolson & Watson.

"Court News" (1904), *The Queen Ladies Newspaper and Court Chronicle*, May 7.

Crosby Nicklas, C. (2009), *Splendid Hues: Color, Dyes, Everyday Science and Women's Fashion 1840–1875*, unpublished PhD thesis, University of Brighton.

Cunnington, C. W. (1990), *Englishwomen's Clothing in the Nineteenth Century*, New York: Dover Publications Reprint.

Drusedow, J. (2011), Kent State University Museum, e-mail correspondence, 02 November 2011.

Fisher H & G (1974), *Bertie & Alix - Anatomy of a Royal Marriage*, London: Tobert Hale & Co.

Giltrap, H. (1925), Royal Archive, RA QM/PRIV/CC58/168.

Kelly, M. (2006), *The Fenian Ideal and Irish Nationalism, 1882–1916*, Woodbridge: Boydell & Brewer.

Longford, E. (ed.) (1979), *Louisa Lady in Waiting*, London: Jonathan Cape.

Mallett, V. (ed.) (1968), *Life with Queen Victoria: Marie Mallet's Letters from Court, 1887–1901*, London: John Murray.

Pittock, M. (2007), "Patriot Dress and Patriot Games: Tartan from the Jacobites to Queen Victoria," in C. McCracken-Flesher (ed.), *Culture, Nation and the New Scottish Parliament*, New Jersey: Associated University Presses.

Pope-Hennessy, J. (1959), *Queen Mary*, London: George Allen & Unwin Ltd.

Russell, W. H. (1863), *The Marriage of the Prince of Wales and Princess Alexandra of Denmark Collated from the Description in The Times*, London: Redding & Co.

Spence, J. (2001), "Flying on One Wing," in A. Guy, E. Green and M. Banim (eds), *Through the Wardrobe: Women's Relationships with Their Clothes*, 173–89, Oxford & New York: Berg.

Taylor, L. (1983), *Mourning Dress: A Costume and Social History*, London: George Allen & Unwin.

"The Court Circular" (1885), *The Times*, April 9.

"The Court Circular" (1885), *The Times*, April 12.

"The Court Circular" (1885), *The Times*, April 22.

"The Court Circular" (1885), *The Times*, May 18.

"The Court Circular" (1874), *The Times*, August 8.

Tooley, S. (1902), *The Life of Queen Alexandra*, London: Hodder & Stoughton.

7

LORD BOSTON'S COURT UNIFORM: A STORY OF COLOR, POLITICS, AND THE PSYCHOLOGY OF BELONGING

Deirdre Murphy

Lord Boston was just twenty-five years old in 1885, when he earned the prestigious title of Lord-in-Waiting to Queen Victoria. In preparation for his ceremonial introduction to the Queen, he spent an enormous sum of money on two dark blue, red, and gold uniforms he needed for his Royal Household duties. Seven months after his appointment, officials informed him that his services as Lord-in-Waiting were no longer required. He appealed to the prime minister for information, explaining that his "exclusion" from this impressive post was "a matter of great concern" to him. Having lost the job, his anxiety prompted him to ask the Lord Chamberlain for special permission to continue to wear the glamorous uniforms he was no longer technically entitled to use. The dark blue cloth, gleaming gold embroidery, and deep scarlet Royal Household cuffs of Lord Boston's suits formed part of a color vocabulary that communicated his high status as an individual and reinforced his membership of the most elite group of men in the United Kingdom. This text will explore Lord Boston's lifelong relationship with the pair of uniforms he wore for over fifty years. Boston's correspondence will demonstrate how deeply the loss of his prestigious appointment affected him. More than this, his desire to continue to visibly display his membership of an elite, collectively identifiable by their luxurious dark blue and gold uniforms, shows how central this membership was to his sense of identity. Lord Boston's blue and gold uniforms defined his public image.

The two suits and their associated accessories have survived in the Royal Ceremonial Dress Collection at Historic Royal Palaces. They were acquired in 1987 from a solicitors' firm, which probably received them from the nephew who inherited Lord Boston's title and estate when he died, without any offspring, in 1941. Their survival must be due to the high value they held before the Second World War and the sharp decline of the same after it, when the subsequent relative informality of court occasions rendered them more useful for fancy dress than for court events.

George Florance Irby, the sixth Baron Boston (1860–1941), was the eldest son of Florance George Irby, the fifth Baron Boston, and his wife Augusta Caroline, daughter of the third Baron de Saumarez. The younger George Florance (from here called Lord Boston) was born into an established aristocratic family: his three times great-grandfather, the first Baron Boston, had enjoyed the prestigious title Lord of the Bedchamber to George III. As a youth, Lord Boston studied at Eton and later at Christ Church, Oxford, where he graduated with a degree in modern history in 1882. In later life, he devoted his time to the study of science— particularly astronomy, botany, and entomology. He was a fellow of the Society of Antiquaries and the Geological Society of London. The University of Wales eventually recognized his involvement in archaeological activities in Wales with an honorary degree in 1936[1] (Plate 7.1).

A life in politics, not science, had been Lord Boston's plan. He inherited the family title in 1877, when his thirty-nine-year-old father, the fifth Baron Boston, died. He was also bequeathed various parcels of land, including the estate of Hedsor, the elegant family seat near Maidenhead, and a large proportion of Anglesey in Wales, including a colliery and a small number of farms with their tenants.[2] He became involved in Conservative Party activities at age twenty, when he attended a party conference in Oxford.[3] A flurry of Conservative Party meetings in Wales followed, then once he had reached the age of majority he took his seat in the House of Lords for the first time in 1882.[4] Locally, Lord Boston's public profile rose when he was appointed Deputy Lieutenant of Anglesey. Now twenty-two, he would theoretically stand in for the Lord Lieutenant when he wasn't available to carry out his ceremonial duties. This established him as a key public figure in Wales. The new Deputy Lieutenant's uniform he purchased for the role served to set him apart from crowds at public gatherings, and identify him as a member of Anglesey's elite. He spent about fifty-seven pounds at the Savile Row tailoring firm Henry Poole on the scarlet tunic with silver embroidery, matching trousers, cocked hat, plume, sword, sword knot, waterproof sword case, belt, some spare linen collars, and the airtight case to store them in.[5]

This first visit to Henry Poole on Savile Row heralded the construction of Lord Boston's public image. Four months later he returned to Henry Poole, where he spent twenty-five pounds on a black twill weave wool frock coat and vest, a tweed jacket, waistcoat and trousers, a pair of striped trousers, and a

packing case. The next summer he spent sixteen pounds on a gray coat and a "homespun" check double-breasted jacket, vest and trousers. On his return to Oxford after the summer in 1883, he spent twenty-one pounds on another frock coat and suit.[6] Now, looking every bit the gentleman, he became heavily involved in Conservative Party politics. He was 24 and his political career looked promising as he hosted and chaired a public party meeting at Hedsor the next year.[7]

Lord Boston's appearances in Parliament, his attendance at several levées, daytime presentations of gentlemen to the monarch, and his increasing engagement with Conservative Party matters got him noticed. In 1885, he received a letter from the prime minister, Lord Salisbury, asking whether he would accept an appointment as Lord-in-Waiting to Queen Victoria.[8] The duties would be nominal but on occasion he could be called to greet political and state leaders on behalf of the Queen. Lord Boston accepted the offer quickly. Ten days later, he returned to his tailor.

According to the dress regulations set out by the Lord Chamberlain, Lords-in-Waiting were required to wear civil uniform for appearances at court. Lord Boston would need to purchase a full-dress uniform for formal events and a less decorative, undress uniform for informal, daytime occasions. He would have known that they should be both made of dark blue cloth embroidered with gold oak leaf embroidery and trimmed with gold lace in all the right places. His tailor knew the coatees, or tail coats, should close with hooks and eyes and the nine decorative gold buttons down the left side should feature the royal arms and supporters, that the full-dress coatee should be lined with white silk. This would ensure a tidy appearance when they were worn with full-dress white kerseymere knee breeches. A comparatively plain undress, or levée dress coatee for daytime events, was lined with black silk for wear with dark blue cloth trousers, the side seams trimmed with gold oak leaf lace. Most important of all, the standing collar and cuffs should be made of scarlet cloth. This single feature distinguished a Royal Household uniform from all the others (Graham Bennet 1903).

The Lord Chamberlain's published regulations gave structure to a codified language of clothing worn at court occasions that had developed during the early nineteenth century. After the French Revolution, high-ranking men in many countries across Europe wore uniforms in a way that illustrated the ascendancy of group solidarity over individuality. As court historian Philip Mansel has argued, the elite presented a unified whole, demonstrating loyalty to the monarch. At this time, Napoleon's court adopted a civil uniform that was clearly hierarchical: higher ranking individuals wore uniforms with more gold embroidery on them. By 1820, every official at the French court wore the civil uniform. They were color-coded according to rank, and regulations were drawn up to ensure courtiers wore them correctly. British officials began to wear the civil uniform in 1817 (Mansel 2005). There were three classes, each distinguishable by the amount

and placement of its gold embroidery. Civil uniforms were eventually embraced wholeheartedly in Britain, the regulations becoming so complicated that they were routinely published in book form to ensure that tailors and wearers followed the established rules.

Color was central to the visual language of the civil uniform. Collectively, a sea of men in dark suits looked impressive. At formal court gatherings such as drawing rooms, state concerts, and state balls, the women's pale and colored silk dresses, shimmering with silver and gold, contrasted sharply with the men's dark blue cloth suits. Individually, the ratio of blue cloth to gold embroidery to scarlet trimmings was enough for someone who knew the regulations to judge the importance of the wearer. As at Napoleon's court, the amount of gold embroidery on each uniform was directly proportional to an individual's rank. A cursory glance around a crowded room could pinpoint the high-ranking individuals who wielded political influence. More than this, the uniform enabled an individual to enjoy membership of the elite, distinguishing him from ordinary people.

Some of these points must have occurred to Lord Boston when he visited Henry Poole's showroom to order the blue undress uniform he needed for his new role as Lord-in-Waiting to the Queen. He spent sixty-nine pounds on the dark blue cloth coatee with a scarlet collar and cuffs embroidered in gold, a pair of dark blue cloth trousers trimmed with gold lace, a cocked hat trimmed with gold bullion, and a dress sword.[9] In the coatee lining, the tailor stitched the company label bearing Lord Boston's name, his own initials, the year and the order number 5368 (Figure 7.1). Three weeks later, Lord Boston spent another eighty-four pounds on a Windsor uniform, which he would wear when the court was at Windsor. It was a comparatively plain, dark blue uniform with a scarlet collar and cuffs, gilt buttons, two pairs of hose, and a japanned traveling case. He paid the extra for a waistcoat with a silk back.[10]

After three months in post, Lord Boston returned to Henry Poole to buy the third and final uniform he needed for his new role. In October 1885, he paid an astonishing 115 pounds—approximately £50,000 by 2015 wage index calculations—for a full-dress, second-class diplomatic uniform, including a coatee with a scarlet collar and cuffs, heavily embroidered in gold[11] (Plate 7.2). The expensive gold wire embroidery was applied in a pattern that enhanced Lord Boston's trim, twenty-five-year-old figure. He asked his tailor for a silk "fit up," meaning all the pockets, linings, and bindings should be made of silk, not of a cheaper material such as cotton.[12] Requests for silk fit ups were rare and the fact that Lord Boston ordered one suggests he wanted the best uniform money could buy.

As the wearer of this new dark blue full-dress uniform, Lord Boston would have looked impressive and important. The four-and-a-half-inch-wide bands of gold embroidered oak leaves spanning his chest signaled he was a man of considerable standing. Only very high-ranking individuals such as ambassadors

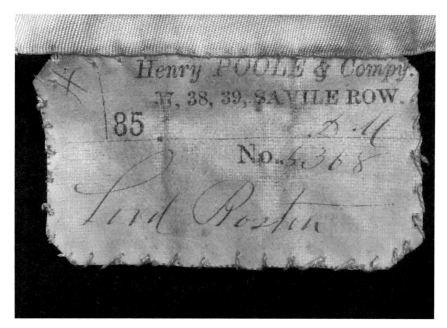

Figure 7.1 Undress Royal Household uniform worn by Lord Boston (detail), 1885.
© Historic Royal Palaces.

and privy councilors wore uniforms so heavily decorated with gold. Undoubtedly the suit cost him a small fortune. The fact that he even had the money to pay for it was impressive.

Perhaps the most obvious signifier of his status was the uniform's scarlet collar and cuffs. To anyone who understood the significance of uniform in 1885, these flashes of red would indicate he was a member of the Royal Household. The coatee's combination of dark blue, gold, and red was a clear visual sign that Lord Boston, aged only twenty-five, was a man to be reckoned with. Dressed alike with ambassadors, senior politicians, even the prime minister, the young and reasonably inexperienced Lord Boston belonged firmly in the upper echelon of society.

Lord Boston wore his new suits almost immediately. On the day he collected his undress uniform from Henry Poole *The Times* announced his attendance at the Prince of Wales's levée at St. James's Palace.[13] He had attended several levees in recent years but crimson Royal Household cuffs now elevated his status. In January 1886, he wore his magnificent full-dress uniform to take part in the royal procession toward the State Opening of Parliament. He then went with the Lord Chamberlain to Buckingham Palace where he met the Queen and was formally installed as Lord-in-Waiting by "kissing hands."[14] On the surviving garment, a sharp cut across the carefully embroidered gold "saw edge" points

at the seam between the collar and coat fronts betrays an unforeseen alteration (Plate 7.3). The pressure on Lord Boston's throat must have been so severe that he requested the neckline be lowered to give him more room to breathe. Henry Poole billed him for the extra work.[15] Comfort was important: he could expect to attend leveés and State Openings of Parliament for the duration of his appointment.

It was widely known that a full-dress civil uniform was an excessively luxurious and expensive garment. The subject excited particular interest around the time of Queen Victoria's Golden Jubilee in 1887, when one writer in the tailoring trade journal *Tailor and Cutter* complained that it cost nearly as much to hire a court suit from a theatrical costumiers as it did to buy the finest of men's suits on Savile Row.[16] The 270 pounds Lord Boston had spent on his three suits was, at the time, an incredible amount of money. The year he bought them, he earned just over 549 pounds on the farms and cottages he rented on the Hedsor Estate. His annual expenses for Anglesey were just over 200 pounds. The amount he spent on uniforms was more than half his mother's annual allowance.[17]

Considering the substantial cost of his Royal Household uniforms, it is no wonder that Lord Boston got a shock in February 1886 when the prime minister told him that his services as Lord-in-Waiting were no longer required. He had only been in post for seven months. The official explanation in the *London Gazette* was that the liberal politician Lord Ribblesdale had been appointed Lord-in-Waiting on Lord Boston's resignation.[18] Still confused, it took Lord Boston six months to muster the courage to contact the prime minister, whom he politely asked for an explanation:

> having to the best of my ability supported the Conservative cause in Lincolnshire and in this country … and having steadily attended the House except this last spring when my health necessitated my being abroad, I feel much pained at the check which has been given my connection with the party, and to the career which I hoped was opening before me.[19]

He went on to explain somewhat tentatively that the situation had "given rise to general comments among my friends" and "in the absence of any communication" about why he lost his post, he did not know what to say to them. He was extremely worried about the damage it would do to his political career.

It is not clear why the Lord-in-Waiting post was offered to someone else. The general election in December 1885 saw a brief shift from a Conservative to a Liberal government; it is possible that William Ewart Gladstone's short time in office precipitated a redistribution of honorary posts. Lord Boston's youth and inexperience may have led him to suspect that his position was

reallocated due to a misunderstanding: that his short stay in Europe during the previous spring had been interpreted as a lack of commitment to the Conservative Party. There were clearly no hard feelings: two years later, he was offered another Lord-in-Waiting post, which he refused for personal reasons.[20] Was he so disturbed by this experience that he could not face yet another disappointment? Whatever the reason behind his dismissal, Lord Boston's deep distress was evident.

His first concern was to ensure that he could still wear his Royal Household uniforms. Just a few days after he lost the post he received a letter from the Lord Chamberlain's office stating: "The Queen has given you permission to continue to wear the Household uniform."[21] There are several possible justifications for his anxiety. First, as previously indicated, the uniforms represented a considerable investment. It is possible that he simply aimed to get a return on this investment. Second, his concerns may have been of a practical nature: if he continued to attend levées and other formal court gatherings he would have to buy another uniform—or hire one from a theatrical costumier or the men's suit hire company Moss Bros in Covent Garden. Third, individual status may have motivated him. His full-dress uniform was a strong visual signifier of his social standing. Its dark blue cloth, four and a half inches of gold embroidery, and scarlet collar and cuffs were the preserve of the powerful elite. Lastly, perhaps it was the "friends" he mentioned in his letter to the prime minister that caused his anxiety. If he could not wear his uniform he would lose the cachet of Royal Household membership. More generally, however, he would not be a part of his visually homogenous, color-coded, elite group.

With permission to wear his Royal Household uniforms secured, Lord Boston continued his life as a reasonably prominent public figure. He was involved in various charitable activities, including the Mansion-house committee of the fund for the Relief of the Unemployed in London.[22] In 1890 he married his cousin Cecelia, known as Cissie. He and Cissie traveled in prestigious circles. They attended royal events such as the State Opening of the Imperial Institute in 1893.[23] They were present during a visit of the Prince and Princess of Wales to nearby Penrhyn Castle in 1894.[24] They enjoyed the company of high-profile individuals such as Prince George and Princess Mary (the future King George V and Queen Mary), artists like John Singer Sargeant, wealthy American businessman William Waldorf Astor, and others.[25] Lord Boston had several opportunities over the years that followed his disappointment to wear one or other of his uniforms. In 1890 he asked Henry Poole to press his tunic and apply a black silk crepe mourning band to its sleeve—there was official court mourning that year for the Empress Queen Augusta of Germany and Prussia and the Duke of Aosta.[26] In 1895 Lord Boston attended the Prince of Wales' levée at St. James's Palace—probably wearing the undress uniform.[27] He also attended various State Openings of Parliament, for which he would have worn the full-dress one.

This special dispensation to wear the Royal Household uniforms offered two advantages. At some gatherings, his gleaming gold torso and scarlet cuffs set him well above the people who surrounded him. But where large crowds of men in civil uniform were present, he retained—visually, at least—his membership of the group he no longer officially belonged to. The people who knew him must have raised their eyebrows at this, but this must have been a reputational risk worth taking.

The death of Queen Victoria in 1901 signaled the end of a period notable for a formality of ceremony, which might well have diminished under a new Sovereign. Lord Boston had not received tickets for the actual funeral ceremony in St. George's Chapel in Windsor but he did watch the Queen's funeral procession. He told his mother, "it was a grand sight. The vast crowds were something extraordinary and while the coffin was passing there was dead silence." Ever keen to wear his uniform, he added, "I am afraid the queen's death will make a big difference to us as regards court functions. I am not sure whether I can continue to wear my Household uniform."[28]

Boston's fears that his special dispensation to wear his uniforms would inevitably expire were unfounded. He wore the full-dress uniform at the coronation of Edward VII and Queen Alexandra in 1902. It can be seen in the photograph he had taken after the ceremony, just visible under the crimson velvet and ermine coronation robe he inherited from his father, which was supplied by the established robe makers Webb (Figure 7.2). "The whole spectacle was one of the very greatest splendour," he reported, "and really defies description."[29] Lord Boston wore the suit and robe again in 1911, for the coronation of George V and Queen Mary. In all likelihood he wore the same for the coronation of George VI and Queen Elizabeth in 1937.

Politics remained one of Boston's key interests. In 1899 he led a committee on the supply of electricity to London.[30] He was a member of the Anti-Sweating League, the social reform group that campaigned against poor conditions for workers in sweatshops, and supported the introduction of a minimum wage.[31] He supported electoral reform: in March 1910, *The Times* published a letter from Lord Boston, in response to Lord Rosebery's assertion "that the possession of a peerage should no longer of itself give the right to sit and vote in the House of Lords." Lord Boston supported this statement, adding that he favored a Parliament "less dominated by an element drawn exclusively from the wealthy and leisured classes, and less under the control of one political party in the State."[32]

By the late 1920s, Lord Boston was becoming increasingly absorbed in his personal interests in archaeology and science. He directed the excavation of a Roman fort in North Wales, he helped to plan a strategy for preservation of Snowdonia as a place of natural interest and historic importance, and he was

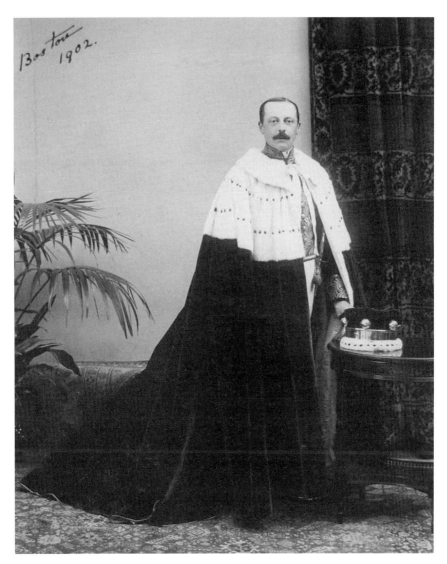

Figure 7.2 George Florance Irby, 6th Baron Boston, wearing coronation robes. William Plumbe, 1902. Reproduced with kind permission of Lord Boston.

president of the Council for the Preservation of Rural Wales and eventually left a large collection of early English pottery to the National Museum of Wales. He was a Fellow of the Society of Antiquaries, and of the Geological Society and in 1936 he was awarded a Doctor of Law by the University of Wales, Bangor, for his services to culture.[33] Lord Boston and his wife Cissie did not have children. In 1923, they sold the Hedsor estate and the contents of the house, including

historic books; an Erard piano and a pair of busts by Roubiliac were sold soon afterward.[34] The rest of the estate and title passed to his nephew.

The uniforms that are now preserved in the Royal Ceremonial Dress Collection record some of Lord Boston's physical characteristics. The alteration he commissioned to lower the neckline of his full-dress coatee reduced the pressure of the collar on his Adam's apple. This small adjustment evokes the early days of his career when his need for personal comfort warranted cutting away the precise embroidered borders of his otherwise perfect coat. A triangular piece of fabric inserted at the back center waist of his undress uniform trousers suggests he gained weight in later life. Despite his expanded waistline, his coatees survive without significant alterations. Any substantial modification to these coats would be a complicated task for any tailor. The gold wire embroidery would have to be reworked to conceal any additional dark blue cloth pieces. Did Lord Boston feel that his uniforms were not worth any further investment? Perhaps he suffered through long hours at court in a coat that was too small for him.

Lord Boston's Royal Household uniforms remained important to him. This is documented in his surviving letters where they are the only personal possessions mentioned. There are no references to the Van Dyck portrait, the busts by Roubiliac, even the Hedsor estate at Maidenhead and its surrounding grounds. This was in part due to his love of ceremony and the enjoyment he had attending formal court occasions since his early twenties. In letters to his mother, he included detailed descriptions of the King's magnificent appearance, the striking scene at the Abbey, the naval review after George V's coronation that resembled "an eastern city of gold, the masts representing the minarets and pagodas."[35] He relished in the personal anecdotes: one insider told him the Archbishop of Canterbury "made a bad shot at first in crowning his Majesty and put the crown on crooked!"[36] Wearing the uniform, Lord Boston was immersed in these occasions as it elevated him from being a spectator to a protagonist.

More than this, Lord Boston's blue, gold, and scarlet Royal Household uniforms helped to define his public image. At the beginning of his career, they embodied the promise of a long career in politics. They reinforced his high social status and labeled him for all to see as a member of the Royal Household. He was already a member of the elite but his uniform provided a cohesive visual association with other members of the Royal Household and, more generally, the ambassadors and other high-ranking officials who demonstrated their status through copious gold embroidery. As a group, these men in uniform added magnificence to the court ceremony that Boston had so enjoyed. The expensive dark blue cloth absorbed the light to show off oak leaves and spangles of gold and flashes of scarlet that twinkled in the candlelight. Losing the Lord-in-Waiting's post in 1886 put Lord Boston's membership of this group in jeopardy. The special dispensation he received to wear the Royal Household uniform

allowed him to preserve his role as an important participant in court ceremonies. But it also secured his continued affiliation with the nation's most powerful and influential group of men. Without it, he might wear his comparatively plain scarlet Deputy Lieutenant's uniform or the even simpler black velvet court dress that any man could wear and thus blend into the crowd.

Acknowledgments

Very special thanks to Lady Boston for allowing such generous access to family documents and photographs. Thanks also to Angus Cundey at Henry Poole & Co. for enabling me to examine the company ledgers and James Sherwood for helping me to navigate them.

Notes

1 Dictionary of Welsh Biography http://yba.llgc.org.uk/en/s2-IRBY-FLO-1860.html (accessed December 1, 2015).

2 Boston Family papers, Statement as to Lord Boston's Estates and as to the Charges Thereon, June 17, 1886.

3 "Great Conservative Demonstration at Oxford," *Oxford Journal*, February 7, 1880, 6.

4 "Imperial Parliament," *Morning Post*, April 21, 1882, 2.

5 Henry Poole archive, ledger A-B-4, 530.

6 Ibid.

7 "Grand Conservative Demonstration," *Buckinghamshire Herald*, September 6, 1884, 5.

8 Boston Family papers, Lord Salisbury to Lord Boston, July 3, 1885.

9 Henry Poole archive, ledger A-B-4, 830.

10 Ibid., 839.

11 http://www.measuringworth.com/ukcompare/relativevalue.php (accessed December 1, 2015).

12 Ibid., 894.

13 *The Times*, July 14, 1885, 12.

14 *The Times*, January 22, 1886, 5.

15 Henry Poole archive, ledger A-B-4, 894.

16 *Tailor and Cutter*, November 8, 188, 509.

17 Boston Family papers, Statement as to Lord Boston's Estates and as to the Charges Thereon, June 17, 1886.

18 *The London Gazette*, March 2, 1886, 1027.

19 Boston Family papers, Lord Boston to Lord Salisbury, August 8, 1886.

20 Boston Family papers, Lord Boston to Lord Kintore, October 17, 1888.

21 Sir Spencer Ponsonby Fane to Lord Boston, February 13, 1886.

22 *The Times*, February 16, 1886, 6.

23 *The Times*, May 11, 1893, 9.

24 *The Times*, July 13, 1894, 10.

25 Private Collection, Autograph album.

26 Henry Poole archive, ledger A-B-4, 894.

27 *The Times*, May 28, 1895, 10.

28 Boston Family papers, Lord Boston to his mother, February 8, 1901.

29 Boston Family papers, Lord Boston to his mother, August 1902.

30 *The Times*, June 23, 1899, 14.

31 *The Times*, October 27, 1906, 3.

32 *The Times*, March 23, 1910, 6.

33 Dictionary of Welsh Biography http://yba.llgc.org.uk/en/s2-IRBY-FLO-1860.html (accessed December 1, 2015).

34 *The Times*, October 30, 1923, 24.

35 Boston Family papers, Lord Boston to his mother, June 26, 1911.

36 Boston Family papers, Lord Boston to his mother, August 1902.

References

Books

Graham Bennet, H. (ed.) (1903), *Dress Worn by Gentlemen at His Majesty's Court and On Occasions of Ceremony*, 19–20, London: Harrison and Sons.

Mansel, Philip. (2005), *Dressed to Rule: Royal and Court Costume from Louis XIV to Elizabeth II*, 77–93, 100, London: Yale University Press.

Archives and papers

Boston Family papers
Henry Poole archive ledgers
Royal Ceremonial Dress Collection archive

Newspapers and periodicals

Buckinghamshire Herald
The London Gazette
Morning Post

Oxford Journal
The Tailor and Cutter
The Times

Website

Dictionary of Welsh Biography, http://yba.llgc.org.uk/en/s2-IRBY-FLO-1860.html (accessed December 1, 2015).

8

YELLOW IS THE NEW RED, OR CLOTHING THE RECESSION AND HOW THE SHADE OF SHAME BECAME CHIC

Jonathan Faiers

In the film *Gone to Earth*, British filmmaking partners Michael Powell and Emeric Pressburger's deliriously beautiful 1950 vision of English paganism versus religious conformity, actress Jennifer Jones plays a liberated gypsy girl named Hazel. She first casts her spell over the repressed Baptist minister played by Cyril Cusack while singing "Harps in Heaven," an ethereal and bewitching song, accompanied by her father playing the harp. Costume designers Julia Squire and Ivy Baker created Hazel's dress for this sequence in a typical mid-twentieth-century cinematic approximation of late-nineteenth-century dress. But what is the most striking feature of the garment is its shocking shade of yellow, made all the more conspicuous by being contrasted against the dazzling Technicolor azure sky and somber tones of the audience, in particular Cusack's priestly black, who is entranced by her performance. In this sequence her yellow costume is understood as shocking, but somehow it is also otherworldly, exotic, sexual, bewitching, and repulsive, in short – wrong.

This roll call of contradictory chromatic characteristics is typical of the geographically specific marginalization, and more recent commercial migration, of yellow in the West from being regarded as the color of disgrace and of degeneracy into the shade of fashionable conformism, a dilution of yellow's reputation from shameful to chic. How color is regarded historically and culturally is as much a constantly fluid and evolving process as it is fixed and unwavering,

its meaning and perception a result of global, economic, and cultural shifts. As French medievalist Michel Pastoureau has so eloquently pointed out: "Any history of color is, above all, a social history. Indeed, for the historian—as for the sociologist and the anthropologist—color is a social phenomenon. It is society that 'makes' color, defines it, gives it its meaning, constructs its codes and values, establishes its uses, and determines whether it is acceptable or not" (Pastoureau 2001: 10).

Yellow in the West, and particularly its representation in art and popular culture, has long shared an affinity, if not an exact correlation, with red. Popular cinema, for example, is littered with scarlet women, dangerous reds and satanic reds. Red's reputation as a sexually provocative, even promiscuous, color, when worn by women at least, is so entrenched in the Western psyche that it can even signal its shamelessness in black and white, a topic explored in detail in the chapter "Seeing Red" in my own *Dressing Dangerously: Dysfunctional Fashion in Film* (Faiers 2013). The bloodiness and therefore implicit deadliness of red is as potent in the colorless world of early film, as it is in lurid Technicolor. But for all of red's shocking, fictional potential, when it comes to its use in fashion, it has also enjoyed a long-established reputation as a stylish color choice. Noticeable, yes, and requiring a certain bravura to wear it well, perhaps, but coming with a chromatic pedigree bestowed on it by its royal, military, and clerical associations. These additional associations mean that even in mainstream film red no longer occupies the oppositional space it once relished.

Yellow, however, is a different matter and as Hank Williams, the celebrated country and Western star, sang in his 1952 hit *Settin' the Woods on Fire*:

> You're my gal and I'm your feller
> Dress up in your frock of yeller
> I'll look swell but you'll look sweller
> Settin' the woods on fire.[1]

Williams's lyric suggests that, like Hazel's dress in *Gone to Earth*, yellow has both an affinity with nature, for example yellow sunshine, but also an accompanying elemental potential for harm that matches red's easily understood incendiary power, and according to *Settin' the Woods on Fire* can burn with a more sulpherous and lasting heat than the fieriest of reds. More recently, yellow has taken on the cinematic mantle as the "shade of shame" once occupied by red (Faiers 2013). Therefore, the color selected for the protagonist's disastrous appearance at the law society dinner, in *Bridget Jones the Edge of Reason* (2004 dir. Beeban Kidron), is an unflattering shade of golden yellow, while American actor, comedian, director, and game show host Cedric the Entertainer, in the 2005 remake of *The Honeymooners* (dir. John Schulz), employs a discourse of yellow ignominy to describe his appearance in a borrowed suit at a fund-raising

event, protesting: *"What do you mean, let it go! I'm stood here lookin' like a bottle of dish washing liquid, a summer squash, a stick of butter, somebody's cracked teeth and you want me to let it go."*

So if we understand that yellow has supplanted red's position as the color of cinematic shame, its more recent journey to the center of fashionable approval from the margins of sartorial acceptability demands equal consideration and an understanding of the color's specific negative associations which, although more particular, have meant that yellow has suffered a much more lasting chromatic quarantine than red's more generalized avoidance.

Yellow clothing in the West is burdened with a symbolic weight as a result of its historic accumulation of fear, mistrust, and ignorance of the unknown—a color synonymous with the "other." As John Gage, author of *Color and Culture*, suggests: *"Yellow has had a bad press in modern times and is now thought to be the least popular color"* (Gage 1995: 63) and while yellow's fortunes have recently changed, as this text will endeavor to show, since Gage made his observation in 1993, historically, at least in the West, yellow's disrepute is undeniable.

There is much visual evidence to reinforce the symbolic interpretation of the color yellow. For example, early Christian examples of xanthophobia, or fear of the color yellow, have been given artistic expression in the numerous examples depicting Judas Iscariot dressed in yellow betraying Christ in the Garden of Gethsemane with a treacherous kiss, the most famous perhaps being *The Kiss of Judas* included in the cycle of frescoes by the early Renaissance master Giotto in The Scrovegni Chapel in Padua (1304–1306), where Judas envelops Christ in his perfidious yellow cloak.

A similar art historical stereotyping of marginalized yellow can be found in the numerous depictions of Judas seated at the edge of the Last Supper in yellowed isolation wreathed in a combination of avarice, guilt, and envy. Holbein the younger's painting *The Last Supper* of 1524–1525, now in the Kunstmuseum Basel, is perhaps one of the most remarkable of these, with a red headed, yellow clad (a double condemnation perhaps given the entrenched mistrust of red and ginger hair in Western culture), hunched, and hooked nosed Judas, seated on the left (as always the position associated with the entrance of evil) contrasted against the deep beatific blue of the sorrowfully knowing Christ. A somewhat more saccharine, yet nonetheless condemning version can be found in Phillip de Champagne's baroque version of the *Last Supper* from 1648, which seats Judas cloaked in yellow on the left, clutching his purse containing the thirty pieces of silver (Plate 8.1).

While there is no biblical evidence of Judas' fondness for yellow (the gospels are curiously achromous), it is easy to see how the growing tide of anti-Semitism staining Europe from the medieval period onwards conflated the increasing number of sumptuary and other vesitmentary laws with the personification of biblical treachery, avarice, and ignominy in the figure of the yellow-clad Judas

Iscariot. These laws condemned Europe's Jews to wear yellow hats, belts, scraps of cloth and badges, typically in the shape of a yellow ring or circle. Further research needs to be undertaken concerning the synchronicity between the emergence of the yellow dressed Judas in Western art and the earliest Judaic vestimentary regulations, but however exact the chronology, or why yellow was chosen as the color used to ostracize a specific ethnic group, this alliance between an adopted chromatic symbolism and institutionalized racism meant that yellow would be consigned to the outer reaches of the Western color palette (with a notable exception which will be addressed further on). This remained largely the case until the twentieth century, when despite the efforts of the Nazis' ideological predilection for classificatory annihilation and the re-demonization of yellow in the concentration camps with Jewish victims identified by a yellow star, the color gradually emerges from its position of disrepute to reach its fashionably ascendant status today (Figure 8.1).

By the sixteenth century "heretics" of all creeds found themselves forced to wear yellow, as were those who refused to renounce their beliefs when brought before the Spanish inquisition and were forced to dress in yellow capes for example. In tandem with the depictions of Judas Iscariot clad in customary shameful yellow, another significant New Testament figure, Saint Peter, is similarly often depicted wearing yellow. Initially this might seem a contradiction to the color's expected usage as the sign of disgrace. However, when we consider that alongside St. Peter's receiving of the keys of the kingdom of heaven and his popular characterization as the first Pope, he is, of course, the disciple that thrice denied Christ following his arrest. This factor suggests that his golden yellow robes are as much symbolic of lies and denial as they are the raiment of celestial glory. At a period when yellow was increasingly becoming invisible in Western art it is entirely fitting that a painter as individual and unclassifiable as El Greco (Domenikos Theotokopoulos, 1541–1614) should favor yellow so strongly in his works, including at least six variations on the theme of the *Penitent St Peter*, caught at the very moment following his denial of Christ and in every version shown wearing a vivid, almost luminous yellow mantle.

While yellow continued its uneven journey in the West into chromatic opprobrium, finding new subjects on the way to cloak in tonal infamy, China maintained a fundamental and deep-rooted cultural regard for the color. An Imperial and spiritual shade, yellow in China is the color of happiness, glory and wisdom. It is also the color of the fifth zone in the Chinese compass—the center—or Middle Kingdom, where the Emperor resides at the exact center of the world bathed in yellow celestial light. Only members of the imperial household were permitted to wear yellow, while distinguished visitors were honored with a yellow, as opposed to red, carpet. Equally indicative of yellow's symbolic, but in this case ominous, power is the fact that those who had wronged the emperor were given a yellow scarf, a golden vestimentary signal, one might even say textile command, for them to commit suicide.

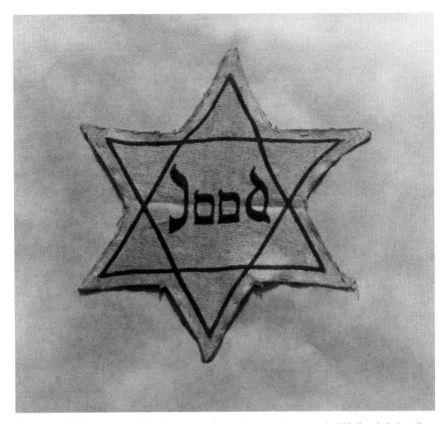

Figure 8.1 Yellow star, which Jews were forced to wear in occupied Holland during the Second World War. © Photo: REX/Shutterstock.

By the late seventeenth and on into the eighteenth century with the establishment of trading relationships between China and Europe, the West enjoyed a brief period during which it basked in the newly fashionable rays of a yellow sun. Simulating China's ancient reverence for the color, European yellow became, briefly, the color of power, wealth, and style for much of the eighteenth century reflecting the Western desire for Chinese silk, porcelain, and tea. The influx of imported Chinese goods, including lacquer ware, silks, and porcelain all of a distinctly vibrant yellow, bathed the fashionable elite of the period in a reflected Oriental glory and provided the catalyst for European Chinoiserie. Yellow covered stylish walls, backs, and canvases alike and the color is perhaps the shade most associated with the refined taste for the exotic that typifies the era.

Allied to this fashionable eighteenth-century yellow craze was the appearance in Europe, due to increased colonial and mercantile expansion, of a series of new yellow dyes made from imported foreign plant material which alongside

simultaneous scientific advances produced some of the first synthetic yellow pigments. *Fustic* obtained from the *Maclura tinctoria* or *Dyer's Mulberry* tree found in many parts of South America and *Quercitron* produced from the bark of the *Eastern Black Oak* indigenous to many parts of North America, both of which produce brilliant yellows when used with the correct mordants to fix the dye, were indicative of this period of intense trade and expansion. The eighteenth and nineteenth centuries saw the discovery of these new dyes from abroad alongside the manufacture of synthetic pigments and dyes, which quickly replaced the traditional yellows made from arsenic, cow urine and other costly substances such as saffron.

This combination of cultural, mercantile, and scientific interest around the color yellow understandably led not only to the demand for the imported yellow artifacts mentioned previously, but an intensification of the color in fashionable clothing, many examples of which still survive in all their dazzling yellowness today. This sartorial brilliance understandably provided irresistible chromatic subject matter for the most celebrated painters of the period such as Antoine Watteau and Jean-Honoré Fragonard, the latter's whose painting *La Liseuse* of 1772 depicts a young girl reading wearing a vivid yellow gown and is typical of the era's xanthophilia, or obsession with the color yellow.

This season in the sun was relatively brief and with the dawn of a new century and the unstoppable advance of Western empire building, and aggressive trading practices, yellow returned to its former status in the West as the hue of hatred. China, and a generalized construction of the Orient, replaced the Jews as the object of Western chromatic sullying. This was fueled by events such as the Opium Wars in the first half of the nineteenth century and a series of so-called unequal treaties (the term applied to any number of treaties signed between Western powers, Quing dynasty China and the late Tokugawa shogunate in Japan following unsuccessful military encounters), culminating in the Boxer Rebellion at the close of the century. The accelerating Sinophobia (or anti-Chinese sentiment) throughout the nineteenth century meant that popular discourse developed a sulfurous efflorescence of racial stereotyping. Terms such as the "yellow peril" and "yellow terror" used to describe the largely imaginary threat to European and North American economic and cultural stability by Chinese immigration came into popular usage.

The Chinese association with opium added to the demonization of the color, with the color taking on additional hues of depravity, decadence, and dependence, rendering those who fell under opium's spell jaundiced and infected, suffering from a narcotic yellow fever, a condition similar to that which artist and writer David Batchelor describes in his illuminating work *Chromophobia* as "*falling into color*," entering an altered, colored state (Batchelor 2000). The anti-hero of Oscar Wilde's 1890 novel *The Picture of Dorian Gray* satisfied his addiction by visiting the opium dens of late nineteenth-century London which were illuminated

by a "*… moon hung low in the sky like a yellow skull. From time to time a huge misshapen cloud stretched a long arm across and hid it*" (Wilde 1971: 140).

Less racially specific but equally negative expressions such as "yellow bellies" and "yellow streaks" gained currency in literature as general derogatory terms denoting cowardice, thus evoking the color's long history of negative associations in the West. This was, of course, the exact opposite of the noble and courageous characteristics traditionally bestowed on the color in China—a typical example of linguistic colonialism and its processes of cultural appropriation and distortion. These verbal shifts and additions characterized the oscillating fortunes of yellow in the West from the color of fashion to the color of fear.

When not linked directly to Sinophobic racial stereotyping, yellow in the nineteenth century becomes increasingly identified as the color of the outsider and wearing yellow, especially, signified at best non-conformity, and more often decadence, degenerescence, and evil. James Tissot, the painter of later nineteenth-century sartorial societal coding, for example, repeatedly used yellow to clothe the female protagonists in his tableaux of fashionable social transgression. Paintings such as *The Ball* of 1880, for example, depicts the arrival at a dance of a young, too young, woman dressed in vivid yellow on the arm of her elderly companion, which of course might be her father but can also be understood as her lover. Her color choice here transforms her into the kept woman in yellow, wearing the shade of shame. While Tissot's earlier work *Chrysanthemums* painted in 1875 has as its subject a woman more poorly dressed than that of the young girl in *The Ball*, but still clad in vivid yellow shawl and bonnet. She is seen stooping, or crouching amid a crop of white, gold, and startling yellow chrysanthemums reminiscent once again of Bachelor's "*fall into color*" both literally and perhaps morally, with the added frisson of exotic danger suggested by that most Oriental of blossoms the chrysanthemum, the imperial symbol of Japan.

Charles Dickens, the great Victorian social commentator, reserved a special place for yellow in his literature. His novels are full of yellowing decay and inhumanity, such as this example from *Nicolas Nickleby*: "*… his nose and chin were sharp and prominent, his jaws had fallen inward from loss of teeth, his face was shriveled and yellow, save where the cheeks were streaked with the color of a dry winter apple …*" (Dickens 1913: 461) describing the repulsive miser Arthur Gride. Similarly this passage from *Great Expectations* where Pip describes Miss Haversham's faded bridal tableaux uses an equally doom laden understanding of yellow: "*But, I saw that everything within my view which ought to be white, had been white long ago, and had lost its lustre, and was faded and yellow. I saw that the bride within the bridal dress had withered like the dress, and like the flowers, and had no brightness left but the brightness of her sunken eyes*" (Dickens 2008: 53). Or Miss Haversham's own description of herself as: "*I am yellow skin and bone*" (Dickens 2008: 79).

Naturally as with all vestimentary proscriptions, the very act of declaring a color as unacceptable, antisocial, and unsuitable makes it irresistible to those who consider themselves outside of conventional society, and oblivious to orthodoxy's strictures. Yellow's popular perception as the color of shame, perversity, and an artistic sensibility so refined as to be "unhealthy," meant that toward the close of the nineteenth century the color entered into an epistemic contract (as did the color green) with what would latterly become known as the Aesthetic Movement, simultaneously linked to and identifying yellow as a color beyond the pale. Yellow is the color of the volume Lord Henry Wooten sends to Dorian Gray in Oscar Wilde's novel to console him after the suicide of his lover. As Dorian starts reading, we are informed that the yellow book: *"was the strangest book that he had ever read. It seemed to him that in exquisite raiment, and to the delicate sound of flutes, the sins of the world were passing in dumb show before him. Things that he dimly dreamed of were suddenly made real to him. Things of which he had never dreamed were gradually revealed"* (Wilde 1971: 101).

The book in Wilde's story with its yellow cover is generally understood as a reference to J.K. Huysman's symbolist masterpiece *À Rebours* (translated as *Against Nature*) published some seven years earlier in 1884. When originally sold in Paris *À Rebours* would have been wrapped in yellow paper both hiding and signaling its scandalous contents (a dazzling forebear to the later plain brown paper covers used to hide pornographic literature). *À Rebours* tells the tale of the ultra-refined aesthete the Duc des Esseintes and is full of chromatic decadence including a catalogue of sickly and febrile yellows.

John Lane's notorious *Yellow Book*, the quarterly literary journal which scandalized conventional late Victorian society, and which initially featured Aubrey Beardsley's shockingly erotic black and white fantasies on its lurid yellow covers, became the handbook for aspiring decadents, reinforcing yellow as the livery of languor. Perhaps second only to lilies was the sunflower's dazzling yellows which reigned supreme as the floral emblem of an aesthetic sensibility and became the yellow object of derision in the popular culture of the time including cartoons and comic operas. Here the color was deployed in thinly disguised attacks on a new victim of shameful yellow to join the list of Jews, Heretics, and Chinese: that of the homosexual, who in popular media of the time was equated on the same level as the insane or the criminal (Plate 8.2). So Gilbert and Sullivan's operetta *Patience* (first performed in 1881) which mocked the Aesthetic Movement, featured the *"fleshly poet"* Bunthorne holding his sunflowers while the operetta's cutting critique of the Grosvenor Gallery established on Bond Street, London, in 1877 and home of British aesthetic painting, contains the famous taunting lines *"greenery yallery Grosvenor Gallery."*

Crossing the Atlantic to America, "yellow journalism" was coined as the term describing a new style of popular sensationalist reporting, named after the early cartoon character Mickey Dugan or The Yellow Kid (so named because he was

drawn wearing an oversized yellow nightshirt) who appeared initially in the *New York World* and subsequently in the *New York Journal—American* in the 1890s. Both newspapers were notorious for prioritizing dramatic, sometimes fictional, "news" stories which was an approach to news journalism that, of course, persists today and has migrated to the proliferation of sensational televised media broadcasting. It was not just the American press that became stained with yellow's negative connotations. One of the most startling works of literature produced in this period was Charlotte Perkins Gilman's novel first published in 1892, *The Yellow Wallpaper*, drenched with a decidedly European yellow decadence with its story of the disturbing and nightmarish fantasies conjured up in the mind of a woman kept prisoner in a yellow papered room: *"It is the strangest yellow, that wall-paper! It makes me think of all the yellow things I ever saw—not beautiful ones like buttercups, but old foul, bad yellow things. But there is something else about that paper—the smell! … The only thing I can think of that it is like is the color of the paper! A yellow smell"* (Gilman 2010: 38).

Returning to yellow's re-emergence in contemporary fashion, it is surprising that even in the twentieth century when most strictures concerning correct color choices had long since been dispensed with, it is still a color that occurs comparatively infrequently. It is not surprising, therefore, that one of the few fashion designers who seems to have had more than a passing fancy for yellow was that supreme individualist and master of both historical and symbolical vestimentary references, Cristóbal Balenciaga (1895–1972). Throughout his career he seems to have had a specific fondness for yellow, which accompanied his signature ecclesiastical blacks, ironic pinks, and virginal whites. Balenciaga even made a direct reference to yellow's previous period of Western fashionability, the eighteenth century, by naming one of his many yellow designs "Watteau". For a designer noted for his strong personal religious belief (Balenciaga was a devout Catholic all of his life and was deeply influenced as a young man by the clerical clothes he saw being worn every day in his native Spain), perhaps yellow with its complex and contradictory Catholic resonances as both the color of renewal and rebirth as well as the color branding the heretic and gentile provided a fitting reference for Balenciaga to conduct his elegant explorations into the relationships between couture, history, and spirituality.

Balenciaga aside, yellow enjoyed momentary periods of glory in the fashion spotlight, but to understand its most recent revival we need to revisit its more positive associations in Eastern, particularly Chinese, culture. It is surely not coincidental that as China becomes increasingly important as a major consumer of Western fashion, especially luxury fashion, that yellow is deployed with escalating regularity by a number of prominent Western designers. Once the crude Sinophiliac tendencies of designers pandering to this new market, who produced collections dripping with heavy-handed, and in some instances frankly racist, Orientalism, had run their course, China's importance to the

survival of many Western luxury fashion brands was understood, ushering in a more measured response to this new commercial opportunity. As has so often been the case historically, color has been fundamental in forging alliances and relationships between cultures as much as it has been a source of division, and so it is with yellow's recent altered regard among Western fashion designers. Undoubtedly the inclusion of yellow with the usual palette of neutrals, pastels, blues, and occasional reds could only have increased the appeal of Western fashion to new consumers from East Asia.

It is now widely accepted that popular culture, especially mainstream cinema, constructs a discourse between fashion and textiles, each influencing the other. How yellow in film has shifted the Western public's perception of the color is an example of this process. Alongside yellow's possible replacement of red as the color of shame and the outsider, other key cinematic yellow moments have prepared the way for the color's reappraisal. Among the numerous possibilities is the character of Cher, the wealthy and socially admired high school student in *Clueless* (dir. Amy Heckerling, 1995), who wears a striking yellow plaid outfit which created discernible sartorial shockwaves since its first appearance, and subsequently was regularly cited as a visual referent in a number of other productions, including music videos as a sort of sartorial shorthand for the typical American preppy high school look. Uma Thurman, as the avenging bride in Quentin Tarantino's *Kill Bill* (Vol. 1) of 2003, has similarly emphasized yellow's liberating and defiant history by wearing a yellow jumpsuit which was a symbol of her emancipation; a factor she seemed well aware of appearing in 2014 at the twentieth anniversary celebrations of the film's release in Cannes dressed in a decidedly more feminine, but as blindingly yellow, Versace gown.

Even more emphatic is yellow's recasting as the color of safety and ironically possibly delusion (shades of its association with opium perhaps) in M. Night Shamalayan's unsettling 2004 film *The Village*, in which the protagonist played by Joaquin Phoenix wears protective yellow; "the good color" when daring to leave the confines of his isolated community, a community where yellow provides a form of chromatic talisman against harm, while red is seen as the sign of the devil and in the list of commandments featured on posters advertising the film is warned against in the following terms: *"Let the bad color not be seen. It attracts them."*

Whether or not these and other cinematic yellows combined with the rise in importance of China as fashionable consumers have effected a vestimentary shift, the spring 2013 collections saw a number of prominent designers using yellow in their collections. Widely different in conception and potential clientele, these included Marc Jacobs for Louis Vuitton, Versace, Prada and Sarah Burton at Alexander McQueen, and it could be argued this sudden cathexis of yellow on some of the most fashionable runways has had a considerable impact on succeeding ready-to-wear and couture collections which have seen a dramatic

rise in the number of designers using the color yellow since that season. Yellow now makes regular appearances on the runways of London, New York, Paris, and Milan, and if not comprising a major part of a collection is included as almost obligatory for at least one outfit among the more customary brights.

Similarly, it is not just on high end runways that yellow is now to be found. Celebrities have realized its show stopping potential, and this has led to the dramatic increase of the color on the racks and hangers of high street retailers, where formerly yellow would have been considered far too great an economic risk by buyers. Perhaps no greater proof of yellow's new found respectability, and it could be argued, its new found mediocrity was its patronage by the newest member of the British royal family, Kate Middleton (Plate 8.3). Her championing of yellow was most famously reported with her appearance at a number of occasions during 2014 in a bright yellow dress designed by the "queen of color blocking" (often yellow), Roksanda Ilincic. Ilincic is quoted as saying, "*My colors are bright and my shapes are sculptural, but there is also a desire not to stand out in a loud way but rather in a different way*" (Sunday Times Style Magazine June 2014). What that "way" is, the reader is not told, but Ilincic's appraisal of color reflects the sartorial U-turn that characterizes yellow's passage from the unlimited, otherworldliness of Dorothy's yellow brick road in *The Wizard of Oz*, to the security and acceptability of the "middle of the road"; a journey from shame to chic.

Notes

1 Extract of song lyrics from *Settin' the Woods on Fire* (performed by Hank Williams, written by Ed Nelson, SR. and Fred Rose. Published by © Sony/ATV Music Publishing LLC).

References

Batchelor, D. (2000), *Chromophobia*. London: Reaktion Books.
Dickens, C. (1913), *The Life and Adventures of Nicholas Nickleby*, London: Chapman & Hall.
Dickens, C. (2008), *Great Expectation*, London: Vintage Books.
Faiers, J. (2013), *Dressing Dangerously: Dysfunctional Fashion in Film*, New Haven and London: Yale University Press.
Gage, J. (1995), *Color and Culture: Practice and Meaning from Antiquity to Abstraction*, London: Thames and Hudson.
Gilman, C. P. (2010), *The Yellow Wallpaper and the History of Its Publication and Reception: A Critical Edition and Documentary Casebook*, Bates Dock (ed.), Pennsylvania: Penn State Press.

Huysmans, J.-K. (2003), *Against Nature (A Rebours)*, London: Penguin

Interview with Roksanda Ilincic Sunday Times *Style* Magazine, June 1, 2014.

Pastoureau, M. (2001), *Blue: The History of a Color*, Princeton, NJ: Princeton University Press.

Wilde, O. (1971), "The Picture of Dorian Gray," in *Complete Works of Oscar Wilde*, pp. 18–167. London: Collins.

SECTION THREE

COLOR AND INNOVATION

9

COLOR BEFORE TECHNICOLOR: COLORIZED FASHION FILMS OF THE SILENT ERA

Michelle Tolini Finamore

One of the early Technicolor films, *Stage Struck* (Famous Players/Paramount, 1925), opens with a dramatic and vividly colored fashion show sequence in which Gloria Swanson morphs from one fantastic creature into the next. She parades out in costumes that range from an Aubrey Beardsley-inspired Salome to the "Queen of the Revue" to Carmen. After the fashion show she is shown at a lavish banquet in which she is offered a peacock on a silver platter but lets the server know that she prefers simple wheat cakes. The chef brings them out, kisses her hand, and, in the intertitles, toasts the actresses who "command our laughter, our tears, our dreams" (*Stage Struck* 1925). The sequence is indeed otherworldly and in those early days of cinema, filmmakers often chose to use the more costly color process for these fantastical fashion-related mise-en-scènes, even if the rest of the film was in black and white. Fashion is doubly implicated in this fantasy role-play because dress is a constructed image that is then projected onto a screen, removing it even further from the real world. Perhaps it is that very unreality which made fashion that much more important to colorize, heightening the dream-like atmosphere of the films discussed in this text.

The early twentieth century is often viewed through a black and white filter, but it was an era full of vivid color, particularly in moving images. An astonishing 80–90 percent of films in the early part of the twentieth century were either fully or partially colorized (Koszarski 1990: 127). The mid-1910s in particular, when much of this experimentation with new film processes was taking place, witnessed the Orientalist creations of Paul Poiret, the Fauvist hues of artists

such as Henri Matisse, and the richly colored costumes of the Ballets Russes. Color lithography, colored electric lights, magic lantern shows with colored glass slides, and artificially-dyed textiles in bright hues achieved through artificial dyes contributed to a visual culture awash in color.

From the very beginning of the history of projected film, color was an essential part of the cinematic presentation but most color footage has not survived due to the volatile aniline pigments that compromised the highly flammable cellulose nitrate film stock. One of the earliest fashion reels at the British Film Institute—a c.1900 film showing the latest hats from Paris—was colorized. *Paris Fashions— Latest Creations in Hats of the House of Francine Arnaud* shows a mannequin from the shoulders up rotating on a turntable in just two millinery creations. The frames were hand-colored in shades of pink and, while the colors were not applied in the most sophisticated manner, they did offer a suggestion of how these hats might look in real life (Finamore 2013: 77). The film also points to a trend that remained the norm throughout the 1910s and 1920s—that fashion and fancy dress were deemed worthy of colorizing, even in the earliest days of cinema when the technology was still in its infancy.

In Western culture, color is a gendered construct and color in fashion has often been more closely associated with women: contrast the sobriety of men's standard uniform black of the nineteenth century with a women's fashion system driven by seasonal color change. A number of authors have explored the cultural significance of color, both within fashion and in a broader contextual sense, including Harvey (1995), Gage (1993), and Batchelor (2000). And although it is no surprise that fashion films were targeted toward women, importantly, the workers who were hand-coloring these images in the film studios were women as well (Yumibe 2013). It is also important to note that the very processes for colorizing these films were often related to textile production processes, explored in more detail later in this text. Thus the clothing creators, the consumers, the viewers, the colorizers, and the wearers associated with these early color fashion films were primarily women.

Female audiences were of particular interest to filmmakers because high fashion was perceived as a way to broaden audience reach and draw a better class of patron into the movie theater (Finamore 2013: 12). In the early twentieth century the performative aspects of fashion display put fashion reels in a category shared by George Meliès' fantasy films and Pathé fairy films, travelogues to exotic places, and multi-reel narrative spectacles such as the seminal 1914 Kinemacolor film *The World, The Flesh and The Devil* many of which were colorized (Kinemacolor is discussed in more detail later). Fashion shows on film were an offshoot of popular burlesque or Vaudeville entertainment featuring the female body in motion, and did retain this connection to spectacle through what is called in film history parlance the "cinema of attractions" (Finamore 2013: 31). A phrase coined by Tom Gunning, the "cinema of attractions" refers

to the continuation of Vaudeville and burlesque-inspired performance styles and stage presentation in early cinema (Gunning 2000: 162).

Annabelle and Her Serpentine Dance is an example of the type of film that one would view at the "cinema of attractions" and, importantly, it was shown at the very first presentation of projected film in 1896 when Thomas Alva Edison premiered his Vitascope in New York City. The film was one of two that were shown in color. Annabelle was a dancer who used new light technology in her stage performances to illuminate her voluminous, swirling ensembles in varied shades. To replicate her stage acts, the film strip for *Annabelle and Her Serpentine Dance* was colored by hand, frame by frame (Plate 9.1). It is believed that the wife of Edmund Kuhn, an Edison employee in Orange, New Jersey, colored the film (Yumibe 2013).

The great variety of techniques for colorizing film in the early part of the century attests to its prevalence as well as the desire on the part of filmmakers to accurately capture real life. There was much experimentation with tinting film, but four basic methods, some more successful than others, were commonly used. The methods included hand-coloring, stenciling, tinting, and toning. There was a very fluid relationship between photography and film in the early days of cinema and the most straightforward form of colorizing had its roots in the hand-coloring of glass slides, which were still part of the cinematic experience and shown alongside films well into the late 1910s. In hand-coloring, the film strips were lit from below on machines that would advance the film frame by frame. One color of an aniline dye would be spread over the frame with a tiny brush, the film would be rewound, and then another color applied. The process yielded quite beautiful results but was very labor-intensive and never fully organized on an industrial scale (Yumibe 2013). Innovative film pioneer George Meliès was a master at this method, and his *Le Papillon Fantastique* of 1909 shows the high quality range of color that could be achieved. As feature films became increasingly popular in the mid-1910s, hand-coloring became less feasible because it was too costly and slow.

Hand-coloring was gradually replaced with a more mechanical system in the form of stenciling, which was similar to the way wallpaper, pochoir fashion plates, and postcards were printed. Pochoir was a stenciling technique popular in France from the late nineteenth century through the 1930s that produced fine quality prints in limited editions (Plate 9.2). A series of hand-cut stencils were used to apply multiple colors and additional colors were often applied by hand. In film, there was a different stencil for each color, applied using a semi-automatic device similar to a sewing machine that would cut the stencils. The needle on this machine followed a stylus that traced the image on the film stock to create the stencil. The stencil would then be placed on top of the film strip and aniline dyes would be spread on the film. Three stencils for each frame could mix primary colors that could achieve an impressive range of twenty colors on one frame.

The similarities between film and textile technology are worth noting; not only did the stenciling process have a connection to the sewing machine, but the cellulose nitrate used in film stock has a base of cotton and, like textiles, was dyed with aniline dyes (Hanssen 2009: 108). As these processes, and materials, were so closely tied to the textile industry, women's "sensitive and nimble fingers" were considered more attuned to the work, and colorizing was some of the earliest film production work available to women. In 1913 the French film company Pathé Frères made color a prominent feature of its business, employing between two and three hundred colorists at their Vincennes factory, many of whom were women who were referred to as the *poules de chez Pathe* (the hens of Pathé) (Yumibe 2013). Because this color process was more time-consuming, it was usually reserved for films for which over two hundred copies would be sold.

Tinting was the third technique for coloring film, a method by which color would be applied to the surface of the film without altering the physical structure of the emulsion. The entire picture would be uniformly washed with color, a strategy that was most useful for night or daytime scenes (e.g., blue for night, yellow for day) but did not allow for any defined detail. It was so popular that by 1926 Pathé was offering a choice of nine different raw film stocks suitable for tinting. A 1912 fashion reel in the Swedish Film Institute archives showing shoes from Paris's Galeries Lafayette is a wonderful example of how the technique can be applied to good effect. The fifty-two-second film uses a different tint for each shoe, ranging from sepia tones to pale pink to shades of blue. While the colors probably did not correspond to the real colors of the shoes, the varied tints served to accentuate the differences between the styles, and played a very important role in communicating the fashion information.

An even more sophisticated range of color variation could be achieved with the fourth technique—toning. Toning was in extensive use by the 1910s, especially in connection with "artistic" films. In toning, a chemical color (e.g., iron or copper) replaced the silver in the film emulsion and dyed only the darker areas of the image, leaving the transparent parts white. The effect was that of an overall color wash, much like tinting, but a wider range of colors could be achieved. Tinted color stock could also be combined with toning for even more dramatic color effects.

Contemporaneously, there was technological experimentation that moved beyond simply coloring the actual film stock. A British scientist named Albert Smith invented the first camera that actually shot film in color using an innovative, and technically successful, technique called Kinemacolor. The film was shot through two colored filters at thirty-two frames per second—twice the normal speed for film in the silent era—and then projected through colored filters in the movie theater. Kinemacolor premiered in London in 1908 and by 1911 an improved product "created a sensation" and was described as the "motographic eighth wonder of the world … [bringing a] scene before millions

with a wonderful realism and gorgeous blaze of color such as never before in the history of moving pictures had been witnessed upon the screen" (Talbot 1912: 296). Such hyperbolic language was typical in the early days of cinema because the technology and the magic of bringing still pictures to life still inspired awe, even sixteen years after its invention. No doubt, the color achieved was another reason for such flowery language. Looking at extant examples such as the fifteen-second 1913 clip of the famous American actress Lillian Russell singing demonstrates that the quality of the color, the realistic flesh tones, and the clarity of the film must have contributed to this remarkable sense of wonder.

Much like the Pathé color films that were reserved for special subjects and high distribution films, the Kinemacolor process was quite costly and the elevated price of the films resulted in its categorization as a high-class product. Such a classification excluded Kinemacolor from the lower-priced nickelodeons and the films were shown primarily in theaters, opera houses, and auditoriums. In keeping with its loftier ambitions, Kinemacolor produced films on topical subjects such as travel, as well as educational films that centered on subjects such as history and natural history. In 1913, the company also decided to add a "Fashion Gazette," showcasing the latest in haute couture, to its usual lineup of short films. As it was an experimental and cutting-edge technology, it is not surprising that avant-garde fashion designer Paul Poiret chose Kinemacolor to document his current line (Figure 9.1). That Kinemacolor could capture the "savage" hues so important

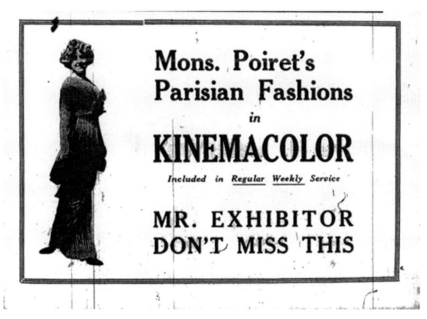

Figure 9.1 Advertisement for Paul Poiret's Kinemacolor fashion films from "Poiret Fashions in Kinemacolor," Moving Picture World, October 25, 1913, 309.

to Poiret's Orientalist creations no doubt also played an important role in the designer's interest in the technology. Indeed, another early colorized film in the British Film Institute collection, *Costume Through the Ages, Remade by Couturier Pascault* (Pathé Frères 1911), incorporated hand-coloring to make a point about the newly popular Fauvist colors that were sweeping the fashion world. The reel used a turntable display to show three-dimensional views of clothing from the past. The modern fashions, however, were shown on mannequins that walked in and out of the set. One of these garments, a Directoire style dress topped with a bird-of-paradise feather hat, was tinted in bright pink hues that were popularized by Poiret and other fashion designers (Finamore 2013: 78).

Poiret's own Kinemacolor film premiered in 1913, and such was the marvel of its presentation that a *New York Times* journalist described the models drifting across the screen as "goddesses from the machine" (Finamore 2013: 74). The film magically brought the viewer into the garden of Poiret's Paris couture house, where his models moved about in a dreamlike way, showing off gorgeous, beautifully crafted garments. Poiret's goddesses appeared to be emerging from a netherworld, in colorful and exotic creations such as his *jupe-culottes* and "lampshade" tunics in "violent" Fauve colors. Given that Poiret took great pride in banishing what he called the "morbid mauves" of the fin-de-siècle from his color palette, color was of utmost importance in communicating his design sensibility. Although the film has not surfaced in archives, one detailed description in the newspaper offers information, with numerous reporters noting that Poiret himself stated that "no light or pastel tones will be admitted" (*The New York Times* 1913).

Kinemacolor was never turned into the commercially viable venture its originators hoped it would, partially because of the high cost of showing the movies, and it went out of business by 1915. Other experimental color processes developed included Prizmacolor, Chronochrome, the Handscheigel process, and Kelly Color. All of these processes eventually coalesced in Technicolor, which was in use as early as 1917, and importantly, for the theme of this volume, was used in a great number of longer narrative films with fashion show sequences. These include films such as *Fig Leaves* (1926), *Irene* (1926), *The American Venus* (1926), *Stage Struck* (1925) starring Gloria Swanson, *Pretty Ladies* (1925) with fashion shows/parades, *The Fire Brigade* (1926), *Lady of the Night* (1923), *His Supreme Moment* (1925), *The Merry Widow* (1925), and *Beverly of Graustark* (1926), among numerous others. Of the three hundred and eighty-five Technicolor films catalogued by the George Eastman House between 1917 and 1937 (Layton et al. 2015: 300–319), the costly Technicolor process was commonly used for fashion shows, spectacular costume scene inserts within the film, or for period costume dramas.

Among the seemingly innumerable fashion reels the author viewed at the British Film Institute and elsewhere, the visual effect of color in Lillian Russell's above mentioned short was astonishing, set amid the period sets, costumes,

and film techniques distinctive of such early film. A similar sense of surprise was evoked by the 1925 film *Stage Struck* starring Gloria Swanson at the George Eastman House archive in Rochester, New York. In contrast to the multitude of surviving black and white reels, this one opened with a startlingly bold Technicolor fashion show. While several copies of this film exist, only two complete examples with the Technicolor inserts are known to survive (Layton et al. 2015: 309). Such colorized fashion shows were almost always highlighted as a selling point in the promotion of the film and *Stage Struck* boasted "… the greatest display of gowns ever shown" in its advertising (*Lewiston Evening Journal* 1925: 9).

Stage Struck tells the story of a young waitress named Jennie Hagen who dreams of becoming a movie star, and the Rene Hubert-designed ensembles are strikingly theatrical, with the intertitle reading "Each new whim of attire [is] accepted by the world of elegance as fashion's decree." Her status as a fashion icon and toast-of-the-town is cemented when the movie cuts to a scene where zealous fans are tearing at her clothes. We learn that this is only a dream, and Jennie's real life—in which she is a waitress working long hours for poor pay in a cheap restaurant—is in the more mundane black and white, which literally pales in comparison to her dramatic, colored dream sequence.

In her black and white world, when she tries to be fashionable, she simply cannot achieve the same heights of elegance, including scenes when Jennie tries to cut her boots into the more fashionable style, imitating a famous actress who has come to town. She also attempts to cut her straw hat into a cloche and starts plucking her eyebrows. When she goes to the town picnic with her new look completed with bobbed hair and makeup, her boyfriend Orme tells her, via the intertitles, she "looks like an accident waiting to happen," shattering her dreams of being as alluring as the fashionable images she sees on the screen. In the end, Jennie returns to her less exciting, humble, yet ennobling (it is implied) existence. Now the owner of her own modest diner, she is shown flipping flapjacks in the final scenes. And yet, because the last scene is also shown in Technicolor, the viewer is left with beautiful images of Jennie's life. This short, but effective, scene is quite striking, full of lovely colorful flowers and imbued with happiness. The color itself is used to make the final point—to confirm the practicality and reality of her choice—that beauty and color could also be found in a simple life, one with which the majority of film audiences could no doubt relate, or at least know they must settle for.

Technicolor was not universally employed in film until around 1949 with the development of a special negative stock that made it less costly to produce. Yet, even in the early days of cinema, the experimental color technologies such as Kinemacolor produced remarkably lifelike moving images and the color quality in *Stage Struck* stands out as exceptionally successful. Many other films no longer exist and the recovery of the original color of those which have survived is extremely difficult and costly, although a few film archives, including Cineteca

Comunale di Bologna and the George Eastman House have been successful in restoring many of them to near their former glory.

The early color fashion films bear witness to a number of phenomena: the importance of using fashion to draw women viewers into the cinema, the continued blurring of the line between high class and lower class forms of entertainment, and the eventual erosion of the boundary between the fashion show and narrative film. All of these developments continued apace with the explosion of popular culture media as the twentieth century progressed. In the very early days of cinema, using color to emphasize fashion marked the dress itself as a protagonist in the story; it too had to perform the *idea* of color—indeed the actual color on the film was itself a construct. This fabricated reality shares a similar impulse to that of fashion, which helps wearers participate in fantasy. As fashion and costume scholar, the late Anne Hollander, wrote so succinctly: "Dressing is always picture making" (Hollander 1978: 311).

References

Batchelor, D. (2000), *Chromophobia*, London: Reaktion.

Finamore, M. T. (2013), *Hollywood Before Glamour: Fashion in American Silent Film*, London: Palgrave.

Gage, J. (1993), *Color and Culture: Practice and Meaning from Antiquity to Abstraction*, Boston, MA: Little, Brown and Company.

Gunning, T. (2000), "The Cinema of Attractions: Early Film, Its Spectators, and the Avant-Garde," in J. Hollows, P. Hutchings and M. Jancovich (eds), *The Film Studies Reader*, 161–65, London: Arnold.

Hanssen, E. F. (2009), "Symptoms of Desire: Colour, Costume and Commodities in Fashion Newsreels of the 1910s and 1920s," *Film History: An International Journal* 21 (2): 107–121. Indiana: Indiana University Press.

Harvey, J. R. (1995), *Men in Black*, Chicago, IL: University of Chicago Press.

Hollander, A. (1978), *Seeing Through Clothes*, New York: Viking Press.

Koszarski, R. (1990), *An Evening's Entertainment: The Age of the Silent Feature Picture, 1915–1928*, New York: Scribner.

Latyon, J., D. Pierce, P. Cherchi Usai, and C. A. Surowiec (2015), *The Dawn of Technicolor, 1915–1935*, Rochester, NY: George Eastman House.

Lewiston Evening Journal (1925), Advertisement for *Stage Struck*, 25 November, 8. Available from: https://news.google.com/newspapers?nid=1913&dat=19251125&id=Sw5HAAAAIBAJ&sjid=4_MMAAAAIBAJ&pg=1439,3761745&hl=en (accessed August 10, 2015).

Parisian Expert Declares the Vivid Colors Will Lead (1913), *The New York Times*, 5 October, X2.

Talbot, F. A. A. (1912), *Moving Pictures how they are Made and Worked*, Philadelphia: J.B. Lippincott Co.

Yumibe, J. (2013), "French Film Colorists," in J. Gaines, R. Vatsal and M. Dall'Asta (eds), *Women Film Pioneers Project*. Center for Digital Research and Scholarship. New York: Columbia University Libraries,. Web. September 27, 2013. Available from: https://wfpp.cdrs.columbia.edu/essay/french-film-colorists/ (accessed September 2, 2015).

10

COLOR AS CONCEPT: FROM INTERNATIONAL KLEIN BLUE TO VIKTOR & ROLF'S "BLUESCREEN"

Michal Lynn Shumate

First there is nothing, then there is a deep nothing, then there is a blue depth.

<div align="right">

Yves Klein quoting Gaston Bachelard (KLEIN 1959)

</div>

In an effort to understand the complicated relationship between fashion and color, this text enlists a case study *Bluescreen (Long Live the Immaterial!)* as a starting point, a point of return, and indeed a maypole around which to weave ideas and references. Staged by fashion design team Viktor & Rolf for their Autumn/Winter 2002 season, *Bluescreen* featured chroma-key blue, a color commonly used to create moving backgrounds in cinematic special effects, to present an alternate reality on projection screens that flanked each side of the runway. The show is at face value a visually arresting and innovative use of film technology within the fashion show genre. Upon closer examination, however, it is a door to the haunting power of blue in art and culture, and to the myriad issues that accompany it: color and line, surface and depth, and nothingness and infinitude—binaries that, as this text will illustrate, are central to the study of fashion, its histories, and its relationship to color.

In their twenty-year career, Viktor & Rolf, Viktor Horsting, and Rolf Snoeren respectively, have often mounted monochromatic (and in many cases non-chromatic) shows: the installations *L'Hiver de l'Amour* (1994) and *L'Apparence du Vide* (1995); the runway shows *Black Hole* (Autumn/Winter 2001) and *All White Show* (Spring/Summer 2002); and more recently *Zen* (Autumn/Winter

2013) and *Red Carpet* (Autumn/Winter 2014). Their work with color extended beyond the runway and into the gallery in 2004 when they guest curated *Fashion in Colors*, an exhibition of historic costume presented along a strict curatorial divide of color groupings (Fukai 2004). As an example of their monochrome projects, the fashion show *Red Carpet* gives a good sense of how the designers employ color: the show was in fact entirely red (Plate 10.1). Dresses made of red carpets were draped over models that walked in red shoes down a red carpeted runway while Steve Reich's 1972 *Clapping Music* was performed on the balcony overhead. The basic shapes of the garments—many reminiscent of a quickly wrapped towel, combined with the cultural signifier of the red carpet and the awkward non-applause clapping of Reich's piece, together formed a kind of surrealist comment on emptiness, pointed sharply at the fashion industry as per usual and, in this instance, directed at celebrity culture as well.

Viktor & Rolf (V&R) appropriate color in their work the same way they appropriate all other elements: as something to be manipulated at the service of a visual commentary. Commenting on fashion with fashion has defined the career of this Dutch design duo; their play with formal elements drawn from sartorial tropes and traditions oscillates between celebrating fashion and all of its infinite possibilities and the cynical exposure of fashion's inevitable unattainability and general absurdity. In fact, a V&R show frequently operates in both modes at the same time, taking the form of a sinister and seductive beauty—an aesthetic experience that is intensely pleasurable in its genuine celebration of fashion and, simultaneously, intensely disturbing in its mocking critique. *Bluescreen (Long Live the Immaterial!)* makes explicit a contradiction that is hinted at in many of their other shows, that is, fashion's association with both nothingness and infinitude: the notion that fashion gives nothing while promising everything.

This text considers how V&R use color in their ongoing mission to unpack fashion's promises, focusing on *Bluescreen* alongside the work of contemporary artists in order to explore some of the parallels between color and fashion—specifically, the ways in which both color and fashion occupy a space of tension between the superficiality of surface and the great, unending expanse of the void. Mid-century French artist Yves Klein looms large over these themes. His oeuvre has long informed the work of Viktor & Rolf, and his 2001 retrospective *Yves Klein: Long Live the Immaterial!* was their stated inspiration for the *Bluescreen* collection and runway performance. In his own work, Klein was preoccupied—perhaps even obsessed—with color, and with blue specifically, creating in the late 1950s the very blue that unites this text: IKB (International Klein Blue).

In pursuit of a context for Viktor & Rolf's *Bluescreen*, this text will first consider color from a broader perspective: What are the challenges inherent to studying color? What is given up by focusing on color and by extension setting aside line (if only momentarily)? Klein expresses his opinion quite clearly on the matter of line: "I am against the line and all its consequences: contours, forms, composition. All

paintings of whatever sort, figurative or abstract, seem to me like prison windows in which the lines, precisely are the bars" (Perlein and Cora 2001). Despite Klein's firm convictions, the question of color versus line is relevant here because the study of fashion has historically been a study of lines: the study of outlines of garment silhouettes, the shapes and markings of historical patterns, timelines and the paths of textile trade routes, lines on graphs showing any number of social or economic trends related to fashion, and of course necklines, waistlines, and hemlines.

The work of James Laver, the beloved patriarch of costume history, will prove useful here. In the introduction to his 1961 *Costume Through the Ages*, a collection of line drawings showing depictions of dress from the history of art, he describes the method employed in the book: "The figures, all founded upon original documents, have been redrawn, but with an absolute minimum of personal expression. The aim has been to preserve the essential lines while giving due attention to detail, and these details are sometimes clearer than they would be in, for example, a photograph of a painting or a piece of sculpture" (Laver 1963: 10). In this passage, we get a sense of line as something reliable and translatable, while color—belonging to the world of expression—is instead extraneous and confusing. A similar approach is evident in Laver's earlier publication, *Style in Costume*, which showcased the parallels between dress and décor through the centuries with a side-by-side comparison of lines: images of garments paired with those of buildings, chimneys, and furniture (Laver 1949). In the hands of the Assistant Keeper of the department known today as Prints and Drawings at the Victoria and Albert Museum (the post Laver held from 1938 through 1959) it is perhaps no surprise that the history of dress was understood and communicated graphically through line via the literal outline of shapes.

Furthermore, it can be suggested that in the study of fashion, line has been adopted in an effort to convey seriousness, rationality, and clear-headedness. Line has been embraced in an effort to cast disapproving glances at the silliness of our subject, to rub off its glittery eye shadow and its wet-looking lipstick, to wash its hair and scrub behind its ears, to give it a square meal and a warm bed and a crisp, clean shirt for its court appearance in the morning. Because it only takes a cursory perusal of the rhetoric in the line versus color debate to see where the line has been drawn between the two: line is rational, honest, and normal, while color is primitive, feminine, messy, superficial, emotional, deceptive, and poisonous. As filmmaker Derek Jarman summarizes, "colour seems to have a Queer bent!" (Jarman 1995a). And perhaps we intuitively seek structure for something so inherently ephemeral, subjective, and slippery as fashion. So what is gained by addressing color's relationship to fashion? What does color mean?

In *Desire in Language: A Semiotic Approach to Literature and Art*, philosopher Julia Kristeva tells us that "color is not zero meaning: it is excess meaning." And again, "color is bodily; it is erotic. It comes from the body, like voice" (Kristeva

1980: 219–221). Color not only comes from the body but is also absorbed by it; color is a corporeal experience. This idea manifests itself frequently in the work of contemporary installation artists such as James Turrell and Ann Veronica Janssens. Visitors to Scandinavian artist Olafur Eliasson's 2009 installation, *360-degree room for all colors* at the Museum of Contemporary Art in Chicago, stood in the middle of a circular enclosure and were presented with nothing but a smooth panoramic wall that slowly throbbed and pulsated with different colors in different tones. The enclosure extended well above head height but not so far as the ceiling, and was bright enough to envelop anyone who stepped in: a real-life, morphing color filter. It was both a room to inhabit and a garment to wear for a moment; visitors felt shifts in mood and bodily awareness with each shift in the environment. Color as employed in Eliasson's installation directly affects the appearance of clothing, and the experience of the body.

This bodily experience of color is at times untranslatable. In her autobiography, fashion editor and curator Diana Vreeland wrote:

> This story went around about me: Apparently I'd wanted a billiard-table green background for a picture. So the photographer went out and took the picture. I didn't like it. He went out and took it again and I *still* didn't like it. "I asked for billiard-table green!" I'm supposed to have said. "But this is a billiard table, Mrs. Vreeland," the photographer replied. "My dear," I apparently said, "I meant the *idea* of billiard-table green." (Vreeland, Plimpton and Hemphill 1997: 105–106)

Similarly, color is at times untrustworthy. In *Chromophobia*, David Batchelor's seminal book on the topic, the artist and writer contextualizes this subject within the tradition of Western philosophy, which, as he describes,

> is used to dealing with ideas of depth and surface, essence and appearance, and this just about always translates into a moral distinction between the profound and the superficial. So where does colour lie along this well-worn path? Well, if colour is make-up, then it is not really on this path at all … It is not simply a deception; it is a double deception. It is a surface on a surface. (Batchelor 2000)

This returns us to the centrality of fashion to the discussion of the surface-ness of color, since fashion is in itself entirely a kind of surface, given that it is a covering for the body, and it is also generally regarded as entirely superficial, among many other pejoratives. The shared surface-ness of color and fashion brings Viktor & Rolf's Autumn/Winter 2002 *Bluescreen: (Long Live the Immaterial!)* into focus.

The first glimpse of blue in *Bluescreen* is a square of pseudo-piping on the interior of a coat; a model holds open an otherwise solid-black coat to make

visible the outline of an oversized pocket (Plate 10.2). The full extent of what is happening is not yet clear to the viewer. Then, on subsequent models there appears a blue collar, a blue hat, blue shoes, then blue stockings and a (very) oversized blue scarf. Eventually there are blue skirts, short blue dresses, blue floor-length dresses worn under blue floor-length coats spread open and lined in blue. But it is not just blue. It is not turquoise, it is not cerulean; it is chroma-key blue, it is International Klein Blue and, as this text will explore further on, it is Derek Jarman blue, David Hammons blue, and Giotto blue.

Contrarily, on the screens that flank the runway, there is no blue at all. Blue stockings, shoes, scarves, and skirts all turn into moving images of nature-scapes and city-views; sometimes the videos are barely glimpsed on a collar ruffle and sometimes they are viewed in their entirety across an evening gown (Plate 10.3). The staged image as a whole is dreamy but uneasy. Viktor & Rolf have broken the cardinal rule of chroma-key blue: be sure your subject isn't wearing blue or "when you remove the color you will also remove the clothing of your [subject] and will instead get the effect of a floating head and arms" (Robertson 2012). And indeed, the models become floating heads above blank screens, more so (or perhaps more literally) than usual: they are a portal for the projection of images and dreams and anxieties. It is not just blue; it is a void that can be filled with unlimited possibilities, infinite garments, or scenes to be imagined in its place. On the one hand, there is cheerfulness in the limitless possibilities (your clothes could become anything!); on the other hand, Viktor & Rolf are showing us that our clothes are hollow, and that our clothes (and ourselves) could disappear, leaving nothing behind. Or worse, they could be perceived in ways that we never intended. Ultimately, V&R give us a mode of camouflage, but with the caveat that this camouflage may prove too effective, sending us from a glossy surface into an infinite void.

This same color blue, as experienced in artist David Hammons's 2002 installation *Concerto in Black and Blue*, was absent until activated by visitors with blue flashlights as they entered a series of pitch-black rooms. As described by one critic, the piece was initially "darkness, emptiness: at least 10,000 square feet of completely lightless space with a very high ceiling in a progression of empty rooms off a central corridor" (Baker 2003). Just as the moving backdrops in the Viktor & Rolf show weren't visible until the models carried the blue garments down the runway, Hammon's piece waited in anticipation, perhaps even non-existence, until inhabited by visitors. It was a study in making something out of nothing, and also a study in simply basking in nothing. As Hammons said in conversation with critic Peter Schjeldahl, the installation was inspired by a trip to Japan and ruminations on the idea that "There are so many kinds of nothingness" (Schjeldahl 2002).

The same blue ten years earlier spoke of absence and presence in Derek Jarman's 1993 film *Blue*. The soundtrack was first broadcast in Britain by BBC

Radio 3, synchronous with a solid chroma-key blue screen broadcast on Channel 4. In subsequent versions, a transcript is sometimes visible at the bottom of the blue screen not unlike subtitles, but in every viewing the overwhelming visual is a single, penetrating blue glow. Jarman's voice is heard alongside Simon Turner's soundtrack of ambient instrumental music and the noise of Jarman's own surroundings: a streetscape, a hospital, a beach.

Blue flashes in my eyes.
Blue Bottle buzzing
Lazy days
The sky blue butterfly
Sways on the cornflower
Lost in the warmth
Of the blue heat haze
Singing the blues
Quiet and slowly
Blue of my heart
Blue of my dreams
Slow blue love
Of delphinium days

(Jarman 1994)

The film is an exploration of the color blue, the experience of losing friends to the AIDS epidemic during the height of the crisis, and Jarman's own physical deterioration from the disease. His symptoms included losing his sight; the blue of the screen is homage to Yves Klein but it is also the blue of Jarman's own blindness, the color that comprised his field of vision more and more as his eyesight waned. The emptiness of the screen becomes the embodiment of his lived visual experience, throwing his words and the sounds of his life into sharp relief. At times he recounts mundane daily interactions, at time he reads poetry, at times he remembers friends and contemplates the future. Completed less than a year before he died from complications due to AIDS, Jarman's blue is a blue of loss and blindness and ultimately death, but also a blue of remembering all the beautiful blue things in the world. The soundtrack, together with the intensity of the glowing screen, makes Jarman's blue a persistent nothingness and everything.

Forty years before the blue of Jarman, there was the blue of Yves Klein: International Klein Blue. And since 1306, almost seven hundred years before IKB, there has been Giotto di Bondone's blue of the Arena Chapel in Padua (Figure 10.1). As art historian Carol Mavor describes the fourteenth-century fresco in *Blue Mythologies: Reflections on a Colour*, "Giotto's blue gives us wings: we inevitably sprout them … It is as if Yves Klein has gone back in time

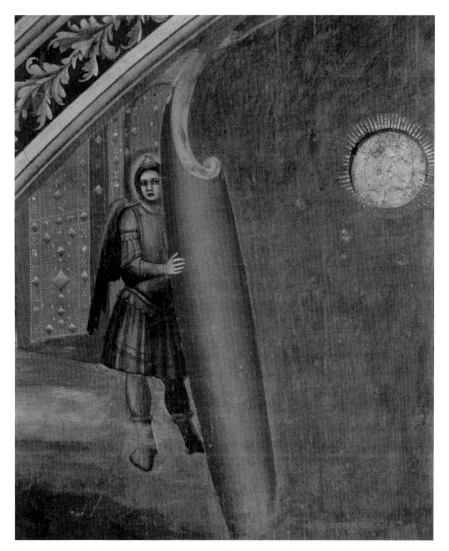

Figure 10.1 Detail, "The Last Judgement," Giotto di Bondone, 1306, Arena Chapel, Padua. © Photo: Wikicommons.

to miraculously join hands with Giotto. Flying is blue. It is as if Giotto has gone forward in time to miraculously join hands with Yves Klein" (Mavor 2013: 20–23). Understanding Klein as a pious Catholic and devotee of Giotto's work makes Mavor's imagining all the more fitting (Schjeldahl 2010), but Giotto's blue is perhaps also a blue of nothing and everything. At the top of his fresco of the *Last Judgment*, which covers the entire interior wall of the entrance, two angels emerge from behind the surface of fresco. As Kristeva describes, "Abruptly, the scroll tears, coiling in upon itself from both sides near the top … revealing the

gates of heaven and exposing the narrative as nothing but a thin layer of color" (Kristeva 1980: 212).

This thin layer of color renders our world flat and at the same time connects our world to the next. This thin layer of color brings us back to Viktor and Rolf's chroma-key blue and the easy slippage that it builds between the second and third dimensions—between the models as flesh and the models as flat surfaces that reveal images of faraway places. The film that documents *Bluescreen* in its eighteen-minute entirety creates another layer of perplexity, as the real-time video projected onto the flanking screens frequently includes one of the screens within the frame alongside the models. The effect is that the blue garments appear to be composed of moving images from another dimension *on the physical runway*. Questions of What is real? What came first? and What dimension is at the service of the other? (Do we privilege the object or an image of the object?) are as relevant to the fashion system as they are to art theory or theological philosophy. V&R's models reveal, emerge from, and fade into the prerecorded series of landscapes, acting as a conduit between here and somewhere else, not unlike Giotto's angels: linchpins between this world and an imagined one, between this world and the way we imagine it to be.

Yves Klein had conduit angel-models of his own. Thought-provoking and ground-breaking despite its misogynistic overtones, his *Anthropometry* (1960) was a performance—and resulting painting—in which nude women were directed to cover the front half of their torso and thighs in IKB paint and then transfer the paint onto an upright canvas while being steered and placed by Klein along the way. Acting as both powerful interlocutors and passive human paintbrushes, the women leave their imprint in blue on the canvas: a three-dimensional body and a four-dimensional performance create a two-dimensional record of the event.

Viktor & Rolf have followed in the footsteps of their dear poet-prankster in this general practice and frequently incorporate models as props in their garment theater. This is seen in *Bluescreen* as well as many other runway shows in which the designers place the models like stones in a rock garden (*Zen*, Autumn/Winter 2013), dress and undress them on stage (*Russian Doll*, Autumn/Winter 1999; Autumn/Winter 2010), or send them down the runway bearing their own lighting and sound rigs on their shoulders (*The Fashion Show*, Autumn/Winter 2007). "For us really the show is the performance, that is the real work. Those ten minutes [are] our work and the clothes are like actors in a play" (Martin 2008). NB: it is the clothes that are the actors and by extension the women who are props. Like Klein's human paintbrushes, the models are simultaneously subhuman and superhuman: treated as objects while elevated to the status of the art they help create.

Giotto's thin layer of color brings us back to International Klein Blue and all that the designers owe to Klein himself. As seen in many of their performances, Viktor &

Rolf had already made a habit of quoting Yves Klein long before they borrowed his blue and named a collection after him. Their odorless "Le Parfum" was conceived as homage to Klein's "Le Vide" from 1958. Sealed shut, the fragrance was given the same reverent attention as a functional branded perfume: packaging, a photo shoot, and full ad campaign. As they later commented, "the scent has an intoxicating effect. Anticipated by its advertisement, [it can] only be imagined: sealed by a wax cap, the flask cannot be opened. The perfume can neither evaporate nor give off its scent, and will forever be the potential of pure promise" (Evans 2008: 53). So clearly *Bluescreen* was not their first quotation of Klein, nor was it their first time celebrating emptiness and all of the possibilities it promises.

"Le Parfum" and "Le Vide" bring us back to this central question of nothingness and its proximity to infinitude. Theoretical physicist and feminist theorist Karen Barad wrote a piece for the catalogue of *documenta (13)*, the thirteenth iteration of Kassel's contemporary art festival, about this very conundrum: "Shall we utter some words about nothingness? … Have we not already said too much simply in pronouncing its name?" Throughout the essay, Barad interlaces quantum theory and the mechanisms of particles and vacuums with poetic reflections cum scientific treatise:

> The void is a lively tension, a desiring orientation toward being/becoming. The vacuum is flush with yearning, bursting with innumerable imaginings of what it could be … Nothingness is not absence, but the infinite plenitude of openness. Infinities are not mere mathematical idealizations, but incarnate marks of in/determinacy.

She concludes with the revelation that these assumed binaries are in fact intrinsically linked: "Infinity is the on-going material reconfiguring of nothingness … Infinity and nothingness are infinitely threaded through one another so that every infinitesimal bit of one always already contains the other" (Barad 2012).

Applying this revelation to color brings us full circle back to Kristeva, back to simultaneous zero meaning and excess meaning, back to the limitations of James Laver and the everything and nothing crafted by David Hammons and Derek Jarman. Applying this to fashion returns us to Viktor & Rolf, back to color as an important and often-used formal element in their work, back to *Bluescreen (Long Live the Immaterial!)* and the ways in which it encapsulates ideas about color and fashion that are central to Viktor & Rolf's entire project. Namely, the shift between surface and the infinite void that it suggests is lurking just below: an exploration of the nothingness and the infinitude of fashion through the nothingness and the infinitude of color. In this vein, fashion is understood as something empty and yet full of promises—or perhaps full of promises precisely because it is empty.

References

Baker, K. (2003), "Is an Empty Room Art? These Days, It Could Be," *Chronicle Art Critic*. Available from: http://www.sfgate.com/entertainment/article/Is-an-empty-room-art-These-days-it-could-be-2671700.php (accessed February 9, 2003).

Barad, K. (2012), *Karen Barad: What is the Measure of Nothingness? Infinity, Virtuality, Justice = was ist wirklich das mass des Nichts? Unendlichkeit, Virtulität, Gerechtigkeit*, Hatje Cantz: Ostfildern.

Batchelor, D. (2000), *Chromophobia*, Reaktion: London.

Evans, C. (2008), *The House of Viktor & Rolf*, London; New York: Merrell.

Fukai, A. (2004), *Fashion in Colors*, New York: Assouline.

Jarman, D. (1994), *Blue: Text of a Film*. Woodstock, NY: Overlook Press.

Jarman, D. (1995a), *Chroma: A Book of Color*, Woodstock, NY: Overlook Press.

Klein, Y. (1959), "L'évolution de l'art vers l'immatériel," Paris, La Sorbonne, June 3, 1959, as published in: Yves Klein, *Vers l'immatériel*, Editions Dilecta, Paris 2006, 118. Translation Charles Penwarden.

Kristeva, J. (1980), "Giotto's Joy," in *Desire in Language: A Semiotic Approach to Literature and Art*, 210–36, New York: Columbia University Press.

Laver, J. (1949), *Style in Costume*, London: Oxford University Press.

Laver, J. (1963), *Costume Through the Ages*, New York: Simon and Schuster.

Martin, P. (2008), "Inside the House of Viktor & Rolf," *Show Studio* (interview transcript). Available from: https://showstudio.com/project/inside_the_house_of_viktor_rolf/interview_transcript (accessed October 24, 2008).

Mavor, C. (2013), *Blue Mythologies: Reflections on a Colour*, London: Reaktion.

Perlein, G. and B. Cora (2001), *Yves Klein: Long Live the Immaterial*, New York: Delano Greenidge Edition.

Robertson, M. (2012), "How to Choose Between Green Screen & Blue Screen for Chroma Keying Video," *ReelSEO*. Available from: http://www.reelseo.com/green-screen-vs-blue-screen-chroma-key/ (accessed August 1, 2012).

Schjeldahl, P. (2002), "The Walker: Rediscovering New York with David Hammons," *The New Yorker*. Available from: http://www.newyorker.com/magazine/2002/12/23/the-walker (accessed December 23, 2002).

Schjeldahl, P. (2010), "True Blue: An Yves Klein Retrospective," *The New Yorker*. Available from: http://www.newyorker.com/magazine/2010/06/28/true-blue-3 (accessed June 28, 2010).

Vreeland, D., G. Plimpton, and C. Hemphill (1997), *D.V.*, New York: Da Capo Press.

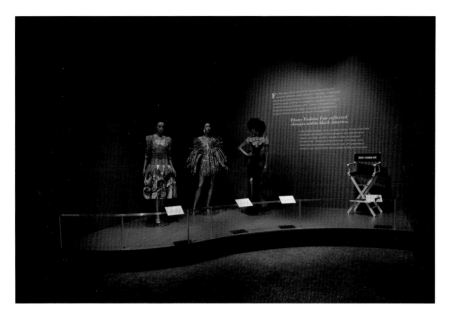

Plate 1.1 Entry alcove of *Inspiring Beauty: 50 Years of Ebony Fashion Fair*. These three garments represent the themes of the exhibition—*Vision* (Stephen Burrows, right), *Innovation* (Tillman Grawe, middle), and *Power* (Yves Saint Laurent, left). © Photograph by and courtesy of the Chicago History Museum.

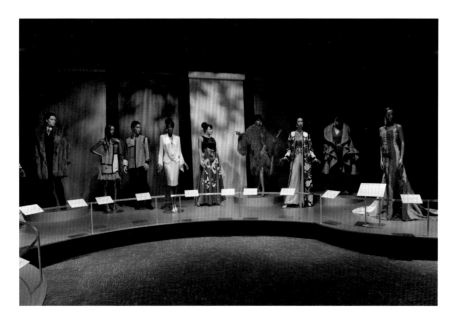

Plate 1.2 Garment grouping entitled "The Power of Color." © Photograph by and courtesy of the Chicago History Museum.

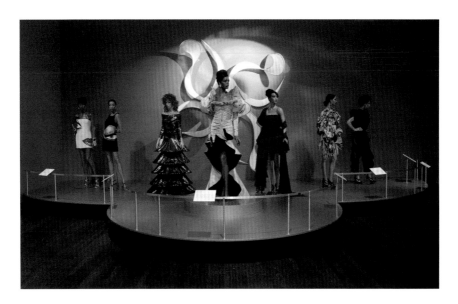

Plate 1.3 Garment grouping entitled "Fashion in Orbit." © Photograph by and courtesy of the Chicago History Museum.

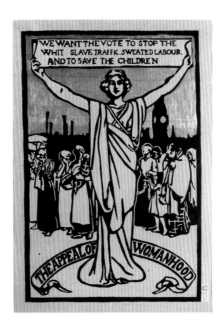

Plate 2.1 Louise Jacobs "The Appeal of Womanhood," Suffrage Atelier 1912. © Museum of London.

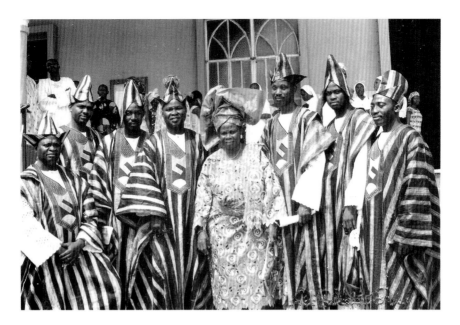

Plate 3.1 *Egbejoda*, a cloth worn by members of a male club or association. © Photograph by Gbemi Areo. Ijebu Ode 2014.

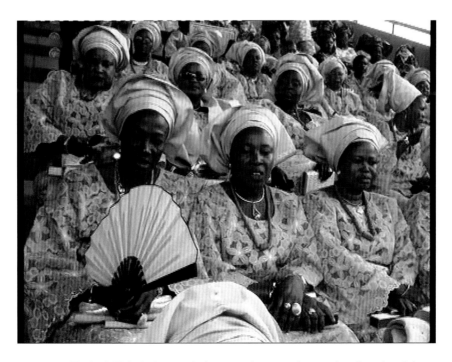

Plate 3.2 Typical *Egbejoda*, a cloth worn by members of a female club or association. © Photograph by Gbemi Areo. Ijebu Ode 2014.

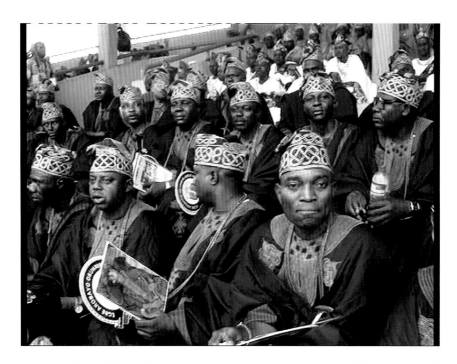

Plate 3.3 "Aso-Ebi, family cloth worn at a funeral by sons of the deceased." © Photograph by Gbemi Areo. Ile-Ife. 2006.

Plate 4.1 Back cover of *Marie Claire* magazine 30/8/1941, evidencing the use of the tricolor flag. Author's image.

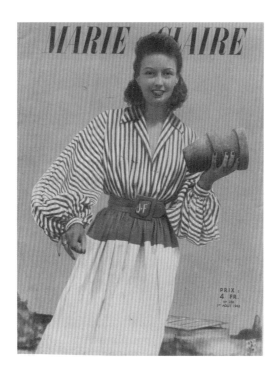

Plate 4.2 Front cover of *Marie Claire* magazine 1/8/1943 model wearing a tricolor ensemble by active collaborator Jaques Fath. Author's image.

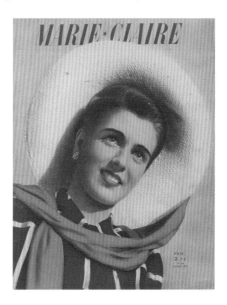

Plate 4.3 Front cover of *Marie Claire* magazine 30/8/1941 in tricolor palette. Author's image.

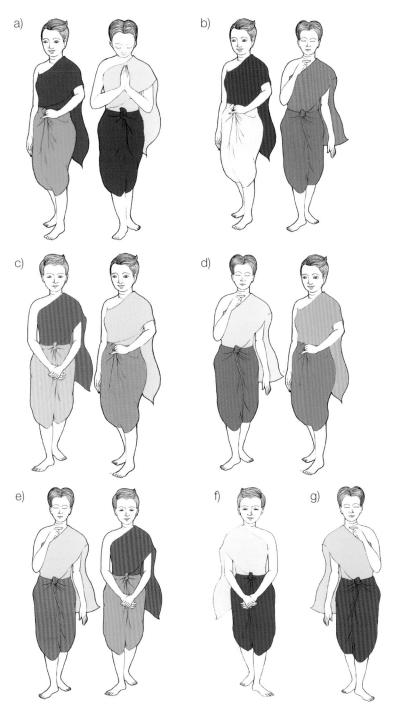

Plate 5.1a–g Auspicious colors, Sunday to Saturday. © Queen Sirikit Museum of Textiles.

Plate 5.2 Afternoon dress of silk georgette designed by Pierre Balmain, 1960. © Queen Sirikit Museum of Textiles.

Plate 5.3 The color blue is associated with Her Majesty Queen Sirikit as she was born on Friday, August 12, 1932. © Office of Her Majesty Queen Sirikit's Private Secretary, Queen Sirikit Museum of Textiles.

Plate 6.1 Blouse belonging to Queen Alexandra, 1860s, L2011.13.31. Courtesy of Pat Kalayjian & Jane Gincig, © FIDM Museum at the Fashion Institute of Design & Merchandising, Los Angeles, CA, photograph by Brian Sanderson.

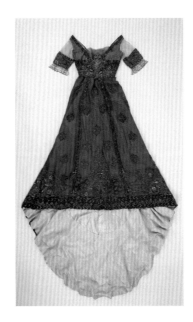

Plate 6.2 Evening dress by Douillet, c.1910. © Fashion Museum, Bath and North East Somerset Council.

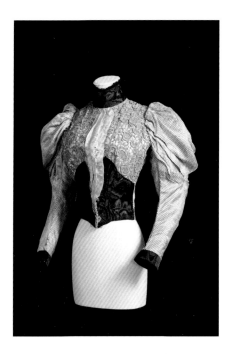

Plate 6.3 Spotted silk and machine lace bodice by Mme Fromont, 1894 © Historic Royal Palaces.

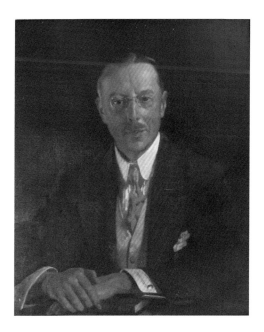

Plate 7.1 George Florance Irby, 6th Baron Boston. William Orpen, oil on canvas, c.1910. Reproduced with kind permission of Lord Boston.

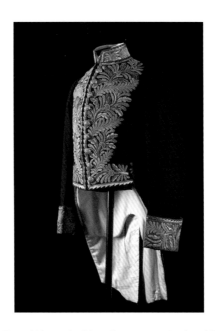

Plate 7.2 Full-dress Royal Household uniform worn by Lord Boston. Henry Poole & Co., wool, 1885. © Historic Royal Palaces. Photo: Robin Forster.

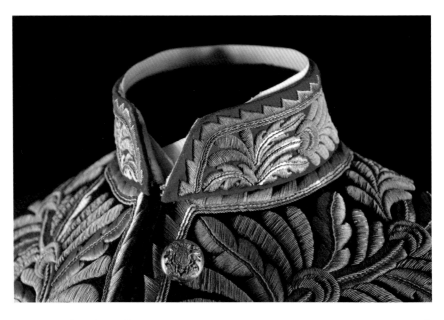

Plate 7.3 Full-dress Royal Household uniform worn by Lord Boston (detail). Henry Poole & Co., wool, 1885. © Historic Royal Palaces. Photo: Robin Forster.

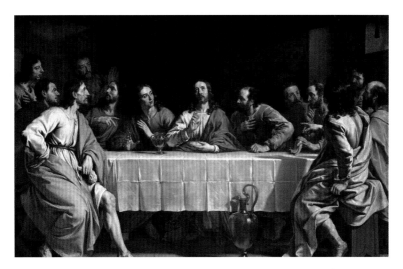

Plate 8.1 Judas seated on the left in yellow in The Last Supper by Philippe de Champaigne, oil on canvas, 1648. © Photo: REX/Shutterstock

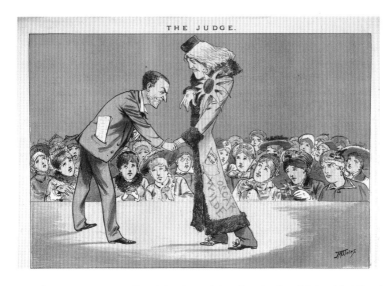

Plate 8.2 Satirical cartoon 'The Meeting of the Cranks,' published in *The Judge* January 1, 1882, New York. The cartoon depicts Oscar Wilde caricatured as an effete aesthete dressed in yellow with a large sunflower in his button hole meeting Charles J Guiteau, who famously pleaded insanity after assassinating President John Garfield. 1882 was the year of Wilde's first lecture tour of America and in June of that year Guiteau's plea was rejected and he was executed. © Photo: Robana/REX/Shutterstock.

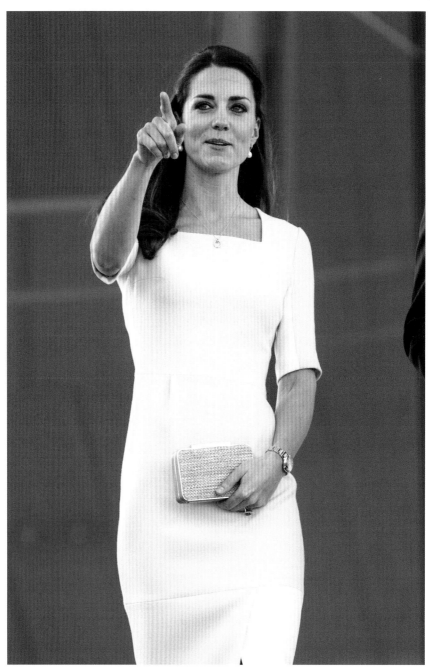

Plate 8.3 Catherine Duchess of Cambridge wearing a yellow dress designed by Roksanda Ilincic on the occasion of her visit to Sydney, Australia, April 16, 2014. © Photo: Tim Rooke/REX/Shutterstock.

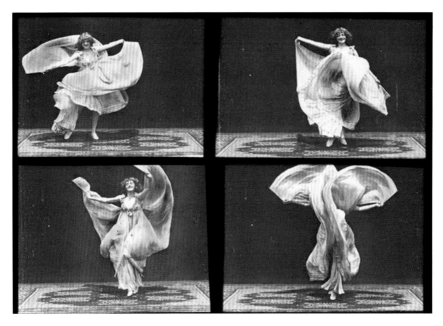

Plate 9.1 Frame shots taken from hand-colored film *Annabelle and Her Serpentine Dance* Dir.: W. K. L. Dickson and William Heise. Edison Mfg. Co, US, 1895.

Plate 9.2 Georges Lepape "Les choses de Paul Poiret," Paris, France, 1911. Musee de la mode et costume. (Photo by Photo12/UIG/Getty Images).

Plate 10.1 "Red Carpet," Viktor & Rolf, Autumn/Winter 2014, Haute Couture Runway Collection, Paris. © Photo: firstVIEW.

Plate 10.2 "Bluescreen (Long Live the Immaterial!)" Viktor & Rolf, Autumn/Winter 2002, Ready-to-Wear Runway Collection, Paris. © Photo: firstVIEW.

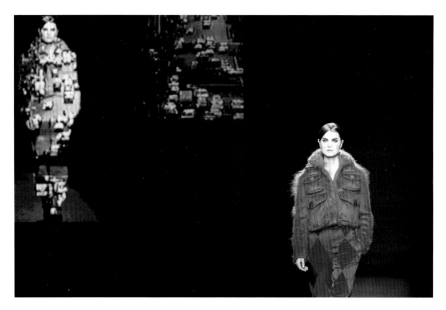

Plate 10.3 "Bluescreen (Long Live the Immaterial!)" Viktor & Rolf, Autumn/Winter 2002, Ready-to-Wear Runway Collection, Paris. © Photo: firstVIEW.

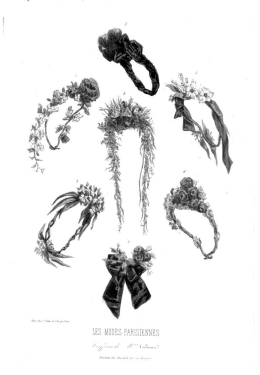

LES MODES PARISIENNES

Plate 11.1a Arsenical wreaths from the Maison Tilmans, Paris, Les Modes Parisiennes, January 24, 1863, Author's collection.

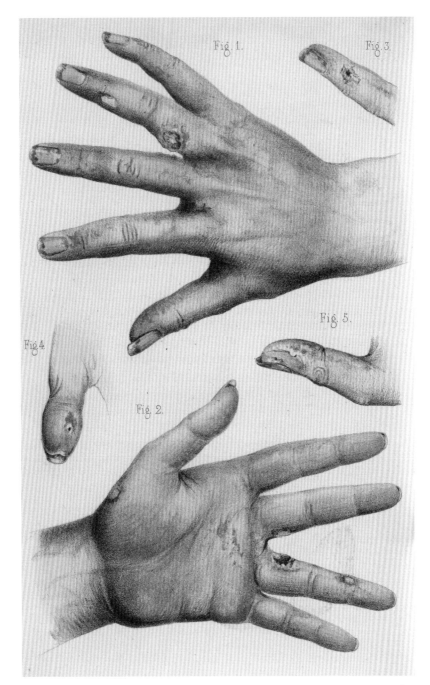

Fig. 1.

Fig. 3.

Fig. 5.

Fig. 4.

Fig. 2.

Plate 11.1b Chromolithograph showing the effect of arsenic used in artificial flower making on professional workers' hands, from Maxime Vernois, 1859. © Wellcome Library, London.

Plate 11.2 Arsenical green silk 3-piece day dress with train and overskirt, c.1868–1870. © Ryerson Fashion Research Collection 2014.07.406 A+B+C, Gift of Suddon-Cleaver Collection. Photo credit: Suzanne Petersen.

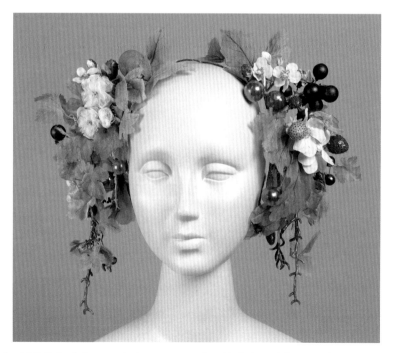

Plate 11.3 Potentially arsenical gauze wreath with fruit and flowers, French, 1850s. Photograph © 2016 Museum of Fine Arts, Boston.

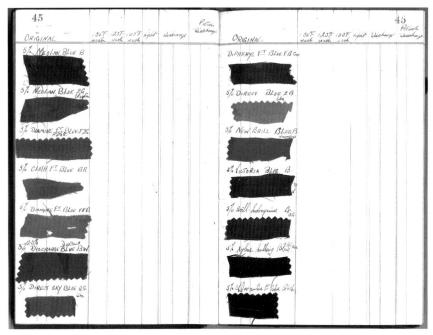

Plate 12.1 Page from F.H. Goodchild's dye book. © Liberty Fabric Ltd.

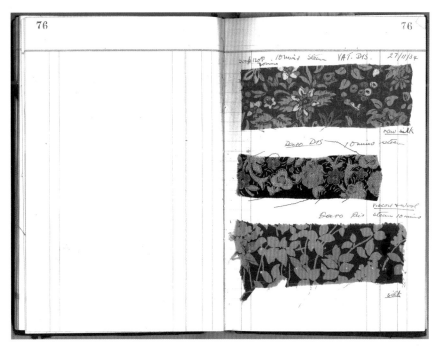

Plate 12.2 Page from F.H. Goodchild's dye book showing Liberty print samples. © Liberty Fabric Ltd.

Plate 12.3 Page from Joyce Clissold's dye book. © Museum and Study Collection, Central St Martins.

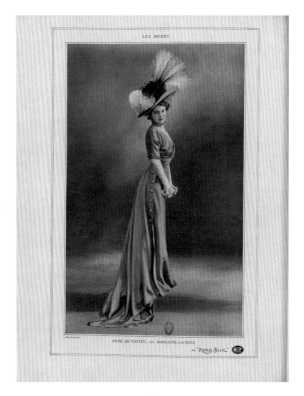

Plate 13.1 Margaine Lacroix, dress in "vert égyptien," Les Modes (Paris), December 1908 facing p33. © Bibliothèque nationale de France.

Plate 13.2 Paul Iribe, evening coats by Paul Poiret, pochoir print, Les Robes de Paul Poiret, racontées par Paul Iribe (Paris: Poiret, 1908) Plate 9. © Getty Research Institute.

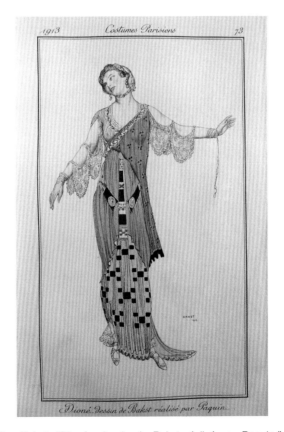

Plate 13.3 Léon Bakst, "Dioné—dessin de Bakst réalisé par Paquin," pochoir print, Journal des dames et des modes (Paris), no34, 1 mai 1913, plate 73. © Bibliothèque nationale de France.

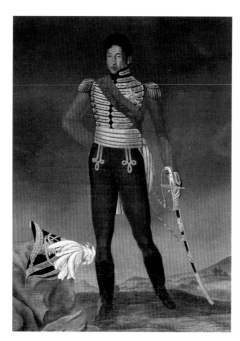

Plate 15.1 Radama I (1793–1828), the first Merina monarch to adopt European dress forms, clothed in a red jacket likely of broadcloth. Oil painting, from life, by Andre Copalle, 1826. Courtesy of the Ministère de la Culture et de l'Artisanat, Antananarivo.

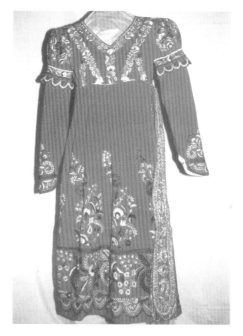

Plate 15.2 A dress having belonged to Queen Rasoaherina (1814–1868), made of red broadcloth and embellished with silk embroidered floral forms and gold braid. Former collections of the Queen's Palace Museum destroyed by fire in 1995. Courtesy of the Ministère de la Culture et de l'Artisanat, Antananarivo.

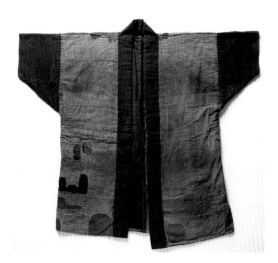

Plate 16.1 Noragi (work coat), early twentieth century. Indigo-dyed cotton. Japanese maker. Collection of the RISD Museum, Elizabeth T. and Dorothy N. Casey Fund 2012.21.1.

Plate 16.2 *in that one moment I can see dust collect on my fingertips,* 2007. Abaca paper, indigo ink (natural indigo, linseed oil). Indigo ink was mulled by hand, applied to zinc plates and printed on an etching press onto handmade abaca paper. Agata Michalowska, Polish. © Agata Michalowska. Photo courtesy of the artist.

Plate 16.3 Travel Coat, 2014 traveller collection. Traditional Miao indigo textile. Dosa, design label. Christina Kim, designer, American. Photo © Christina Kim.

11

TAINTED LOVE: OSCAR WILDE'S TOXIC GREEN CARNATION, QUEERNESS, AND CHROMOPHOBIA

Alison Matthews David

If you would take that hideous green flower out of your coat … I might answer your question differently. If you could forget what you call art, if you could see life at all with a simple, untrammelled vision, if you could be like a man, instead of like nothing at all in heaven or earth except that dyed flower, I might perhaps care for you in the right way. But your mind is artificially coloured: it comes from the dyers. It is a green carnation; and I want a natural blossom to wear in my heart.

Lady Locke refusing Lord Reggie's offer of marriage in Robert Hichens's
The Green Carnation ([1894] 1970: 109)

In Hichens's fin-de-siècle novel satirizing Oscar Wilde, Lord Alfred Douglas, and their decadent lifestyle and entourage, the titular green carnation plays a pivotal, if malevolent, role. Although at first Lady Locke is fascinated, even entranced by young Lord Reginald Hastings or "Reggie," she comes to find him and his flower of choice repulsive. The artificially tinted flower he sports in his buttonhole symbolizes the tainted, artificial nature of his mind and heart. As Hichens writes of Reggie, "He chose his friends partly for their charm, and partly for their bad reputations; and the white flower of a blameless life was much too inartistic to have any attraction for him" ([1894] 1970: 3). Yet the dyed flower proves too much for Lady Locke. The book, which was a great commercial success, ends

with Reggie making a somewhat desultory offer of marriage to Lady Locke, an offer that she refuses, claiming that she wants a more "natural blossom to wear in her heart" (Hichens: 109). Her rejection of Reggie is perhaps not surprising in light of the homoerotic meanings encoded in the green bloom. Although Hitchens, who was homosexual, could not make the green carnation's sexual meanings explicit, the dyed buttonhole flowers visibly displayed "invert" sexuality on a man's lapel. If a white carnation conveyed sentiments of "pure" love, green ones spoke the "love that dare not speak its name."

Literary scholars, like Karl Beckson, have looked at the importance of the green carnation and its potential meanings in homosexual subcultures of the late nineteenth century, but this text seeks to situate it in broader debates and controversies over toxic arsenical greens in the nineteenth century (Gagnier 1986; Kaplan and Stowell 1994; Beckson 2000). Several decades before the distinctive dyed flower appeared on Wilde's evening coat, there had been a moral and medical panic over artificial flowers that had been tinted green with arsenic, a deadly poison (Whorton 2010; David 2015: 72–101).[1] The brilliant emerald green pigment that became a fashionable craze in the early nineteenth century was publicly feared and shunned by the mid-1860s. This text argues that Wilde's green carnation, in the 1890s, should be seen against the backdrop of earlier, scientifically and medically justified fears over poisonous pigments. The link between literally toxic greens and invert sexualities are part of larger debates over sex and sexuality, artistic creativity, commerce, queerness, and color in late nineteenth-century Britain. David Batchelor, in his discussion of color in Western culture, gives this sort of "loathing of color, this fear of corruption through color" a name: "chromophobia." He notes that color is alternately seen as the "property of some 'foreign' body—usually the feminine, the oriental, the primitive, the infantile, the vulgar, the queer or the pathological," or "relegated to the realm of the superficial." He concludes that "Color is dangerous, or it is trivial, or it is both" (2000: 22–23). Using Batchelor's view of color to explore the actual medical and perceived moral dangers of green, this essay examines the complex links between fashion, chromophobia, and homophobia played out in the substance and on the surface of natural and artificial green flowers and foliage.

At a time when Britain's landscapes were mined for coal and ore and its cities blackened by chimneys and smokestacks, green recalled the healthy, verdant colors of unspoiled countryside and flourishing plant life. But as Michel Pastoureau, a French historian who has written on the history and symbolism of blue, black, and green has observed, green has always been ambiguous: it has long been a suspect color, considered "dangerous, corrosive, toxic," a cause of disease and sometimes death (2014: 205). The complex technology and chemistry of green provides some of the explanation for this long-standing suspicion. Medieval guild regulations forbade dyers of blues and blacks from using reds and yellows. These tints were licensed to two different sets of

professional dyers, and it was illegal to possess vats of both blue and yellow dye and to mix them in a combination every modern schoolchild takes for granted (Pastoureau 2014: 112–117). It was possible to produce greens with toxic and corrosive copper mixtures called *verdets*, but most greens looked "washed out" and assumed a greyish or blackish cast in light from oil lamps or candles (Pastoureau 2014: 116). Before the late eighteenth century, green was a difficult color to achieve and was rarely colorfast. A reliable, bright, vivid green simply did not exist.

One green pigment invented during the Industrial Revolution embodies the contradictions between green as a symbol for both verdant plant life and deadly poison. In 1778 chemical experimentation produced an entirely new green pigment. In his laboratory, Carl Wilhelm Scheele, a Swedish Pomeranian experimental chemist, mixed copper with arsenic trioxide to produce a gorgeous but toxic green. Arsenic trioxide, obtained increasingly cheaply as a by-product of smelting metals like tin, cobalt, and copper, was also used to formulate the color. Dubbed Scheele's Green, among other names, the new tint was still fairly pallid, but a more intense shade of the color with a slightly different chemical composition, often called Schweinfurt or emerald green, was invented in 1814 and became commercially available in France and Britain by the late 1820s (Beaugrand 1859: 1).[2] Despite its toxicity, the new pigment had many advantages over previous greens, and delighted consumers ensured that it enjoyed a widespread and fairly unchallenged vogue during the first half of the century, and through the 1860s. It was prolifically slathered over wallpaper, brushed onto artists' canvases, and used to enliven everything from toys to textiles. It tinted fashion plates, gloves, ball gowns, and artificial flowers. To affix it to cloth, dyers mixed it with a binding agent like gelatin or albumen, but even more dangerously it was blended with adhesive starch and dusted over gauze flower leaves, making it liable to flake off and be inhaled as powder (Schutzenberger 1867: 292–296).[3] As a pigment rather than a water-soluble dye, it was technically difficult to apply. Nonetheless, emerald green has left substantial traces in the material record. Scientific tests have revealed its presence in a wide range of consumer goods: it adorned and poisoned the shops, homes, and bodies of men, women, and children across the social spectrum.

Color presented one of the biggest sartorial challenges for middle-class Victorian women, who, as dress historian Charlotte Nicklas has demonstrated, took both an aesthetic and scientific interest in color (2014). How were they to dress both becomingly and appropriately for social events at different times of the day with a limited number of gowns? Lighting technologies, particularly gas lighting, changed the perception of the hues of women's dress, sometimes quite radically. Advice manuals and newspaper columns warn women that the gown that looked one color in daylight could metamorphose, chameleon-like, into a completely different and perhaps unflattering shade at the ball that evening. One

source complains that "colour in gas light is so deceiving" (Fitzmaurice 1896: 626) and an advertisement for a new form of "perfectly white" gaslight uses purity of color as its selling point: "During the dark months a great obstacle has hitherto existed for the selection of garments the colors of which are required to be adapted for daylight;—by ordinary gaslight it is well known that blue appears to be green, and other colours are much affected" (Advertisement 1861: 20). And thus an advantage of emerald green was that it maintained its luminous color in both natural and gas lighting (Draper 1872: 29–30). Period commentators described its almost eerie radiance, noting "brilliant ball-room wreaths" were "green with an unearthly verdure." In artificial flower making, a craft that became a large-scale industry as well as a leisure pursuit for ladies in the nineteenth century, emerald green was the pigment of choice to color stems and leaves like the ones on these artificial hair wreaths (see Plate 11.1a). The "Dryad" model in the center, complete with blue butterfly, presumably transformed its fair wearer into a seductive woodland nymph. With an estimated 15,000 professional flower makers in Paris in 1858 (Beaugrand 1859), and 3,510 in Great Britain, mostly concentrated in London in 1851, this now-lost industry was an important urban trade but one plagued by health hazards (Guy 1863: 138). An amateur flower-making kit, sold by a London establishment in Regent Street, for example, was analyzed by the conservation laboratory of the Victoria and Albert Museum, where their scientists found it to contain arsenic in four of the five spots tested, including the lovely little round boxes holding the parts to fashion paper carnations, violets, and daisies.

By the late 1850s, doctors, forensic chemists, women's societies, politicians, and the media began debating the hazards presented by the increasingly fashionable pigment, and artificial florists and their blooms were at the heart of the debates. In 1856, Parisian workers went to the Préfecture de Police to complain about the chronic poisoning they were suffering from their trade and doctors published horrifically illustrated scientific articles on its medical hazards (Vernois 1859: 319–349) (see Plate 11.1b). The historical link between literary and literal "Flowers of Evil" coalesced in France in the late 1850s, when a collection of poems—Charles Baudelaire's poetry anthology Les Fleurs du Mal (1857)—was causing controversy on the literary stage. Because of the volume's scandalous contents, it was called "an outrage to public morals." Both author and publisher were prosecuted, and six of the poems were banned. Baudelaire's flowers stemmed from a long tradition of writers and poets offering "bouquets" or "anthologies" of poems: each poem was a blossom. The term "anthology" comes from *anthos*, the word for flower in Ancient Greek. After each poem Baudelaire would say that he had "made a new flower" (Syme 2010: 2). Baudelaire's self-described "unhealthy flowers," poems on the subjects of prostitution, murder, and lesbianism, grew out of the cultural soil of artificial flowers fashioned in mid-nineteenth-century Paris, which sickened the men and women who made them.

The criminal and sexual associations of Baudelaire's flowers were taken up by Wilde and others in the 1890s. Before turning to these fin-de-siècle flowers, the rapidly shifting material culture and science of color in the 1850s and 1860s should be mentioned. Wilde's green carnation came in the wake not only of toxic greens but of a panoply of health scares caused by the brilliant rainbow of new aniline dyes tinting consumer goods. Mauve, the first aniline dye, was invented in 1856 and named after the purple mallow flower or mauve in French (Garfield 2000). It was followed by the almost electrically bright purples, magentas, oranges, and reds that flooded the market and went "viral" in a fashionable epidemic satirized as the "Mauve Measles." Garments dyed with the new vivid aniline dyes were incredibly popular with the public, but in the late 1860s some new shades used for men's hosiery had caused striped skin burns to their feet. Dyed shirts worn next to their skin in the late 1860s also raised alarms over the safety of these new colorants, compounding public fears over poisonous colors (David 2015: 102–125). The potential dangers presented by dyes were common knowledge by the 1880s, leading to a fad for supposedly healthy and sanitary undyed woolen underwear and socks, including garments promoted and sold by dress reform advocates like Gustav Jaeger, and advised by doctors like the dermatologist Dr. James Startin (Carr 1883; Startin 1884: 8).[4] Colored clothing's reputation had been compromised. By the late 1870s, as aniline became cheaper to produce and purchase, the Aesthetic Movement spurned "crude" primary colors, on the grounds of taste (and possibly health), in favor of more subtle "artistic" and indeterminate shades like the famous "greenery-yallery" of the Grosvenor Gallery (Matthews 1999: 172–191).[5] By the late nineteenth century, intense, saturated colors were perceived by the artistic elite as repulsive and even terrifying. True Aesthetes preferred the subtle artistic shades painted by James McNeill Whistler and sold by Liberty's of London. One late Victorian commentator bemoaned the stubborn persistence of public taste for bright hues, noting that "agonies in red, livid horrors in green, ghastly lilacs, and monstrous mauves" could still "be found among the repertory of the leaders of fashion" (Ware 1909: 3–4).

Exactly how dangerous was emerald green? While some period sources warned the public that these fashionable poisons presented a potentially deadly risk to home and health, different agendas informed debates at the highest levels of government. When newspapers printed atrocious accounts of the death of nineteen-year-old Matilda Scheurer, an artificial florist in London who died in 1861, the case spurred a Parliamentary Committee report on the "*Alleged*" (my quotation marks) *Fatal Cases of Poisoning by Emerald Green; and on the Poisonous Effects of that Substance as Used in the Arts*. Yet despite this governmental enquiry, the interests of industry won the day: Scheurer's death was ruled "accidental" and the committee decided that proof of "one sole case of death" was not enough to spur regulation (Guy 1863: 125–162).

Since legal means were not enough to ameliorate the flower makers' plight, female activists sought to call attention to it as a question of taste and what we would call ethical consumption. The Ladies' Sanitary Association tried a double-pronged approach: they appealed to the emotions of female consumers by publishing a sickening and heart-wrenching firsthand account of the headaches, bleeding noses, and excoriated fingers of young girls and teenagers making flowers in the *English Woman's Journal* (July 1, 1861: 308–314). They urged their readers to "forego their taste in the purchasing of artificial flower devices, declining the green, and discouraging its adoption in others" (314). Perhaps even more effectively, they turned to the facts and figures furnished by chemical science to scare consumers away from these lethally appealing fashions. They hired Dr. A.W. Hofmann, one of the most famous analytical chemists in the world, to test green hair wreaths and ball gowns for arsenic. He used the same tests developed to detect the presence of arsenic in bodies in criminal poisoning trials.[6] Hofmann published his findings in "The Dance of Death," a sensationally titled letter in the *London Times* (February 1, 1862: 12). The expert concluded that an average headdress alone contained enough arsenic to poison twenty people, and that the "green tarlatanes so much of late in vogue for ball dresses" contained as much as half their weight in arsenic. A ball gown fashioned from twenty yards of this fabric would have nine hundred grains of white arsenic.[7] Four or five grains were lethal for an average adult. These scare tactics, along with *Punch* articles and caricatures like the terrifying "Arsenic Waltz" (Figure 11.1), published only a week after Hoffman's letter, eventually succeeded in making the color feared and unfashionable. While arsenical greens should have been banished by the 1880s, a study by Wilhelm Grandhomme, one of the first on-site doctors in a dye factory, compiled a table of occupational poisonings in the 1880s and concluded that 15 percent of artificial flower workers still suffered from arsenical poisoning (Weyl 1892: 30).[8]

Recent scientific tests performed by molecular biologist Andrew Meharg have confirmed that some historical wallpapers contained arsenic (2005: 66; 2010). Historian Andrew Whorton devotes a chapter of his book on arsenic in Victorian Britain to arsenical dress, but actual historical dress and artificial flowers had not been tested to verify or refute the findings of Victorian chemists and doctors. The Physics Department at Ryerson University in Toronto, Canada, tested a range of shoes, shoeboxes, textiles, and fashion plates for arsenic using X-ray fluorescence spectrometry.[9] Although arsenic has long been used in museum collections as a pesticide, scientific testing of a range of suspiciously green nineteenth-century museum artifacts in Canada and Britain has demonstrated the presence of both copper and arsenic. This combination suggests emerald green pigments, and appeared in a substantial number of green objects dating from about 1815–1865[10] (Plate 11.2). Scientific analysis had confirmed that toxic greens were used to fashion flowers, but why were flowers important to the Victorians and what symbolic meanings did they carry?

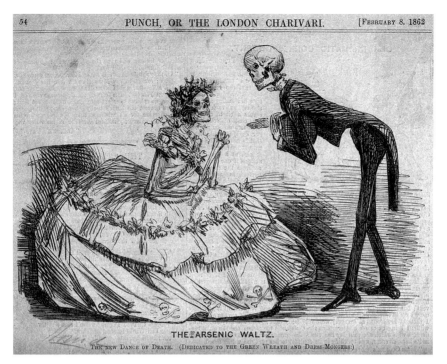

Figure 11.1 "The Arsenic Waltz" or The New Dance of Death (dedicated to the green wreath and dress-mongers), Punch (February 8, 1862). © Wellcome Library, London.

As Art Historian Alison Syme argues in her book *A Touch of Blossom*, flower buds and blooms were erotically charged in Western art and literature. By the mid-nineteenth century, these sometimes graphically sexualized fruits, flowers, and their insect pollinators appear in popular prints, greeting cards, and picture postcards in a range of amusing and suggestive poses. Syme writes that "vegetal arousal came to be associated with Decadents and Aesthetes" and a range of non-reproductive "vices" and pleasures. What was then called "invert" sexuality appeared in descriptions of a boy or man as a "Hyacinth," or "Narcissus." From the 1880s, gay men were called "buttercups," "pansies," and even "horticultural lads" (44, 46). Flowers and fruits were used as slang terms in English and French for male and female body parts, as well as sexual acts and practices, including masturbation and same-sex love. For example, engaging in intercourse with a woman "entailed picking or gathering strawberries, nuts, flowers, and so on" (Syme 2010: 31). These appetizing fruits adorned women's hair in botanical creations like a French hair-wreath festooned with juicy grapes, some of them already plucked and presumably eaten, and equally delicious-looking strawberries (Plate 11.3). Although the wreath has not been tested, the fact that it was produced in the 1850s in Paris suggests that despite the

tantalizing fruit and the sexual invitation it broadcast, its gauze leaves were likely toxic, and doctors noted cases where women wearing green wreaths developed skin rashes and "painful eruptions" around the shoulders where the powder flaked off onto their décolletage (Draper 1872: 31).

While artificial florists cultivated entire cloth gardens to deck women's hats and decorate their hair and dresses, men were strictly forbidden from wearing artificial blooms (Angeloni 2000: 63).[11] One popular newspaper story from the 1890s entitled "A Mad Englishman" revolves around a stylish young English couple in Paris whose money has run out. They devise a scheme to win money. Simply by trimming his masculine top hat with his wife's fashionable red and violet artificial flowers and daring to stroll along the boulevards, Mr. Cecil Berkely De La Hoope wins a thousand louis bet with the men from his private club (*Pick-Me-Up*, March 23, 1895: 394). As this mainstream story suggests, men wearing "feminine" artificial flowers were diagnosed as perverse or insane. Doctors, sexologists, and even François Carlier, the head of the Parisian vice squad, made supposedly "scientific" associations between "invert" sexuality and a preference for artificial flowers. Carlier claimed that "pederasts" were "drawn to trades like floristry, and they liked to dress as women and deck themselves with 'artificial flowers, chaplets, and garlands' on special occasions" (Carlier in Syme 2010: 243 n.4). In 1884, Rachilde, the pen name of writer Margeurite Vallette-Eymery, makes Jacques Silvert, a "sexually ambiguous" male artificial flower maker, the object of her aggressive female heroine's lust in the novel *Monsieur Venus* (Rachilde [1884] 2004; Syme 2010: 243). Her contemporary, the author Joris-Karl Huysmans' famous decadent dandy Des Esseintes, prefers artificial blooms that look real and real hothouse flowers that look fake. He revels in his new tropical plants created by the gardener's skill and exclaims "without a shadow of a doubt, the horticulturists are the only true artists left to us nowadays" (Huysmans [1884] 2003: 88).

> A really well-made buttonhole is the only link between Art and Nature.
>
> Oscar Wilde, "Phrases and Philosophies for the
> Use of the Young" (Bauer 1997: 75)

Like Des Esseintes, who admires the art of cultivated flowers, Wilde describes an artful floral accessory that he cultivated daily as part of his dandified dress. The boutonnière or its English translation buttonhole was, and still is, a fashionable and often expensive flower or bouquet inserted through a hole in jacket lapels (Chenoune 1993: 102–112). Even bare of floral adornment, buttons and the holes cut for them had suggestive potential, and displaying and unbuttoning these little objects was often erotic and eroticized in an age before zippers. In the exhibition *Déboutonner la mode* (from February 10 to July 19, 2015), the Musée des Arts Décoratifs displayed flirtatious "rebus" buttons of the late eighteenth century.

These large mother-of-pearl buttons were carved with word puzzles to decipher; for example, one is inscribed "GCD à son amour" (J'ai cédé à son amour) or "I yielded to his/her love" (Belloir 2015).[12] The French makes the gender of the lover indeterminate. In addition to the multitude of buttons that fastened waistcoats, suit jackets, and breeches, flower motifs were popular for men's formal dress in the Ancien Régime.

During the nineteenth century, male flowers were banished to the buttonhole. The thick reinforced woolen broadcloth of suits allowed tailors to deliberately cut and hand-stitch this design feature into the lapels of most fine men's suits. The male chest became a surface to publicly display awards and honors, but it also sprouted specially prepared flowers, sometimes with their own little silver vase. In principle a man bought his own buttonhole, but it could also be romantic gift from his ladylove. Yet the type of blooms inserted into this empty sartorial "slash," as George Bauer, a scholar of homosexuality in French literature, calls it, and the gesture of penetrating it with a floral decoration could be blatantly homoerotic (1997: 64–82). In Marcel Proust's novel *À la recherche du temps perdu (In Search of Lost Time)*, one character "seductively slips his posy into his future lover's hole," and "… taking the flowers from his buttonhole, he put them into mine with one hand, whilst he slipped his left arm round my waist and clasped me tightly, pressing me against my whole body for a few seconds" (Proust 1913 in Syme 2010: 50–51).

> As gay figures begin to emerge in nineteenth-century French literature, they are nosegays whose bouquets are perfumed and dandy floral offerings that flirt with a certain language of criminality and real and artificial flowers.
>
> George Bauer, "Gay Incipit: Botanical Connections,
> Nosegays, and Bouquets," p.65

In light of these invert floral associations, we may interpret Wilde's green carnation as an intentionally provocative sexual in-joke and a deliberate, artificially dyed "perversion" of the natural blooms worn by heterosexual men. The fragrant carnation had one set of meanings in mainstream Victorian society and radically different connotations in nineteenth-century gay subcultures. White carnations expressed pure love, and are still the buttonhole of choice for weddings (Foulkes in Angeloni 2000: 35). By contrast, in French culture, Wilde's carnation, or *oeillet* ("little eye") in French, was slang for anus. Its suggestively wrinkled folds, fragrant perfume, and jagged petals inspired several homoerotic poems. Henri Cantel, a now little-known admirer of Baudelaire, concluded his 1860 poem *Éphèbe* with these lines:

> My bottom can without shame or jealous remorse,
> Open itself to your phallus, like a carnation that opens …
> –Beautiful marble, adieu! Return to your cushion in the Louvre!

The author spurns the cold, carved marble hermaphrodite in the Louvre museum, longing instead for a young man whose floral "buttocks smell like the lily, and the bashfulness of the morning rose." The poet longs to penetrate his lover and caress the ephebe's "nubile garden" and the ephebe is invited to open the poet's own "carnation" in return as the culmination of these floral pleasures (Cantel 1860).[13]

More famously, only two years later, lovers Paul Verlaine and Arthur Rimbaud co-wrote a *Sonnet au trou de cul or Asshole Sonnet*.[14] It was written as a parody of a collection of sonnets written by poet Albert Mérat about the beauties of his mistress' individual body parts but Verlaine and Rimbaud wanted to "remedy" Mérat's one omission—the anus. The first verse reads:

> Crumpled like a carnation, mauve and dim
> It breathes, cowering humbly in the moss
> Still wet with love which trickles down across
> The soft slope of white buttocks to its rim.[15]

The fashion historian cannot help but read *oeillet* as a sartorial double-entendre. In English an *oeillet* can also be another small eye or "eyelet," a tiny hole made in linen underclothes, shirts, and garments, reinforced by a thread.[16] The poets' word for "rim" is another technical sewing term: the *ourlet* is a garment's stitched hem.

Like the colored bandannas that can communicate sexual preferences in LGBTQ culture today, specific colors of accessories in the male wardrobe seem to have been used for over a century as visual codes for "invert" sexuality. These supposedly included the green cravats "worn by a band of pederasts at Paris" according to sexologist Havelock Ellis (1942: 299–300).[17] Ellis stressed that "inverts exhibit a preference for green garments." What follows will discuss how the combination of the color green and carnations as potent signifiers in their own right was received in the popular press.

> too often, it is… that part of the garment which first gives signs of mortality.
> "Button-hole Devotion," *Leeds Mercury*, April 19, 1890

Although two years after its debut in 1892, Oscar Wilde takes sole credit for inventing "that magnificent flower", the green carnation had been on display in florists' windows in Paris for at least a month before its opening night in Wilde's lapel. It seems to have made its first appearance on the playwright's person at the premiere of *Lady Windermere's* Fan (Wilde, October 2, 1894: 3). The *Glasgow Herald's* "Notes on Dress in France" announced a month before the play that the "blue carnation," from Paris, "has been dubbed chic … [and] looks blue in some lights, green in others; so persons buying the novel blossom

can, according to taste, call it blue or green" (January 20, 1892: 9).[18] Wilde accessorized it with a scandalously lit cigarette at curtain call on February 22, 1892. It reappeared on Wilde, who was accompanied by "a suite of young gentlemen all wearing the vivid dyed carnation which has superseded the lily and the sunflower" (Beckson 1987: 83–84). The novel artificially tinted flower began to attract a range of mostly negative and sometimes disproportionately vitriolic commentary. The *Pall Mall Gazette* denounced it as a "freak," a "hybrid produced by over-culture out of the creamy white carnation that was indeed one of the loveliest of midsummer garden flowers" (*Pall Mall Gazette* February 25, 1892: 1). Perhaps this was even more of a travesty because the carnation is also a luxurious and elegant bloom: carnations, which survive well without water, were at the top of the boutonnière hierarchy, and cost the same as rare orchids.[19]

Other journalists added their thoughts to the debate: *The County Gentleman* calls the green carnation "inartistic," "ghastly," an "atrocity," and warns that "it is crude enough to set one's teeth on edge and affect the observer, let alone the wearer, with cholera morbus at the very least." It then recommends two West-End florists' shops where the blooms can be seen and, tongue-in-cheek, advises its readers that if they are "taken seriously ill after having seen this poor, degraded flower, that there are several restaurants handy wherein you can purchase restoratives" (*The County Gentleman* March 5, 1892: 298). Scents and scented flowers were historically believed to ward and fend off illness, not to spread it. Wilde's choice of lapel ornament challenged sentimental and nostalgic fantasies about England's rural beauties as appropriate for the buttonhole. One poet waxed romantic about green hillsides and birdsong evoked by the "faint and fleeting" perfume of a spray of lilies of the valley that he has pinned to his coat. The smell of his "dear heart's" gift takes him from the "city gutters, gusts, and grimes/to lowland fields and fences" and functions much like the prophylactic scent of a Medieval or Renaissance pomander (Luders 1889: 9).

Other articles indignantly call it an "ill-used and utterly destroyed specimen," a "spoiled white carnation," a "green and sickly flower," an "abomination," a "villainous vogue spread from Paris salon to London drawing-room," and a "hideous button-hole anomaly" (*The Preston Guardian* March 5, 1892: 7; *The Hampshire Advertiser* March 9, 1892: 3; *County Gentleman* March 12, 1892: 334). Less judgmental gardening and natural history magazines tried to explain the mystery of the green flower's origins and the science behind its color: several claimed that the green carnation was discovered by an anonymous Parisian artificial flower worker, who dipped a real bloom into her coloring solution, observing that the green dye spread up the stem and into the flower. The result was a white flower veined and spotted with green from "tetrae" or "malachite green" dye, or violet produced with methyl-violet, aniline dyes that "last a

very long time, and are not injurious to the health of any person using it" (*The Gardener's Chronicle* March 5, 1892: 302).[20] Nevertheless, many still saw the ghost of arsenic in its vivid green hue.

In feminist author Violet Hunt's "Green Carnation," a short story published soon after Wilde's premiere, the perplexed heroine Isabel asks her young male friend at a dance, "What's that green thing in your button-hole?" Billy nonchalantly replies: "Oh, haven't you seen them? A green carnation. Newest thing out. They water them with arsenic, you know, and it turns them green." Isabel wants it but Billy refuses to part with his "gage d'amour" or "pledge of love" from an older gentleman called Dacre (*Black and White* March 12, 1892: 350–351; Beckson 2000: 389).[21] Even though Dacre turns his attentions to Isabel, this love story is ambiguous at best. Two years later, Hichens' Wilde figure, Mr. Esmé Amarinth, is reputed to have come up with the idea for the green carnation, calling it "… the arsenic flower of an exquisite life. He wore it, in the first instance, because it blended so well with the color of absinthe. Lord Reggie and he are great friends. They are quite inseparable" (Hichens [1894] 1970: 11; Beckson 2000: 392).[22] These references to arsenic, which was never used to tint natural flowers, in the same paragraph as allusions to Esmé and Reggie's inseparability conflate toxicity, queerness, and "tainted" love.[23] The paragraph also mentions another toxic green associated with literary and artistic creativity in Baudelairean and Wildean circles. Bitter wormwood root was used to make absinthe, the pale green alcohol known as "La Fée Verte" (Delahaye 2000; Adams 2004).

By the time Oscar Wilde was sentenced to two years hard labor for sodomy in 1895, fashion and taste had condemned green as both a literally and sexually tainted color. Chromophobia reared its fearful head and incriminated both arsenical hair wreaths tinted to resemble real plants and the artificially dyed natural flower that Wilde wore in his lapel. Yet the outcomes of these medical and moral panics illustrate larger structural inequalities. The famous writer was brought to trial and put under lock and key for his sexual preferences, based in part on evidence supposedly supplied by his sartorial eccentricities, including his carnation's "villainous vogue." His imprisonment led to a decline in his health and contributed to his death. By contrast, industrialists like Monsieur Bergeron, who owned the London workshop where Matilda Scheurer toiled with toxic emerald green until her early death at the age of nineteen, were never condemned, much less imprisoned for forcing their workers to use a deadly poison. As these two different moments in the history of fashionable green flowers suggest, criminal negligence causing death and the criminalization of same-sex love were not given equal social or legal importance. While it was acceptable to taint artificial flowers adorning the bodies of women in the name of fashion, Wilde's love for his own sex, a love he communicated through flowers, was a seemingly unforgivable crime.

Notes

1 Whorton's excellent book gives a full account of the history and importance of arsenic in Victorian Britain, see also chapter 3 of my book *Fashion Victims*: 72–101 and chapter 4 "Dangerous Dyes: A pretty, deadly rainbow" on aniline dyes: 102–125.

2 Copper acetoarsenite was discovered in Schweinfurt, Germany by Rulz and Sattler, a paint manufacturer.

3 It was almost certainly applied differently to silk than to cotton, almost as a "tint" bound to the cloth with gelatin or albumen, but an 1867 manual suggests the use of some of the elements found in samples in the dyeing process, including potassium and sulfur.

4 Carr's text was popular text and published in three editions. See also the Healthy Dress Exhibition of 1884.

5 In an earlier article I discuss color and "physiological aesthetics" in more detail (Matthews, 1999).

6 The Marsh test was developed by James Marsh in 1836. Technical treatises suggest that the textile industry had access to sophisticated chemical testing as early as the 1840s in the form of Strasbourg chemistry professor Persoz, and were not concerned when burning fabrics with copper and arsenic revealed the presence of a telltale black spot on a mirror (1846: 152–154, 537).

7 A grain, based on the weight of a wheat grain, is equivalent to 64.8 milligrams or 1/7,000th of a pound. Hofmann's letter reprinted a week later as "Arsenical Pigments in Common Life," (1862) Chemical News 8 February: 75).

8 Grandhomme in Weyl (1892): 30.

9 Professor Ana Pejović-Milić and Eric Da Silva, Assistant Professor of Physics and an expert, kindly opened their state of the art analytical facilities to me and scientifically tested a wide range of objects. The science of detecting arsenic is complicated by an overlap between arsenic and lead in XRF (X-ray fluorescence) spectra, and sophisticated numerical and statistical analyses are required to distinguish arsenic from lead, another common toxin and contaminator of pigments. Further and ongoing research suggests the possibility that arsenic may become removed over time, diminishing the quantity of arsenic we can detect in Victorian artifacts today. This can happen even at room temperature, and may enter the air we breathe. At Ryerson the artifacts were analyzed using an S2 PicoFox (Bruker-AXS, Madison, WI, USA) with monochromatic Mo K radiation and SDD detection. The analysis was performed by Eric Da Silva, who also helped me detect lead in Victorian face powder and contemporary lipsticks, mercury in fur felt hats, and even to check whether a 'Radium' hospital blanket from the 1920s might still be radioactive. See Da Silva, E., Matthews David, A. and Pejović-Milić, A. "The quantification of total lead in lipstick specimens by total reflection X-ray fluorescence spectrometry," *X-ray Spectrometry* 44 (2015), pp. 451–457. I am extremely grateful to my colleagues at Ryerson for these detailed analyses that were invaluable for the Bata Shoe Museum Exhibition and my *Fashion Victims* book.

10 Not every green object was arsenical, but the poison showed up in much more minute quantities in green-tinted Victorian fashion plates I purchased on e-Bay,

several shoes and shoe boxes from the Bata Shoe Museum, the artificial flower kit in the Victoria and Albert Museum, a child's cotton dress at the Museum of London, a printed cotton dress at the Royal Ontario Museum, and two 1860s silk gowns, one from a private collector in Australia and the second from the Ryerson Fashion Research Collection. I wish to thank these Museums and their conservators for testing their objects to assist with this research.

11 A contemporary book states that "there is one major caveat that bears mentioning: artificial flowers, no matter how realistic, should never be worn in place of a living bloom" (Angeloni 2000: 63).

12 This 1780s button is but one of the many sexualized rebus buttons in the collection, see: http://www.lesartsdecoratifs.fr/IMG/pdf/depliant_boutons_1201.pdf (accessed November 10, 2015).

13

Ma fesse peut sans honte et sans remords jaloux
S'ouvrir à ton phallus, comme un oeillet qui s'ouvre …
– Beau marbre, adieu! retourne a ton cousin du Louvre!
<div align="right">From "Éphebe," in Amours et Priapées, (1860).</div>

14

Obscur et froncé comme un œillet violet
Il respire, humblement tapi parmi la mousse
Humide encor d'amour qui suit la fuite douce
Des Fesses blanches jusqu'au cœur de son ourlet.

15 Verlaine, ed. Eliot, pp.128–129, cited in Bauer, p.75.

16 OEILLET. s. m. Petit trou entouré de fil, de soie, etc., qu'on fait à du linge, à des habits, pour passer un lacet, une aiguillette, un cordon, etc. Faire un oeillet. Faire des oeillets à un corset, à des brodequins. Dictionnaire de l'Académie française, 6th Edition (1835) consulted on Artfl Dictionnaires d'autrefois, https://artfl-project.uchicago.edu/content/dictionnaires-dautrefois, (accessed November 8, 2015). See also Bauer, p. 75.

17 Ellis's volume *Sexual Inversion* was first published in 1897, and these quotes are taken from the 3rd edition (1924).

18 In 1880, a Paris Fashions column in a Scottish journal advertised the debut of a "peculiar" new green dress fabric for blondes in "carnation stalk" green but the actual green-dyed carnation did not appear on the scene until over a decade later. "Paris Fashions," *Aberdeen Weekly Journal* 7911, 24 June 24: 2.

19 Several articles discuss the carnation's cost, and the *Pall Mall Gazette* notes that a simple buttonhole cost sixpence, while a small orchid or carnation was thrice the price at eighteen-pence. "The Shops and the Fashions," (1892), 25 February 25: 1.

20 This article also remarks that "The Parisian press hints that the traditional bridal orange-flowers can now be obtained of a delicate violet, suitable for ladies entering for a second time into the holy estate of matrimony." If white signaled the bride's virginity, dyed flowers broadcast sexual knowledge.

21 Hunt knew and admired Wilde.

22 Amarinth is a play on the legendary unfading or unwilting flower called the Amaranth (Beckson 2000: 392). Victorians believed that in small quantities, arsenic could impart physical vigour, like the legendary Arsenic-eaters of Styria. It also preserves dead flesh and was extensively used in Victorian taxidermy.

23 For contemporary debates over queerness and toxicity, see Mel Chen's excellent book *Animacies*: *Biopolitics, Racial Mattering, and Queer Affect* (Durham: Duke University Press, 2012).

References

Adams, J. (2004), *Hideous Absinthe: A History of the Devil in a Bottle*, London: I.B. Tauris.

Advertisement (1861), *Art Journal 271*, January:20.

"A Mad Englishman," (1895), *Pick-Me-Up* 338, 23 March:394

Angeloni, U. (2000), *The Boutonniere: Style in One's Lapel*, New York: Universe Publishing.

"Artificial Colouring for Real Flowers," (1892), *The Gardener's Chronicle*, 5 March:302.

Bauer, G. (1997), "Gay Incipit: Botanical Connections, Nosegays, and Bouquets," in Dominique Fisher and Larence Schehr (eds), *Articulations of Difference: Gender Studies and Writing in French*, 64–82, Stanford, CA: Stanford University Press.

Batchelor, D. (2000), *Chromophobia*, London: Reaktion Books.

Beaugrand, É. (1859), *Des différentes sortes d'accidents causés par les verts arsénicaux employés dans l'industrie, et en particulier les ouvriers fleuristes*, Paris: Henri Plon.

Beckson, K. (1987), *Arthur Symons: A Life*, Oxford: Clarendon Press.

Beckson, K. (2000), "Oscar Wilde and the Green Carnation," *English Literature in Transition, 1880–1920* 43 (4):387–97.

Belloir, V. (2015), *Déboutonner la mode*, Paris: Musée des Arts Décoratifs.

Cantel, H. (1860), *Amours et priapées, sonnets par Henri Cantel*, Bruxelles: Lomapasque.

Carr, H. (1883), *Our Domestic Poisons or, the Poisonous Effects of Certain Dyes and Colors Used in Domestic Fabrics*, 3rd edn, London: William Ridgway.

Chenoune, F. (1993), *Des modes et des hommes*, Paris: Flammarion.

David, A. M. (2015), *Fashion Victims: The Dangers of Dress Past and Present*, London: Bloomsbury.

Delahaye, M.-C. (2000) *L'Absinthe, muse des poètes*, Auvers-sur-Oise: Musée de l'Absinthe.

Draper, F. (1872), "Evil Effects of the Use of Arsenic in Green Colors," *Chemical News*, 19 July:29–30.

Ellis, H. (1942), *Studies in the Psychology of Sex*, Vol. 1, Part 4, New York: Random House.

"Emerald Green," (1861), *The English Woman's Journal* 41 (7), 1 July:308–14.

Fitzmaurice, B. (1896), "Art of the Needle," *Hearth and Home* (277), 3 September:626.

Gagnier, R. (1986), *Idylls of the Marketplace: Oscar Wilde and the Victorian Public*, Stanford, CA: Stanford University Press.

Garfield, S. (2000), *Mauve*, London: Faber and Faber.

Guy, W. (1863), "Dr. Guy's Report on Alleged Fatal Cases of Arsenic Poisoning by Emerald Green; and on the Poisonous Effects of that Substance as Used in the Arts," *House of Commons Parliamentary Papers Online*, Public Health. Fifth Report of the Medical Officer of the Privy Council, (161):138.

Hichens, R. ([1894] 1970), *The Green Carnation*, New York: Dover.

Hoffmann, W. (1862), "The Dance of Death," *London Times*, 1 February:12.

Hunt, V. (1892), "The Green Carnation," *Black and White*, 12 March:350–1.

Huysmans, J. K. ([1884] 2003), *Against Nature (À Rebours)*, London: Penguin Books.

Kaplan, J. and S. Stowell (1994), *Theatre and Fashion: Oscar Wilde to the Suffragettes*, Cambridge: Cambridge University Press.

Luders, C. H. (1889), "A Boutonniere," *Hampshire Telegraph and Sussex Chronicle* 5648: 14 September:9.

"The Man About Town," (1892), *The County Gentleman: Sporting Gazette, Agricultural Journal* 1556, 5 March:298.

Matthews, A. (1999), "Aestheticism's True Colors: The Politics of Pigment in Victorian Art, Criticism, and Fashion," in T. Schaffer and K. A. Psomiades (eds), *Women in British Aestheticism*, 172–91, Charlottesville: University of Virginia Press.

Meharg, A. (2005), *Venomous Earth: How Arsenic Caused the World's Worst Mass Poisoning*, New York: Macmillan.

Meharg, A. "Killer Wallpaper," reprinted in Popular Science (June 21, 2010), Available from: http://popsciencebooks.blogspot.co.uk/search?q=killer%20wallpaper%27 (accessed July 10, 2013).

Nicklas, C. (2014), "One Essential Thing to Learn Is Color: Harmony, Science and Color Theory in Mid Nineteenth-Century Fashion Advice," *Journal of Design History* 27 (3):1–19. doi:10.1093/djh/ept030.

"Notes by the Way" (1892), *The Hampshire Advertiser* 4773, 9 March:3.

"Notes on Dress in France," (1892), *Glasgow Herald* 17, 20 January:9.

"Our Ladies' Column," (1892), *The Preston Guardian* 4111, 5 March:7.

Pastoureau, M. (2014), *Green: The History of a Color*, Princeton, NJ: Princeton University Press.

Persoz, J. (1846), *Traité théorique et pratique de l'impression des tissus, tome 3*, Paris: V. Masson.

Rachilde, ([1884] 2004), *Monsieur Vénus*, A Materialist Novel trans. Melanie Hawthorne, New York: Modern Language Association.

Schutzenberger, M. P. (1867), *Traité des matières colorantes comprenant leur applications à la teinture et à l'impression*, Paris: Victor Masson.

"The Shops and the Fashions," (1892), *Pall Mall Gazette* 8403 25 February (25):1.

Startin, J. (1884), "Aniline Dyes," *London Times*, 17 September:8.

Syme, A. (2010), *A Touch of Blossom: John Singer Sargent and The Queer Flora of Fin-de-siècle Art*, University Park: Pennsylvania State University Press.

Vernois, M. (1859), "Mémoire sur les accidents produits par l'emploi des verts arsenicaux chez les ouvriers fleuristes en général, et chez les apprêteurs d'étoffes pour fleurs artificielles en particulier," *Annales d'hygiène publique et de médecine légale, 2ème série, tome* 12:319–49.

Ware, J. R. (1909), *A Dictionary of Victorian Slang*, London: Routledge.

Weyl, T. (1892), *The Coal-Tar Colors:With Especial Reference to their Injurious Qualities and the Restriction of their Use*, Philadelphia, PA: P. Blakiston.

Whorton, J. (2010), *The Arsenic Century: How Victorian Britain was Poisoned at Home, Work and Play*, Oxford: Oxford University Press.

Wilde, O. (1894), "The Green Carnation," *Pall Mall Gazette* 9212, 2 October:3.

12

STARLIT SKIES BLUE VERSUS DURINDONE BLUE

Anna Buruma

There are three small books dealing with dyes at both my places of work. One is an insignificant looking exercise book with notes and processes of dyes in the Liberty textile archive, the other two are index books with mainly dye recipes at Central Saint Martins Museum & Study Collection (referred to as CSM museum from now on).[1] The books are from the same period, the 1930s, but they are from two very different London firms, Liberty & Co. Ltd.[2] (referred to as Liberty from now on) and Footprints. These books are invaluable for the textile historian as they give an insight into the practical side of the printing business at this time, both for the artisan textile printer and for more commercial operations. They show us the kind of dyestuffs that were used at a time when new products and processes were still being discovered.

Liberty has an extensive textile archive, which has always been used as a resource for the business. When I started, the archive was spread out in piles all over a warehouse, having been moved there some twenty years before from Liberty's printworks. Today most of the material has been sorted and is on a database. Central Saint Martins has had a registered museum attached to the college since the 1980s. It is an eclectic collection, which includes teaching material purchased at the end of the nineteenth century up to the 1920s, such as medieval manuscripts, nineteenth-century textile samples, and Japanese prints, as well as the work of past teachers and students.

Liberty had been established for over fifty years by the 1930s, both as an influential department store and as a fabric printing business. From their earliest beginnings in 1875 as an oriental emporium with fabrics and artifacts from Japan, China, India, and Persia, it was known as a shop for people of taste. Articles in the press praised the quality and coloring of the fabrics they sold, as in *The Gentlewoman* where the writer goes into ecstasies over the merchandise: "how daintily are the delicate-hued draperies disposed; how symphonically the

tones seem to melt into each other."[3] As Liberty became more successful, they went on to commission various printers in Britain to provide textiles to sell in their shop. One of the printworks involved was a silk printing business owned by the Littler family in Merton in southwest London, which specialized in block printing. By the late 1890s Liberty had become their main source of income and it was mutually decided that Liberty should take over the lease of the works in 1904. They owned the Merton Abbey Printworks until it was sold in 1972.

The majority of material at Liberty's present archives originates from this printworks. The archive contains the paper print impressions, which are the tests made before the printing blocks go near the cloth. During various periods Liberty would print for other firms as well, therefore these impressions give a wonderful snapshot of a particular aspect of twentieth-century design history. In the archive there are also a large number of pattern books, textiles, and artwork, as well as some of the surviving printing blocks. Liberty was never very interested in keeping the written records to go with all this material, wanting it solely for the designs, so this little book, recording the dyes they used, is a rare survivor. It belonged to F.H. Goodchild of Witham in Essex, who was working as a chemist at the Merton Abbey Printworks. Inside the cover of Goodchild's exercise book are written, in black ink, his name and address as well as the date, September 1929, and written in blue below, 1930–1937. It is clear from a later page that Goodchild was employed by Liberty between those later dates.[4]

Normally a printworks will have expertise in a particular fabric and/or class of dyestuff, and test printing will be ongoing, but at the same time there will be research into improving practices as well as trialing new products. This explains the need for the chemist Goodchild's attachment to the works. Liberty was starting to experiment with screen printing in the early 1930s and apart from their silks, they were now also printing at Merton on other fabrics. The directors' minutes of January 1933 mention that a new range of Special Merton Printed designs on silk, cotton, wool, and mixed fibers should be prepared for the purpose of offering to the making-up trades.[5]

The book opens with various chemistry tests followed by dye recipes and tests done for Liberty. It is highly organized and has dyed samples with notes on the dyes that were used, on discharge pastes and other dye related experiments.

Goodchild was obviously asked to look at colors for block printing, but also for screen printing. As would be expected of all good works chemists, he built up his own reference files of colors and methods used (Storey 1978: 99). His dyestuffs came from various manufacturers and there are a number of pages in the book with tiny identically sized color samples tested for light and washing and for discharge with columns beside each sample showing numbers from "1" for excellent to "6" for very poor. Goodchild seemed to have given up on this method early on, as despite the many pages of samples, the columns next to them stop being filled in after the first few pages. This section is particularly

interesting because we are given the manufacturers' names alongside the dyes that are used for these tests; therefore, we see firms mentioned such as Clayton Aniline Company for Neolan Blue, also L.B. Holliday and Sons Ltd. for a fast jasmine, Ciba for chlorantine yellow, Geigy for metanile yellow and chrome citronine, Sandoz for solar red brown, and the British Dyestuffs Corporation Ltd. for auramine (Plate 12.1).

Later in the book there are color strips of various vat dyes for printing, such as BASF's Indanthrene, Geigy's Tinon and Scottish Dyes' Durindone colors, annotated with Goodchild's comments. Here, there is an extra emphasis on the discharge printing technique and many recipes are given for thickening pastes to go with different classes of dyes. Discharge printing is a method by which a block produces a pattern with a paste that will extract the dye, thus creating a pale pattern on a darker colored textile (Plate 12.2). The same block can be used to subsequently color in the pale pattern or a color can be used in combination with the discharge paste to create other color effects. Many of Liberty's textiles were produced in this manner, which resulted in the intensely colored prints, which were characteristic of the period.

Throughout the book, comments and notes on vat dyes surpass all the other classes of dyes. A vat dye is one of the most colorfast, both to light and to washing. Indigo is a typical example of a vat dye. The name is derived from the vats used in the process of reduction of indigo plants through fermentation. These dyes were used traditionally for cottons, but could be used for other fibers and Goodchild does many tests using the vat dyes on silks. Rayon fabrics dye in the same way as cotton and there are notes for using vat dyes on this base as well.

In the Liberty archive there are two pattern books bearing the inscription "Special Merton Prints."[6] All the samples have been block printed, but there are a large variety of techniques on display. There are brocades woven in a Liberty pattern with another design printed onto them; there are printed jacquard woven silks, samples using the devoré technique (where a blended fabric, such as a silk velvet on a cotton base, has a chemical paste applied, which "burns-out" the silk to create a pattern), warp-printed samples, and straightforward block prints. These fabrics appear on many surviving garments in museums, which reflect their special nature, their importance, and their cost. The fabrics show the printing skill involved, but also the expertise in the color management and the quality of the various dyes and pastes used, which must be partly due to a works chemist such as F.H. Goodchild.

Footprints was established in Hammersmith in 1925 by Celandine Kennington, the wife of the artist Eric Kennington, in order to provide space and work for young recently graduated artists to design and print textiles (Clark 1994: 82). These would be sold through Modern Textiles, the small shop opened by Elspeth Little in Beauchamp Place. Gwen Pike, who had trained at the Birmingham

School of Art, ran Footprints. Little had trained at Central School of Arts and Crafts (later Central School of Art and Design, today Central Saint Martins)[7] and the Slade. She had met Gwen Pike while working at Grace Lovat Fraser's theater workshop Fraser, Trelevan, and Wilkinson in Fitzroy Street. Modern Textiles was one of several galleries and outlets that were set up in London during the interwar years to sell handcrafted products (Roscoe 1987: 147). Elspeth Little had been encouraged in her venture by the painter Paul Nash and he designed and painted her shop signboard. Modern Textiles sold not only Footprints fabrics, but also pots by Norah Braden, Bernard Leach, and Sybil Finnemore, textiles by Marion Dorn, Barron & Larcher and Enid Marx, as well as the work of Nash's students at the Royal College of Art.

Footprints was mainly staffed by young art students. The printing method used was block printing, but rather than using wood blocks, the majority of the designs were cut in linoleum (commonly known as lino), which was then attached to wood to give the blocks the solidity they needed. Whereas woodblocks are more durable, the advantage of lino is that it is lighter in weight and easier to cut than wood. Footprints were printing the work of various students and artists including that of Doris Carter, Margaret Stansfield, Doris Scull, the "Dazzle Camouflage" painter Norman Wilkinson, and Paul Nash. Sadly, Nash would eventually take his designs to the firm G.P. & J. Baker when Footprints failed to print to his exacting standards.

One of the art students working at Footprints was Joyce Clissold. She was a student at Central School of Arts and Crafts between 1924 and 1927. The school was then a relatively small art college that the London County Council had set up in order to further the development in design and workmanship of British handicrafts and industries. Departments included silversmithing, textiles, stained glass, furniture, dress design, architectural decoration, and book production.[8] This last department taught the designing and making of beautiful books, including bookbinding, leather tooling, wood engraving, typesetting, and printing. As well as studying textile design, Clissold also followed Noel Rooke's inspirational wood engraving classes in this department. These lessons would prove to be highly influential and stand her in good stead for her later work at Footprints (Schoeser 1995: 9).

In 1929 Gwen Pike died and Kennington decided she wanted to sell Footprints. With the help of a small legacy from her parents, Joyce Clissold was able to buy the firm and she would make considerable changes in the operation of it. These changes started by going into partnership with Germaine Tallents, who took on the financial role, which meant that Clissold, who had little interest in money, could concentrate on the creative side of the business. From this time on, she undertook virtually all the designing and block cutting herself. She trained young local girls to help her in the production of the textiles. At least one of these

girls, Cicily Swingler, stayed with her until the end and she in turn would train the next generation.

Joyce Clissold found a more suitable location at Brentford, on the Thames in west London, where there was more room for the workforce and living space for herself. Here she was able to expand the range considerably. Footprints had always printed on both dress and furnishing fabrics, now some of these were made into scarves and ready-made garments, such as blouses, opera coats, dressing gowns, and pyjamas as well as made-to-measure evening dresses. In 1933 she opened Footprints' first shop in New Bond Street; followed two years later by another one in Knightsbridge. These locations clearly indicate that the product was aimed at women who had money to spend on something a little out of the ordinary for their clothes and their houses, described as "the wealthy Bohemian" in the *Manchester Guardian* (Clark 1994: 84).

At its height, Footprints had between forty and fifty employees, but the war would put an end to this success and although Clissold continued with Footprints after the war, it was to be a much smaller operation. She died in 1982 and the major part of her archive was donated to the Central School of Art and Design. It provides valuable evidence how Clissold produced her textiles and it includes a large collection of fabrics and garments, the blocks used for printing them and some of her drawings.

The two index books are part of this legacy. They are very different in feel to Goodchild's exercise book; the covers are encrusted with dye and the pages inside, particularly of the first book, are covered with spilt dyes that make some of the writing totally unreadable (Plate 12.3). They contain recipes for dyes as well as little sketches of layouts for printing garments and were clearly much used by several members of the Footprints team.

Like Liberty, Footprints used synthetic dyes. While Liberty used a large variety of dyes, Footprints mostly used the basic dyes, such as Methylene Blue, Rhodamine, Chrysoidine, or Auramine. "Basic Colors" were the original nineteenth-century aniline dyes. They were not very fast to either light or washing but they did produce very brilliant and intense colors and were easy to use. They were used for printing but could also be used to paint on silk and on other materials, such as leather and wood. Many of these dyes have now been discontinued as they were found to be carcinogenic to those who worked with them. The two Footprints books appear to follow each other. Presumably, when the first one became unreadable, a new one was started. The books are packed with recipes for the many different colors used at Footprints.

Along with the dye books and fabrics at the CSM Museum there are a few of Clissold's travel diaries and Christmas cards, illustrated with her quirky drawings which give viewers a good idea of Clissold's sense of humor, and her textile designs reflect this same humor. The often idiosyncratic, sometimes poetic names given to each color also seem to be characteristic of Clissold's way of

thinking (she was the daughter of a vicar), such as Holy Ghost Blue, Celestial Dirt, Pale Purgatory, Nearly Neither, Starlit Sky Blue, Sick Mole, or Strong Manure. Some of the colors have a date beside them, one is for April 1929, so perhaps the names reflect the overall jolly atmosphere of the Footprints studio team rather than being purely that of Clissold, as she had only just taken over the business at this time. The colors are numbered and this seems to have been part of Footprints' own system as these numbers do not appear to relate to any official systems such as the "Colour Index," first created by the 'Society of Dyers and Colourists' in 1924.

Many of the Footprints blocks had a complete repeat design to cover the whole textile, with separate blocks for each color. Footprints also created garments with placement prints, where a pattern for the garment has been cut out but not yet sewn up, so that the printer can place the blocks on a particular part of that garment. For example, in the CSM collection there is an evening dress where the back of the garment has had such a placement print with a garland of flowers running down the back of the dress. Footprints have used some of the many smaller blocks with separate motifs, which have been reused in different configurations to produce this pattern. There are other garments, such as a day dress, where the blocks have been used to produce a pattern along the hem. The first dye book contains several pages with instructions on how and with which blocks and what colors to print a particular style of coat, but leaves some decisions to the person printing (Figure 12.1). One of the pages has the comment "leaves in Footprints grey, not too many," implying that the printer can use their judgment on where and how many times to apply a small leaf-shaped block. However, for the same coat, the correct placement of a trellis, in what color and how applied is clearly and precisely indicated, leaving no doubt as to its arrangement.

There are references to discharge recipes in the books, but there aren't many examples of this technique among the textiles in the museum collection. There are lists of Indigosol colors, a synthetic dye first introduced by Durand and Huguenin of Basel in 1922, which produced a true Indigo blue, for the first time completely soluble in water. There are also several pages devoted to pigment colors, recommending some as being useful for painting on tin, glass, wood, and shoes. Among the garments in the collection, there are many examples of Footprints painting colors on to them, as well as printing them.

Footprints used many different fabric bases, heavy linen, and cotton for furnishing fabrics, cotton, rayon, and silk for dress fabrics. The dress fabrics were often bought at Pontings department store of Kensington High Street in London where interesting short lengths of woven silks were sold at reasonable prices. In the museum there is a collection of 1930s evening dresses, which are made of brocaded silks, damask weaves, devoréd silk velvets, each surface producing a different effect when printed. Most of the scarves were made of georgette

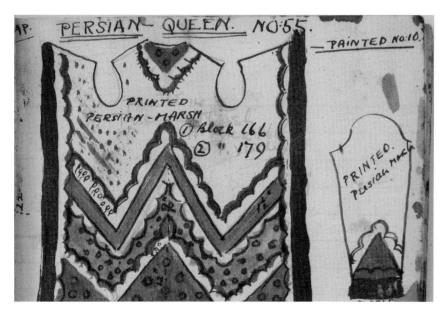

Figure 12.1 Page from Joyce Clissold's dye book showing instructions for printing on a coat. © Museum and Study Collection, Central St. Martins

silk, which was purchased wholesale. Some of the best-selling furnishing fabrics would be sent for printing by silkscreen at Amersham Prints, who were able to cope with a higher volume of material. Joyce Clissold hated routine work and where larger orders of clothing came in, these were also sent out if that was financially viable (Clark 1994: 86).

Clissold's dye books exhibit a similar hatred of routine. Where the chemist Goodchild worked diligently and systematically through all the dyes, testing them for their properties, Clissold appeared to have a more improvizational way of working, splashing the colors around the dye room. Appearances can be deceptive however; there was after all a system in place at Footprints as well. The numbering of the dyes ensured that anyone who mixed them would achieve the correct colors.

The Liberty book gives us some idea about what Goodchild was doing at the Merton Printworks. In the book there is a note that refers to the reorganization of the old color house and it is probable that Liberty were planning to introduce new dyes into the works at this stage. In one of the Directors' Minute Books in January 1935 there is a mention of some experimental printing happening at Merton: "An agreement under Seal with Madame Astra Sark in relation to a Multi-Color Printing Process and Machine."[9] It is possible that Goodchild was involved in this part of the operation as well.

The Merton printers were experienced in printing on silk, but acetate or rayon, which Liberty called Sungleam, was a new textile for them and the Liberty book shows that Goodchild is experimenting on this base with both dyes and discharge. Screen printing at Merton started in the early 1930s, at a time when it was still a fairly new development and one that would have needed many tests before it could be exploited commercially. From the evidence of the paper impressions, the colors used for the two different printing methods differ in that the block prints seem to be crisper and richer, while the screen prints are more like watercolors, a difference that disappears later. It is probable therefore that working on colors for screen printing was one of the main tasks that Goodchild was involved in.

Liberty's book and the two Footprints books are actually different things; while showing the working practices in the two businesses, they serve different functions. One is primarily concerned with testing the properties of dyes, discharge, and thickening pastes; the other two are principally recipe books for use by members of a small team of three local girls employed solely in making up the dyes.[10] The colors produced by both firms were not dissimilar; it was rather in the execution of the printing that the differences show up. There is a deliberate haphazardness to the printing techniques of Footprints, giving a more spontaneous feel to the patterns. The Liberty prints are much more precise; there are no awkward seams where the placement of the blocks is obvious as on a Footprints textile. There is less of the muddiness to the Liberty prints, which occasionally happens with those by Footprints, the consequence of them printing layers of colors on top of each other.

The Merton silk printing operation was a relatively small one compared to the printing companies in Lancashire. However, compared to Merton, Footprints was even smaller; it was based in Joyce Clissold's own home, where the bathroom served a double function in both the domestic and professional spheres, in being used for washing and fixing printed cloth (Clark 1988: 58). The skillful Merton printers and dyers printed fabrics for Liberty as well as for outside customers and the Liberty textiles were sold not only in the Regent Street store, but all over the world. Consistency of pattern and color is essential in that kind of business. As has been shown, Footprints themselves printed shorter lengths, often one-off placement prints and so consistency would have been much less of a priority.

Although it is tempting to compare the two companies as professional versus amateur, the truth is actually more complicated than that. Joyce Clissold was a highly trained artist running a successful business with shops in upmarket locations. The printers at Merton were skilled craftsmen, able to cut the most intricate patterns into woodblocks and printing with them to create what are now museum pieces. The great difference between the two firms is that Joyce Clissold was closely involved in both the designing and the printing, while at Liberty the design process was completely separate from the manufacturing.

This would certainly preclude any of the happy accidents that appear on the Footprints fabrics, something that the Liberty printers would have prided themselves on avoiding at all cost. Despite these differences the three books show the importance of the manipulation of color in printed and dyed fabrics and in the end the beautiful textiles produced by both companies were expressions of the taste and skills of the people who worked there in the dye rooms and at the printing table

Notes

1 Liberty ar.B.342; Central Saint Martins Museum & Study Collection T.1.1992.96–T.1.1992.97.

2 The firm's name has gone through many versions, in the 1930s it was Liberty & Co Ltd.

3 "A Lounge at Liberty's," *The Gentlewoman* (1890), 420.

4 Page 19 has this note in pencil: "following is some experimental work done at Liberty's … Silk Printing works Merton Abbey SW London Between 1930–1937."

5 *Liberty Directors' Minute Book 1910 to 1948*, 215 (January 2, 1933). This idea is vetoed at a later director's meeting, but the print impressions show that they did indeed print on a variety of fabric bases.

6 Liberty ar.B.038, ar.B.191.

7 Central Saint Martins recently shortened their name from Central Saint Martins College of Art & Design to Central Saint Martins.

8 *Central School of Arts and Crafts Prospectus* (1924).

9 *Liberty Directors' Minute Book 1928 to 1952*, 133 (January 30, 1935).

10 Ibid., 58.

References

Clark, H. (1988), "Printed Textiles: Artist Craftswomen 1919–1939," in Ralph Stanton (ed.), *Ars Textrina 10*, Winnipeg: Charles Babbage Research Centre.

Clark, H. (1994), "Joyce Clissold and the 'Footprints' Textile Workshop," in J. Seddon and S. Worden (eds), *Women Designing: Redefining Design in Britain Between the Wars*, 82–88, Brighton: University of Brighton.

Roscoe, B. (1987), "Artist Craftswomen Between The Wars," in G. Elinor, S. Richardson, S. Scott, A. Thomas and K. Walker (eds), *Women and Craft*, 139–49, London: Trafalgar Square.

Schoeser, M. (1995), *Bold Impressions, Block Printing 1910–1950*, London: Central Saint Martins College of Art & Design.

Storey, J. (1978), *The Thames and Hudson Manual of Dyes and Fabrics*, London: Thames and Hudson.

SECTION FOUR

COLOR AND DESIRE

13

ROUGH WOLVES IN THE SHEEPCOTE: THE MEANINGS OF FASHIONABLE COLOR, 1900–1914

Clare Rose

This text focuses on the shift in fashionable colors that occurred prior to the First World War, when intense and contrasting hues replaced harmonious pastels. The change in color sensibility was noted by contemporaries; the artist Henri Matisse attributed it to the productions of Diaghilev's Ballets Russes from 1909, which "overflowed with colour … from then on colour had universal freedom" (in Wollen 1987: 22). Paul Poiret, who established his couture house in 1903, notoriously claimed personal responsibility for introducing the "rough wolves" that chased away the "sheep" of pale colors (Poiret 2009 [1931]: 93).

An examination of the collection record books and surviving garments from the houses of Lucile Ltd., London, and Jeanne Paquin, Paris, preserved in the archives of the Victoria & Albert Museum, London, reveals that intense color schemes were apparent from 1900 and throughout the fashion trade. Information about fashionable color was disseminated through a variety of media, including the stage, and through specialist fashion journals such as *Les Modes* and the *Gazette du bon ton*, both of which featured color images. English-language publications, even those aimed at fashion consumers such as *Vogue* (New York) were largely monochrome, but had a highly developed language for discussing color schemes. The terms used for color are of interest, as they created a network of cultural and nationalistic references for specific hues. They also located color in both time and place, as youthful or old, modern or traditional,

and exotic or local. The London *Pall Mall Gazette* used color terminology to create a specifically British sensibility that was in tune with Paris fashion, but did not follow it slavishly. American local newspapers positioned local trends with reference to fashion authorities in New York, and to international events such as Balkan wars. This text argues that the lack of color images in periodicals may have been not a constraint but an asset, allowing both advertisers and consumers to select colors that suited them. It also considers how the *idea* of a color can convey meaning independently of its physical appearance.

Investigating the history of color in fashion raises some deep paradoxes. Color was evidently important as a part of the fashion system before the First World War. As color historians such as Garfield (2000), Blaszczyk (2012), and Kay-Williams (2013) have established, there was a strong drive in the mid nineteenth-century to produce brighter and more varied colors for textiles. The intensity produced by the aniline dyes of the 1860s gave added impetus to scientific theories of color harmonies, notably those of Michel-Eugène Chevreul, which gained wide currency through fashion magazines (Nicklas 2014). In the 1870s, the Aesthetic Movement in art was defined partly through its rejection of aniline colors in favor of the subtle, "greenery-yallery" shades mocked in Gilbert and Sullivan's *Patience* (1881). The cultural associations of specific color schemes were well known enough to be a reliable target for satirists such as the cartoonist George du Maurier (Walkley 1985: fig.173). Color preferences were seen as an index of civilization, with bright or clashing color schemes associated with "primitive" societies, or with the uneducated (Gage 1999: 250). Color theorists such as Milton Bradley and A.H. Munsell stressed the importance of color education in schools, producing materials that would guide the tastes of the new generation (Blaszczyk 2012: 45–60). Color choices were also commercially important, with color forecasting services in operation by the 1880s, if not before (Blaszczyk 2012: 40).

There is, however, a gap in our understanding of how—and to what extent—seasonal changes in fashionable colors were implemented. Of the tens of thousands of fashion images produced each year, the majority were monochrome, as were the widely distributed photographs of trendsetters, from actresses to aristocrats (Majer 2012). Even top fashion houses, like Worth, relied on monochrome images to record and publicize their work (Mendes and de la Haye 2014). Where color images were produced, these were largely for circulation to private clients rather than for reproduction. This was the case with the seasonal volumes of colored sketches from the couture houses of Paquin and Lucile now in the archives of the V&A Museum, which will be discussed below (Paquin, E.1 to E.2804–1957 and AAD 1/ 1 to 1/79–1982; Lucile, T.89A–1986, published in Mendes and de la Haye, 2009).

This gap in information was filled by fashion journalism, both in specialist publications and in newspaper columns. As Margaret Beetham (1996) has shown, women's magazines were key sites for the creation of modern forms of

femininity, to the extent that they were seen as a threat by autocratic regimes like Tsarist Russia (Ruane 2009: 98–113). They related innovations to wider cultural trends in the arts and politics, creating a web of meaning which was particularly important when discussing color in a monochrome format (Lehmann 1999). Fashion columns in daily newspapers tailored their advice to specific local audiences, suggesting how the reader could position herself in relation to national and international trends. Publications in London, Paris, New York, and San Francisco recommended different color schemes to their readers, and these schemes were in turn linked to different nations, creating a complex interplay of geographical references. Thus any change in fashionable colors was not absolute, as Poiret claimed, but modified by regional and cultural influences, as will be discussed below.

In his 1931 autobiography, the designer Paul Poiret claimed that when he founded his fashion house in 1903:

> lilacs, sky blue hortensias, straw, anything that was cloying, washed out, and dull to the eye, was held in the highest regard. I threw into the sheepcote a few rough wolves … reds, greens, violets, royal blues, that made all the rest of the colors sing loud. (Poiret 2009 [1931]: 93)

It is true that delicate colors were used at this time, as *Les Modes* reported in 1906: "there is a new shade in the color palette, water-green … a strong rival to pale blue and mauve, the two champions this year—with the exception of white, which triumphs as usual" [author's translation] (de Lancy 1906: 20). Nevertheless this washed-out palette was a trend, rather than a prevailing aesthetic, as can be seen from a 1904 prediction that the coming season would feature:

> Bright, even violent colors … And what colors: all shades of purple, from prune through amethyst to violet and mauve; browns from bronze, to khaki, to cock-of-the-rock, to chestnut and mandarin; greens, as always, from the most striking to the softest shade of verdigris; blues, from royal blue to a bluish white; reds from madder to cherry. Indeed, nothing is excluded, all colors are in fashion, not forgetting black and white [author's translation]. (de Lancy 1904: 14–16)

This wider range of fashionable colors can be found in colored sketches and surviving garments by leading Paris couturiers such as Jeanne Paquin. Paquin, organizer of the Fashion Section of the 1900 Paris Exposition Universelle, was known for a particular shade called "Paquin Red" (Arrizoli-Clémentel 1989: 11). This was the color of one of the ensembles Paquin exhibited in Paris in 1900, memorialized in the lavishly illustrated catalogue published by the Collectivité de la Couture (Rose 2014: 60). The same hue appears in a surviving Paquin dress

from 1905 in the Costume Institute collections at the Metropolitan Museum of Art, New York (1979.346.27). An even more striking color scheme, black with bold scrolls of magenta, was used in a 1900 Paquin ensemble in the same collection (C.I.48.70.1). Lucile of Paris and London, known for ethereal creations of semitransparent layers, also produced gowns in striking shades of scarlet, orange, violet, and emerald. These can be seen in a seasonal album for 1905 in the collections of the V&A with attached fabric swatches which confirm the intensity of the colors used (Mendes and de la Haye 2009). After 1908, these strong colors became more dominant in all designers' ranges, as can be seen in the sequence of Paquin seasonal albums in the V&A archives (Rose 2014: 23). These albums of hand-colored drawings were, however, restricted in circulation and were seen only by private clients or the staff of the fashion house.

Couture garments, whether by Paquin, Lucile, or Poiret, could be viewed in full color at elite gatherings in Paris, London, or New York, at public events such as race meetings and theater premieres, and in the vitrines of international exhibitions (Saillard 2013; Rose 2014). Up-to-date fashion was also an important element of theater productions, as Kaplan and Stowell (1994) and Majer (2012) have shown. But for those living outside major cities, or for consumers wanting advance notice of fashion trends, fashion publications performed an essential role. *Les Modes* was especially important for updates on color themes as it had two or three tinted photographic plates in each issue, unlike *Vogue*, which had color only on its front cover. *Les Modes*, although published in French, was also distributed in London, Berlin, and New York, and on transatlantic liners bringing American couture clients to Europe (Mackrell 2004: 114). The *Les Modes* plates show the "violent" colors described in the 1904 text; for example, a 1908 day dress by Margaine-Lacroix in "Egyptian green," accessorized with a matching hat (Plate 13.1).

Even brighter colors can be seen in the images in Paul Poiret's promotional albums, *Les robes de Paul Poiret racontées par Paul Iribe* (1908) and *Les choses de Paul Poiret* (1911). These contained plates in the pochoir technique, hand-stencilled using gouache paints, which produced colors that were much more intense than the color lithography or tinted photographs used in other fashion publications (Davis 2007) (Plate 13.2).

These albums were produced in limited editions, but Poiret's garments were also frequently reproduced in the *Gazette du bon ton* (published 1912–1925), which developed the visual style and the pochoir technique used by Poiret (Davis 2008: 48–92).

Monochrome publications, such as daily newspapers, used a variety of methods to convey seasonal changes in color. One way was to refer to named designers, whom readers might have heard about through other sources. Around 1910, Poiret was frequently cited as an innovator in fashionable colors, particularly in American newspapers:

Vivid tones used as accessory colors are the height of style in gowns. These daring splashes of color were the inspiration several seasons ago of Paul Poiret, a Parisian dressmaker, but it is only recently that his brother artists have acknowledged his success by following in his wake. (Talbot 1910)

A Washington DC drapery store, Kann Sons & Co., linked the new season's colors both to Poiret and to Middle Eastern culture:

Out of a thousand purchases we might not again find the color range so replete with the shades that are in highest favour. Here we have the vivid colorings made fashionable by that famous French costumer Paul Poiret … the strange yet harmonious tones of oriental embroideries and mosaics … the new Byzantine greens. (Kann 1910)

Not all fashion reports linked intense color schemes to Poiret; often they were presented as the result of designs from Serge Diaghilev's Ballets Russes. The arrival of this company in Paris in 1909 had reinforced existing links between the stage and fashion, with journals such as *Le Courrier musical* and *Comoedia illustré* featuring portraits of Russian dancers both onstage and off (Davis 2008: 16–21). Ballets Russes productions presented themes that were both exotic and erotic: the 1909 Paris season had dancers dressed as central Asian warriors (*Prince Igor*) and Egyptian courtiers (*Cleopatra*) and the 1910 season staged a Russian fairy tale (*Firebird*) and an orgy in a harem (*Schéhérazade*) (Pritchard 2010: 220–221). *Schéhérazade*, in particular, with an intensely colored backdrop and body-revealing costumes designed by Léon Bakst, was seen by contemporaries as heralding a new design sensibility. Robert Irwin, writing about the American fashion system in 1911, noted the effect:

The so-called Russian styles, which swept over the United States and Europe within a year … [of] the appearance of the Russian Imperial Ballet at a Paris theatre. This beautiful combination of women and clothes took Paris by storm. The barbaric simplicity of form turned to envy the pride of the corseted modiste. The daring color combinations challenged, to chagrin, the subdued and effete tints of the richest of Paquin-made gowns. (Irwin 1911: 6)

While this commentator characterized the "effete" Paquin in opposition to Russian innovation, the couturier was one of the first to recognize the importance of the Russian styles. In 1912, Paquin collaborated with Bakst to produce a handful of garments which were illustrated in fashion magazines such as *Vogue* (Davis 2010: 174), the *Gazette du bon ton* (Mourey 1913), and the *Journal des dames et des modes* (Plate 13.3).

Bakst's designs for this project were also reviewed as art in the London *Times* ("M. Léon Bakst's Exhibition, Costumes and Scenery," 1913) and the *Illustrated London News* ("Expressing the Spring Time of the Earth," 1913). Bakst's fashion designs were discussed in the American press even before they were exhibited in New York in November 1913:

> Another popular tone is the new Bakst green, named for the Russian scenic artist whose success with the Russian ballet has been phenomenal. Bakst used lots of greens in the costumes for his ballet, and likewise in the gowns which he designed for Mme Paquin, and it is a fitting tribute to name the popular green shade in his honor. ("Colors that will be popular," 1913)

Intense emerald green had indeed been prominent in Bakst's stage designs for Prince Igor and Schéhérazade, but the most frequently used colors in his Paquin sketches were mustard yellow and cobalt blue. This misattribution of a specific shade to the designer shows how, in the absence of color reproductions, the *idea* of a color might be used as a promotional device or as a means of creating cultural context for fashion.

The critical approval of Bakst's foray into fashion would have been especially galling for Poiret as in January 1912 his own designs had been satirized on the Paris stage in a comedy of modern life, *Rue de la Paix* (Troy 2002b: 133). The costumes for this play were originated by Paul Iribe and made up by Paquin, allowing the couturier to show her mastery of the most extreme fashion trends, while maintaining a critical distance from them (Troy 2002b: 137–140). Poiret responded in 1913 by designing the costumes for *Le Minaret*, which was like *Schéhérazade* in its harem setting and its erotic theme, but presented as a light comedy (Troy 2002a). Critics applauded the costumes and sets in harmonizing colors of white, silver, and pink as "of a most delicate taste; Persian costumes accommodated to the Parisian imagination" (Launay 1913; cited in Troy 2002a: 124). The publicity attracted by these costumes encouraged Poiret to take a collection of "Minaret" inspired clothes on a tour of the United States in September of 1913. This tour consolidated Poiret's reputation in North America, with *Vogue* acclaiming him as "The Prophet of Simplicity" (Troy 2002b: 211–215). Yet there remained an association between the new Orientalist styles and the Russian ballet. In February of 1914 an Oregon newspaper described a fancy dress costume worn in New York as "a copy of the 'Bakst Minaret' costume seen in the play, 'The Minaret' at the Theatre Renaissance, Paris" ("Newest 'Bakst Minaret'," 1914).

Newspaper associations of design innovation with Russia rested not only on the productions of the Ballets Russes but also on news reports from the region, as Irwin noted:

For instance, when we were all excited over that Bosnia—Herzegovina affair! Remember it? Remember how Austria wanted better access to the sea, and simply went south and grabbed it, regardless of the protests of Servia [sic] and Bulgaria? Well, those Bosnians and Herzegovinians wore some very striking costumes. They were Slavic, like those of the Russian ballet; startling in color, but amazingly winsome in gracefulness and ease. (Irwin 1911: 7)

The annexation of Bosnia-Herzegovina by Austria-Hungary in 1908 was seen as a threat by Bulgaria, which responded by declaring independence from the Ottoman Empire, with Prince Ferdinand declaring himself Tsar. These events were closely reported in the press from the time of the declaration of independence in October 1908 to diplomatic recognition of the new state in May 1909 ("In the Public Eye," 1908; "Taft Recognises Ferdinand," 1909). This was reflected in a vogue for "Russian" ensembles with loose blouse tops trimmed with fur or with military braid ("The Glass of Fashion," 1909). In 1912–1913 this region was in the news again with the First and Second Balkan Wars between Bulgaria, Serbia, Greece, and Turkey, and then between Bulgaria and its erstwhile allies ("Bulgaria," 2015). By February 1913 an American newspaper commented: "The Slavic invasion is in hand. A one piece black satin suit has its satin sash and Bulgarian collar, a la Paquin … gowns of all kinds have their Bulgarian trimmings" ("Davis-Schonwasser Display Delights," 1913). In London, fashionable consumers were advised that "we find Bulgarian embroidery very prominent. It shows itself in an original manner in the square upon the Russian blouse" (Gisele 1913b). The mingling of design references from countries currently at war with each other in the same outfit suggests the way in which fashion engages with contemporary events through a process of selection and appropriation, rather than simple reflection (Lehmann 1999).

The "Bulgarian" color schemes discussed in the press seem to have been typified by bold contrasts rather than by specific hues. Geographical names were also applied to individual colors or color combinations, as part of a fashion discourse which presented new styles as originating from some places, and as selected for wear in others. This was particularly noticeable in the regional press, where the readership was located within a tightly defined area. In February 1913, a San Francisco newspaper ran a whole page on the coming season's fashions, as displayed in a local fashion show and in the stock of local retailers. The introduction highlighted two major trends: the "Bulgarian blouse suit," inspired by news reports from the Balkans, and the color "Nell rose," named after the daughter of U.S. president-elect Woodrow Wilson ("Riot of Color Rules," 1913). Individual articles about the stock of local stores mentioned colors including "Indian red," "Copenhagen blue," and "mustard yellow." One retailer was quoted as saying: "It is largely a case of keeping all shades of the rainbow on hand, for sooner or later someone will want it, either in constituent colors or the ensemble"

("Davis-Schonwasser Display Delights," 1913). Another commented: "This is a period of strong color contrasts, brilliant, unusual shades and bizarre, even daring effects. The spring and summer of 1913 will be long remembered for the revival of strong shades" ("Roos Brothers Have Brilliant Contrasts," 1913). One article summed up the process of localizing fashion in its title: "Livingston Brothers Are Making A Hit; Russian blouse has come west for spring styles and hat materials are in bright color effects" (1913). Altogether, the agreement of fourteen different stores on trends in colors implies not the hegemony of Paris fashion, rather a local consensus between competing retailers. The emphasis on bright colors in this newspaper may reflect the beginnings of a Californian aesthetic attuned to the sunny climate and outdoor lifestyle, further developed in the 1930s (Scott 2009).

In the London press, discussions of color schemes were framed in terms of both national aesthetics and moral codes. Suffrage organizations' adoption, from 1908 onwards, of specific colors—purple, white, and green for the Women's Social and Political Union; red, white, and green for the National Union of Women's Suffrage Societies—may have informed this moralization of color (Kaplan and Stowell 1994: 169–174; Parkins 2002). This connection, however, was not made explicit in the *Pall Mall Gazette*, a daily newspaper for the upper-middle classes living in London or in the provinces. This featured several different sorts of fashion information: articles on current fashion trends from Paris, analyses of the costumes worn on the London stage, reports on outfits worn at society events in Britain, and columns advising readers about goods available in London shops. There were also occasional pieces on the philosophy of fashion, with or without illustrations.

When bright colors dominated Paris fashions in 1910, the *Pall Mall Gazette* recommended them with a word of warning:

> Colors for the autumn and winter are to be gorgeous, especially in evening and house gowns generally, as the passion for all Eastern things is growing stronger as time goes on. The difficulty will lie in learning how to mix them, and probably we shall see some shocking failures. But, on the other hand, we shall see some wonderful successes. One or two harmonies already shown to me were gowns in orange, violet and black. ("Paris Fashion," 1910)

If color was used incautiously, the wearer was likely to transgress not only aesthetic, but moral boundaries, as the most extreme fashions were associated with women of easy virtue:

> [at] a "first night" or a "répétition générale" [dress rehearsal] the dresses are quite wonderful, as not only does one see the society woman, but also the demimondaine, and there is a perfect orgy of luxury … the society woman

might be known at once by her restraint in this respect, whereas the actress and the demimondaine allowed themselves greater licence, and followed the latest fashion. ("Fashions in Paris," 1911)

Instead of blindly following fashion, readers of the *Pall Mall Gazette* were encouraged to cultivate a personal taste in harmony with their surroundings. In April 1911, a columnist addressed the difficulty of describing fashionable colors:

Some of the new ones are puzzling in their nomenclature; some of their names tell one nothing, some are literally false. Like the growers of sweet peas (and these include myself), we are apt to be annoyed by the "official" styles and titles of certain colors nowadays, and it has amused me for some time to rechristen for myself, according to necessity or from mere inclination, many shades and tints which seemed to me all the better for it. (Nepean 1911)

The article goes on to create a color palette drawn from the English country house, with the brown of antique furniture, the cream color of old ivory, and the reds and pinks of garden flowers. Bright shades of blue are associated with delphinium flowers, with kingfisher and peacock feathers, and even with antique medicine bottles. The writer insists on the correct naming of colors; a shade of red described in Paris as "chaloupe" (a small boat) in London becomes "Coronation" (after the velvet robes worn by peers) and in the countryside is called after the flower "gloxinia" (Nepean 1911). This article is interesting as it addresses the problems of describing color in a monochrome publication, but dwells on color's emotional, rather than aesthetic effects.

The difference between the imagined reader of the *Pall Mall Gazette* and that of the *San Francisco Call* emerges clearly in the fashion columns for spring 1913. The London preview of the season identified the same fashion trends noted in San Francisco: Russian blouse shapes, Bulgarian embroideries, and striking color combinations, including bright green and black. The reader was warned, however, that some of the more extreme Paris styles were intended for export to South America, and would not be acceptable in Europe (Gisele 1913a). Even when dealing with a leading Paris couture house, the British reader was encouraged not to accept the garments as they stand, but to adapt them to her own taste:

The art of the dressmaker is to combine the new materials and the embroideries with the taste that she possesses to make the costume acceptable. The creations in Paris are often too vivid, but they serve as a basis for another attempt that the saleswoman, if she is clever, arranges with her client. (Gisele 1913b)

Sometimes it was the client's taste that was at fault, requiring guidance from fashion professionals. A humorous short story published in February 1913 was told in the voice of an unmarried young woman going shopping with her elder sister. The narrator establishes at the outset that she sees color as the crucial factor in planning her spring wardrobe: "think what a responsibility you would incur by forcing a sister to decide in a hurry whether she would be pink, green, purple or bright yellow for the next four months" (A.S. 1913). She is so confused by conflicting recommendations that she threatens to order a dress like "a Post-Impressionist pirate, the color scheme being red and yellow and green." At the fashion house, the sisters are shown sample dresses in shades of orange; in purple and saffron trimmed with bright pink; and in white and silver. The older sister chooses the purple and saffron dress, but without the pink trimming, while the narrator is persuaded by the designer to order a dress in white and silver. This story warns the reader that the wise consumer is one who negotiates with fashion professionals, being guided by them, but not adopting their ideas indiscriminately. This is very different from the consumption process envisaged by the San Francisco newspaper, where the process of taste-making rests with the fashion professionals, who offer consumers a variety of fashionable styles and colors. This is partly a function of the greater flexibility offered by the made-to-order garments described in the *Pall Mall Gazette* as opposed to the ready-to-wear of the *San Francisco Call*. But the exuberant descriptions of rainbow colors and clashing shades in California strike a very different note from the language of restraint and decorum used to address British readers, suggesting the nationalist rhetoric identified by Marlis Schweitzer in American fashion writing from 1908 (Schweitzer 2009).

Underlying the discussions of color schemes for specific locations was an understanding of the relationship between dress and its setting. This had been a point of principle in Art Nouveau, with clothing designed to reflect the aesthetic of interiors by Charles Rennie Mackintosh, Henri van de Velde, or Josef Hoffman (Rose 2014: 108–112). Bakst and Poiret, while aligned to Art Nouveau by their use of Orientalist references, were often associated in the press with Futurism, characterized by its startling color schemes and striking abstract patterns: "Bakst—a modern artist who is as daring in form as in color" ("Futurist fashions," 1913).

Bessie Ascough, in the *Pall Mall Gazette*, pointed out the difficulty of harmonizing intensely colored garments with traditional interiors:

> The present "war of color" has to do with pastel tints versus futurist splashes. In Paris we have the soft color schemes of Watteau and Lancret, and also the most pronounced futurist splashes of the ultra-modern school … several leading dressmakers in Paris are making a determined stand against violent color splashes, especially where evening gowns are concerned …

> They argue—again rightly—that futurist gowns demand futurist surroundings: that for ordinary evening wear—at theatre or opera—they are unsuitable. (Ascough 1914)

This article creates a chronology of color, contrasting pastel tones based on eighteenth-century paintings with bright "futurist splashes." Another way of locating the new color schemes in time was to identify them with the younger generation:

> I saw one lady receiving this week in a tomato-colored dress of cachemire de soie, veiled with a peacock blue silk Indian cachemire stamped in figures of blue and green and trimmed with a touch of tarnished gold soutache [braid] at the neck and waist. Over this she wore a lovely Indian scarf … Her mother, essentially a lady of the ancient regime, told me softly that she did not quite approve of her daughter's toilette. ("Present Paris fashions," 1911)

This account identified modern trends, but also recognized that some readers would have a color sensibility formed in the past.

Fashion writers' discussion of color before 1914 was deeply contradictory, stressing the importance of specific hues in their absence (Jeffries 1914) (Figure 13.1).

Yet this absence gave fashion writers an opportunity to present their own interpretation of fashionable trends. Fashion designs presented in monochrome could be described using fashionable color terms, and these terms could then be applied to the stock of local retailers with no fear of contradiction. The color sold in New York as "Bakst green" might have nothing to do with the eponymous designer, but few consumers would be in a position to know this. Descriptive text could also be used to establish a chronology and geography of color, with "Futurist" shades contesting those based on eighteenth-century art, and "Bulgarian" colors vying for popularity with "Copenhagen" blue. Fashion texts also stressed the ethics of color, warning readers against inappropriately bright shades that might draw unwanted attention. The definition of appropriateness was bound by both time and place; the mustard yellow hats that were advertised in San Francisco for Spring 1913 would have been ahead of their time in Fall 1912, and by Fall 1913 were likely to be passé, while orange, violet, and black ensembles worn at Paris theaters would be out of place in an English drawing room. It was this specificity that made color such an important indicator of fashionable change, and of consumers' relation to it. On the eve of the First World War, American *Vogue* commented:

> In nothing has the conservative taste of the English been so utterly changed as in the use of color. Time was when flamboyant effects were considered vulgar, but now the more bizarre the combination, the more credit it reflects upon its originator.

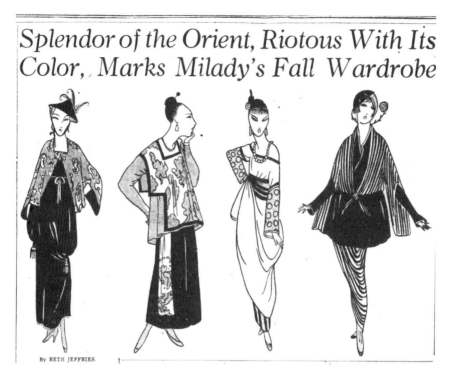

Splendor of the Orient, Riotous With Its Color, Marks Milady's Fall Wardrobe

By BETH JEFFRIES.

Figure 13.1 Beth Jeffries, "Splendor of the Orient, Riotous with its Color, Marks Milady's Fall Wardrobe," *The Washington Times*, (Washington [DC]), August 18, 1914. Courtesy of the Serial and Government Publications Division of the Library of Congress, Washington, DC.

Purple, which was once considered the emblem of age and sorrow, is now confidently combined with every imaginable shade of red and yellow. As for orange, it no longer remains a glaring and daring splash of recklessness, but combined with sapphire blue and black, has become a very popular color scheme … Neutral is taboo … nothing neutral can be endured. ("Keying up the Color Scale,' 1914)

References

A.S. (1913), "A Brighter Purple," *Pall Mall Gazette* (London), 26 February:10.

Arrizoli-Clémentel, Philllipe (1989), "Paquin," in Dominique Sirop (ed.), *Paquin, une rétrospective de 60 ans de haute couture*, 9–12, Lyon: Musée Historique des Tissus.

Ascough, Bessie (1914), "Latest Paris Fashions: Futurists Wage War of Color with Watteau Enthusiasts, Champions of Pastel Tints Being Victorious in Evening Gowns Worn with White Wigs," *New-York Tribune*, 19 April:11.

Beetham, Margaret (1996), *A Magazine of her Own? Domesticity and Desire in the Woman's Magazine, 1800–1914*, London: Routledge.

Blaszczyk, Regina Lee (2012), *The Color Revolution*, Cambridge, MA: MIT Press.

"Bulgaria" (2015), *Encyclopædia Britannica Online Library Edition*, Encyclopædia Britannica, Inc. Available from: http://library.eb.co.uk/levels/adult/article/110560#129471.toc (accessed September 3, 2015)

"Colors that will be Popular" (1913), *New-York Tribune*, August 17:11.

Davis, Mary (2007), "Refashioning the Fashion Plate: Poiret's Clothing in Context," in H. Koda and A. Bolton. (eds), *Poiret*, 35–8, New York: Metropolitan Museum of Art.

Davis, Mary (2008), *Classic Chic, Music, Fashion and Modernism*, Berkeley: University of California Press.

Davis, Mary (2010), *Ballets Russes Style, Diaghilev's Dancers and Paris Fashion*, London: Reaktion.

"Davis-Schonwasser Display Delights: All Shades and All Possible Styles Are Placed Before Customers of Well Known House" (1913), *San Francisco Call*, 28 February:9.

de Lancy, Sybil (1904), "La mode et les modes," *Les Modes* (Paris), (46), 1 October:6–16.

de Lancy, Sybil (1906), "La mode et les modes," *Les Modes* (Paris), (67), 1 July:10–20.

"Expressing the Spring Time of the Earth: and with Futurist Effects: Modern Dresses by M. Léon Bakst," (1913), *Illustrated London News* (London), 17 May:698–9.

"Fashions in Paris—At a Theatre" (1911), *Pall Mall Gazette* (London), 8 June:3.

"Futurist Fashions Fresh from Paris" (1913), *Ogden Standard* (UT), 24 September:12.

Gage, John (1999) *Color and Meaning: Art, Science and Symbolism*, London: Thames & Hudson.

Garfield, Simon (2000), *Mauve, How One Man Invented a Color that Changed the World*, London: Faber & Faber.

Gisele (1913a), "The Mirror of the Modes—A Page from Paris—By a Parisienne," *Pall Mall Gazette* (London), 10 February:12.

Gisele (1913b), "The Mirror of The Modes, A Page From Paris," *Pall Mall Gazette* (London), 22 February:10.

"The Glass of Fashion—Some Smart Walking Gowns" (1909), *Pall Mall Gazette* (London), 27 October:11.

"In the Public Eye" (1908), *Los Angeles Herald*, 22 November:2.

Irwin, Arthur (1911), "The Machinery of a Fine Art," *San Francisco Call*, 2 July:6–7, 12–13.

Jeffries, Beth (1914), "Splendor of the Orient, Riotous with its Color, Marks Milady's Fall Wardrobe," *The Washington Times*, (Washington, DC), August 18:8.

Kann Sons & Co. (1910), "A Sale to Interest You," *Washington Times* (Washington, DC), 31 May:16.

Kaplan, Joel and Sheila Stowell (1994), *Theatre and Fashion: Oscar Wilde to the Suffragettes*, Cambridge: Cambridge University Press.

Kay-Williams, Susan (2013), *The Story of Color in Textiles: Imperial Purple to Denim Blue*, London: Bloomsbury.

"Keying up the Color Scale" (1914), *Vogue* (New York), 1 September:51.

Lehmann, Ulrich (1999), "Tigersprung: Fashioning History," *Fashion Theory: The Journal of Dress, Body & Culture*, 3 (3):297–321.

"Livingston Brothers Are Making A Hit; Russian Blouse has Come West for Spring Styles and Hat Materials are in Bright Color Effects" (1913), *San Francisco Call*, 28 February:9.

"M. Léon Bakst's Exhibition, Costumes and Scenery" (1913), *Times* (London), 27 June:72

Mackrell, Alice (2004), *Art and Fashion*, London: B T Batsford.

Majer, Michele (ed.) (2012), *Staging Fashion 1880–1920, Jane Hading, Lily Elsie, Billie Burke*, New York: Bard Graduate Center.

Mendes, Valerie and Amy de la Haye (2009), *Lucile Ltd.: London, Paris, New York and Chicago 1890s–1930s*, London: V&A Publishing.

Mendes, Valerie and Amy de la Haye (2014), *Worth, Portrait of an Archive*, London: V&A Publishing.

Mourey, Gabriel (1913), "Les "Robes de Bakst," *Gazette du bon ton* (Paris), 1 (6):166–7.

Nepean, Mrs Evan (1911), "Modes and Moods—New Names for Old," *Pall Mall Gazette* (London), 3 April:3.

"Newest 'Bakst Minaret'" (1914), *Evening Herald* (Klamath Falls, OR) February 23:3.

Nicklas, Charlotte (2014), "One Essential Thing to Learn is Color: Harmony, Science and Color Theory in Mid-Nineteenth- Century Fashion Advice," *Journal of Design History* 27 (3):218–36.

"Paris Fashion" (1910), *Pall Mall Gazette* (London), 11 August:3.

Parkins, Wendy (2002), "'The Epidemic of Purple, White and Green': Fashion and the Suffragette Movement in Britain, 1908–14," in Wendy Parkins (ed.), *Fashioning the Body Politic: Dress, Gender, Citizenship*, 97–124, Oxford: Berg.

Poiret, Paul ([1931] 2009), *King of Fashion*, trans. Stephen Haden Guest, London: V&A Publishing.

"Present Paris Fashions" (1911), *Pall Mall Gazette* (London), 12 January:3.

Pritchard, Jane (ed.) (2010), Diaghilev and the Golden Age of the Ballets Russes, 1909–1929, London: V&A Publishing.

"Riot of Color Rules at City's 1913 Fashion Show; Striking Balkan Styles are Predominating in the Splendid displays of the Local Stores; Femininity Views Marvelous Gowns; Never has City Seen Such Exhibits of Beautiful Spring Materials" (1913), *San Francisco Call*, 28 February:9.

"Roos Brothers Have Brilliant Contrasts; Elegant simplicity shown in effects and strong shades are being revived for the season" (1913), *San Francisco Call*, 28 February:9.

Rose, Clare (2014), *Art Nouveau Fashion*, London: V&A Publishing.

Ruane, Christine (2009), *The Empire's New Clothes, A History of the Russian fashion Industry 1700–1917*, New Haven: Yale University Press.

Saillard, Olivier and Zazzo, Anne (eds) (2013), *Paris Haute Couture*, Paris: Flammarion.

Schweitzer, Marlis (2009), "American Fashions for American Women: The Rise and Fall of Fashion Nationalism," in Regina Lee Blaszczyk (ed.), *Producing Fashion: Commerce, Culture, and Consumers*, 130–49, Philadelphia: University of Pennsylvania Press.

Scott, William R. (2009), "California Casual: Lifestyle Marketing and Men's Leisurewear, 1930–1960," in Regina Lee Blaszczyk (ed.), *Producing Fashion: Commerce, Culture, and Consumers*, 169–86, Philadelphia: University of Pennsylvania Press.

"Taft Recognises Ferdinand; Congratulates Czar of Bulgaria on his Country's Independence," 1909, *New York Times*, 4 May:2.

Talbot, Catherine (1910), "The New Two Story Hats from Paris," *Washington Herald* (Washington, DC), September 18:29.

Troy, Nancy J. (2002a), "Paul Poiret's Minaret Style: Originality, Reproduction, and Art in Fashion," *Fashion Theory* 6 (1):117–44.

Troy, Nancy J. (2002b), *Couture Culture, A Study in Modern Art and Fashion*, Cambridge MA/London: MIT Press.

Walkley, Christina (1985), *The Way to Wear'Em, 150 Years of Punch on Fashion*, London: Peter Owen.

Wollen, Peter (1987), "Fashion/Orientalism/The 'Body'," *New Formations* 1:5–33.

14

"LE NOIR ÉTANT LA DOMINANTE DE NOTRE VÊTURE ...":THE MANY MEANINGS OF THE COLOR BLACK IN POSTWAR PARIS[1]

Beatrice Behlen

In *Force of Circumstance*, the third installment of her autobiography, Simone de Beauvoir remembered the look of the rising star of her local Paris neighborhood Saint-Germain-des-Prés. In the autumn of 1947 the aspiring actress Juliette Gréco had turned into "a beautiful young girl with long black hair" who dressed in "the new 'Existentialist' uniform." Beauvoir traced Gréco's style back to Italy via the French Riviera: "The musicians from the various *caves* [italics in original] and their fans had been down to the Côte d'Azur during the summer and brought back the new fashion imported from Capri—itself originally inspired by the Fascist tradition—of black sweaters, black shirts and black pants" (Beauvoir 1975: 152).[2] In reality, Gréco would not go to the south of France until the summer of 1949, but this slight confusion on Beauvoir's part does not affect her interpretation of Gréco's style. What are the origins of the polysemy of Gréco's clothing that seems to oscillate between fascist and fashionable?

In August of 1944, Paris had been liberated after more than four years of German occupation. Already in June of 1943 Jean-Paul Sartre, Beauvoir's partner, had published *L'Être et le Néant* [Being and Nothingness], the bible of the new existentialism and in the autumn of 1945 began what Beauvoir later called their "Existentialist offensive" (1975: 46). Within three months, the couple brought out three novels, began to publish a new journal, *Les Temps Modernes*, and staged a play. During this period, on October 29, Sartre took the métro

to the Maison des Centraux not far from the Champs Elysées to deliver his lecture "Is Existentialism a Humanism?" The next morning French newspapers reported that there had been such a crush that women fainted (Cohen-Solal 1987: 249–252). Susan Weiner (2001:123) describes Sartre as "the first media personality of the period" and his lecture as "one of the first media events." Beauvoir became a celebrity in her own right and the couple duly featured in the popular American weekly *Life* as the "King and Queen of Existentialism" (Frizell 1946: 59). Whether they liked it or not, the "existentialist" label was freely applied to anything that could vaguely be related to Sartre-Beauvoir, including what was possibly the first postwar youth subculture (Beauvoir 1975: 151–153; Cohen-Solal 1987: 266). Its figurehead was the beautiful girl with the long black hair.

In the autumn of 1947, Juliette Gréco was twenty years old. Born in Montpellier in 1927, she was the second daughter of Gérard Gréco, a Corsican police officer, and Juliette Lafeychine, a *Bordelaise* from a bourgeois background.[3] The ill-matched couple had separated not long after Juliette's birth and the two sisters had been brought up with their maternal grandparents in Bordeaux before moving to Paris with their mother in 1933. After the outbreak of war, Madame Lafeychine had returned with her two daughters to the southwest of France and had become an active member of the Resistance. When their mother had been arrested in 1943, the two teenagers had fled to Paris but had soon been caught. Madame Lafeychine and her eldest daughter had been interned at Royallieu-Compiègne before being deported first to Ravensbrück, then to Holleischen concentration camps (Audhuy and L'Herminier: 90, 189). Juliette had been imprisoned in Fresnes to the south of Paris. After three weeks, in October of 1943, the sixteen-year-old had been released onto the cold streets of the capital, wearing "des chaussures de raphia à ses pieds gelés, une veste assortie et un mince robe bleu marine" [raffia shoes on her frozen feet, a matching jacket and a thin, navy blue dress] (Gréco 1982: 63). Gréco had found refuge with her former teacher, now turned actress, Hélène Duc, who lived near the Church of Saint-Sulpice in the sixth arrondissement.

Aspiring to be an actress, Gréco landed a few small parts on the stage and met the journalist Anne-Marie Cazalis, three years her senior and already well-known in the quartier. Cazalis introduced Gréco to Marc Doelnitz, the well-connected son of an affluent art dealer who had appeared in a few plays and films before the war but now worked as a fashion illustrator. This "sacré trio" [sacred trio] (Gréco 2012: 86) and their friends needed a place to congregate at night. In the winter of 1946, Gréco discovered Le Tabou, an all-night bistro, which served the employees of a nearby courier company. The bistro's cellar had served as "un cabaret bizarre" [a bizarre cabaret] during the German occupation but had been closed by the police some months earlier (Gréco 1982: 104). The necessary authorizations obtained, the *Club de Tabou* opened for business on

April 11, 1947 (Gréco 1982: 105–106). Doelnitz acted as Master of Ceremonies, Cazalis was in charge of Communications, and Gréco became the cellar's main attraction. Less than a month after the club's opening—on May 3, 1947—the first page of *Samedi-Soir*, a successful weekly newspaper run by one of Cazaliz's friends, was dominated by a photo of the nineteen-year-old future film director Roger Vadim and Juliette Gréco. On page six, the more than 400,000 readers of the paper could learn about the lifestyle of the "troglodytes" [cave-dwellers] of Saint-Germain-des-Prés (*Samedi-Soir* [95]: 6). The first sentence of the article introduced the name of the new subterranean culture: "Il ne faut plus chercher les existentialistes au café de Flore, ils se sont réfugiés dans les caves" (*Samedi-Soir* [95]: 6). Soon the Tabou was inundated with society visitors staring at Gréco who vented her discomfort by pinching the ankles of "diorised" and "new-lookised" women. Doelnitz and Cazalis, however, were having a great time (Gréco 1982: 106).

Juliette Gréco claimed that her style was due to practical reasons. During the winter of 1943, her lack of suitable clothes forced the teenager to stay indoors until her boyfriend, the painter Bernard Quentin, gave her a threadbare brown suit, a sweater, and an old shirt. Quentin's clothes were too large and Gréco had to roll up her trouser legs (Gréco 1982: 69 and 2012: 65). When a generous female donor enabled Gréco to replace her raffia footwear with an almost new pair of crepe-soled shoes (Gréco 1982: 70), Jujube—as Gréco calls herself in her first autobiography—was ready to explore her neighborhood: "Dans la rue, les gens se retournent sur elle, un peu supris [*sic*] de son accoutrement, mais Jujube, elle, se sent fière allure. Elle ignore qu'une nouvelle mode vient de naître" (Gréco 1982: 71). [On the street, people turn round, a little surprised by her outfit, but Jujube thinks she looks great. She does not know that a new fashion has just been born.] Several photographs show Gréco apparently in the kind of clothes she describes including the image accompanying an article about "Bohemian Paris" shot by Carl Perutz which appeared in *Life* magazine at the end of September 1947. Gréco is slow-dancing wearing a large, light-colored sweater over wide trousers of a medium hue with rolled-up legs (*Life* 1947: 146)[4] (Figure 14.1).

It is surprising that Gréco was still wearing what looked like Quentin's donations in the autumn of 1947, for by this time she had another source of clothes: her close friend François Bamberger, a "résistant devenu industriel" [resistance fighter turned industrialist] (Dicale 2001: 141). Bamberger descended of Alsatian Jews who had moved to Lille in the north of France to remain citizens of the French Republic after the annexation of Alsace-Moselle by the German Empire in 1871. There they began to manufacture men's clothes and between the wars, Hauser et Cie, as the company was called from 1923, obtained lucrative government contracts producing post office and air force uniforms. During the German occupation of Lille, Hauser et Cie was "aryanized," transferred to non-Jewish owners and probably produced

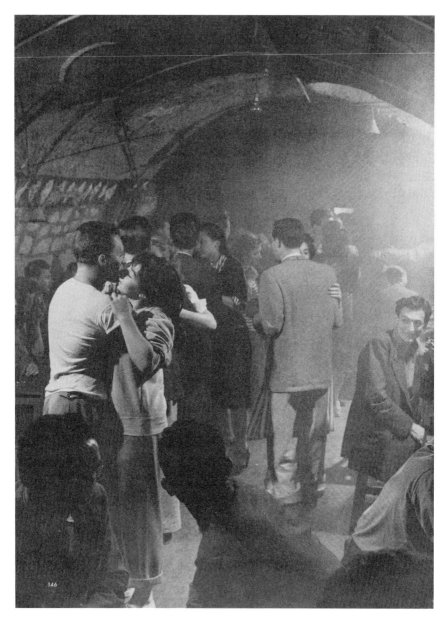

Figure 14.1 Juliette Gréco wearing what seem to be men's trousers at Le Tabou, published in in *Life* magazine, September 29, 1947. Photo by Carl Perutz, © Pete Livingston, www.perutz.net.

uniforms for the German army. François Bamberger joined the Resistance at the age of eighteen in September 1940 and occupied several important roles despite his young age. After the war, his father having been killed in Auschwitz, Bamberger

sacrificed a promising political career to run the family business. Bamberger had many friends in Saint-Germain-des-Prés and even after regaining the company, he divided his time between Lille and the capital (Bamberger 2015).

In a TV program devoted to her life first broadcast in France in 1962, Gréco seems to suggest that necessity, or maybe opportunity, resulted in her sartorial move toward black:

> Les choses commencèrent comme ça. D'abord, on fut vêtu de draps kakis, par la force des choses, de la guerre. Et ensuite, on eût droit à un certain lot de loden gris-verts, qui probablement devaient venir de l'occupation allemande, j'imagine. Et puis alors, vint la période faste, la période de la gabardine noire!
>
> Et nous fûmes tous habillés, par la force des choses une fois de plus, en garçon parce que la maison de confection de François ne comportait pas de département féminin. Nous étions habillés comme des garçons, vous savez: de grandes épaules carrées, des petits boutons, dans le mauvais sens. On était finalement assez élégants et c'est comme ça que commença la mode de Saint-Germain-des-Prés. (Juliette Gréco 1962)
>
> [This is how things started. At first we were dressed in khaki cloth, out of necessity, because of the war. And then, we got hold of a lot of grey-green Loden cloth, which probably, I imagine, stemmed from the German Occupation. And then came the good times, the period of the black gabardine!
>
> And we were all dressed, by necessity once again, "en garçon" because François' ready-to-wear company did not have a womenswear section. We were dressed like boys, you know: large square shoulders, little buttons fastening the wrong way. We were actually quite elegant and this is how the fashion of Saint-Germain-des-Prés started.]

Not all of Gréco's clothing consisted of menswear manufactured in Lille. Both Cazalis and Gréco took their fabric allocations to "une ravissante Tahitienne" [a lovely Tahitian] who could sew "comme une fée" [like a fairy] and wielded her scissors like none other (Gréco 1982: 107). On August 2, 1947, *Samedi-soir* ran an article on Taï Moana Kermarec,[5] the Tahitian dressmaker who, it was claimed, had just presented the first "existentialist collection" at Le Tabou. The article was accompanied by photographs of Taï with her sewing machine, a Tabou regular in what looks like a perfectly ordinary striped summer dress and Cazalis in a kind of night gown made of batik fabric. No doubt Gréco could have had her black gabardine fashioned into a dress or skirt suit but she continued to wear trousers, albeit better fitting ones, which for this article she coordinated with a long-sleeved Breton shirt and white sandals (*Samedi-Soir* [108]: 9) (Figure 14.2).

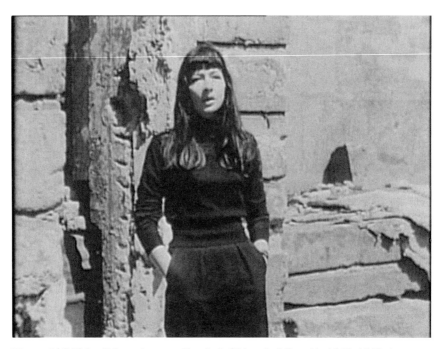

Figure 14.2 This still from Jacques Baratier's "Désordre" filmed in 1947–1948 shows Juliette Gréco in fitted black trousers. "Désordre" by Jacques Baratier © 1949 Argos Films. All rights reserved.

The Cazalis-Doelnitz-Gréco triumvirate did not leave their local village often, but occasionally they walked across the Pont Alexandre III to explore the *Rive Droite*. While Gréco's clothes had been tolerated—even admired—in Saint-Germain-des-Prés, they did not find favor here:

> Avec mes pantalons noirs, mes cheveux longs et lâches, mes yeux soulignés de crayon noir et ma bouche sans fard, on me jette des regards stupéfaits, surpris par mon excentricité et mon allure provocante. (Gréco 2012: 89)
> [With my black trousers, my long and loose hair, my eyes underlined with black crayon and my make-up-free mouth, I am being given stupefied looks, surprised by my eccentricity and my provocative appearance.]

Marc Doelnitz remembered the treatment the friends received during an expedition to the Champs-Elysées:

> Nos tenues—dites existentialistes—déclenchèrent immédiatement sur la rive droite un tollé de sarcasmes et d'injures qui me fît me souvenir du temps des zazous. Le noir étant la dominante de notre vêture, nous eûmes droit à des: "Saint-Anne, c'est par là", "Maman j'ai peur", "Vous vous habillez chez Borniol?" et autres amabilités … (Doelnitz 1979: 168)

[Our clothes—so-called existentialist—immediately sparked off a torrent of sarcasms and insults on the right bank, which reminded me of the times of the zazous. Black was the dominant feature of our clothing, and we earned ourselves the "Saint-Anne, that's this way," "Mum, I'm afraid," "Do you buy your clothes at Borniol?" and other niceties.]

Saint-Anne was a psychiatric hospital in Paris and Maison Borniol a famous undertaker. This last allusion was not entirely off the mark, as Gréco is said to have obtained her black sweaters from a store for ecclesiastical vestments near the Church of Saint-Sulpice, the area where she first lived after her prison release (Dicale 2001: 140).

So what was it that annoyed the inhabitants of the *beaux quartiers* [beautiful quarters] so much? It was probably not just the color black. Anne-Marie Cazalis also recalled a foray to the Champs-Elysées—it is not unlikely that the three friends described the same traumatic experience. Cazalis claimed that stones were thrown at the trio because of Doelnitz's hairstyle and Gréco's trousers, despite the fact that Christian Bérard had devised them. As these designer trousers were not made of black gabardine but of check fabric (Cazalis 1976: 89; Gréco 1982: 107), it was more likely the garment itself that shocked the bourgeoisie.

Photographs taken on the streets of Paris during and just after the war suggest that women rarely resorted to wearing slacks. André Zucca's extraordinary images from the period of the Occupation include one of a young female cyclist on the Cours de Vincennes wearing what seem to be men's trousers. Zucca might have photographed the young woman because this was such a rare sight, but we also know that she reminded him of a popular actress (Zucca 2008: 136). The more than two hundred of Zucca's images published in 2008 do not seem to depict any other women wearing trousers but the garment creeps into his oeuvre in other ways. Above the window displays of "Fashionable," a shop in in Montmartre, a large sign advises potential female clients in 1943 "Pour avoir chaud cet Hiver! … Portez le pantalon à semelles de bois" (Zucca 2008: 66). [To be warm this winter! … Wear trousers with your wooden soles.]

It might have been more acceptable to wear trousers in winter. Henry-Georges Clouzot's film *Quai des Orfèvres*, filmed between February and May of 1947 and released later the same year, is set in the cold season. At the beginning of the film, we briefly see a young woman in slacks climbing up some stairs. Simone Renant as the photographer Dora Monier wears trousers in her studio but not outside, and her sartorial preference might also have been used to allude to her sexual inclination. When *Elle* revealed the secrets of the coming winter fashions in October of 1946, the magazine reported: "Sur les Pantaloons … [*sic*] tout le monde est unanime: il en faut un." [With regards to trousers … everyone agrees: you have to have them.] But these were trousers by Balmain (for the cold city, for the snow and for the home), Hermès (for everywhere), and Lanvin

(a "jupe-culotte" for cycling and for walking) (*Elle* 1946 [46]: 5). Trousers had also previously appeared in several summer issues of the fashion magazine, but they appear to be associated with holidays by the sea, rather than urban wear.[6] Judging from the issues of *Elle* published between April 1946 and October 1947 trousers were acceptable on certain occasions and when necessity demanded, for a short period after the war. The arrival of Dior seems to have put an end to their use.

Jane Aubaile, born in August 1929, was brought up in the capital and lived there after the war. Jane, then called Huguette, accompanied her older brother to the popular haunts of Saint-Germain-des-Prés where she encountered Juliette Gréco, two years her senior, several times. Huguette/Jane remembered that trouser-wearing women were indeed rare:

> Juliette Greco et ses pantalons! Encore un moyen de se faire remarquer car le port du pantalon n'était pas courant, et même exceptionnel. Les femmes qui en portaient étaient rares, il n'y avait aucun pantalon dans les boutiques pour femmes. Il fallait alors les faires [sic] faire par une couturière. Moi j'ai porté quelque fois des pantalons qui étaient faits par ma mère mais je ne le portais pas pour sortir dans la rue. (Aubaile 2014)
>
> [Juliette Gréco and her trousers! Another means of getting herself noticed, as wearing trousers was not common, in fact exceptional. Women who wore trousers were rare, you could not get any trousers in women's shops. You had to have them made by a dressmaker. I sometimes wore trousers which my mother had made, but I never wore them on the streets.]

Gréco's trousers became a symbol, a shorthand, and a cliché for a world that was upside down, where the young preferred to live beneath the earth. During the 1950s, Leo Malet published a series of crime stories each set in one of the capital's arrondissements. In *La nuit de Saint-Germain-des-Prés* [The Night of Saint-Germain-des-Prés], the detective Nestor Burma, having to make way for a small group of American tourists, muses about the reasons behind the recent fame of the quartier:

> Je songeais, qu'en somme, le nez de Cléopâtre de Saint-Germain-des-Prés, c'est un falzar d'homme porté par une fille. [...] Ça a suffi pour changer, sinon la face du monde, en tout cas l'atmosphère de ce quartier, plutôt familial et bourgeois, et le rendre célèbre dans les contrées les plus reculées de la planète. Tout cela du jour où une jeune fille qui n'avait pas plus de fric pour aller chez le coiffeur que pour s'acheter une jupe à l'Uniprix de la rue de Rennes a emprunté le grimpant d'un copain. (Malet 1973: 18–19)
>
> [I think, in short, that the Saint-Germain-des-Prés' equivalent of the nose of Cleopatra are a pair of men's trousers worn by a girl. [...] That's been

enough to change, if not the entire world, in any case the atmosphere of this neighborhood, rather family-orientated and bourgeois, and make it famous in the most remote regions of the planet. All this because of the day when a girl ran out of dosh, could not go to the hairdresser or buy herself a skirt in the Uniprix in the rue de Rennes, and borrowed the trousers from a male friend.]

The two photos by Serge Jacques gracing the dust cover of a small book on *La légende de Saint-Germain-des-Prés* [*The Legend of Saint-Germain-des-Prés*], published in September 1950, each show a young woman with long hair in slacks. The Gréco lookalike on the front in her light sweater, black culottes, and espadrilles is unnamed while the pensive looking woman on the back in check trousers and Breton shirt is identified as the teenage actress Anouk Aimée. Inside, twenty-four hours in the life of Saint-Germain-des-Prés are charted in eighty-seven black and white photographs, which seem to have been taken over a number of years. Two further Gréco doppelgangers can be found toward the end of the book looking tired in the Tabou at 5 a.m. and, even more tired, waiting for the first metro, an hour later (Tavriger 1950). The sparse text and the captions were printed in both French and English, making the book a perfect souvenir for Americans in Paris.

Gréco is at pains to point out that she never intended to start a new fashion, but that she was fully aware of what was happening:

> On commence à copier sa façon de maquiller ses yeux. Un célèbre visagiste lui donnera le nom d'oeil de biche. On copie aussi sa non-coiffure, la couleur noire et les pantalons font fureur. Elle regarde. Indifférente. Elle ignore la mode. (Gréco 1982: 114)
> [They start to copy how she makes up her eyes. A famous beautician calls her doe-eyed. They also copy her non-hairstyle, the color black and trousers are all the rage. She looks on. Indifferent. She does not know what fashion is.]

Gréco's main imitator was her friend Annabel Schwob de Lur, later Buffet, who even followed suit when Gréco had her nose modified. Doelnitz described how Annabel, after a hard day's work as a model for Jacques Heim, changed each night into a sweater and black trousers to haunt the quartier (Doelnitz 1979: 187). The two young women were often photographed together and, in one series taken by Georges Dudognon in 1950, Gréco in black and Annabel in check trousers were shot in a variety of locations, at one point being joined by a third, trouser-wearing woman[7] (Figure 14.3).

The many photos taken in the cellars of Saint-Germain-des-Prés depict the odd women in slacks but not many entirely in black. In June of 1947, Simone de Beauvoir described (in English) a recent visit to the Tabou to her lover, the American author Nelson Algren:

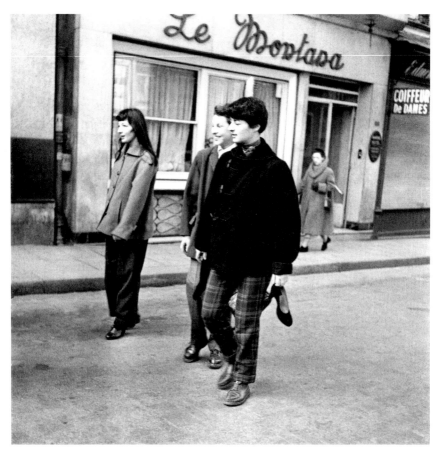

Figure 14.3 Juliette Gréco, Annabel, and an unidentified woman walk past the bar Le Montana in Saint-Germain-des-Prés, 1950. Georges Dudognon/adoc-photos.

> So about midnight I went to a very crazy but funny place where the young French so-called intellectual people dance and drink with very pretty pseudo-intellectual girls. It is a long cave under a little bar, a rather dark cave with reddish walls and ceiling, little tables and stools and hundreds of people dancing where there is place only for twenty of them. But it is nice because boys and girls were dressed in a very fancy way, with many colors, and they dance in a very fancy way too; some boys have brain [*sic*] and some girls very good faces. (Beauvoir 1999: 26–27)

Was black clothing really such an unusual sight? The street photographs taken by André Zucca during the Occupation include many women wearing black.[8] The somber color seems to have been slightly more favored by women of a certain age and above, even if younger women can also be seen dressed in

black. Jean Baronnet, in his text for the book about Zucca's images, stated that particularly in working class areas such as Belleville or Ménilmontant, rules relating to mourning attire were still strictly observed and "beaucoup de femmes portent encore des vêtements noirs" [many women still wore black clothes]. The degree of mourning was affected by the closeness of the relation to the deceased. Even in the 1940s, the loss of a husband necessitated wearing a black veil for many months (Zucca 2008: 142). The reason behind someone's choice of color is difficult to tell from a photograph. Some women might have been in the same position as Simone de Beauvoir after the Liberation who owned only very old clothes except for "a black suit that I kept for special occasions" (Beauvoir 1975: 19).

Black could be fashionable. In April 1946, *Elle* magazine declared that it was now clear what women wanted to wear in the spring. This included—for the period from noon to dusk—"robes noires" [black dresses] which are described as "très 'amusantes'; très décolletées; vonlontairement 'pauvres'" [very "amusing"; "very low-cut" voluntarily "poor"] (*Elle* 1946 [2]: 6). In July of the same year, Monique Danon advised *Elle* readers that if one felt like appearing "toute simple, unie, sobre, 'mono-tone'" [simple, plain, sober, "mono-tone"], black was acceptable even for the summer. The non-color, however, had its disadvantages, including that it was difficult to wear, showed up stains, and was "sans pitié" [without pity] demanding a perfect makeup (Danon 1946: 6–7).

It seems to have been the color black in combination with the trousers which reminded Beauvoir of fascists, presumably the Italian "Blackshirts" rather than the German occupiers who, as we heard above, preferred grey-green loden cloth. Whether and how the fascist penchant for black relates to the color's popularity in Capri in the late 1940s is still to be determined. This penchant was picked up by British *Vogue* in November of 1948 in the article "Black on the Beach" (*Vogue* 1948: 60–61). The anonymous writer of the very brief text and image captions singled out "the covered-up look," "the cult of identical shirts for men and women," "the passion for poplin" and "the prevalence for black." One of the Clifford Coffin photographs show the Count and Countess Uberto Corti acting as a "foil to the brilliance of sun and sea" in their black beach shirts, while in another image the countess "muffles herself in a huge turtle-necked black sweater" and "black velvet knee breeches." The Count and Countess Rudolfo Crespi looked resplendent in "identical open-necked shirts in black poplin" by Simonetta Visconti that "had great chic at Capri this summer" (*Vogue* 1948: 61). This *Caprese* fashion for black seemed to have lasted a long time, perhaps as an attempt by the aristocrats to hold on to the recent fascist past? *Go*, the short-lived British postwar travel and leisure magazine, reported only in its Holiday Number for 1953 that "Beach clothes are bright and gay this year. The Capri vogue for unrelieved black is on its way out. The trend is for vivid colors and nonsense clothes" (*Go* 1953: 20).

Gréco's near contemporary Huguette, already mentioned above, did not aspire to become a Juliette Gréco imitation. She preferred feminine clothes and in her view

Le noir s'imposait en opposition à la rue fleurie: en ville, les femmes portaient les robes fleuries aux multiples couleurs. Elles s'habillaient en couleurs exubérantes pour marquer la fin des années sombres, tandis que les existentialistes revendiquaient la couleur noire.

Les existentialistes vivaient en « ambiance close », tournés vers un « intellectualisme » trouvant sa source dans la négation. Les jeunes écoutaient cette forme de philosophie, dont Juliette Greco, ne devaient pas comprendre le fond. Qu'importe, on était existentialiste! (Aubaile 2014)

[Black positioned itself against the florid street: in the city, women wore flowery robes in multiple colors. They dressed in exuberant colors to mark the end of the somber years, while the existentialists laid claim to the color black.

The existentialists lived in a "closed environment", turned towards an "intellectualism" that had its roots in negation. The young people listened to this kind of philosophy, including Juliette Gréco, but did not really understand it. It did not matter, one was existentialist!]

Whether or not the existentialists really wore black does not really matter. The color seemed to fit those who lived by night as well as the popular conception of the philosophy they were said to follow. This can be gleaned from an article written by Sartre in December of 1944 for the communist weekly *Action* in defense of his version of existentialism against the most commonly voiced criticisms. Existentialism had been accused of "upholding nihilistic doctrines" and corrupting the youth encouraging them to turn away from action and to "cultivate a refined despair" (Sartre 1944: 155). While Sartre protested against the idea that existentialism was merely a "mournful delectation" (Sartre 1944: 160), he also made it clear that his was not an uplifting philosophy and that despair, anguish, and a feeling of being alone were necessary.

Sartre explained that existence preceded essence: "man first *is*, and only subsequently is this or that." Man creates his own essence: "it is in throwing himself into the world, suffering there, struggling there, that he gradually defines himself" (Sartre 1944: 157). Since there is no set morality, nor are there guidelines; man is alone in his decisions but at the same time responsible for everyone else. This "total responsibility," according to Sartre, rightly induces fear and anguish. Despair stems from the realization that man "can count on nothing but himself: that he is alone, left alone on earth in the middle of his infinite responsibilities, with neither help nor succor, with no other goal but the one he will set for himself, with no destiny but the one he will forge on this earth" (Sartre 1944: 159). While for Sartre despair is the origin of optimism and he speaks of man rejoicing "in

counting on himself alone and in acting alone for the good of all" (Sartre 1944: 159), existentialism's bleak reputation is maybe not surprising. Anguish, despair, being alone, being "nothing" before making something of oneself seem aligned with darkness rather than light and might have made the assumed preference of the cellar-existentialists for black clothes seem natural.

There is another aspect of the color black. During the First World War, African American soldiers had reached France in large numbers. Many stayed, followed by artists, writers, and musicians, who contributed to the popularity of jazz between the wars. The condemnation of jazz by the Nazis during the Occupation made it into a symbol of anti-fascism and it became an essential part of the existentialist culture and myth. One of the main promoters of jazz was Boris Vian, another pillar of Saint-Germain-des-Prés. Born in 1920, Vian was a jazz fan from an early age, who played the trumpet professionally, and wrote novels, plays, articles, as well as music reviews for the magazine *Jazz Hot*. He gained notoriety for his translation of a novel of the black American author Vernon Sullivan, allegedly banned in the United States for its subject matter and graphic descriptions of sex and violence. *I Shall Spit on Your Graves* was one of the best sellers of 1947 but in 1953 it was revealed what many had suspected: that Vian had been the real author of the story.

The real or mythical preference for the color black by the so-called existentialists is probably not a conscious symbol of solidarity with black Americans or Africans. Nevertheless, the latter's presence in Paris might have heightened what James Naremore, the author of *More than Night*, calls "a noir sensibility" (Naremore 1998: 11). It is not surprising that this emerged after the Occupation, a period often referred to as the "années noires" or "black years." This preoccupation with darkness also had other symptoms. In 1945 Marcel Duhamel founded the *Série Noire*, a publishing imprint for Gallimard, which released crime fiction mainly by Anglo-American authors but also Vian's pseudo-translations. And it was French critics who coined the phrase "film noir" to describe Hollywood crime dramas (Naremore 1998: 15–16).

As if there were not enough already, there are further connotations of the color black. Huguette, described a postwar fashion for "slumming it":

Dans ces clubs il y avait les « snob de la pauvreté ». Etaient-ils si pauvres? Ils étaient en tout cas toujours habillés en noir. Le noir vient certainement d'un refoulement du mode de vie des bourgeois, peu importe leur richesse. (Aubaile 2014)

[In the clubs you had the "snobs de la pauvreté." Were they so poor? Regardless, they were always dressed in black. Black certainly came from a suppression of the bourgeois way of life, regardless of wealth.]

This is a theme picked up by Anne-Marie Cazalis:

En 1945, la France était pauvre. Il y eut un snobisme de la pauvreté. François de La Rochefoucauld,/duc de Liancourt, se fit portier du *Tabou*. Gréco fut une fille pauvre qui inquiète parce qu'elle belle. Quand les journalistes disaient: « Elle a les cheveux trop longs » ou « Je n'aime pas ses pantalons », c'est de la pauvreté qu'ils essayaient de nous dégoûter. Mais c'est sa beauté qu'ils lui reprochaient secrètement. Belle sans argent, Gréco fut le symbole de notre après-guerre. (Cazalis 1976: 91–92)

 [In 1945, France was poor. There existed a snobbery of poverty. François de La Rochefoucauld, duc de Liancourt, became the doorman of the *Tabou*. Gréco was a poor girl who disturbed people because she was beautiful. When the journalists said: "Her hair is too long" or "I don't like her trousers," they tried to put us off poverty. But her beauty served as secret criticism of them. Beautiful without money, Gréco was the symbol of our post-war.]

At times Gréco's black clothes seem to have been an act of passive aggression, a way of trying to attract attention while pretending to want to blend into the background, similar to her often-mentioned silence during the conversations of friends. Black also highlighted her beautiful face and hands, an effect that she was to employ throughout her life.

Encouraged by Sartre, Gréco took up singing in 1949 at the same time as Doelnitz had been asked to revive the faded interwar glory of a cabaret off the dreaded Champs-Elysées (Schlesser 2006: 94–95). On June 22, 1949, Gréco made her debut at the Bœuf sur le Toit wearing her customary black trousers and sweater, albeit accentuated with gold sandals. Not long thereafter, Gréco appeared at the Rose Rogue, another Left Bank subterranean establishment but far removed from an existentialist cellar. *Chanteuses* did not wear trousers there and the cabaret's owner Niko Papatakis dragged Gréco to the sale at Balmain, where he purchased a long black dress with a train of gold satin. Unhappy with this intrusion of lightness into her wardrobe, Gréco cut off the offensive appendage (Gréco 1982: 138).

Black was not an uncommon choice for a female French singer and Gréco was following in the footsteps of Damia and Edith Piaf. But the severity of Gréco's working wardrobe—the long, narrow sleeves, the absence of jewelry, the lack of makeup, and the often mentioned long hair—was nevertheless deemed to be scandalous, at least for a while (Figure 14.4).

À cette époque, et pour la majeure partie des gens, l'image de la femme que je représente n'est pas recevable. Ma propre personne, ma voix, mon interprétation, mes formes ne sont que provocation. Dans ma robe noire moulante, les cheveux défaits, la voix grave, je suis une image violente, un scandale, un interdit! (Gréco 1982: 155)

 [At that time, and for most people, the image of woman that I represented was not acceptable. My own person, my voice, my interpretation, my shape

was nothing but a provocation. In my figure-hugging dress, my hair undone, the deep voice, I was a violent image, a scandal, something forbidden!]

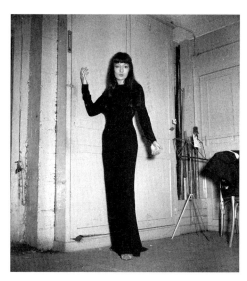

Figure 14.4 Juliette Gréco behind the scenes at the Paris music hall theater Bobino, November 1951. Photo by Lipnitzki/Roger Viollet/Getty Images.

Doelnitz went even further, explaining that in the eyes of the bourgeoisie of the sixteenth arrondissement:

Juliette n'eût pas été plus indécente uniquement vêtue d'une feuille de vigne. […] Mais cette trop grande simplicité choquait le conformisme endiamanté. Comment pouvait-il y avoir du talent là-dessous, alors qu'on n'avait même pas fait un effort de toilette pour se présenter devant les gens convenables! (Doelnitz 1979: 196)

 [Juliette couldn't have been more indecent if she had worn a fig leaf … But this simplicity, which was too much, shocked the bejeweled conformism. How could there be talent underneath, if one hadn't even made an effort with ones clothes to present oneself to respectable folk!]

Gréco likened her working wardrobe, "le noir de travail" [the black for work] to a blackboard liberating the imagination of her audience (Gréco 1982: 138). Maybe she still remembered her school days when as a teenager she stared at the "tableau noir qui m'ouvre son monde imaginaire" (Gréco 2012: 44) [the blackboard that opened its imaginary world to me]. In her first autobiography, Gréco had separated *Jujube*, the real Juliette, from Gréco, her public persona, and her choice of working wardrobe similarly suggests that the singer used black

as a shield or coat of armor to protect her true self. The blackboard analogy also seems to suggest that the color black had no meaning. As we have seen, that was not the case.

Acknowledgments

With many thanks to Jane Aubaile, Marion and Olivier Bamberger, Sarah Piettre and Melina Plottu.

English translations in square brackets have been provided by the author.

Notes

1 "Black being the dominant colour of our wardrobe …" (Doelnitz 1979: 168).

2 For the use of autobiographies to recover Saint-Germain-des-Prés see Benjamin Steiner, particularly part 3, chapter 2: "Individuelle and kollektive Erinnerung an Saint-Germain-des-Prés" [Individual and collective memories of Saint-Germain-des-Prés] (2004: 95–104).

3 The main sources for Gréco's biography are her two autobiographies *Jujube* (1982) and *Je suis faite comme ça* (2012) as well as Bertrand Dicale's biography (2001).

4 See also Serge Jacques's photograph of Gréco and "Le Major" (Jacques Loustalot) at the Café Flore, c. 1945–1947, in Caracalla (1993: 154).

5 The last name was difficult to make out on the micro-film of *Samedi-Soir* held at the Bibliothèque Nationale. According to Gréco, the dressmaker became the wife of the lawyer Jean-Pierre Le Mée (Gréco 1982: 107).

6 See *Elle* (33), July 2, 1946: 10–11; *Elle* (37), July 30, 1946: 12–13; *Elle* (44), September 17, 1946: cover and 5.

7 See photos by Georges Dudognon on the website of the adoc-photos picture library, image numbers: 00024078, 00024079, 00024085, 00024094, 00056952 (accessed October 29, 2015).

8 See in particular Zucca's photos of the "Terasse du Colisée sur les Champs-Elysées" (2008: 26–27); "À l'angle du boulevard des Capucines et de la place de l'Opéra" 1943, (60–61); "Place de la Republique," 1943 or 1944 (72); "Foire du Trône," 1941 (132–133); "Boulevard de Clichy," 1943 (148–149); "Rue de Belleville, 1944" (158–159).

References

Aubaile, J. (Huguette) (2014), Text emailed to author, 27 September.
Audhuy, C. and J. L'Herminie (2011), "Les Robe Grises: Dessins et manuscrits clandestins de Bibliothèque Nationale Universitaire." Available from: http://issuu.com/bnustrasbourg/docs/cataloguerobesgrisesweb (accessed October 31, 2015).
Bamberger, O. (2015), Telephone conversation with author, 12 October.

"Beach Parade" (1953), *Go*, Holiday Number:20.

Beauvoir, S. de ([1968] 1975), *Force of Circumstance*, London: Penguin Books. (Please note the book was first published in French in 1963, 1968 refers to the first Penguin publishing date.)

Beauvoir, S. de (1999), *Transatlantic Love Affair*, New York: New Press.

"Black on the Beach" (1948), *Vogue* (UK), 104 (11), November:60–61.

Caracalla, J.-P. (1993), *Saint-Germain-des-Prés*, Paris: Flammarion.

Cazalis, A.-M., (1976), *Les mémoires d'une Anne*, Paris: Éditions Stock.

Cohen-Solal, A. ([1985] 1987), *Sartre: A Life*, London: Heineman.

Danon, M. (1946), "Cette Robe Noire vous tend 10 pièges," *Elle* (36) July:6–7.

Dicale, B. (2001), *Gréco: Les vies d'une chanteuse*, Paris: JC Lattés.

Doelnitz, M. (1979), *La Fête à Saint-Germain-des-Prés*, Paris: Éditions Robert Laffont.

"Elle dévoile les secrets de la mode nouvelle" (1946), *Elle* (46), 1 October:5.

Frizell, B. (1946), "Existentialism," *Life*, 20 (24), 17 June:59–60, 62, 64, 66.

Gréco, J. (1982), *Jujube*, Paris: Éditions Stock.

Gréco, J. (2012), *Je suis faite comme ça*, Paris: Flammarion.

Juliette Gréco (1962), [TV programme] Dir. Pierre Cardinal, France: Radiodiffusion Television Française, 13 July, Available from: http://www.ina.fr/video/CPF86648603/juliette-greco-video.html (accessed October 23, 2015).

"La Mode de Printemps" (1946), *Elle* (20), April:6.

"Les nouvelles tournées Cook stoppent devant: Ces jeunes fille en quête de vérité … [*sic*]" (1947), *Elle* (90), 5 August:4–5.

"Life Visits Bohemian Paris" (1947), *Life* 23 (13), 29 September:146–48.

Malet, L. ([1955] 1973), *La Nuit de Saint-Germain-des-Prés*, Paris: Le Livre de Poche [original title: *Le sapin pousse dans les caves*].

Naremore, J. (1998), *More than Night: Film Noir in its Contexts*, Berkeley/Los Angeles/London: University of California Press.

Quai des Orfèvres (1947), [Film] Dir. Henri-Georges Cluzot, France: Majestic Films.

"Samedi-Soir à deux ans: il dépasse largement la tour Eiffel" (1947), *Samedi-Soir*, (101), 7 June:2.

Sartre, J.-P. (1944), "À propos de l'existentialisme: Mise au point," *Action*, (17) 29 December:11, in: Sartre, J.-P., Rybalka, M. and Contat, M. (eds) (1974), *Selected Prose: The Writings of Jean-Paul Sartre*, Volume 2, trans. R.C. McCleary, 155–60, Evanston: Northwestern University Press.

Schlesser, G. (2006), *Le Cabaret "rive gauche,"* Paris: Archipel.

Steiner, B. (2004), *Die Existentialisten. Generationengeschichte einer Jugendbewegung im Paris der Nachkriegszeit*, Magisterarbeit [MA Thesis], Fakultät für Geschichts- und Kunstwissenschaften Historisches Seminar Ludwig-Maximilians-Universität München, Available from: https://epub.ub.uni-muenchen.de/664/1/Steiner_Benjamin.pdf (accessed October 29, 2015).

Tavriger, M. (1950), *La légende de Saint-Germain-des-Prés*, photographs Serge Jacques, foreword Pierre Seghers, Paris: La Roulotte.

"Une Tahitienne a présenté à Saint-Germain-des-Prés la première collection existentialiste" (1947), *Samedi-Soir* (108), 2 August:9.

"Voici comment vivent les troglodytes de Saint-Germain-des-Prés" (1947), *Samedi-Soir*, (95), 3 May:6.

Weiner, S. (2001), *Enfants Terribles: Youth & Femininity in the Mass Media in France, 1945–1968*, Baltimore: The John Hopkins University Press.

Zucca, A. (2008), *Les Parisiens sous l'occupation: photographies en couleurs d'André Zucca*, contributor Jean Baronnet, preface Jean-Pierre Azéma, Paris: Gallimard.

15

BRITISH SCARLET BROADCLOTH, THE PERFECT RED IN EASTERN AFRICA, c.1820–1885

Sarah Fee

Fifteen of my young men died one day because I said I must have a certain red cloth that was thrown down [to my rivals] as a challenge.

Chief Mirambo of Unyanyembe, Tanzania, to Henry Morton Stanley, 1882.

African fashion exists, a point that has been firmly established by many recent essays, monographs, and edited volumes (Gott and Loughran 2010; Jennings 2011; Hansen and Madison 2013; Rovine 2014) and this holds true for the past as well as the present. Before the widespread adoption of tailored garments in Africa, "wrapper dress"—a large rectangle of cloth wrapped around the waist, hip, or shoulders—was subject to fashionability, gauged by fiber, weave, pattern, finish, and color. As throughout the world and across time, translocal trade often provided inspiration (Lemire 2010). In eastern Africa, the area examined in this text, from the medieval period, records show that people enthusiastically demanded and consumed foreign fabrics, and their quickly changing tastes had to be satisfied by producers or they risked poor sales (Prestholdt 1998, 2004, 2014; Machado 2014). In the nineteenth century in particular, intensification in global commerce attracted merchants from Asia, Europe, and America who aggressively marketed hundreds of types of cloth, but the residents of eastern Africa were interested in just a few. Only two products of purely European design captured a tiny share of the market. They were British-made fabrics of brilliant red shades: broadcloth and bunting, woolen goods that are defined and described

below. Across the wide expanse of the eastern half of Africa, from Uganda to Madagascar, broadcloth especially was adopted as part of a system of political elite fashion. How and why this came about forms the subject of this text.

It begins with a few comprehensive observations on the color red in human history in general, and in sub-Saharan Africa in particular. Next, it examines the appropriation of foreign red woolens in West Africa, and red broadcloth as a perfect vehicle for the color red, before turning to the select consumption of this cloth in eastern Africa, a vast interlinked trading zone that comprised present-day southern Somalia, Kenya, Tanzania, Mozambique, Uganda, northern Zambia, and the offshore islands of Madagascar and the Comoros Islands. Finally, it examines the case study of the royal dress of highland Madagascar, where the demand for British scarlet broadcloth was fueled by a complex mix of preexisting symbolism and the political need for novelty.

It has long been appreciated that the color red holds a special place in human perception, cognition, and cultural codes. In a highly influential cross-cultural survey of the 1960s, the anthropologist Brett Berlin and linguist Paul Kay (Berlin and Kay 1969) found that in many language groups, only two color terms exist: black and white. In cultures where a third term exists, it is red. In such cases, other hues are linguistically assimilated to one of these three, as among the Ndembu of Central Africa, where "blue cloth … is described as 'black' cloth, and yellow and orange objects are lumped together as 'red'" (Turner [1966] 2013). Other scholars point out that "that red is the oldest-identified, or at least oldest named, color" (Kay-Williams 2013: 16). This explains why in some ancient societies—Egypt, China, and Coptic Arabic, for instance—the term for red is the general term for color. Berlin and Kay attributed this special status of red to innate, physiological processes. Goggin (2012: 30) neatly explains that the color has unique properties, being "the lowest of light frequencies discernable to the eye"; red is known to make the eyes dilate and the heart beat faster. Amy Butler Greenfield (2006) concludes in her popular study of the color red in human history, "before there was blue or yellow or green there was red, the color of blood and fire."

A large body of anthropological literature has, however, questioned this "color science" and its universalizing assumptions. Although there may exist innate human cognitive response to colors, the *cultural* associations, meanings, emotions, and uses which different societies assign to them vary widely. Anthropologist Diane Young (2006) underscores that "cognition is always mediated by other people and altered by social experience." Sub-Saharan Africa—an immense area populated by hundreds of ethnic groups speaking hundreds of languages—offers a case in point. In his famous study, anthropologist Victor W. Turner ([1966] 2013) showed that color symbolism is contextual, relational, often ambiguous, and tinged with moral evaluations. In Central Africa, different societies may classify blood as "black" or "white" depending on the context. Yet even these studies of "color

as language and as symbolic meaning"—what people *perceive* or *say* in regard to color—are insufficient according to Young. They tend to dematerialize color, neglecting to study its *vehicle*, which is often key to cultural appreciations of it. Further, it must be recognized that color has agency which individuals harness to their own ends. We thus also need to consider what people *do* "with material colored things within the dynamics of social practice" (Young 2006).

Ethnographic studies reveal that in several areas of sub-Saharan Africa, red is understood as an ambiguous hue, associated with life-force, supernatural powers, and rulers; it signals both "distinctiveness and threatening power" (Renne 1995). Acquiring, wearing, and displaying red items of dress were thus often central to leaders' claims to divine status and political legitimacy. In West Africa, this ongoing need for certain types of colored red adornment inspired people to trade across incredible distances and odds. Red corral and magenta silk, among other objects, formed an important part of the trans-Saharan trade route, which flourished from the eighth to sixteenth centuries, linking the Mediterranean and North Africa to sub-Saharan Africa across hundreds of miles of lifeless desert. From the fifteenth century, when the Portuguese—followed by the Dutch, English, and French—began to frequent West Africa's coastline, these trade patterns shifted southward. One inducement for West Africans to redirect their trade to Atlantic ports were the Indian and other foreign textiles Europeans brought to trade; some of the most popular being British red woolens.

Historian Colleen Kriger (2006) has considered the contributory factors for this popular reception of British red woolen yarn and fabric in West Africa, and why it topped the list of imported trade goods from the 1600s. Local artisans had access to sources for dyeing their cotton thread red; but the color was surpassed by the better dye-absorbing properties of wool, which produced "greater intensity and saturated quality of the color" (Kriger 2006: 36). With its "exceptional luminosity," British red wool created a "visual power that was … seized upon by political and religious elites and deployed in their service" (36). Its initial high cost further added to its luxury status. The top echelons of society in many West African locales thus coveted cloths made of the fiber, though for different uses and purposes. Kriger does not specifically mention broadcloth among the British red woolens traded to West Africa, but her descriptions imply that they were.

Broadcloth takes its name from the process of its creation: wool was woven in broad widths, up to 4 meters wide, then fulled in hot water to shrink it and create a felted surface (Munro 2009). A dense nap was further formed by using short staple English wool and a variety of methods to brush, press, and/or shear it. Broadcloth was valued in Europe for its warmth, durability, stiff drape, waterproof features, and hard edges, which did not fray and therefore did not require hemming. In the Medieval period, it was a heavy, luxury fabric produced in many areas of Europe in a wide variety of colors and qualities. In early modern

times, England emerged as the major center, mass-producing lightweight, lower-quality versions, with the West Country and Gloucestershire in particular leading production. Into the eighteenth century, the town of Stroud produced the famous "Stroudwater reds"—chosen to clothe the Army's Redcoats—their superior color attributed to the special qualities of the local waters.

Thus color mattered deeply. In most places, scarlet broadcloth was the most costly and valued. Historian John Munro argues that in Europe it was the dye that made the cloth so prestigious. It was not the quality of the wool or the shearing of the cloth that elevated its price, but the expense of scarce insect-based kermes dye which added 181 percent value to the wool and accounted for 63 percent of the price of the finished product. Exorbitantly expensive, scarlets were the cloth of rulers and the Church. Color historian Amy Butler Greenfield (2006: 3) summarizes, "Elusive, expensive, and invested with powerful symbolism, red cloth became the prize possession of the wealthy and well-born."

The overseas demand for broadcloth greatly stimulated British production. From the late 1500s, English merchants joined other Europeans in traveling to Asia, initially with the purpose of finding new markets for broadcloth. The cloth failed to appeal to consumers in India, who acquired only small amounts as furnishings and animal trappings, but it proved wildly popular in the Levant, and far into Central Asia, where it was imported in colossal amounts, giving new life to Gloucestershire production. In the new world, too, there was avid demand. Anthropologist Cory Willmott (2005) has shown that the First Peoples of the Great Lakes region demanded woolen textiles—more so than arms, beads, or iron goods—in exchange for the furs the Europeans sought. Broadcloth—not the better-known blankets—topped their list of desired goods. A variety known as "stroud" in fur trade circles was developed specifically to appeal to Native Americans, who used it widely to fashion and adorn pouches, leggings, breechcloths, wrappers, and tunics. Curiously, Willmott devotes little attention to color, noting only that blue broadcloth was most in demand, followed by red, with others a distant third. In West Africa, as noted earlier, color mattered deeply; red woolens met with greatest success, a preference that applied to eastern Africa, but with some singular variations.

While West Africans welcomed a variety of types of woolen cloth from Europe, in eastern Africa consumers largely rejected them.[1] The only exceptions were broadcloth and a distantly related woolen prototype, bunting, the vast majority of it a bright red. Although imported in only small amounts, broadcloth in particular was integral to the reshaping of economic and social life in the eastern half of sub-Saharan East Africa in the nineteenth century. From c.1820 to 1885, this vast area became linked through a network of caravan trading trails that moved ivory, slaves, and copal to ports on the Indian Ocean, most importantly Zanzibar, for export to India, Europe, and, increasingly, the United States. As important in the creation of this vast commercial empire was the local African desire for

imported cloth. The largest volume was coarse blue or white cotton yardage from India and the United States, which served as common dress (Alpers 1975; Sheriff 1987; Prestholdt 2004). The remaining approximately 20 percent consisted of costlier more luxurious fabrics, known as "cloth with names" (Fee in press). These included (1) finer grades of cotton cloth, (2) printed cotton wrappers, largely the fashion of coastal Swahili women, (3) Asian striped silk and cotton blends, and (4) broadcloth and bunting, usually of a brilliant red shade. Every trading caravan carried a selection of all these cloth types into the interior of eastern Africa, and each had a specific role to play in the complex intertwining of commercial and social relations.

The elite consumption of scarlet broadcloth during this period had multiple origins. Firstly it was due to what anthropologist Nicholas Thomas termed "localization": a foreign object being selected for consumption because it fits with preexisting cultural exigencies.[2] In eastern Africa, as in other parts of the globe described in this text, red had deep symbolic signification attached to notions of life force, fertility, and strength. Long before the arrival of Europeans in eastern Africa, red cloth of Indian manufacture appears to have served as the wrapper dress and regalia of rulers in some regions. Imported from Gujarat to the Swahili coast, it tended to be the most expensive of cotton cloths, perhaps because of the cost of the dyes involved, or their complexity. In the 1850s, the highest-ranking silk cloth, the *deuli*, was also most likely red (Alpers 1975: 22). Although evidence is sparse, observations suggest that the appeal of broadcloth laid not only its familiarity, but also in its novel features. First was its distinctive shade of red. Its scarlet hue may have been made from cochineal—which in England in the 1820s was used for making broadcloth of a fashionable "flame" color—and thus a change from the madder-based dyes of Gujarat (Partridge 1823: 143, 239; Chenciner 2000: 216). Certainly its wool base made for a unique product, with its luminous features as described above by Kriger. Arabs in eastern Africa reportedly valued broadcloth for its sheen, while African consumers were observed to judge quality by the length of nap (Burton 1860). In hiding the weave of the cloth and any hint of grid or pattern by a felted surface, a long nap effectively caused the cloth to appear as pure color. While referencing long-established color hierarchies, scarlet broadcloth also provided a novelty, an essential ingredient in claims to distinction, status, and ultimately power in the "prestige economy" of eastern Africa (Glassman 1995; Prestholdt 1998: 23, 27).

Four general social groups appear to have consumed broadcloth in eastern Africa. Swahili and Arab men of means, who were concentrated on the coasts, but also traded, traveled, and settled inland, used broadcloth in a variety of colors—blue, black, red, or light green—for tailoring Omani-style vests and overcoats that they wore on formal occasions. A second group of consumers were rulers in the interior, who ranged from village headmen to hereditary kings of vast territories. As formal dress they generally wore either

hand-woven silks from India and Oman or broadcloth. They might follow Arab styles and have broadcloth tailored into robes, but fashions from the coast never moved wholesale to the interior. Inland rulers overwhelmingly preferred red broadcloth, and as often wore it African fashion, wrapped around the hip or chest as a wrapper (Grant 1864: 101; Livingstone 1875: 516; Stanley 1878: 458; von Hohnel 1894: 177). In some areas, such as Madagascar and Uganda, sumptuary laws restricted broadcloth to royalty (Callet 1878). Elsewhere, notably the wealthy ivory market of Ujiji in Tanzania—with its ready access to trade and trade goods—broadcloth was worn more generally by men and "women of wealth" (Burton 1860: 320). A final distinctive group of consumers of scarlet broadcloth were caravan "elders" and guides; these men were hired by Arab and Swahili merchants—as well as European explorers—to manage the hundreds of porters who carried the trade goods necessary for lengthy journeys, and to lead, interpret, and serve as intermediaries with local populations. As distinct emblems of their responsibilities, they wore scarlet broadcloth as great capes, robes, and/or turbans, which they were particularly careful to don before entering important villages. If these guides were not provided with this cloth, they might refuse to proceed, as a group of Belgian missionaries discovered to their dismay in 1880, when forced to send an emissary eighty kilometers back to the Tanzanian coast in search of it (Leblond 1884: 62).

Broadcloth was available for sale at shops and markets but, as indicated in the foregoing incident, it tended to circulate in the context of exchanges, as gifts that recognized legitimacy and authority. The most vital and expensive of these were the "tributes" or "tolls" that caravans had to pay in imported goods to local rulers to trade and travel in the territory (Prestholdt 2004; Fee 2012). The bulk of the goods consisted in cloth, the ruler typically demanding specific, expensive types for himself. If unsatisfied, he might hold the caravan captive for days of negotiation. British explorer R.F. Burton (1860) noted in the interior, broadcloth was worth four times the price on the coast, making it a "present for a prince"; he also counseled that "a bit of scarlet broadcloth, thrown in at the end of a lengthened haggle, opens a road and renders impossibilities possible." Actual recorded gifts indeed suggest that red cloth played a regular and special part in the multi-phased, protracted gift-giving, with leaders requesting it in cases where it was not offered (Speke 1863: 210–211, 511; Grant 1864: 118; Stanley 1878: 248–249; Johnston 1886: 288). The fatal consequences for not recognizing sovereignty with the proscribed gift can be seen in this text's opening quote, wherein the famous Wanyamwezi chief Mirambo met his Arab opponents in pitched battle when they refused his demand for a "certain red cloth." In terms of volume and monetary value, British scarlet broadcloth was marginal in the trade to eastern Africa, accounting for as little as 1 percent of annual cloth imports (Rigby 1859), but in terms of local political and commercial dealings, it was indispensable.

The second imported red cloth based on a British woolen prototype that consumers desired in eastern Africa was bunting. Originally a worsted woolen fabric with a heavy glaze made in various areas of Europe, the bunting imported to eastern Africa was a lighter version made of cotton. It appears that only bright red varieties were desired (Stanley 1872: 50; Gamitto 1960, 2: 132, 143). Known in eastern Africa as *bendera*, from the Portuguese "flag" (*bandeira*), scarlet bunting indeed served for making the flag of the Omani sultanate—a red ground with the Union Jack in one corner and a crescent and star in the center—which was flown by numerous ships and official residences (Burton 1872, 1: 321; Krapf 1880: 24). In interior eastern Africa, meanwhile, red bunting, like broadcloth, was appropriated for wrapper garments. As the century progressed, the term *bendera* came to be applied to any bright "turkey-red"-dyed cotton, pointing again to the overriding importance of color. Originally developed in Turkey or India, these "turkey-red" dyes departed from those historically exported from Gujarat to eastern Africa. Although also based on madder, they entailed a complex recipe utilizing oils that produced a particularly bright and resilient shade that could withstand tropical sunlight, techniques mastered in England only from 1780. Much cheaper than broadcloth, British-made turkey-red cotton bunting was not reserved for the dress of leaders. In certain areas of the interior, the cloth was "especially prized by women" as wrapper dress (Burton 1860: 532). In others, warriors wore it in small amounts, either as headbands, or as stripes and fringes appliquéd onto a wrapper of unbleached cotton; thousands of these latter composite garments, known as *naibere* in Masaii country, were stitched together by caravan personnel for use in the Kilimanjaro area. In Madagascar turkey red cotton was appropriated for items of ritual dress, notably the tunics of boys to be circumcised.

The demand for these brilliant red fabrics in eastern Africa had far-reaching consequences, what historian Jeremy Prestholdt calls "global repercussions," as it compelled textile mills in other distant locales to begin producing them specially for that market. The first were the cloth factories of Salem, Massachusetts, that had been originally created in the 1830s to supply unbleached coarse cottons to eastern Africa. Salem's plain cottons achieved great success until the U.S. Civil War, when disruptions in supply provided a window of opportunity for industrial competitors, including the new factories of Mumbai. To regain their foothold in the East African ivory trade after the War, Salem merchants diversified their cloth offerings, in part by ordering scarlet broadcloth from the Salem mills, a shift necessitating considerable investments in new methods and machinery (Prestholdt 2012). Mumbai's factories similarly diversified, and by the end of the century captured the production of *bendera*, scarlet red cottons (Anonymous 1898: 306).

The term "eastern Africa" covers a huge swathe of land, ethnic groups, and languages. To understand red woolens' precise roles and meanings, it is

necessary to consider a smaller cultural unit. Madagascar offers an instructive localized case study of the nexus of red, royal dress and the parameters of political fashion. "A conventional Western sense of color is highly biased and based on ideas of aesthetics," observes Young (2006). The Madagascar evidence suggests that red was not merely "seen," or "perceived," but employed and experienced as a potent force.

Lying off the coast of Mozambique, Madagascar is the fourth largest island in the world, larger than all the British Isles combined. It was settled several thousand years ago, by immigrants coming from across the Indian Ocean, initially from Indonesia. By the nineteenth century the island was home to several million people and, like continental eastern Africa, was linked to western Indian Ocean trade networks. In their consumption and deployment of foreign red fibers and fabrics, they surpassed even their counterparts on the continent.

Madagascar had a highly developed and widespread hand-weaving tradition of cotton, bast, leaf, and indigenous "wild" silk. Weavers mastered a variety of local sources for creating red dyes, notably the bark of the *nato* tree, which produced a matte, brick-red hue, known as *mena*. *Mena* was one of the four named colors that included black, white, and yellow. Together, they were part of a complex cosmological matrix linking time and space. Madagascar color symbolism is closely related to systems in Indonesia, Java in particular, with additional elements drawn from Arabic astrology (Beaujard 1988; Crossland 2014). The system assigns each cardinal direction an element, destiny, force, color, and social category. Red was linked with the northeast corner, with strength, maturity, heat, life-force, ancestors, anger, and violence. Only rulers and nobles were endowed with the mystical strength necessary to wear red-dyed cloth and gold (also classified as red), and certain imported red ornaments, namely carnelian beads. By the first decades of the nineteenth century, the mightiest of Madagascar's rulers were the monarchs of the Merina kingdom of the central highlands, who controlled much of the island, including its major trading ports.

At this same time foreign imports came to supplement and then supplant local sources of red cloth as the most prestigious vehicle of red. One form was magenta Bombyx silk (*silimena*), imported as pre-dyed skeins by Arab merchants. Initially its cost was exorbitant and local weavers incorporated only small amounts into their weavings, giving rise to new cloth types, including spectacular mantles with supplementary wefts known as *akotifahana* (Fee 2013). By the 1820s, however, Merina rulers did not wear locally woven cloth, apart from a few ritual events; for most formal appearances they dressed instead in imported British scarlet broadcloth. British missionaries pointedly observed that: "The royal [cloth] … which is held in highest estimation, is of fine scarlet English broad-cloth, bordered and richly ornamented with gold lace … worn by the king on sacred festivals, and other state occasions" (Ellis 1838 vol.1: 279).

Red broadcloth—known in highland Madagascar as *jaky*—was the key material manifestation of Merina political legitimacy and supremacy (Callet 1878, 2: 1034). Sumptuary laws—the breaking of which were reportedly punishable by death—forbade it to all but kings and queens and the royal family, although rivals did attempt to usurp this prerogative. It was worn as wrappers, and it was further made into traveling tents and to cover royal objects: palanquins, corpses, tombs, the royal talismans; at the death of a monarch, the entire roof of the large royal palace—visible throughout the capital city of Antananarivo—would be covered in *jaky*. Indicative of the inseparable associations between *jaky* and political legitimacy, the key moment of Merina enthronement was the wrapping of the new Merina sovereign in scarlet broadcloth; symptomatic of its perceived independent agency, *jaky* was further believed to have the power to select a successor: boys were covered with red broadcloth as they slept, the cloth magically moving during the night to cover the head of the worthy child. *Jaky* was used, too, as an extension of the monarch; kings and queens dressed their private English-trained militia in red broadcloth, and granted honored subjects the right to wear small amounts. Extant items reveal that ritual objects associated with state powers, such as the hats worn by circumcisers, might also be made of *jaky*. The regular royal public proclamations and countryside tours, surrounded by the *jaky*-clad monarch, militia, tent, and talismans, presented a literal wall of brilliant red, a projection of divine force and temporal power.

In their study of cloth and dress in West Africa, art historians Perani and Wolf (1999) found royal regalia to be inherently "anti-fashion": purposefully unchanging and staid in fiber, cut, and color to mark allegiance to ancestral custom. In Madagascar, other patterns prevailed. Innovation—the ability to acquire and withstand the new—was interpreted as evidence of a sovereign's mystical strength. This was evident not only in the initial adoption of broadcloth, but also in further transformations of royal fashion. Over the course of the nineteenth century, not only fabrics but also silhouettes were radically altered. Although retaining the religious convention and historic practice of wearing the color red, from the 1820s, monarchs adopted European-style tailored dress for their daily wear: trousers, shirts, vests, robes, and dresses (Plates 15.1 and 15.2). Similarly, the list of royal red objects was continually expanded; imported red silk parasols, red satins, gold braid, red leather shoes, and stockings were all over time classified and appropriated as distinctive insignia of royalty; by the late 1800s, it appears that scarlet velvet had replaced broadcloth as the main royal fashionable fabric.

In 1858, British explorer Richard Burton viewed eastern Africa's imported scarlet broadcloth as a "cheap English article" costing 50 cents a yard. Looking at the same fabric, the people of Madagascar saw something extraordinary, divine, and fashionably royal. This text has endeavored to show that fashionability existed in pre-colonial eastern Africa, and long before tailored dress became the

norm. Local consumers sought novel goods for wrapper dress which producers as far away as India, Britain, and the United States competed to satisfy. Unlike the "anti-fashion" strategy of some leaders in West Africa, political elites on the eastern half of the continent partially based claims for legitimacy on claiming novel fashions. Understanding why they chose scarlet broadcloth among the many other foreign fabrics available to the region has required an investigation of the cloth as a "material colored thing." On the one hand, the desire for the cloth grew from preexisting color symbolism that associated certain objects classified as "red" with life-forces and authority. On the other, the physicality of broadcloth rendered it novel. Made of wool, which readily took red dyes, of novel colorants such as cochineal, and of a unique texture that obscured the weave pattern, broadcloth in this part of the world formed the perfect red.

Acknowledgments

I wish to express my thanks to Drs. Alexandra Palmer and Bako Rasoarifetra for their encouragement and help with various aspects of this paper. Research was made possible by grants from the Social Science and Humanities Research Council of Canada, and the ROM Department of World Cultures.

Notes

1 In 1811, British mariners exploring the coast of eastern Africa observed there existed "no demand for English woolens" there and consequently the cloth was "not imported" (Smee and Hardy cited in Burton 1872, 2: 512).

2 Other terms to indicate this phenomenon include "domestication" and "cultural authentication."

References

Alpers, A. (1975), *Ivory and Slaves in East Central Africa*, Berkeley: University of California Press.

Anonymous (1898), "German East Africa," in *U.S. Commercial Relations with Foreign Countries for the Year 1897*, Washington, DC: Government Press.

Beaujard, P. (1988), "Les couleurs et les quatre éléments dans le Sud-est de Madagascar: L'héritage indonésien," *Omaly sy Anio*, no. 27, January-June, pp. 31–48

Berlin, B. and P. Kay (1969), *Basic Color Terms: Their Universality and Evolution*, Berkeley: University of California Press.

Burton, R. F. (1860), *The Lake Regions of Central Africa*, New York: Harper and Brothers.

Burton, R. F. (1872), *Zanzibar: City, Island and Coast*, 2 vols., London: Tinsley Brothers.

Butler Greenfield, A. (2006), *A Perfect Red. Empire, Espionage and the Quest for the Colour of Desire*, London: Harper.

Callet, F. (ed.) (1878), *Tantara ny Andriana eto Madagascar. Documents Historiques d'après les Manuscrits Malgaches*, 3 vols., Antananarivo: Presse Catholique.

Chenciner, R. (2000), *Madder Red: A History of Luxury and Trade*, Richmond: Curzon.

Crossland, Z. (2014), *Ancestral Encounters in Highland Madagascar: Material Signs and Traces of the Dead*, Cambridge: Cambridge University Press.

Ellis, W. (1838), *History of Madagascar*, 2 vols., London: Fisher & Sons.

Fee, S. (2012), "Hostage to Cloth: European Explorers in East Africa, 1850–1890," *Proceedings of the Textile Society of America 13th Bi-annual Symposium, "Textiles and Politics," Washington, DC, 2012*. University of Nebraska Digital Commons.

Fee, S. (2013), "The Shape of Fashion: The Historic Silk Brocades (*Akotifahana*) of Highland Madagascar," *African Arts* 46 (3): 26–39.

Fee, S. (in press), "'Cloth with names': The Luxury Textile Trade to Eastern Africa in the Nineteenth Century," Textile History, special number: 'The Textile Trades of Eastern Africa'.

Gamitto, A. C. P. ([1831–1832] 1960), *King Kazembe and the Marave, Cheva, Bisa, Bemba, Lunda and Other Peoles of Southern Africa*, 2 vols., Lisbon: Junta de Investigações do Ultramar.

Glassman, J. (1995), *Feasts and Riot: Revelry, Rebellion, & Popular Consciousness on the Swahili Coast, 1856–1888*, London: Heinemann.

Goggin, M. D. (2012), "The Extra-Ordinary Powers of Red in 18th- and 19th-Century English Needlework," in A. Feeser, M. D. Goggin and B. Fowkes (eds), *The Materiality of Color. The Production, Circulation, and Application of Dyes and Pigments, 1400–1800*, London: Ashgate.

Gott, S. and Kristyne Loughran (eds) (2010), *Contemporary African Fashion*, Bloomington: Indiana University Press.

Grant, J. A. (1864), *A Walk Across Africa, or Domestic Scenes from my Nile Journey*, Edinburgh, London: William Blackwood and Sons.

Hansen, K. T. and D. Soyini Madison (2013), *African Dress. Fashion, Agency, Performance*, London: Bloomsbury.

Jennings, H. (2011), *New African Fashion*, New York: Prestel Publishing.

Johnston, H. H. (1886), *Kilima-njaro Expedition. A Record of Scientific Expedition in Equatorial Africa*, London: Kegan Paul.

Kay-Williams, S. (2013), *The Story of Colour in Textiles*, London: Bloomsbury.

Krapf, L. (1880), *A Dictionary of the Suahili Language*, London: Trubner and Co.

Kriger, C. E. (2006), *Cloth in West African History*, Lanham: Altamira.

Leblond, G. (1884), *A l'Assaut des Pays Negres. Journal des Missionaires d'Alger dans l'Afrique Equatoriale*. Paris : À l'Oeuvre des Écoles d'Orient.

Lemire, B. (2010), "Introduction. Fashion and Practice of History: A Political Legacy," in B. Lemire (ed.) *The Force of Fashion in Politics and Society. Global Perspectives from Early Modern to Contemporary Times*, London: Ashgate.

Livingstone, D. (1875), *The Last Journals of David Livingstone in Central Africa*, New York: Harper and Brothers.

Machado, P. (2014), *Ocean of Trade: South Asian Merchants, Africa and the Indian Ocean, c. 1750–1850*, Cambridge: Cambridge University Press.

Munro, J. (2009), "Three Centuries of Luxury Textile Consumption in the Low Countries and England, 1330–1570: Trends and Comparisons of Real Values of Woollen Broadcloth (then and Now)," in K. Vestergård Pedersen and M.-L. B. Nosch (eds), *The Medieval Broadcloth: Changing Trends in Fashions, Manufacturing and Consumption*, Oxford: Oxbow Books.

Partridge, W. (1823), *A Practical Treatise of Dying of Woolen, Cotton and Silk Skein, The Manufacturing of Broadcloth and Cassimere*, New York: Wallis & Co.

Perani, J. and Norma H. Wolff (1999), *Cloth, Dress and Art Patronage in Africa*, London: Berg.

Prestholdt, J. (1998), "'As Artistry Permits and Custom may Ordain'. The Social Fabric of Material Consumption in the Swahili World, circa 1450 to 1600," Evanston: Northwestern University, *PAS Working* (3).

Prestholdt, J. (2004), "On the Global Repercussions of Eastern African Consumerism," *The American Historical Review* 109 (3): 754–781.

Prestholdt, J. (2012), *Domesticating the World. African Consumerism and the Genealogies of Globalization*, Berkeley: University of California Press.

Prestholdt, J. (2014), "Africa and the Global Lives of Things," in F. Trentmann (ed.), *The Oxford Handbook of the History of Consumption*, 85–110, Oxford: Oxford University Press.

Renne, E. (1995), *Cloth that Does Not Die. The Meaning of Cloth in Bunu Social Life*, Seattle and London: University of Washington Press.

Rigby, C. P. (1859), "Return of the Exports of the Port of Zanzibar in the Year 1859," *British National Archives*, FO 54, vol. 17.

Rovine, V. (2014), *African Fashion, Global Styles. Histories, Innovations, and Ideas You can Wear*, Bloomington: Indiana University Press.

Sheriff, A. (1987), *Slaves, Spices and Ivory in Zanzibar*, London: James Curry.

Smee, T. and Lt. Hardy.(1872), "Observations During a Voyage of Research on the East Coast of Africa," [1811], reprinted in R. F. Burton (ed.), *Zanzibar: City, Island and Coast*, 2 vols., 493–94, London: Tinsley Brothers, vol. 2.

Speke, J. H. (1863), *Journal of the Discovery of the Nile*, Edinburgh, London: W. Blackwood and Sons.

Stanley, H. M. (1872), *How I found Livingstone. Travels, Adventures and Discoveries in Central Africa*, London: Sampson, Low, Marston and Co.

Stanley, H. M. (1878), *Through the Dark Continent*, 2 vols., New York: Harper and Brothers.

Turner, V. W. ([1966] 2013), "Colour Classification in Ndembu Ritual," Reprinted in M. Banton (ed.), *Anthropological Approaches to the Study of Religion*, 47–84, London: Routledge.

von Hohnel (1894), *Discovery of Lakes Rudolf and Stefanie*, 2 vols., trans. Nancy Bell, London: Longmans, Green & Co.

Willmott, Cory (2005), "From Stroud to Strouds: The Hidden History of a British Fur Trade Textile," *Textile History* 36 (2): 196–234.

Young, D. (2006), "The Colours of Things," in C. Tilley, W. Keane and S. Kuechler-Fogden (eds), *The Handbook of Material Culture*, 173–186, London: Sage.

16

LIVES LIVED: AN ARCHAEOLOGY OF FADED INDIGO

Kate Irvin

Saturated cloth, inundated with vibrant and precious coloring agents, has for centuries served as a material expression of power and wealth across the globe. Such surfaces protect, deflect, and project, astounding onlookers with the riches and otherworldly hues infused in and bound to the fibers. But what becomes of such armor as it is used and worn, once the surface cracks and the color fades into a seemingly shallow pool that merely echoes its former depth?

A potent response to this question may be found in the close study of an early-twentieth-century Japanese worker's garment made of, and patched with, layers of indigo blue cotton painstakingly colored with indigo dyestuff extracted from the leaves of the *Indigofera tinctoria* plant (Plate 16.1). This garment and others like it provide examples of the beauty and intimacy to be found in the well-worn blues of cotton workwear, as well as epitomize an aesthetic that has garnered increasing attention among artists and, most recently, in the world of avant-garde and sustainable fashion. Those of our contemporaries who are drawn to such pieces look to them expressly for the personal history that coats the surfaces bared of their formerly intense color, seeing in them a patina created by wear and repair that acts as another shield, this time warding off the chill of perfection. As bright sunlight, habitual movements, and repeated washings strip away brightness and stiffness, a bygone gloss is replaced by intimate narratives that can only be guessed at by most of us today.

In his painfully poetic film *Blue* of 1993, English filmmaker Derek Jarman has stated: "In the pandemonium of image/I present you with the universal Blue/Blue an open door to soul/An infinite possibility/Becoming tangible."[1] In this short text, I will explore that "open door to the soul" and some of the artists and designers

it has beckoned to its threshold. From a close look at the fading of indigo-dyed cottons, I will move to the meanings they have taken on in contemporary art and fashion culture as narratives of wear and personal history, and end by investigating the new interpretations they have engendered.

First let us consider the garment illustrated in Plate 16.1, a piece that might well serve as an exemplar of Jarman's tangible blue offering "infinite possibility." A far cry from garments fashioned for an elite clientele, this indigo-dyed cotton worker's jacket, or *noragi*, from rural Japan represents the height of meaningful production that has captured the imagination of the contemporary designers I will consider later in this text. In lieu of tales of wealth and privilege, the *noragi*, now in the collections of the Rhode Island School of Design (RISD) Museum, tells stories of hardship and labor at the same time that it expresses profound care, respect, and (we can only hope) love. It is an example of Japanese *boro*, literally translated as "ragged," and now used to refer to utilitarian items, often of cotton dyed blue with natural indigo. Such garments show not only heavy wear (and resulting tear) but also a loving, sometimes desperate hand that has utilized every resource within reach, recycling used cloth and repairing tatters by patching and layering bits and pieces together to create a regenerated, strengthened whole.

This particular *noragi* features an arrhythmic patchwork of cotton fragments in various shades of formerly deep indigo blues that allude to a long and layered history of ceaseless use. As opposed to that of many museum objects, this history is one that came to the RISD Museum without specific names and provenance. We can only deduce a line of ownership underscored by economic want, but a want that has been ameliorated by the strengthening stitches of a stable hand. Reconstructive patches across the shoulder, hem, front, and back at close inspection show the value of even the smallest scraps that, when pieced together, form amorphous lakes of differing blue depths in a landscape of faded down-to-earth hues. Even the larger expanse of fabric that forms the main body of the garment shows at the center back seam the former concentrated blue that survived possibly due to its safe nestling in a previous life within the recesses of a seam that protected it from the light's damaging rays.

Illustrative of Derek Jarman's musings, in this well-loved *noragi*, "Blue stretches, yawns, and is awake." Indeed, dyers across the world, from Mexico to Japan, consider indigo to be alive as they mix, stir, and coddle the dyeing vat to cajole from it a magical color that converts before one's eyes from a pale yellow-green to blue as soon as it is exposed to oxygen, as soon as the cloth is pulled from the vat. This is merely the first cry that develops into deepening blues with successive dips into the dye bath, a layered process that ensures that the dyed cloth retains its hue no matter how old or faded it becomes (Balfour-Paul 2000: 117). Anthropologist Michael Taussig has observed of this process: "Color here will not stand. Indeed, it is not so much color that is changing here in the indigo vat, but change itself that is on the view" (Taussig 2009: 149). Though long

removed from the vat, with most of the original dark indigo blues rubbed away, this *noragi* nonetheless comes to life even as we consider it off of the human body.

The indigo dye used in *boro* garments was readily available, and therefore plentiful enough to enable overdyeing to refresh the color if necessary. It was also considered by rural communities across Asia to have medicinal properties that, in rubbing off on the wearer's skin, could offer protection from snakebites, among other potential threats in the field (Balfour-Paul 2000: 194–195). Given its cultural importance, as well as the intricacies involved in the preparation and dyeing processes, indigo growers and dyers to this day in Japan are classified as "national living treasures," and in Japanese spoken language the word *ai* means both "indigo" and "love" (Balfour-Paul 2000: 9, 127–128).

Boro clothing such as the *noragi*, made out of precious scraps of cotton and showing the remains of rich blue indigo dye, is a product of necessity but also expresses a deep-seated Japanese cultural tradition termed *mottainai*, which stresses the value of everything on earth and the need to use our creations fully. Originally a Buddhist concept, *mottainai* translates as the admonition "do not waste," as well as the act of being "thankful." This perception of one's place and actions in the world has deeper roots in ancient Shinto religious beliefs that consider all objects to have souls, a view that extends to the recognition that everything in our physical universe is interconnected (Durston 2011: 2, 58). *Wabi-sabi*, another Japanese aesthetic derived from Buddhism, supports and encourages the appreciation of such worn, tattered, and faded pieces as poignant models for the beauty to be found in the physical evidence of time passing, of change as a natural and inevitable part of an object's life cycle. They remind us that "nothing lasts, nothing is finished, and nothing is perfect" (Powell 2004: 19).

In 2013 Domaine de Boisbuchet, a country estate in southwestern France and site of summer design workshops organized by design curator and collector Alexander von Vegesack, mounted the exhibition *Boro: The Fabric of Life* in collaboration with Brooklyn-based curator and dealer Stephen Szczepanek. In this display, installed in the elegant yet ramshackle rooms of a nineteenth-century chateau, variegated indigo hues efflorescing within threadbare *noragi* and other *boro* pieces offered Boisbuchet's design-conscious audience a lesson in the beauty of aged designs nurtured and revealed by daily use, attention, and preservation.[2]

In their state as exhibited relics of another culture and time period, the original functional purpose of the indigo-dyed pieces as workwear had very clearly come to a close, but they nonetheless pulsed with life within a sympathetic environment dedicated to "the relationship between culture, agriculture, and nature."[3] The journey of such pieces to the assuredly unexpected end of gallery display was prolonged, extended, and certainly enabled by the carefully hand-sewn patches

(distinguished by their darker color) bolstering the rents that emerged with heavy use. In his memoir *Passions and Impressions* the Chilean poet Pablo Neruda wrote:

> It is worth one's while, at certain hours of the day or night, to scrutinize useful objects in repose: wheels that have rolled across long dusty distances with their enormous loads of crops or ore, charcoal sacks, barrels, baskets, the hafts and handles of carpenter's tools. The contact these objects have had with man and earth may serve as a valuable lesson to a tortured lyric poet. Worn surfaces, the wear inflicted by human hands, the sometimes tragic, always pathetic, emanations from these objects give reality a magnetism that should not be scorned. (Neruda 1983)[4]

The *noragi* and other *boro* garments, in their current state as objects on display, well serve the vision called forth by Neruda. They are now among the "useful objects in repose," sighing under the weight of intense personal use, as well as layered cultural histories specific both to their origins in rural Japan and to the crisscrossing paths that brought the materials to their makers and wearers.

Despite the end of their functional life, the *boro* pieces resonate with a haunting beauty that is enlivened by the many different indigo hues drifting across their surfaces. Their magnetism remains precisely because of the ways in which the naturally faded blue fabrics provide seductive evidence of an intimate, though anonymous narrative arc of care and devotion. Allowing ourselves to contemplate the lives lived in such garments—to feel (even for a moment) such a relationship to the history embodied in the sea of blue patchwork comprising such heavily used objects—connects us to the broad concepts of *mottainai* and *wabi sabi*, and therefore to a universe much bigger than the material world we face on a daily basis.

Quite the same may be said about the quilts of patched-together denim workwear scraps made by members of the now-famed Gee's Bend, Alabama, African American community, items that are among a group of pieces praised in a *New York Times* review as "some of the most miraculous works of modern art America has produced" (Kimmelman 2002). Many quilts made by the women of Gee's Bend in the mid-twentieth century comprised precious pieces of deconstructed denim (sometimes stitched together in memory of a deceased husband or other family member) that highlight the poetic undulations of indigo-dyed cotton twill worn during the lifetime of one's beloved.[5] Similar to the *noragi*, such quilts were born out of necessity and practicality. They were also made with a steady craftswoman's hand and an artistic eye.

Like the remnants of denim trousers in the Gee's Bend quilts, workwear around the globe is most often indigo dyed, from European sailors' uniforms to the original Levi-Strauss overalls made for California goldminers. Such

European and American utility wear is now regularly culled by vintage dealers and presented as honest and functional material rich with meaning and history. Toile de Chine is one of many such vintage design enterprises. The label was started by a former fashion designer who named the company after a specific and highly valued indigo-dyed sateen cloth imported from China to Europe in the seventeenth century and after. The garments for sale at Toile de Chine in fact show characteristics most similar to the more utilitarian product labelled *jean fustian* (a cotton twill-woven cloth made in Genoa, Italy, that has given us the English term "jeans") and the slightly better quality *serge de nimes* ("serge from Nimes," from which the English word "denim" derives). Both types of textile were employed for workwear across Europe for centuries due to its durability and wash-fast indigo dye (see Balfour-Paul 2007).

Three of the earliest surviving Levi Strauss & Co. jeans, dating between 1879 and about 1890, are now preserved in the American company's archives and travel around the world as historical and aesthetic relics. When on display in 2011 at the brand's Japanese Shibuya location in celebration of the launch of the "Overalls the Origin" initiative, these "artifacts" were literally given "white-glove" care by the exhibition curatorial staff. This event was designed to celebrate the re-working and re-release of three of Levi's original styles, capitalizing on the deep history embedded in the surviving garments, and hence the Levis brand. More than their vintage silhouettes, one can only assume that the heavily guarded archive pieces resonate in the Japanese context, as well that of Europe and America, because of the essence of universal labor that can be read as radiating from the creases and scuffs of the chafed indigo cotton. Despite much wear and tear, the denim has survived with many stories to tell in both the areas where the blue has been rubbed away, as well as in the transitions to depths of blue closer to their original hue.

The Austrian painter Gustav Klimt, active in the first decades of the twentieth century, evidently shared in our contemporary desire to experience the power of working and dwelling within the folds of an indigo-dyed worker's garment. Following in the footsteps of agricultural laborers throughout Europe, Klimt donned a deep blue cotton smock as he set out to labor over his canvasses, embarking on the imprinting of his own particular narrative in the billowing blue of his raiment. In this light, might we look at Klimt's smock and the items mentioned above as examples of what Michael Taussig has termed "polymorphous magical substance," defined as that which "affects all the senses, not just sight. It moves. It has depth and motion just as a stream has depth and motion, and it connects such that it changes whatever it comes into contact with. Or is it the other way around? That in changing, it connects?" (Taussig 2009: 40). I would argue that the ever-shifting indigo garments—whether worn and inhabited, as by Klimt, or admired from a distance—invite contemplation, emotional response, and, most importantly, an almost irrational bonding as they morph and slip from our grasp as stable material objects.

Certainly the Polish-French painter Balthus felt viscerally connected to the transformations taking place as he wore his indigo coat daily in his studio for over sixty years. According to Katerina Jebb, the artist who created an image of the garment by scanning the original coat and printing the image full-sized, this piece of clothing was "the central piece of his working life. He was obsessed by it, and it seemed to hold more for him than just an ordinary object of clothing" (Thawley 2013). Balthus got this so-called *tablier* at the American Hospital in Paris during the Second World War and wore it religiously when painting, asserting that "When I'm wearing this *tablier*, I'm really me" (Thawley 2013).

Instead of donning the artist smock herself, the American fiber artist Sheila Hicks chose to display worn and faded denim smocks as a challenge to the prevailing language of art in the 1970s. Hicks stated, "… this basic material has a profound echo. You can sense the presence; it is powerful … I found I could work with it and say meaningful, significant things about the world" (Hicks 2004). Imbued with the memories and hallmarks of use created by countless unnamed individuals, the smocks blossomed in the artist's mind as, above all else, "objects of patience" (Hicks 2004). She saw them as items that were made to last, made to incorporate rather than defy the flow of time. Similarly, Ann Hamilton's 1991 installation in Charleston, South Carolina, titled *indigo blue*, included as its focal point an enormous stack comprised of thousands of blue denim work pants and shirts. In the absence of the countless blue-collar workers' voices left out of mainstream historical narratives, Hamilton's installation sought to give the anonymous worker agency through the sweat and tears embedded in the lifespan and in the making of the heap of now-disembodied clothing (see Hamilton 2007: 333–336).

As one last example of the inspiration that fine artists have found in faded indigo, the work of Polish artist Agata Michalowska, a 2007 graduate of the Rhode Island School of Design's printmaking department, offers a more contemporary instance of the magnetism of the ebb and flow of indigo blue. Plate 16.2 shows a piece that Michalowska has evocatively titled: *in that one moment I can see dust collect on my fingertips*. The meaning of this title becomes beautifully clear as we contemplate the artist's laborious process of handcrafting the paper rectangles, studiously rubbing them with indigo, and then burnishing them by hand to produce a surface that, like the *boro* workers' garments, seems almost unfathomable. Time suddenly stands still as we view this artwork, allowing us the space to connect with the materiality of the piece and contemplate the labor involved in its making.[6]

Fashion designers, of course, have traditionally had little interest in slowing down time to the extent that dust might be perceived as collecting on one's fingertips. Nor has fashion typically celebrated the patina of the old and ragged, beloved and well-used garment. But in her book *Fashion at the Edge*, fashion historian Caroline Evans has mined and highlighted the atypical, in stating: "When

designers fetishized craft techniques, emphasizing the beauty of the flaw and the value of the mark of the hand, they performed a kind of alchemy." I posit that the fashion examples that follow attempt such alchemy, expressly through their focus on the magical storytelling possibilities enabled by the surface inconstancies and mysteries of faded blue denim. These are qualities that foster deeply personal connections and awaken in us an appreciation for the beauty of imperfection and the vagaries of time.

The designs of Maison Martin Margiela, one of Evans's exemplars of fashionable dereliction, have for decades quoted from the rag-picker's aesthetic lauded by Charles Baudelaire. In particular, several designs from the Spring 2009 Artisanal line employed strips of second-hand, torn denim strips reassembled into a new moving canvas of dark to light ombré coloration. Here the Margiela tropes of faceless model and collective designer credit cleave with the anonymous workaday connotations of frayed and worn denim and its spectrum of eroded, bleached hues. Yohji Yamamoto has likewise long incorporated an "aesthetic of poverty" in his designs as he has looked to August Sander's early twentieth-century portraits of anonymous workers, as well as to the *wabi sabi* aesthetic of his native Japan. In his menswear collection of S/S 2015, workwear became prominent once again and was eloquently expressed in layers of blue shades pooling together in a variety of ensembles referencing diverse indigo traditions.

Junya Watanabe has taken many dips into the world of indigo workwear, giving emphasis to the rise and fall of color in the folds, creases, and complex patchwork of his creations. Themes of worldwide textile traditions, artisanship, and utility are suggested by his incorporation of traditional indigo-dyed cottons and pointed quotations of reinforcement techniques used in *boro* (Figure 16.1). Now trademarks of the designer's aesthetic, these citations have reverberated in his womenswear collections since the deconstructed denim pieces that featured in his Spring 2002 collection, and they have increasingly cropped up in his menswear collections since Spring 2012. Given that the designer tends to be tight-lipped in regard to his conceptual process, his uncharacteristically emotional statement in a 2009 interview that, "I love workwear and the American tradition,"[7] reveals the profound inspiration he finds in the "universal blue" of the world's laborers.

Founded in 1991 in Osaka, the Japanese designer jean label Evisu (first named Evis in homage to the famous company but without the "L") was at the forefront of the Japanese craze for replicating vintage Levi's and Lee jeans, introducing its first sub-label in 1995 aptly called "Labor." The brand's "Dirty Dozen plus one" reworked denim project (2007–2009) was conceived in collaboration with the online community Supertalk as a collective action designed to produce a special edition collection as follows: "Worn for one month by thirteen devoted volunteers from all over the world, each dedicated wearer of a pair of EVISU jeans lends a helping hand—well, lower body—in the breaking-down and wearing-in of the

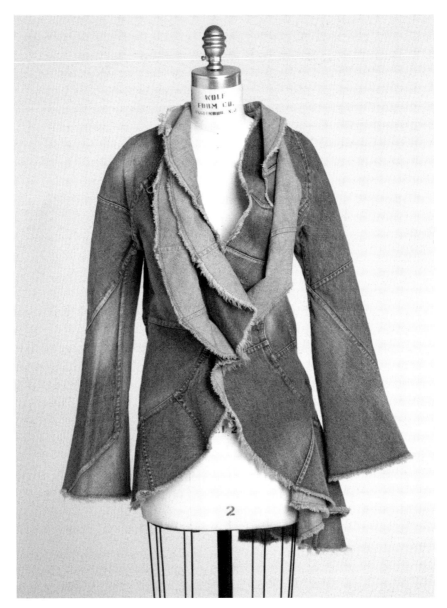

Figure 16.1 Woman's jacket, spring/summer 2002. Pieced cotton twill weave. Junya Watanabe, design label. Junya Watanabe, designer, Japanese. Collection of the RISD Museum, Gift of John W. Smith 2015.34.

fabric, ensuring that the result is a one-of-a-kind customization, and all kinds of badassness."[8] Individuals from New York to Berlin to Singapore and back (with many points between) made their mark on the pair, adding layers of global

narrative and meaning usually accumulated over decades. Here time races forward in celebration of slow and steady labor and artisanship.

In designs for his fashion label Visvim, Hiroki Nakamura also mines the heritage of Japanese indigo-dyed workwear while freely incorporating the feel of 1960s countercultural jeans-wearing youth. As a teenager, the designer travelled the United States looking for vintage Levi's to wear back in his native Tokyo. Nakamura's recent travelling pop-up project, the Indigo Camping Trailer, was offered as an antidote to what he sees as the increasingly corporate urban shopping experience. As one review put it: "Nakamura began the show in Sendai where he set up his '40s era trailer filled with an eclectic array of indigo goods much of which are exclusive to the project. Much of the team was on hand to man the flea market wearing some of the products, including patchwork paisley quilted jackets, *noragis*, and rugged chore coats" (Trotman 2013). Apropos of this context, Visvim's denim line is named "Social Sculpture," after Joseph Beuys's concept of art-making as a conscious, collective act of creation, transformation, and recreation.[9]

As a guest member of the Chambre Syndicale de la Haute Couture, the Chinese fashion designer Ma Ke presented her conceptual Wuyong (translated as "Useless") collection in the gardens of the Palais Royal during the 2008 Paris haute couture collection shows. A cotton spinner, indigo dyer, and weaver worked alongside performers wearing naturally dyed and hand-woven garments inspired by the clothing of Chinese peasants. In this presentation, the indigo garments among the earth tones of the other collection pieces might be read as expressing the balance of the celestial and the earthly in the natural world. In an ensuing Ma Ke installation that was part of the 2010 "Taking a Stance" exhibition in Shanghai, garments of sturdy cotton in natural shades, including indigo, were displayed as if they were in archaeological grave sites, mottled and wrinkled yet carefully laid out on a bed of dirt. In the words of Ma Ke: "Genuine Fashion today should not follow the glamor of trends. It should instead uncover the extraordinary in the ordinary, for I believe that the ultimate luxury is not the price of the clothing, but its spirit."[10]

One last example, in an admittedly fast romp through some of contemporary fashion's more studied responses to lived-in indigo garments, is the work of the Los Angeles-based label Dosa, in particular its thirty year anniversary "reissue" collection (Plate 16.3). Of this collection, Cristina Kim, the label's founder, says that she wanted to "capture a sense of returning home. For weeks, I reviewed and studied thirty years of archives—mesmerizing color palettes and textiles chronicling all the places I traveled and artisans I met. With every piece of Dosa clothing, there is an imprint of me that is passed along, becoming a part of someone else's story." Over the years, Kim used traditional natural indigo fabrics made in Mexico and India, as well as by Yoruba, Tuareg, and Miao artisans for her designs with the express purpose that they will last long, grow old, transform,

and, as such, meld with the wearer to add at least one more layer to an already rich history of making and creativity. Part of this anniversary collection, a coat made of a deep blue glazed cotton handmade by Miao women from the Guizhou Province of China comes accompanied with the reminder: "Because the travel coat is dyed naturally, the indigo color may bleed or rub off while wearing." Hardly a deterrent, this statement reads more as an invitation to record one's life, love, and labor in the structure of the coat.

In the presence of indigo-dyed workwear such as the *noragi* discussed at the beginning of this text, I conclude that it is hard not to be intimately, perhaps inexplicably touched by a foreign object, one that is drained of its formerly saturated blues and sensitively patched and repaired, but whose color, in Michael Taussig's words, is nonetheless "bigger than the biggest ocean" (Taussig 2009: 152). With pools of color that are hardly shallow, such pieces offer much for contemplation and appreciation, inviting us to become archaeologists of sorts in a world of consumer goods that is most often moving much too fast for the accumulation of deep meaning. Made to last, the indigo blue of sturdy cottons may recede and morph with use and time, but such changes mark an intensified meaning that animates the garment and binds it to us with memory and emotion. Such well-used, well-loved, and well-maintained pieces have inspired many contemporary designers, who in turn ask us to find meaning and beauty in not only the ravages of time but in the care and attention that guided such pieces into the present and into our collective vision. It is now our turn to inscribe our history, our narrative, our care and repair.

Notes

1 Text quoted from the web site evanizer.com (http://www.evanizer.com/articles/blue/ index.html [accessed October 14, 2014]).

2 See also the exhibitions "Ragged Beauty: Repair and Reuse, Past and Present," guest curated by Yoshiko Wada at the Museum of Craft and Folk Art in San Francisco (2004); and "Boro: Threads of Life" at Somerset House in London (2014).

3 See http://www.boisbuchet.org/category/exhibitions/ (accessed August 27, 2015).

4 Thanks to Peter Stallybrass, "Worn Worlds: Clothes, Mourning, and the Life of Things," in *Cultural Memory and the Construction of Identity* (Detroit: Wayne State University Press, 1999) for this reference.

5 See, for example, Annie Mae Young's 1976 work clothes quilt now in the collection of the Tinwood Alliance. This piece was reportedly the first Gee's Bend quilt to catch the eye of the collector William Arnett, whose collection served as the basis for the Gee's Bend quilt exhibitions that travelled around the United States for several years.

6 E-mail correspondence with the artist, 2014.

7 "Sentimental Journey," *Interview*, published February 27, 2009. See http://www. interviewmagazine.com/fashion/junya-watanabe/# (accessed November 26, 2015).

8 This information comes from the Facebook page for "Evisu Project—Dirty Dozen + 1": https://www.facebook.com/media/set/?set=a.10150739859051974.46772 7.72958496973&type=1&comment_id=23246903&offset=0&total_comments=12 (accessed August 31, 2015).

9 Beuys's statement in regard to his own art is equally applicable to the themes laid out in this essay: "That is why the nature of my sculpture is not fixed and finished, processes continue in most of them: chemical reactions, fermentations, color changes, decay, drying up. Everything is in a state of change." Quoted in Carin Kuoni, ed., *Energy Plan for the Western Man: Joseph Beuys in America* (New York: Four Walls Eight Windows, 1990), 19.

10 "Ma Ke and Wuyong, Chinese Designer," *Tarde o Temprano*, March 22, 2010. See http://www.tardeotemprano.net/ma-ke-wuyong-chinese-designer/ (accessed November 26, 2015).

References

Balfour-Paul, Jenny (2000), *Indigo*, Chicago, IL: Fitzroy Dearborn Publishers.

Balfour-Paul, Jenny (2007), *Indigo*, London: Archetype Books.

Blue (1993), [Film] Dir. Derek Jarman, London.

Durston, Diane (2011), *Mottainai: The Fabric of Life: Lessons in Frugality from Traditional Japan*, Portland, OR: Gallery Kei and Sri at Portland Japanese Garden.

Hamilton, Ann (2007), "From Indigo Blue," in *The Object of Labor: Art, Cloth, and Cultural Production*, Joan Livingstone and John Ploof (eds), Chicago, IL and Cambridge, MA: School of the Art Institute of Chicago Press and The MIT Press.

Hicks, Sheila (2004), Oral History Interview, February 3, 2004–2011 to March 2004, Archives of American Art, Smithsonian Institution.

Kimmelman, Michael (2002), "Art Review: Jazzy Geometry, Cool Quilters," *New York Times*, 29 November.

Neruda, Pablo (1983), *Passions and Impressions*, New York: Farrar, Straus, Giroux.

Powell, Richard R. (2004), *Wabi Sabi Simple: Create Beauty, Value Imperfection, Live Deeply*, Avon, MA: Adams Media.

Taussig, Michael (2009), *What Color Is the Sacred?*, Chicago, IL and London: University of Chicago Press.

Thawley, Dan (2013), "Katerina Jebb Scans Balthus at DSM New York," *Interview Magazine*, 23 December. Available from: http://www.interviewmagazine.com/art/ katerina-jebb-scans-balthus-at-dsm-new-york/(accessed November 26, 2015).

Trotman, Samuel (2013), "Visvim's Indigo Camping Trailer," *WGSN Insider*, 21 November. Available from: http://www.wgsn.com/blogs/visvims-indigo-camping-trailer/(accessed November 26, 2015).

INDEX

Note: Locators with letter 'n' refer to notes.